The Disney
Animation Renaissance

The Disney Animation Renaissance

Behind the Glass at the Florida Studio

MARY E. LESCHER

UNIVERSITY OF
ILLINOIS PRESS
Urbana, Chicago, and Springfield

Library of Congress Cataloging-in-Publication Data
Names: Lescher, Mary E., 1957–2019, author.
Title: The Disney animation renaissance : behind the
 glass at the Florida studio / Mary E. Lescher.
Description: Urbana : University of Illinois Press,
 [2023] | Includes bibliographical references and
 index.
Identifiers: LCCN 2022020580 (print) | LCCN
 2022020581 (ebook) | ISBN 9780252044779
 (cloth ; acid-free paper) | ISBN 9780252086861
 (paperback ; acid-free paper) | ISBN
 9780252053825 (ebook)
Subjects: LCSH: Walt Disney Feature Animation
 Florida—History. | Animation (Cinematography)—
 United States—History—20th century. | Animated
 films—United States—History and criticism. |
 Computer animation—History.
Classification: LCC NC1766.U52 L5456 2023
 (print) | LCC NC1766.U52 (ebook) | DDC
 791.5/8097924—dc23/eng/20220525
LC record available at https://lccn.loc.gov/2022020580
LC ebook record available at https://lccn.loc.gov/2022020581

I dedicate this book to all those
connected in some way with the Florida studio;
to the people who devoted their time, talent, and skills
to the art created by this unique animation family.
May it inspire future generations just as we were inspired
by those who came before us.

You bring honor to us all.

Contents

Acknowledgments

Thank you to all the people who helped me during the creation of this history, first and foremost Dr. Robert Neuman at Florida State University, who believed I had something to say and kept me on track when I was overwhelmed by its enormity. There was also the patience and support of Daniel Nasset and the team at University of Illinois Press, who understood the importance of this project and worked with me to make it better. Thank you to all those in the Department of Art History at Florida State University who watched me struggle over the years and knew I would find my way eventually: Dr. Laura Lee, Dr. Adam Jolles, Jean Hudson, Kathy Braun, Sheri Patton, Pamela Brown, Dr. Paula Gerson, Dr. Valliere Richard Auzenne, Dr. Karen Bearor, and Peter Weishar. I am grateful for the grant and fellowship funding from Florida State University in helping to offset the costs incurred by my research.

I must acknowledge the amazing support and encouragement I received from the Walt Disney Company itself. I am truly grateful for being allowed access to the resources at the Walt Disney Animation Research Library (ARL), the Walt Disney Archives, and Walt Disney Imagineering's Information Research Center (IRC). I could never have been so precise in my data without their devotion to, and preservation of, the artwork and records related to this period. I especially want to give my heartfelt thanks to the entire ARL team, most notably to Mary Walsh, who corresponded with me for years before I even submitted my proposal, and to Fox Carney and Doug Engalla, for their sense of humor and belief in my ability to document this funny little studio in a reverent and respectable manner. They answered many of my never-ending questions, bringing out treasured resources they have tucked

away in those temperature-controlled vaults. You are truly the guardians of the legacy! At the Walt Disney Archives, I am indebted to Rebecca Cline and her talented team: Stephen, Justin, Kevin, and Alesha. I want to also thank Aileen Kutaka and her staff at the IRC; even though we spent a short amount of time together, Diane and Denise opened all the files they had on the attraction, and Charles answered my questions about construction and design. I still have so much more to ask! I'm also grateful for the cooperation extended to me by the Disney Enterprises division, where Margaret Adamic and Maxine Hof assisted in making my research with the company possible and provided me with guidance in requesting permission to use their images.

My research included time spent at the Museum of Modern Art in New York, where film curator Ron Magliozzi and his assistant Ashley Swinnerton were kind enough to discuss Disney's long-standing relationship with the museum and grant me access to their available records. I want to also thank professional colleagues Howard Beckerman and John Canemaker, who took time out to talk with me about the industry and give me their perspective on this special moment in animation history. And I want to acknowledge the importance of the independent documentary *Dream On, Silly Dreamer* (2005) by Dan Lund and Tony West. These filmmakers had the courage to document not one, but two, occurrences in the Disney Studios' history when the artists were stunned to learn that their talent and passion were no longer valuable to the company. This honest, if painful, documentary confirms facts and events but also reminds us that the human element is an important part of this story. This fact should never be lost when considering that animation is a form of fine art, even while it is a commercial venture.

I am especially grateful to my entire animation family from four studios on three continents who have shown support and enthusiasm for this project and understand how special our time was together. Thanks for all the interviews, the dinners, and the bottles of wine; I am conscious of how many people opened up their hearts and their memories to talk about our years working in Orlando. I have spent long hours and sleepless nights trying to find the right words to describe the wonders we achieved and the magnificent creative spirit that surrounded us. It was our combined efforts in working on these fascinating projects, in such a magical place, that keep those memories alive. I am gratified by the words, the ideas, and the anecdotes I have been able to share. Through frenzied times, migraine headaches, and killer deadlines, we achieved amazing results that will withstand the test of time. It has not always been easy harkening back to those days, and I can readily understand those who chose not to participate in this project. Even so, they are family to me. So I say thank you, my family at Walt Disney Feature Animation Florida,

for believing that I could complete this history and for supporting me in the success of this academic adventure. I remain humble to think of being both a participant and a recorder of those events.

Finally, I truly appreciate the patience and love shown by all my family as I was driven on by their confidence in my ability: my mom and dad, Rick, Mark, Melissa, Mary, and all the kids. There is also my other family: Judy and Bruce, Jeneine and Chuck, and the kids. Added to this are those friends who are like family to me, who watched this adventure unfold over the years: Richard Gorey; Lisa Gillespie; Sylvie, Lawrence, Stanley, and Clément Bennett, Matthew McLendon; Kathy Schoeppner; Pam Darley; Jay Shindell; Max Howard; Rosemary Healey; Brent Tiano; Cherry Weiner; Mark Wollard and Bryan Fitzgerald; River and Troy Spencer; my fairy goddaughter, Kayla; and the indomitable Paul Rothenberg. Most of all, I want to thank my partner, John Urbancik, without whom I would never have had the courage, nor the resilience, to take this project on, much less complete it. Thank you for all the meals, the emotional support during my temper tantrums and hysteria, and for believing my vocabulary and grammar would somehow show up one day. This book would not exist if not for your confidence and support.

This work has come about not because I am fixated on the past; it is so that I may preserve a glimpse of this period for the future, a legacy for future generations of artists and lovers of the animated art form. We gave our passion, our creativity, our hunger, our bruises, and our sleepless nights to create lasting works of moving imagery. Drawing from the hand and the heart, and assisted by bold and innovative new technology, it is the human spirit, the organic touch, that gives these films a sentient quality all their own. I contributed one small part to their creation, but I am sincerely glad to have been that part. *Merci beaucoup!*

Introduction

From 1989 through 1999, Walt Disney Feature Animation experienced a revitalization often referred to as the Disney Renaissance. It elevated the animated art form in terms of both its creativity and technological achievement, evidenced by such blockbuster films as *Beauty and the Beast* (1991), *Aladdin* (1992), *The Lion King* (1994), and *Mulan* (1998). While much of the academic scholarship on this period focuses on the Disney Company's Burbank studio, another animation studio existed. Walt Disney Feature Animation Florida (WDFAF) operated as part of an attraction from May 1989 through March 2004 at the Disney-MGM Studios theme park, part of the Walt Disney World Resort in Orlando, Florida. A study of this Florida studio is essential because the facility represents a microcosm of the entirety of Walt Disney Feature Animation during this extraordinary period. It is an illustration of what was occurring in the animated art form, specifically the dramatic shift from traditional hand-drawn animation to a purely digital format—the movement from a state of *mechanization* to *computerization*. Debuting on May 1, 1989, the Florida studio also served as part of a grand experiment whereby Disney displayed its animation process to the public in an attraction called the Magic of Disney Animation, allowing theme park guests to act as silent observers as animators worked on the other side of a large glass partition. Thus, this history of the Florida studio is emblematic of how advancements in computer technology revolutionized animation as an art form—moving from a supporting role to a dominant position within the industry—and how a cultural revolution was also taking place, demonstrated by the continuing evolution of the Magic of Disney Animation as theme park entertainment.

The Florida studio was part of a real-life experiment: a production facility operating within a theme park environment, a studio/attraction if you will, that exposed working professionals to the gaze of the general public. This characterizes the Florida studio as the alter ego of the Magic of Disney Animation, and it is this dual identity that demonstrates how the studio was initially presented as "entertainment" within the attraction. To distinguish the various time frames within this discussion, I will be referring to specific phases encompassed within its twenty-six-year life span (1989–2015). The best known of these phases is the Disney Renaissance itself, a decade that lasted from 1989 through 1999. Within that time frame, the blockbuster period (1991–1994), featuring *Beauty and the Beast*, *Aladdin*, and *The Lion King*, caught the attention of the ticket-buying public. In the chronology of this studio/attraction, it is possible to distinguish each film's importance in relation to those that came before, its overall significance within the Disney filmography, how it demonstrates the Florida studio's contribution, and its reception by the public at large. In association with the films, I identify key individuals who shaped the studio's history within areas of management, directorial teams, and the crew itself. By introducing important personalities involved in the making of the films, we can determine why decisions were made to include or discard various elements during the production process. With this evidence of the artists, the technology, and the production environment, and by keeping in mind its larger relationship with the California facility, I reveal this little-known studio to be a key player in the Disney Renaissance.

The Magic of Disney Animation was part of the overall entertainment complex known as the Disney-MGM Studios (now Disney's Hollywood Studios), conceived and constructed by Walt Disney Imagineering (WDI), the company's theme park design group. The attraction was set up to teach theme park guests about the animation process through a display of the production pipeline, making animation more accessible to the general public. It showed the visitor concrete examples of the steps necessary in creating a Disney animated film, basically allowing them to see the animators in action.

While the Florida studio might have begun as "entertainment" within a theme park attraction, it quickly evolved into a full-service production facility, later creating three full-length feature films of its own. Open since 1989, by the time the studio approached its fifteenth year of operation, internal and external events had contributed to management's decision to shut down all cartoon production in Florida. In 2004 the premises of the studio/attraction were transformed into an interactive exhibition space where guests could experiment with various facets of the animation process for themselves. The

Magic of Disney Animation outlived the Florida studio, existing for another eleven years in a new and radically different form until its final closure in 2015.

What makes this studio/attraction so important? The life span of the Florida studio encompasses a technological revolution as animation production entered the digital age. Even with increasing scholarly attention being paid to the advancements made during the Disney Renaissance, the Florida studio has received little investigation thus far. Through examples from its history and filmography, I offer evidence of how the computer affected the method of animation production at the end of the twentieth century and how American culture itself reflected those advancements. Examining multiple films within each chapter, I demonstrate how various elements such as art direction, character development, special effects, and camera mechanics, in tandem with narrative and sound, reflect aesthetic and technological developments. These developments were made possible particularly through the introduction of two significant computer advancements. One was the birth of computer-generated images (CGI or 3D), which led to the development of the Pixar animation style with which we are familiar. The other, more important to this discussion, was Disney's proprietary software CAPS, the acronym for Computer Animation Production System, which allowed the computer to alleviate various labor-intensive processes within the traditional cel animation process and contributed to the increasingly more sophisticated visual solutions.

Thus, this studio/attraction serves as an example of rapid technological growth and how traditional production methods were being challenged, modified, and ultimately abandoned. These changes are evident in the films being released during this time, as they display a growing complexity that could not have been achieved otherwise. However, something less often associated with the Disney Renaissance is how the computer revolutionized communications capabilities, affecting both business and personal transactions, necessitating a steep learning curve within all facets of society. I characterize this situation as a major step in cultural development, so much so that within the first fifteen years of the studio/attraction's timeline (1989–2004), we see a decided shift to the increasingly computer-dependent society we know today. Thus, this narrative also examines social modifications due to technological growth at the end of the twentieth century and moving into the new millennium.

The studio/attraction demonstrates these concurrent cultural developments due to its role as an entertainment outlet. To visualize the role of the computer in its technological and sociological aspects, this history examines steps in the evolution from being a mechanized society to a computerized

one. Compared to the 1970s and 1980s, when only hardware technicians and software engineers understood the capabilities and advantages of this new technological apparatus, the 1990s saw increasing integration of computer systems into everyday life. The Renaissance films highlighted within each of the following chapters provide a framework for this development by showing how the computer was introduced into the traditional animation process and demonstrating how the technology continually raised the level of complexity within the films' visuals until the ultimate metamorphosis of Disney's *illusion of life* aesthetic into a completely digital format. CAPS began by playing a supporting role in Disney's traditional animation pipeline. It was initially intended to handle tasks in the latter stages of production that required extensive time to complete each film. However, this proprietary software gained an ever-increasing presence throughout the years of the Disney Renaissance, resulting in aesthetic and technological leaps forward that can be recognized as a vital component in the success of Disney's blockbuster period. This book investigates how the computer's role throughout the Renaissance was necessary, helping us understand the challenges affecting the entire animation industry at this time. Thus, this account of the Florida studio's contribution to animation history is invaluable, as it provides an insider's perspective of how these now classic films influenced an entire generation—and how that generation matured in a dramatic leap forward in mass communication and computing power.

Defining Animation

This discussion builds upon previous scholarship heavily devoted to the origins of animation in the first half of the twentieth century—specifically, the golden age of Disney animation in the late 1930s and early 1940s. It took time for a serious appreciation of animation as an art form in academic circles to be accepted. In 1942 the Walt Disney Studios cooperated with Dr. Robert Feild, a professor at Harvard University, who authored one of the earliest art-historical analyses of Disney's animated films in *The Art of Walt Disney* (1942).[1] This volume is an exception to most books illustrating Disney's golden age because it is written with a contemporary critical eye toward reigning aesthetic trends and mass cultural acceptance.

As curiosity about Disney's method of animation creation grew with the general public, another book, *The Art of Animation*, written by Bob Thomas, was released with the *Sleeping Beauty* traveling exhibition in 1959.[2] The Thomas volume was patterned after a mock-up edition was occasionally featured on Walt Disney's *Disneyland* anthology television series. Animation

veteran and School of Visual Arts instructor Howard Beckerman recalls that in 1958, a year before *Sleeping Beauty* was released, a museum-like exhibition was set up in the windows of the Stern Brothers department store in New York City. This display highlighted the animation process using both artwork and small video monitors running continuous loops using 8mm film cartridges. It was the latest technology showcasing Disney's newest film.[3]

Today this early period in animation history has been well researched and documented by leading academicians such as John Canemaker, Donald Crafton, John Culhane, Didier Ghez, J. B. Kaufman, and Charles Solomon. Other books on animation include practical instruction from the now legendary artists who forged the Disney house style during Walt Disney's lifetime: Frank Thomas, Ollie Johnston, Marc Davis, Joe Grant, Floyd Norman, and Walt Stanchfield.[4] For a general survey of animation history, Michael Barrier and Leonard Maltin provide broad overviews and complete filmographies of animated shorts and feature-length films categorized by individual studios, including Disney, while other authors focus on individual films, often in the form of coffee-table books released simultaneously with the film's debut.[5] As these latter publications were created under the direct auspices of the Disney Company, they do not always provide a balanced perspective of their subject matter. Therefore, it is necessary to include critical texts outside the company-sponsored volumes, though I acknowledge their importance in gathering facts and imagery that are directly connected with the films.

Before the advent of the internet, much of the information about actual animation production came in the form of early documentaries and television episodes that provided glimpses of the working pipeline, often just enough to whet the appetite of Disney's audience. These featurettes, episodes, and television specials served to attract the public's attention and advertised current releases from the studio. They raised the public's awareness of animation as a form of entertainment, albeit with less emphasis of its value as a form of fine art. With the advent of television in the 1950s and 1960s, animation soon came to be regarded as simply children's fare, with isolated adult-oriented films being released theatrically for an older demographic.[6] It was not until the 1980s, when Frank Thomas and Ollie Johnston wrote the tome that would become Disney's animation bible, *The Illusion of Life*, that the actual nuts and bolts of the animation process were explained for the layperson.[7]

Since the widespread acceptance of animation as a form of fine art, historians have been struggling to reach an all-inclusive definition of the art form and its theoretical connotations. In 1986 Canadian animator Norman McLaren defined animation as the interstitial movement that occurs between frames in an animated film.[8] In 1989 Edward Small and Eugene Levinson

published an article outlining the animation community's difficulty in devising a theory that covered such a diverse art form under one ubiquitous label.[9] In academic texts, theory-driven scholarship often focuses less on defining the art form and more on individual filters when regarding its influence, such as feminism, gender, ethnicity, aesthetic stylization, and structuralism, discussed by such scholars as Robin Allan, Esther Leslie, Eric Smoodin, Annalee R. Ward, and Paul Wells. The scholarship that guided much of my research came primarily from the work of three authors: Chris Pallant, Tom Sito, and J. P. Telotte.[10] These scholars have analyzed various aspects of the Disney Renaissance in terms of both its aesthetic style and its technological achievements.

In his dissertation-turned-publication, Chris Pallant worked to relabel the recognizable Disney *illusion of life* motif, wherein he hoped to separate this hyperrealistic style from the ubiquitous title of "Classic Disney" with its many alternate connotations; Pallant identifies it as "Disney Formalism." Most important to this discussion is how he notes the resurgence and refinement of this classic house style during the Disney Renaissance.[11] Pallant's analysis of the art form leads to a theory of animation determined by the influences of its creators. He cites the work of Mark Langer, whose groundbreaking article "Regionalism in Disney Animation: Pink Elephants and Dumbo" identifies two differing motifs existing in the Disney Studio during the 1940s.[12] Pallant uses Langer's argument to support his own theories extending to the aesthetic properties in creating hyperrealistic movement through traditionally hand-drawn animation. Using Pallant's discussion of Disney Formalism, I propose to take this argument a step further by examining how the computer entered Disney's production pipeline and, once there, became subject to the same aesthetic requirements of hyperrealistic movement as the traditional artwork that came before.

While Pallant's reclassification of the hyperrealistic style, Disney Formalism, can be used to acknowledge the inclusion of the computer—first with CAPS and later its total integration into computer-generated (3D) imagery—the entry of the computer into animation production is not a vital element in his discussion. Sito and Telotte, on the other hand, examine both the entry and subsequent domination of 3D in the animation process, with Telotte going a step further in examining the concept of the total immersion of the guest within the theme park experience. This background fits in with the other aspect of the Florida studio—its counterpart, the Magic of Disney Animation. Telotte draws his theories from Paul Virilio's "reality effect," where he equates this concept to the completely "cinematized" experience when moving through a theme park attraction.[13] Virilio suggests that postmodern

culture has become "cinematized" by the technological advancements in the "mediatization" of everyday life.[14] This complete immersion of guests within a theme park attraction allows them to experience the narrative firsthand. Thus, Telotte's discourse can be applied to the original narrative of the Magic of Disney Animation attraction, which served as a surrogate experience for guests as they moved through the tour vicariously experiencing the animation pipeline as the action took place before them. This scenario later transformed into a proactive experience, whereby the spectator now enjoyed personal "hands-on" interaction in the attraction. Although they did not produce an actual film, they experienced the act of creation.

While Telotte provides a foundation for groundbreaking technological advancements during the Disney Renaissance and demonstrates the emerging pioneer spirit at the turn of the twenty-first century, when it comes to the discussion of computers entering the animated art form, he falls down the same rabbit hole as other academicians. Telotte moves directly onto the subject of computer-generated animation without giving serious attention to the offshoot of CAPS and its role as a stepping-stone in the transition from two-dimensional to three-dimensional animation production. Sito provides more information on how CAPS supported and enabled the Disney Renaissance films; however, he devotes only a single chapter to his history of the introduction of computer technology. This is only fair, since he is documenting a broader scope of how the technology advanced. However, I suggest that CAPS should be acknowledged as evidence of the wide range of possible avenues the computer offered during the late 1980s and the 1990s, before the total commitment and overwhelming immersion of animation into a completely digital form.

Pallant has already noted a lack of critical engagement with this period known as the Disney Renaissance.[15] And even with this limited scholarly engagement, the Florida studio has received little notice thus far—hardly more than a few sentences recognizing its role in contributing to the blockbuster films. I find this amazing, as the Florida studio was also part of a much larger experiment displaying sociological change as well as technological advancement affecting American culture, albeit it on a miniature scale. Therefore, recalling Telotte's theories of Virilio's "reality effect" as a point of reference, this book examines how these two roles are evident in their simultaneous existence within one structure—one as the attraction, the other as the studio entity. Both are present for the introduction and expansion of computerization within society at the end of the twentieth century and demonstrate how this dual identity is useful when analyzing the transition as experienced by both the artists and the visitors who passed through its doors.

Collating Facts and Archiving Memories

My search for information about this relatively obscure production facility followed several avenues of investigation. The first resource was the Walt Disney Company itself, whose records contain many of the unique details and copyrighted images produced during the years the Florida studio was in operation. These hard facts, however, must be tempered with the human story of what life was like living and working within a theme park. Therefore, I chose to use oral histories, producing an archive of eyewitness interviews from the artists, support staff, and animation authorities who were present during those years of production. My own personal experience of working at the Florida studio provides a strong impetus to make sure this history is not forgotten. To these personal and institutional perspectives, I added the public record found in contemporary newspaper and journal articles, highlighting the events and activities that were regarded as noteworthy along with authorized publicity statements released by the company. These avenues of research produced source materials that stand as evidence of the historical accuracy of what was occurring both culturally and technologically, in both filmic and experiential entertainment.

INSTITUTIONAL PERSPECTIVES

My research included visits to three of the Walt Disney Company's private archives in Burbank, California: the Walt Disney Animation Research Library (ARL); the Walt Disney Archives; and the Information Research Center (IRC), the latter being devoted exclusively to the work of Walt Disney Imagineering (WDI). For my purposes, the most important of these institutions was the ARL, a facility that collects, collates, and preserves millions of individual artworks and artifacts directly related to the Disney Studios' animation legacy. This archive was once introduced as the "Morgue" on *Walt Disney's Wonderful World of Color* television series.[16] In a dramatic opening sequence, Walt himself presented the storage facility, likening it to a newspaper's file room, used to house drawings, paintings, photographs, and other memorabilia that are vital evidence of the steps in creating an animated film.

With the generous help and guidance of the ARL's expert staff, I was able to pinpoint specific case studies to be used in each of the following chapters. The facility provided answers to questions about individual scenes and sequences in terms of their animation, layouts, exposure sheets (referred to as x-sheets), and other production materials. (To aid readers with the specialized terminology used in discussing animation, I have provided a glossary

in the back of the book defining industry jargon used by professionals in the business.) The Walt Disney Archives provided evidence of the public reception of the films, including journalistic accounts of the critical, financial, and political controversies that arose during the Disney Renaissance period. The archives maintain extensive files of contemporary newspaper articles, magazine features, and trade publications providing a concentrated public record connected to the period. WDI's Information Research Center is a resource devoted entirely to the artwork, photography, and other design details related specifically to the construction of the Walt Disney Company's theme parks, including those at the Orlando resort. With the generous help of the IRC's staff, I was able to piece together information from two vital sources. The art library contains digitized files of conceptual drawings, architectural blueprints, and elevations, with various renderings of the Magic of Disney Animation attraction during its initial and latter design phases. The photography library contains documentary images from the various stages of construction for the original theme park attraction, as well as the animation department's new building, which was erected toward the end of the Florida studio's existence. The IRC also preserves printed materials that were made available in the theme parks, including maps, information booklets, and show schedules. This material, available as reference for WDI's Imagineers (the architects, engineers, and designers responsible for creating the theme parks), was used to research, redesign, and renovate the Magic of Disney Animation attraction after the animators were gone.[17]

GATHERING PERSONAL MEMORIES

The most fascinating part of my research was recording the oral histories—eyewitness interviews with individuals connected with the studio/attraction. These testimonies come from the artists, management, and support staff who worked within the studio and the attraction, as well as contemporaries within the animation industry. My prior association with these talented professionals led to fascinating and informative conversations, confirming events taking place on both sides of the glass. From these stories emerged the human factor and how these people contributed to a new visual style, through the aid of computerization, that sparked, and later overwhelmed, the more traditionally accepted look of cel animation. They talked about how much was gained by digitalization and, equally, what was lost.

The people I interviewed came from all facets of the animation pipeline. They were not confined to the directors, producers, and lead animators, although many of them contributed their time and memories to this project.

I was determined to hear from the entire crew—those who worked in the trenches, up in the tour corridor, many who were on loan from California, and others connected within the industry. My subjects included cleanup animators, effects animators, background artists, inkers and painters, production managers and assistants, administrators, computer technicians—basically anyone willing to talk about their experiences. Integrated with the public record, their perspective shows how Disney's animated films display evidence of contemporary events happening within the studio, the industry, and American culture. With this information, I soon realized how a history of the Florida studio encompassed important issues concerning the computer as it entered decades-old production methods and transformed animation into a new kind of visual language—moving from a mimicry of cel animation style to the seamless integration of three-dimensional elements into a two-dimensional world, before its ultimate transition into a purely digital format. (While this period also includes the debut of completely computer-generated animation as a viable production technique, these events have been more thoroughly investigated by leading animation authorities, including Valliere Richard Auzenne, Tom Sito, J. P. Telotte, and Peter Weishar.[18])

THE PUBLIC FORUM:
PRESS RELEASES AND NEWS COVERAGE

I also researched newspaper and journal articles related to the Florida studio while it was in operation. National and global press coverage documented the films, illustrating the evolution of a newly emerging visual culture. The articles reflect how the animated films were received publicly; therefore, a large portion of my material includes media coverage of each milestone in the Florida filmography, including their critical reviews and marketing publicity. While the *New York Times* and the *Los Angeles Times* provided an all-inclusive perspective on the Walt Disney Company and their films, the *Orlando Sentinel* and the *Orlando Weekly* covered events more directly connected with the Orlando facility. Industry-driven events were covered by professional periodicals like the *Hollywood Reporter* and *Variety*. A large amount of this information was gathered during my visit to the Walt Disney Archives.

Other published sources include magazines and trade journals devoted to film and animation as an art form, including *Animation: An Interdisciplinary Journal*, *Animation Magazine*, *Cinefex*, *Cinema Journal*, *Computer Graphics World*, *Journal of Popular Film and Television*, and the *Quarterly Review of Film Studies*. These journals feature articles on the industry in general

and often showcased Disney's films at the time of their release. These materials provide a published perspective on the activities and advancements that helped shape the art form. Many of these journals are available online, along with exclusively internet sites focusing on animation and theme park industries. These latter sources include *MousePlanet*, the *Bancroft Brothers Animation Podcast*, and *Ain't It Cool News*, among others. With information gleaned from these sources, and building on a bibliography of animation scholarship, this book documents an important transformation taking place, both culturally and technologically, at the turn of the twenty-first century.

Why the Florida Studio?

One of the most extraordinary aspects of this studio/attraction is the fact that it was initially conceived as theme park entertainment. Each of the parks at the Walt Disney World Resort is themed to an overall style of entertainment appealing to a wide variety of audiences. The Magic Kingdom (opened in 1971) caters to families with small children, even while providing plenty of entertainment for adolescents and adults. Epcot (opened in 1982) is targeted toward an older audience, offering sophisticated technology- and science-based attractions in Future World, and shopping, dining, and cultural exploration in its World Showcase. The later addition of Disney's Animal Kingdom (opened in 1998) provides an active/passive environment within idealized nature, encouraging family exploration supplemented with educational and cultural diversity.

Disney-MGM Studios was the third of the Florida parks (opened in 1989) and was targeted toward young adults as well as film and television aficionados, reflecting the importance of film and television within our modern social consciousness.[19] The park's imitation of Hollywood's golden era, through its "street-mosphere" and architecture, presented guests with both live-action and animated references and can be acknowledged as one of the main reasons an animation studio was included on the premises. Blueprints were drawn up to construct a fully functioning production facility that served to complement the live-action filmmaking happening in other areas of the park. This was perfect synergy, since the corporation owed its beginnings to the animation industry. It also capitalized on emerging trends in cross-corporate branding. The inclusion of an animation studio within the idealized Hollywood metaphor enriched the ambience of the park and brought with it an association with Disney's classic animated films. Profiting from this association, Michael Eisner and Jeffrey Katzenberg were eager to align these much-beloved films with the promise of the company's upcoming releases.

The crossover provided free publicity for the films and allowed the company to leap over years of less-than-memorable releases.

Yet, why should we focus on the Florida studio at all? To answer this question, the dual nature of the studio/attraction is examined through the following chapters, exposing differing levels of maturation during the studio's brief life span (1989–2004). It presents an opportunity to evaluate significant milestones during the decade of the Disney Renaissance, which marks a time of extreme creativity in both artistic and technological innovation. With a return to imaginative storytelling and a renewed association with contemporary musical theater, the animators touched upon entertainment values that were well received by critics and the general public alike. The infusion of new technology took up where Disney's multiplane camera left off, freeing the artists from limitations inherent in traditional cel animation methods. Unfortunately, in retaining a formulaic structure in the later films, the original sparkle of the blockbuster years was soon lost and Disney failed to keep up with audience expectations.

We must also remain aware of the transformation in global culture during that decade. At the close of the 1980s, the computer was not an everyday item within the American household. There was still a hesitancy to depend on its practical uses, and the internet was not yet wholeheartedly adopted by the general public. By the end of the 1990s and into the 2000s, cell phones, email, and instant internet access had become commonplace, and purely computer-generated films took the lead at the box office. Unfortunately, instead of seeing problems with the formulaic repetition of the films, Disney's management concluded that slipping box office numbers were the result of "old-fashioned" production practices and lost appreciation for the artistic talents they had fought to keep only five years earlier. While the tools of animation changed during this time, the audience itself adjusted to appreciate the innovative storytelling offered by Disney's competitors utilizing the full spectacle of the latest technology.

Another reason for documenting the Florida studio is that the facility was conceived as a production facility in miniature—a singular experiment in animation history—and existed as a public showcase of Walt Disney Feature Animation during the rise, peak, and subsequent decline of its celebrity status. Thus, I have reconstructed its legacy through an appreciation of its staff, the ever-widening scope of its projects, and its contributions to the Disney filmography. By integrating eyewitness accounts with current events, it is possible to see how this unique production facility functioned within an unprecedented sphere of technological and cultural change. The importance of understanding this period of transition becomes even more apparent as

advancements in computer technology now offer ways of returning to hand-drawn animation in combination with computer-generated imagery. These were only beginning to be explored by Disney in their Oscar-winning short *Paperman* (2012) and the full-length feature *Moana* (2016). Both films were well received by the public, and there is a certain nostalgia, from both the artists and their audience, for the elegance that hand-drawn animation provides. It creates a different aesthetic from character models constructed within the computer. Both production styles have a legitimate place in the animation marketplace, where their use should be dictated by the needs of the story rather than the availability of the technology. Now that the computer has the capacity to capture hand-drawn/hand-painted artwork, I am confident the right story will come along to once again fill theaters with top-notch animated entertainment.

1

A Theme Park Attraction
(1989–1990)

To begin a history of the Florida studio, it is necessary to review the political situation that led to the revitalization of the Walt Disney Company in 1984. Intense corporate maneuverings culminated with the installation of a new executive board (1984–2005) including Michael Eisner, Frank G. Wells, and Roy E. Disney. While this history touches on the rise of the Eisner management team in California, it will not go into great detail, since other, more comprehensive investigative works are readily available.[1] Instead, I concentrate on a singular aspect that was a result of this political shift: how Walt Disney Feature Animation's Florida studio came into existence as an integral part of the overall construction design for a new theme park, one based on Hollywood's golden age: the Disney-MGM Studios.

It begins with the rescue of the Walt Disney Company in the 1980s, a pivotal situation that led to the epic rejuvenation of the company's reputation and fiscal well-being. During a particularly hostile takeover bid of the company's stock in 1984, the old power structure under Chairman Ron Miller gave way to the appointment of Michael Eisner as chairman of the executive board.[2] This consolidation of the California headquarters under the new power triumvirate of Eisner, Wells, and Jeffrey Katzenberg created a unique set of circumstances that led to new energy being directed toward faltering aspects of the company. Eisner took control as chief executive officer, Wells held the financial reins as chief operating officer, Katzenberg took over as studio chairman of the film division, while Roy E. was made director of the animation department.[3] The soft-spoken but farseeing Roy E. (son of Roy O. Disney and nephew of Walt) was the only family member still active within

the company; moreover, he was a staunch believer in the integrity of its animation division.[4] This sympathy is evidenced by the vital role he played in bringing the computer into traditional animation with the innovative new program called CAPS. It is also witnessed in the unconventional projects he chose to produce (*Fantasia 2000* [1999] and *Destino* [2003]).[5]

The first five years of the new Eisner management (1984–1989) demonstrate a significant transition in the company, moving from a family-run institution to a corporate entity using contemporary business strategies. These events connect the establishment of the Florida studio to a series of decisions made in rebranding the company's image. The theme parks were the first to feel the changing of the guard by refurbishing the existing parks, raising admission prices, and creating advertising campaigns that emphasized family and social values to attract a wider audience. In her biography of Michael Eisner, Kim Masters notes how eager he was to become identified as the new figurehead of the corporation and sought to make Disney's parks a vacation destination with locations all over the world.[6] Calculated to gain a wider share of the entertainment market, Eisner saw that investing in new attractions would capitalize on repeat business as well as attracting new consumers. The decision was made at the executive level to create a third theme park in Florida, one dedicated to filmmaking with an emphasis on classic Hollywood style. Thus, in July 1985 Eisner shocked rival Sid Sheinberg, president of Universal's parent company, MCA (Multi-Cultural Arts), with the announcement of the new Disney-MGM Studios theme park being constructed at the Walt Disney World Resort.[7] With that, Eisner green-lit a filmmaking facility within the guise of a vacation destination.[8] With legitimacy conveyed through the contracted use of the Metro-Goldwyn-Mayer name and filmography, the creation of the Disney-MGM Studios can be seen as a rival to any local competition, particularly the subsequent premiere of Universal Studios Florida a year later. With a third theme park, Walt Disney World became a truly immersive experience, keeping families on property longer and thereby avoiding their patronizing other Orlando-area attractions.[9]

In the meantime, the animation division, now under Roy E.'s supervision, was reorganized, renamed, and refocused on creating new, more exciting, and contemporary entertainment. Under the new identity of Walt Disney Feature Animation (WDFA), the California studio moved forward with each new release, gaining momentum as seen in *The Great Mouse Detective* (1986) and *Oliver and Company* (1988).[10] But the first real hint of the revolution that was about to take place was the groundbreaking live-action/animation collaboration *Who Framed Roger Rabbit* (1988).[11] The film proved that animation still appealed to general audiences. It introduced new generations to the

concept of animated and live-action characters coexisting within the same dimensional space.[12] One year later, the Magic of Disney Animation offered park guests the chance to experience, vicariously, a sort of pseudo-existence within a real working animation studio. The attraction's cast members and the animation crew showed up for work each day, week after week, while thousands of guests streamed through the tour corridors and witnessed fragments of the studio's production cycle.

Thus, the Florida studio came about as the result of a corporate decision to open a Hollywood-based theme park at the Walt Disney World Resort. The inclusion of a real working studio within a tourist destination was easily the most authentic way of displaying the animation process to the general public. This chapter provides an introduction to this unique facility, locating it within prior public displays of animation creation and outlining the original tour's format with its "Disneyfied" narrative of the production pipeline. When it opened, the Florida studio served as a working model of the hand-drawn cel animation method, illustrating how Disney's films were created *before* the computer was introduced into the process.

Prior Displays of the Animation Process

Before discussing the Magic of Disney Animation attraction and its presentation of the production pipeline, it should be noted that animation is a long and tedious process, and its disclosure was not always common practice. During the late nineteenth and early twentieth centuries, film pioneers carefully guarded their secrets of visual effects production.[13] Innovators such as J. Stuart Blackton, Émile Cohl, and Georges Méliès relied on the mystique of animation and special effects to beguile their audience and maintain creative control over their illusions.[14] In contrast to these predecessors, Walt Disney sought to deconstruct the process of animation production so that his audience could better understand the wonders of its mechanical complexity. He was eager to display the creative process in his bid to elevate animation to the status of fine art. There was a deep-rooted desire to promote animation as an equal to drawing, painting, and sculpture. Thus, Walt openly demonstrated the procedures, skills, and materials that combined to create a single frame of film. In order to educate his audience about the highly complex nature of production, he utilized various formats of communication, including literature (how-to and academic), documentaries, and museum exhibitions.[15] Multiple exhibitions can be used as evidence of the long-standing collaboration between Disney and New York's Museum of Modern Art (MoMA), a relationship that remains strong to this day.[16]

Whenever Walt sought to display his studio's animation process through the medium of film, it was always with its own sense of Disneyfication.[17] Therefore, in the company's early documentaries, we do not always find a realistic depiction of how animation was created but rather an idealized version of the various stages that contributed to its realization. To better understand the enormous appeal of the Magic of Disney Animation attraction from the vantage point of its audience, it is helpful to review prior examples of Walt Disney's attempts to showcase the animation process. Filmic evidence was produced by the Walt Disney Studios to educate both their advertising partners and the general public. Several examples focus on singular aspects of the animation process, while a few contain a complete overview of the entire assembly line.[18] These early films were often produced with specific demographics in mind and provided their audience with a better appreciation for the labor—or at least the complexity—involved in making a cartoon. As early as 1937, Walt Disney, at the request of his distributor RKO Radio Pictures Inc., produced a short film titled *A Trip through the Walt Disney Studios* (1937).[19] This barebones documentary was created with advertising executives in mind as an aid in selling the film *Snow White and the Seven Dwarfs* (1937) to theater owners. It illustrated a simplified version of the animation pipeline, occasionally out of order and sometimes omitting entire departments but suited to a layperson's understanding of the complicated steps involved. This "how-to" film received such a good response that RKO suggested editing a second version, *How Walt Disney Cartoons Are Made* (1938), to be released as a coming attraction to movie theaters within America's heartland. With this second version, distributors and theater owners sought to generate public anticipation for *Snow White* when it finally arrived at their establishment.

A few years later, in 1941, Walt Disney harkened back to his distributor's request for a film showcasing the Disney method of animation production. *The Reluctant Dragon* (1941) was produced to appease the public's interest in the creative process. This pseudo-documentary features popular author and radio and film comedian Robert Benchley, who takes a haphazard tour around the studio campus in Burbank encountering several creative departments within the production pipeline. Unlike the straightforward assembly line portrayed in the RKO documentaries, *The Reluctant Dragon* focused entirely on entertaining the audience through comedic vignettes demonstrating various artistic skills. The film purports to offer the public "a glimpse" into the animator's world, a glimpse into the studio behind the man, and displays the mythical figure that Walt Disney had become.[20] Overall, author Steven Watts claims the film "smacked of superficiality" and was conducted in a

tongue-in-cheek manner that played to Benchley's mode of performance.[21] While the film's narrative touched on many of the basic production departments—Story, Animation, Camera, Paint, and Sound—the audience would have had a tough time understanding how these areas combined to achieve the final result. Yet, through its "edutainment" devices, *The Reluctant Dragon* can be seen as an early progenitor to the Magic of Disney Animation attraction and its video presentations.[22]

Further evidence of Walt's urge to enlighten the public is gathered from several television episodes of *Walt Disney's Disneyland* series in the 1950s. In pivotal shows, Walt escorted his audience behind the scenes at his studio. Various aspects of production were displayed—again without a comprehensive overview of the actual process. Three key *Disneyland* episodes include "The Story of the Animated Drawing" (aired November 1955), "The Plausible Impossible" (October 1956), and "The Tricks of Our Trade" (February 1957).[23] In his introduction to the *Behind the Scenes at the Walt Disney Studio* DVD, Leonard Maltin comments that, as a boy, he was particularly thrilled when Walt Disney announced episodes dedicated to various aspects of filmmaking in the animation studio. Maltin, like many of Disney's young fans, was enthralled with a closer examination, in simplified terms, of the techniques and talents used within the creative process.[24] For example, in "The Story of the Animated Drawing," Walt gave his audience an art history lesson on the beginnings of animation, moving from prehistoric cave drawings, through nineteenth-century technological innovations, to the early film pioneers who inspired Disney himself to go into the film business. This episode also displays evidence of Walt's goal in promoting animation as a form of high art. He emphasizes the artistic ability necessary in creating the films. In his own words, "The animated drawing has matured and has taken its rightful place among the fine arts."[25] Walt Disney in the 1930s and 1940s sought to have his films recognized as fine art rather than relegated to simply children's fare.

The other two *Disneyland* episodes, "The Plausible Impossible" and "Tricks of Our Trade," along with television specials like "One Hour in Wonderland" (shown on Christmas Day 1950) and "Operation Wonderland" (June 1951), both themed to Disney's latest release, *Alice in Wonderland* (1951), displayed key elements of the animation pipeline.[26] "Operation Wonderland" contained a more accurate visual representation of the process without going into a lot of technical explanation. There's even a clip of the multiplane camera in use; however, there's no discussion of what's actually going on. Yet, it can be argued that these episodes were created with an eye more toward entertaining rather than educating their audience. The episodes were fashioned by Disney and

his distributors to tie in with the studio's latest projects, beautifully illustrated by the two *Wonderland* specials, which promoted their newest upcoming release.

These examples of animation narratives demonstrate how popular this concept was for both the filmmaker and his audience. However, the notion of realistically capturing the laborious human/mechanical process on film was not consistent with Walt Disney's practice of documentary filmmaking. Animator Randy Cartwright elaborates on Walt's notions of what a documentary should present to its audience: "Walt Disney didn't seem to ever support real documentary material. He always wanted to create a fantasy world about his real world for the audience. He didn't want the audience to see the machinery behind his fantasies. . . . Hollywood itself was presented as a fantasy world as well as the Hollywood movie, and all of Disney's documentaries were kind of in that vein."[27] Thus, it is not surprising that these filmic explorations into the inner workings of Disney's studio emphasized entertainment over education.

As an actual physical experience, the Magic of Disney Animation was not the first attempt by Disney to display the animation process. The initial concept of an animation tour grew out of the public's constant curiosity to see how animation was created. As more and more people inveigled invitations to visit the studio to see the animators at work, Walt conflated this idea with his own dissatisfaction for typical amusement parks of the day. That idea transformed into his first theme park, Disneyland, in Anaheim, California. J. P. Telotte and Steven Watts both point to events that illustrate Walt's gestation of the idea.[28] They cite a 1948 memo from Walt to Dick Kelsey outlining his original suggestions and concerns about the creation of a theme park.[29] Furthermore, in his text Watts outlines the incremental steps leading to the maturation of this idea: "On a 1940 trip to New York, Walt told Ben Sharpsteen at some length about his plan to display 'Disney characters in their fantasy surroundings: at a park near his Burbank headquarters, a scheme that would give studio visitors a place to experience something more than just seeing people at work.'" This idea is seen developing from this dialogue with Ben Sharpsteen, continuing with the 1948 memo, and leading to Walt's request for permission from the Burbank Chamber of Commerce in 1952 to construct a theme park adjacent to his main studio lot.[30] When that petition was denied, Walt headed south to the rural agricultural area surrounding Anaheim, and Disneyland eventually opened in 1955. Yet, in 1948 Disney clearly envisioned the park as an annex of his studio complex, where patrons could ride various film-related attractions when they grew tired of watching the animators draw.[31] Ultimately, Walt removed the studio component

from the park altogether, and the original idea of allowing a curious public to witness the animation process in person was sidelined until decades later when the Magic of Disney Animation attraction opened in Florida in 1989.

The Magic of Disney Animation: Layout of the Walkthrough

The design of the studio/attraction was laid out well before the rapid upsurge in animation's popularity in the 1990s, years before animated films returned to their higher status within the company's hierarchy. In discussing the Magic of Disney Animation, it is particularly helpful to emphasize its original conception as a theme park attraction. Walt Disney Imagineering was in charge of designing all the attractions for the new filmmaking theme park. Many of those attractions were essentially two entities existing within a single structure.[32] The Magic of Disney Animation was conceived in two zones—integrated, yet separated by a thick barrier of glass. On one side was the theme park attraction; on the other the Florida studio, formally known as Walt Disney Feature Animation Florida. The Florida studio was conceived as a fully functioning cel animation studio in miniature, meaning all steps in the pipeline would be represented but with a smaller crew.[33] It was intended to be entertainment for theme park guests; the facility and its crew would be on display as an educational novelty. The attraction side allowed visitors to wander through its tour corridors, acting as silent observers to the everyday activities of animation creation, whereas the studio side comprised a small satellite unit of the main California studio, employing approximately eighty artists and support personnel.[34] Thus, the Florida studio is a singular experiment in animation history; it existed as a showcase for the public persona of Walt Disney Feature Animation during its peak of celebrity status and technical innovation.

In its original concept, the Magic of Disney Animation was set up as a walk-through attraction: a simplified tour illustrating key departments in the hand-drawn, cel animation pipeline. Guests followed a prescribed route through six sections: the museum lobby, Theater One, the tour corridor, the Reassembly Area, Theater Two, and the Animation Gallery. Two short films framed the beginning and end of a self-guided tour through a glass-lined corridor where various stages of the animation process were on display. The following is a description of how each of these sections contributed to the entertainment and educational experience of the park guest, a close approximation of what Walt Disney was attempting to depict in his documentaries of the animation process. The attraction can thus be seen as the fulfillment

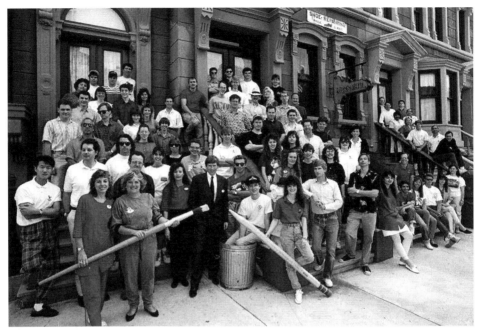

Figure 1.1. Opening crew of Walt Disney Feature Animation Florida. Standing in the center is Max Howard, director of operations. Source: Collection of the author.

of Walt's dream, educating his audience about the complex process of animation production within an enjoyable format. In addition, the attraction served as a natural outlet for promoting the latest upcoming releases from the company.

MUSEUM LOBBY

Guests entered the Magic of Disney Animation through a temperature-controlled museum lobby space. When the park initially opened, the museum lobby contained an exhibition of art and artifacts from Disney's early classic films representing various facets of the animation process: preproduction sketches, storyboards, layout and animation drawings, background paintings, cel setups, and character statues known as *maquettes*. An octagonal glass case at the center of the room featured several Academy Award Oscar statuettes, serving as the focal point of the collection. If the attraction can be seen as ideologically representing the past, present, and future of Disney's animation, the museum lobby connected visitors with the company's glorious past. The Oscar statuettes are evidence of appreciation from

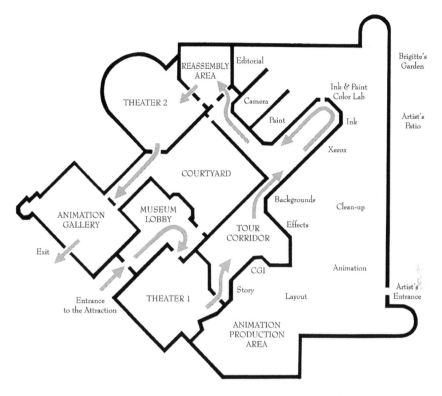

Figure 1.2. Diagram outlining the use of space within the Magic of Disney Animation. Source: Author's diagram adapted from the back cover of Roy E. Disney, *The Magic of Disney Animation, Premiere Edition* (1989).

Disney's industry peers for the studio's elevation of the animated art form into a popular source of public entertainment. In the following years, due to the huge success of the Disney Renaissance, artwork and collectibles originating from the newer films were displayed within the museum lobby, promoting the studio's latest releases alongside samples of preproduction imagery hinting at what was to come.

The museum lobby performed the vital function of elevating the status of these animation by-products to high art, displayed in the conventional mode of a curated exhibition space. These exhibitions were designed and installed by the team at Disney's Animation Research Library.[35] All of the art and artifacts were high-quality facsimiles made from the originals.[36] Working with WDI, the exhibitions were curated with two objectives in mind. According to design manager Tamara Khalaf, "We highlighted past films

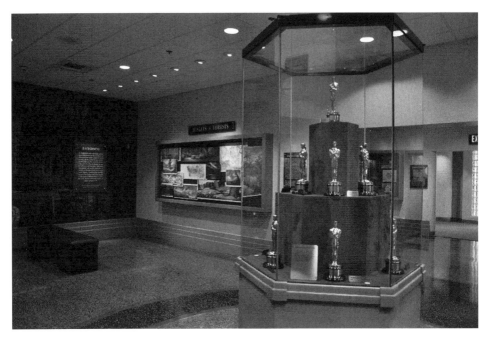

Figure 1.3. Photograph of the museum lobby featuring twelve Oscar statuettes. Source: Author photo.

to show where the studio had come from and we had a regularly changing exhibit dedicated to the upcoming film in production."[37] The gallery space emphasized the significant connection between animation as a form of high art and what the public had come to recognize as iconic imagery from the films. Placed within the context of a museum space, these objects take on an aura normally reserved for priceless works of art displayed for the edification of the museum patron. In another way, the museum lobby played a more subtle role within the attraction's narrative. It connected with the final section of the tour, the Animation Gallery, designed to recall the museum space and to remind visitors of the precious commodity these objects embody in their connection with the films. Happily, in the case of the Animation Gallery, these objects could be taken home, at a price, as souvenirs of their personal experience of walking through the halls of the animation studio.

THEATER ONE

Once a group gathered in the museum lobby, the doors were closed and an animation host or hostess introduced the attraction. Guests were then ushered

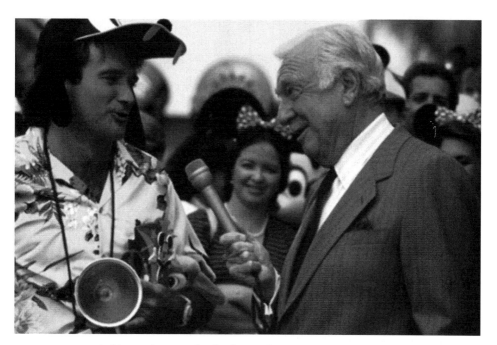

Figure 1.4. Publicity photograph of Robin Williams and Walter Cronkite, stars of the *Back to Neverland* film shown to guests in Theater One. Source: Internet Movie Database.

into Theater One to view a short film, *Back to Neverland* (1989), starring the unlikely comedic pairing of venerated television news anchor Walter Cronkite and comic actor Robin Williams.[38] This live-action/animated short whimsically illustrated the cel animation process; it provided a simple narrative that traced the pipeline from preproduction through postproduction. Cronkite convinces Williams to help him explain the animation process by becoming a cartoon character in *Back to Neverland*, a fictional *Peter Pan* (1953) sequel. Reduced to a voice recording, Williams moves through the production pipeline while Cronkite narrates each stage of the journey. Williams is cast as one of Peter Pan's little Lost Boys, making him a sympathetic character identifiable to the audience. He advances through the rough and cleanup animation stages, is placed within a black-and-white (layout) environment, and finally transformed into color. Step-by-step the film demonstrates the series of departments that contribute to the look of the final frame. By the end of the film, Williams has moved beyond the restrictions of the original narrative and enjoys the unlimited freedom available to an animated character. He breaks the fourth wall, encouraging the audience to follow him inside

the attraction. Thus, in simple and comedic terms, the film provided a quick education for the lay audience of what they were about to see inside.

The Imagineers based the attraction on the same method Walt Disney and his crew used in the 1930s and 1940s, which was still widely used during the 1980s. The *Neverland* film demonstrated the hand-drawn cel animation method Walt Disney made famous. Astonishingly, the filmic portions of this attraction were not produced by the studio but outsourced to BRC Imagination Arts, a California-based production house specializing in creating rides and attractions for theme parks and other entertainment venues around the world.[39] In 1988 BRC was invited by the Imagineers to collaborate in creating the film segments for the new attraction.[40] As Feature Animation was consumed by production on *Oliver and Company* and *The Little Mermaid* (1989), the park's featurette was given to this commercial production house. In an article for *Animation World*, freelance writer Rita Street notes that "working closely with Imagineers, BRC artists developed, scripted, and produced all the short films exhibited throughout the experience."[41] In hindsight, working with an outside agency gives rise to the conjecture that this may be the reason for the concentrated display of the cel animation process. Feature Animation's new ink and paint program, CAPS, would not be ready for practical application until 1989. So as production on the films occurred well before that, CAPS would still have been in its development phase when the attraction debuted. It was not known then how radically production methods would change within the eighteen months after the Florida studio's opening. This, then, is why the Imagineers based the attraction on the traditional method of animation production rather than incorporating the computer into their production display.

THE TOUR CORRIDOR

Upon leaving Theater One, guests entered a wide corridor lined along one side with floor-to-ceiling glass walls overlooking the production area. The tour corridor stood approximately five feet above the studio floor, providing optimum visibility of the open space below. The Imagineers conceived the tour as an "over the shoulder" experience for the guests yet maintained a discreet distance so as not to disturb the artists' concentration. The main room had twenty-foot ceilings, and guests could see across the space to a frieze displaying simple Mickey Mouse drawings moving through the animation process, step-by-step.[42] Animation desks were lined up in rows at various angles to the audience. As part of the walking tour, guests were guided to key positions along the corridor by video monitors playing short vignettes

illustrating that department's function. BRC and the Imagineers designed these vignettes to follow a simplified cel animation pipeline—Story, Layout, Rough Animation, Cleanup Animation, Effects Animation, Backgrounds, Ink and Paint, Camera, and Editorial.[43] The vignettes were a continuation of the *Back to Neverland* film seen in Theater One. Although much shorter in length, they were reminiscent of the comedic interludes seen in *The Reluctant Dragon*, where Robert Benchley, now Robin Williams, experienced various stages of the animation process.

The tour corridor allowed guests to wander through the attraction at their own pace. It was designed with multiple levels to make viewing easier for everyone in the group. The video monitors were placed high overhead so that guests had an unobstructed view of the artists below. The video monitors repeatedly played the vignettes featuring Williams's Lost Boy character demonstrating each department in simple and comedic terms. The dialogue in these vignettes played a significant role in moving the group from one station to the next, enticing guests to move efficiently through the attraction. As they moved along the tour, the back walls of the corridor contained information panels and museum-style vitrines showcasing specific processes, art materials, and visual examples from previous Disney films. Tour hosts and hostesses were continually on hand to answer questions and maintain crowd control. The tour corridor acted as a prime example of the "edutainment" quality of the attraction, specifically in its ability to inform viewers about the complexity of animation production while keeping them amused with Williams's ongoing hilarious installments.

In a training film created for new cast members working in the animation attraction, the Florida studio's director of operations, Max Howard, explained how the production floor behind the glass "was a real working studio, a hub of animation activity."[44] This cast member video provided a detailed explanation of the animation process, much like the original RKO documentaries, giving the new tour guides a better understanding of what was going on behind the glass. Armed with this knowledge, they could answer many of the guests' questions as they made their way through the tour. Thus, the artists found themselves featured as a form of entertainment for the guests, as their actions and activities provided a more interesting voyeuristic experience than that of most animals seen in a zoo.

THE REASSEMBLY AREA

At the end of the tour corridor, past the camera and editorial departments, guests gathered in a waiting area before entering Theater Two.[45] This small

room featured large black-and-white photographs and outdated filmmaking equipment meant to evoke a continuing sense of the animation environment. A bank of television monitors played a short film, *Animators on Animation* (1988), again produced by BRC Imagination Arts. The film consisted of contemporary animators talking about the reasons they chose animation as their profession.[46] This provided the guests with a virtual encounter with the artists. As Howard remarked in the cast member orientation video, "In these corridors, perhaps we can create the next generation of Disney animators."[47] These words proved prophetic, as various artists who later joined the California and Florida crews credit the attraction with strengthening their resolve to make animation their chosen profession.[48] The Reassembly Area acted as a gathering place for the guests, similar to the museum lobby at the beginning of the tour, before entering the final film presentation in Theater Two, better known as the Disney Classics Theater.

THEATER TWO

Once inside the automatic doors, guests were seated in another theater and treated to a film montage containing classic highlights from Disney's golden age.[49] It showcased memorable moments built on varying emotions—fear, joy, love, and sadness—skillfully edited from the company's animated filmography. Through this film, guests could better connect the color images with the pencil-and-paper, brush-and-board examples they had seen earlier on the production floor. The film also reminded guests of the presence of Walt himself and how he was responsible for every frame that went out with his name on it. It allowed for a psychological connection between the golden age films and the many releases after his death.

At the time of the Magic of Disney Animation's debut, these classic moments were drawn from the studio's sixty-year history.[50] Familiar iconic images were edited from *Snow White* through *Oliver and Company*. (As the years progressed, the film would be updated to include scenes from the more recent releases.) These moments combined to create a sense of nostalgia, an emotion evoked throughout the studio tour. Nostalgia was a large part of what brought guests into the attraction in the first place, making it a popular destination in the park. Throughout the tour, the back wall of the corridor displayed recognizable images from Disney's past, while the production floor promised more iconic scenes in future productions. As Howard remarked, "Perhaps one day, films produced at this studio will be deemed worthy of the term 'classic.'" Seeing such imagery often evoked special memories for each guest, associating personal feelings with what they experienced inside the at-

traction. These memories would be recalled days, months, or even years later when seeing advertisements for the release of Disney's newest "classic" film.

THE ANIMATION GALLERY

Upon exiting Theater Two, guests found themselves in the Animation Gallery, a small retail store that offered merchandise specifically aimed at the Disney animation fan. Most theme park attractions nowadays have merchandise outlets at the exit of each ride or spectacle, often themed to complement that attraction. The Animation Gallery was unique in that it can be identified as fulfilling the same function as an earlier shopping experience that once existed in the original Disneyland: the Disneyland Art Corner. The Art Corner was a specialized animation boutique that served as an outlet store of the Walt Disney Studios, catering to guests seeking a closer relationship with the art of animation.[51] It opened its doors the same day as Disneyland but debuted in a temporary location outside the park until Tomorrowland was completed later that year.[52] In its permanent location, the store sold animation artwork, artifacts, and related merchandise until its final closure in 1966.[53]

The Art Corner accommodated various kinds of shoppers, from the budding artist to the knowledgeable collector. An extraordinary fact about Disneyland's Art Corner is that it played a vital role in preserving hundreds of original production cels, which otherwise would have been lost to the rubbish bin. Except for a select few, designated as Courvoisier cels, most of the animation by-products like cels, drawings, and backgrounds were believed to have little value. It was a common practice within the industry to wash the ink and paint off of production cels and reuse them for the next film. Courvoisier cels were a different story; they displayed particularly iconic images consisting of original cel and background setups.[54] Unlike simple cels, which sold anywhere from seventy-five cents to five dollars, Courvoisier cels could run as much as fifty dollars for an original panning background containing multiple characters from significant scenes.[55] Many iconic cel setups were retained by the company and its artists or given away as promotional gifts. Thus, many of the materials that are still available today exist because of these extraordinary circumstances that kept the artwork from being reused or thrown away.

Similar to Disneyland's Art Corner, Florida's Animation Gallery offered a wide variety of animation-themed merchandise, including books on drawing, sketch pads and art supplies, fine art and children's books, porcelain figurines, videotapes of Disney films and documentaries, production and reproduction cels, buttons, pins, autograph books and pens, coffee mugs, and mouse pads.

Many of the production cels for sale were sourced from a variety of Disney's television series during the 1980s and 1990s, including *Duck Tales, Chip 'n Dale: Rescue Rangers, Darkwing Duck, Goof Troop,* and *TaleSpin*.[56] Limited edition reproduction cels featured images from classic Disney moments, recently glimpsed in the Disney Classics Theater and offered for retail sale at just the right time. These reproduction cels were created strictly as collectible artwork and not used in making the actual film. Painstakingly faithful to the original image, they were sourced from the original drawings and inked and painted using colors matching those in the films. They even included hand-drawn *self-lines*, which are colored ink lines used to enhance the characters' palette at a time when all cels were created by hand. These limited edition cels were produced in runs of 250–500 copies only. The Animation Gallery also carried a series of commemorative cels available as souvenirs directly related to the Florida studio experience. This display of merchandise recalled the museum lobby at the beginning of the tour, where the artwork was displayed as fine art. Yet in the Animation Gallery, these items were available for sale to even the most casual collector. Guests could take home treasured mementos, reminding them of their favorite childhood films as well as memorializing their visit through the tour corridors of the studio/attraction.

When the Magic of Disney Animation first opened, cels were just beginning to reemerge as a highly collectable item. For example, in 1989 and 1990 New York's fine-art auction house, Sotheby's, held two exhibition/auctions for *The Art of Who Framed Roger Rabbit* (June 28, 1989) and *The Art of the Little Mermaid* (December 15, 1990).[57] At this early point in the Disney Renaissance, it is possible to see how the explosion of the animation art market was only beginning. A majority of the cels for the *Roger Rabbit* exhibition were not estimated to sell for more than two thousand dollars. Compare this with the higher estimates given for the *Little Mermaid*'s artworks, which were expected to sell anywhere from two thousand up to fifteen thousand dollars! These cel setups were being sold as investments in fine art, confirming Walt's original premise of equating animation by-products with drawings and paintings displayed in a museum. This is extremely poignant when we realize that these two landmark films, *Roger Rabbit* and *The Little Mermaid*, were also the last gasp of Disney's cel animation process. Once the computer took over, production cels became a thing of the past.

Entertainment in the Theme Park

When creating a theme park attraction, Disney's Imagineers consider a number of attributes that contribute to a successful design. For the Magic

of Disney Animation, they began with two questions: How authentic is this representation of Disney's animation process, and how should it be displayed so that the layperson can understand?[58] All attractions designed by Imagineering must contain several key elements that combine to create a successful guest experience.[59] Three distinct qualities can always be recognized in varying degrees: entertainment, education, and promotion. Evidence of these qualities is critical during the design phase in order for the attraction to fulfill its role within the theme park.

How did this attraction demonstrate the qualities of entertainment, education, and promotion within its experience? Differing amounts of these qualities are often infused into the attraction's ideology and philosophy, evident within its narrative structure. The Magic of Disney Animation had to demonstrate these criteria to be considered a success. Just the name, the "Magic" of Disney Animation, is analogous to revealing the process of the film's creation. Here, the tour demonstrated the human/mechanical procedures, replacing the image of pixie-dusted elves (or dwarfs) making drawings magically appear out of thin air. The "Disney Animation" part of the title immediately associates the attraction with high-quality animated entertainment through its identification with the company's classic filmography. This association is what enticed the visitor into the attraction and, once there, kept them moving steadily through it, learning about the creative process as they went along.

I have already mentioned nostalgia and how Disney's animation is regarded as timeless to an entire baby boomer generation (and beyond). Many of the older members of the audience grew up watching the Disney classics (*Bambi* [1942], *Cinderella* [1950], *Sleeping Beauty* [1959], and *Snow White*) as well as television episodes of *Walt Disney's Wonderful World of Color* and *The Mickey Mouse Club*.[60] Nostalgia is evident in the previously mentioned *The Reluctant Dragon*, where the live-action/animated feature displays a romanticized vision of Disney's California studio complex wherein the action is completely scripted. By 1989, almost fifty years later, that nostalgia was being passed along to their children and grandchildren. In the past the public had always responded well to the unveiling of the inner workings of Disney's studio, so in the Florida attraction the Imagineers promoted a living demonstration of animation production. Inside the Magic of Disney Animation, any of Walt Disney World's guests could, for the price of admission, line up and see the animators at work. Unlike 1941's *Reluctant Dragon*, the attraction offered a more personal experience for the guests than merely showing limited facets of the production process. Thus, nostalgia played a significant role in drawing guests into the attraction, banking on their entertainment memory.

Once inside the tour corridor, the simplified assembly line provided guests with a linear understanding of how the films were made. In other words, the Magic of Disney Animation can be recognized as a tangible realization of Walt Disney's lifelong dream of demonstrating the animation process to the general public. In this modern rendition of Walt's dream, the animation pipeline was transformed into a journey, a progression that wound itself along a predetermined route. For the first time, the press and general public alike were allowed a glimpse of real Disney artists drawing, painting, filming, and editing. In the opening literature, the attraction was billed as follows:

> The new Animation Building at the Disney-MGM Studios, Walt Disney World Resort, is a working animation studio—that just happens to have visiting hours. The magic of Disney animation is created here, every day, by a staff of over 80 talented artists and technicians who are producing new featurettes, starring classic Disney characters, for theatrical and cable release.[61]

The attraction's intention, as expressed above, was to demonstrate the process of animation by walking guests through the production pipeline. It should also be noted that the assignments for each animator changed frequently, so even when guests revisited the attraction, chances were good they'd never see the same thing twice. Thus, with the lingering popularity of *Who Framed Roger Rabbit*, guests lined up each day to walk through the Magic of Disney Animation's tour corridor with its bevy of attendant tour guides who answered questions and announced the current projects on display. Howard confirms, "We had two or three million [guests] a year come through the tour corridor."[62]

The Magic of Disney Animation added a distinctly new experience to the usual entertainment formula. In many of Walt Disney World's attractions, guests have been able to relive the narratives of their favorite Disney films—Peter Pan's Flight, Seven Dwarfs Mine Train, The Many Adventures of Winnie the Pooh, and Under the Sea: Journey of the Little Mermaid, to name a few.[63] J. P. Telotte cites this kind of experience as "one of the key attractions of the Disney parks . . . [in] the way they help us negotiate our own place in the postmodern scene; for a price we 'inhabit' a new promising space, engaging in an almost physical version of what Bukatman terms 'the narrative process of technological accommodation' (28)."[64] Telotte is referring to Scott Bukatman's book *Matters of Gravity: Special Effects and Supermen in the 20th Century*, where he defines the "technological spectacle" as an affirmation of popular American culture, helping to integrate the individual in their relationship with the "complex technologies of modern life."[65] In the

film-based attractions, spectators experience their favorite story lines and come away with a happy ending—technologically provided, of course.

In the Magic of Disney Animation, Bukatman's "technological spectacle" is transformed into a voyeuristic exercise whereby guests witnessed animation's creative process, essentially looking over the artists' shoulders as they drew the character, painted the background, colored the cel, or shot the frame, each step necessary in the production of an animated film. The spectator then, hopefully, would come away with a better understanding of the multiple talents required by the process and, subsequently, upon viewing the final result at a later date, would hold a deeper appreciation of the artistic and technological factors that went into making it. Thus, to manufacture the "technological spectacle," the Imagineers conceived the attraction from a layperson's perspective. When it first opened, the Magic of Disney Animation became one of the most popular attractions within the park, where guests could see famous Disney characters brought to life. However, unlike the above-mentioned film-based narrative attractions, this audience was not participating in an already familiar story line. Indeed, they were unable to participate in the attraction's narrative at all, merely passively watching from the sidelines as they walked by the multiple stages of production. In this attraction's narrative, the daily routine of the animators was considered the key element of the spectacle.

In a concept similar to nostalgia, the artists on display evoked childhood dreams of becoming a Disney animator or, better yet, becoming the next Walt Disney. In his book *One Little Spark*, Marty Sklar cites one of Mickey's Ten Commandments, "For every ounce of treatment, provide a ton of treat" (Commandment #9).[66] This rule addresses the psychology of providing an entertaining space that encourages guests to explore and learn from their surroundings. This aspect emphasizes the educational quality of the attraction as its audience gained more knowledge about the actual production process, showcasing a variety of artistic talents necessary in the creation of an animated film. It allowed guests, especially young guests, to imagine how they might contribute to that process and to identify with the artists behind the glass. Many a budding artist and future animator drove their parents to distraction to visit the working studio. Playing upon this fact, the Animation Gallery offered a wide variety of artist-themed merchandise for sale, including sketch pads, art supplies, drawings, and cels, alongside the usual kitschy souvenirs. The shop fulfilled this demand by selling "how-to" books on animation drawing and creating flip books.

The studio/attraction also served the function of being a promotional outlet, advertising current and upcoming releases to a receptive audience.

In fact, the quality of promotion was ingrained into the very essence of what the Florida studio symbolized throughout its existence. Beginning in 1989, the studio served as a touchstone, a public presence representing the larger entity in California, connecting both its past legacy and its newest creative endeavors. Not only did romantic notions of animators as "actors with a pencil" play upon the audience's imagination, but artwork seen while visiting the attraction served to create a buzz for the anticipated release of whatever was currently in production. Promotional one-sheet movie posters and preproduction artwork were often displayed in the Museum Gallery to whet the public's appetite. Yet, there was also a note of hesitancy in presenting certain visuals before the film was released, because much of the imagery was not copyright-protected at the time it appeared on the production floor. While the whole of Walt Disney World serves as an advertisement for the company's many assets, the Magic of Disney Animation promoted the foundational art form for which the studio was best known. It represented the classic films that parents and grandparents held within their nostalgic memory while instilling excitement and anticipation for the release of new productions and evoking ambition to become part of that process.

The Other Side of the Glass

Within the Magic of Disney Animation, on the other side of the glass resided the second entity: Walt Disney Feature Animation's Florida studio. This small production unit was initially associated with the Disney parks system while also answering to the main studio in California. How did this dual responsibility affect the Florida studio, being both theme park entertainment and industry participant? Let's begin by examining the interdepartmental relationships that existed between the Walt Disney World (WDW) Parks and Resorts, Walt Disney Feature Animation, and Walt Disney Imagineering. All three were necessary to the successful running of the studio/attraction. Just as each contributed a different facet of support, they looked at the facility with differing agendas. The studio was designed and constructed by Imagineering, with daily maintenance provided by Walt Disney World Parks, while Feature Animation controlled the studio's production assignments. In the beginning, the expectation was that the Florida studio would work only on in-house projects, mainly shorts and featurettes, needed throughout the company.[67] That concept radically changed as work on the feature films soon became higher priority for "the little studio that could." The importance of quality and quantity of the animation footage soon exceeded that of the guest experience.

Yet, there are questions about the working relationship that existed between the Florida studio and its host, the Walt Disney World Parks. How did the parks management view this creative microcosm operating within their midst? How did they regard the animation crew, and what was their status when compared with other cast members working throughout the parks? How did the security department adapt to the creative antics that erupted at all hours of the day and night, inside and outside the studio premises? It is particularly important to consider how the parks management saw the Magic of Disney Animation as a valid attraction for their guests. These questions demonstrate how life for the animation crew was unique from the thousands of other Walt Disney World cast members employed at the Orlando resort.

A kind of balance was struck by the artists who, while onstage every day for the guests' enjoyment, were also required to meet weekly footage quotas for Feature Animation. Since the studio's crew was initially designated as cast members within the attraction, the parks administration expected them to follow the same rules required of other cast members working in the parks. They requested a work schedule that maximized visual interest during peak operating hours. Adjusting to the parks schedule, the Florida studio's administration devised a seven-day work week beginning at 10:00 in the morning, when the attraction opened, and ending at 7:00 in the evening, just when guests began looking for dinner or to gather around the main courtyard for the nightly fireworks display.

Each department in the studio had a minimum staff of at least two people so that they could alternate days off and maintain a continuous presence. The work week was split into Sunday through Thursday and Tuesday through Saturday. This arrangement helped keep more artists on the production floor during the park's peak operating hours. The schedule placed difficulty on many of the animation families with small children, as the hours precluded normal family time and, on many occasions, meant long days of not seeing the kids at all. After the first few hectic months, the kinks were worked out of the system when the California studio insisted on regular working hours. The schedule was amended to a normal Monday through Friday work week using Eastern Standard Time business hours between 8:00 a.m. and 6:00 p.m.[68] Flex-time was offered to those preferring earlier or later shifts, but communication with California dictated the studio's working schedule. The result was that during peak tourist season, when the park was open late, not many animators could be found inside. It also precluded weekend coverage except for overtime shifts and student interns sitting by the glass.[69] While the parks management might not have been happy with the amended hours, they were pleased with the guest response of having animators working in

the park. As one of the original attractions within the new Disney-MGM Studios park, the animation tour surprisingly became not just a hit but also one of the most popular destinations for the guests.

The parks' operating hours were a big consideration when it came to working on production. For example, guests were constantly taking flash pictures throughout the animation tour. It was unavoidable, but around the camera department it became a real hazard to production. One flash frame could ruin hours of work. "No Photography" signs were put up all around that section, but many people ignored them. Finally, a cast member had to be stationed in the corridor outside the department to prevent guests from taking flash pictures in that space. During a highly complex scene in *Roller Coaster Rabbit* (1990), the Florida studio's first official project, the camera crew stayed until well after the attraction had closed and the fireworks show was over. During the roller-coaster sequence, as Roger Rabbit and Baby Herman plummet toward the earth, the rails and ties of the coaster actually spin into a blur until the car pulls up at the bottom of the drop. This scene required a special in-camera blur effect achieved using traditionally painted cels of the roller-coaster tracks shot with the camera lens open, exposing the film while the artwork on the camera table spun faster and faster in rotation. The lights in the tour corridor had to be dimmed and all personnel restricted from the area. They couldn't take the chance that a camera flash would go off while the shutter was open for so long and white out the frame. Such conditions rarely happened, but in certain instances it was easier to wait until the guests were gone for the day so that there was no chance of exposing a bad frame and having to start the scene all over again.

THE DISNEY DRESS CODE

An important factor in every cast member's agreement when accepting employment at the Walt Disney World's Parks and Resorts is the mandatory compliance with the Disney dress code. In the original Disneyland park, Walt Disney required the highest level of professional appearance and courtesy from all of his employees, known as "cast members."[70] Steven Watts identifies two employee handbooks from that period—*Your Disneyland: A Guide for Hosts and Hostesses* (1955) and *You're on Stage at Disneyland* (1962)—that spelled out the rules of personal grooming and fashion regulations for all cast members.[71] As the animation crew was initially identified as part of the cast-member corps, they were expected to follow the same grooming techniques and dress codes. Their restrictions, however, were held to corporate casual attire, meaning that instead of wearing costumes, they were allowed to wear

collared shirts and jeans. They were also expected to follow the company's guidelines concerning hair, makeup, jewelry, shoes, and the appropriateness of apparel, meaning no controversial T-shirts or sexualized clothing. Dress restrictions prohibited women from wearing any earrings larger than a dime, with no hoops or dangles, and no high heels (1–2" heels maximum). No platform, open-toed shoes, or flip-flops were allowed. Neutral makeup was required for all women, with no lipstick, just neutral lip gloss. Male cast members were required to be clean-shaven. However, since this stipulation was not mandatory for the animators working in California, any animator who relocated east could grandfather in a beard or mustache.

Unlike the other attractions controlled by the Walt Disney World Parks administration, the Florida studio's director of operations, Max Howard, insisted on maintaining an informal, creative atmosphere within the production floor while still providing an interesting display for the guests.[72] Even in the beginning, the Disney dress regulations were fairly relaxed for the new crew; studio management merely asked that they not be blatantly abused.[73] During the first twelve months, they pretty much followed the guidelines, but as film quotas increasingly became more important than the attraction experience, the dress codes became even more relaxed. As long as the animators delivered their scenes with the highest level of acting ability and draftsmanship (as required of any Disney animator), management allowed minor infractions of the dress code to slip by.[74]

These preliminary injunctions demonstrate the ways in which the Florida studio's crew was unique, not only compared with other attractions found in the Walt Disney World Parks but also compared with other animation studios working within the industry. While live-action film production was on display to guests in the Backstage Studio Tour, the viewing platforms for those guests were stationed high above the soundstage floor, shrouded in darkened corridors, and mostly unseen by the production personnel below. Many of the live-action film and television projects were temporary in nature, so there was not a great consistency of artists, actors, and technicians working throughout the calendar year. The Magic of Disney Animation was perhaps most similar to the television series that held long-term residence on some of the soundstages, like *Star Search*, *The All-New Mickey Mouse Club*, and *Wheel of Fortune*.[75] The new Mouseketeers, including young teen celebrities like Christina Aguilera, Britney Spears, and Justin Timberlake, were given the same freedom of the park as the animators; however, these child stars did not enjoy the same anonymity as the artists to wander about during operating hours.

Unlike the animators, who were continuously found working inside the studio/attraction, the Mouseketeers traversed multiple locations around

Disney World, filming comedic skits and dancing to music videos. These occurred both during operating hours and after the park had closed. In fact, the studio/attraction and the Animation Courtyard were often used as backdrops for these musical performances, underscoring how deeply ingrained the premises were in the Disneyfied realm of reality meets performance. In one instance, early in the studio's history, *The All-New Mickey Mouse Club* scheduled a taping of *The Jungle Book* (1967) song "The Bare Necessities" within the open space of the production floor (an area often referred to as "the fishbowl"). A video crew, the Mouseketeers, and costumed characters of King Louis and Baloo the Bear danced and mimed to a prerecorded soundtrack. This performance occurred at the end of the day, when the studio was mostly empty.

LIFE UNDER GLASS

This discussion of the cast member status of the animation crew must be expanded to include the reactions of the artists themselves as they were presented live and onstage as an integral component of the attraction's success. Disney animators are renowned for thinking outside the box, and they soon began using the theme park as their own personal playground after spending tedious hours at their drawing boards. What was their impression from the other side of the glass? Although each side of the studio/attraction was essentially autonomous, a rapport quickly sprang up between the two sides of the glass. To those who worked within the confines of the fishbowl, the guests passed by like living wallpaper through the tour corridor each day. Sometimes the artists got into the act, playing charades or pantomiming with the guests. They put up signs in the windows like "Keep Us in Feed, Go See a Cartoon" and acted out scenarios for the guests' amusement.[76]

Elliot Bour talked about the time he was an intern at the studio:

One of my first initiations as an intern working at the Florida studio was when I was working next to the glass on the tour corridor. Tracy Lee, of course, was famous for his pranks. One day I'm sitting there drawing and everyone keeps knocking, knocking, knocking on the glass and waving "Hi!" to me. I kept getting disturbed like every five seconds and I kept looking up. I asked myself, "Why are so many people knocking?" Finally, after about an hour, somebody on the other side of the glass pointed to something, and I saw that Tracy had hidden a sign that I couldn't see but that they could out in the corridor: "Hi, my name is Elliot Bour. I'm only 16 years old and this is my first job in animation. Please knock and wave to me to make me feel at home." Well, it was funny. There were a lot of pranks

that we would play on each other. It became one of the studio traditions, pranking the interns.[77]

Another tale was that several animators appeared to be holding a serious discussion in the studio's Story room. They made dramatic sweeping gestures toward the storyboard panels and appeared to be having an intense debate. In reality they were merely trying to decide where to go for lunch. The studio's environment reflected this casual atmosphere. The artists personalized their desks, decorating them with all sorts of interesting objects and reference material connected with their roles on the film. As production wrapped on one project, often the crew would be rearranged into new teams and desks reassigned. This resulted in an ever-changing landscape seen from the tour corridor.

Holidays took on a particular significance within the studio. Christmas featured family parties, decorating the premises, and enjoying special festivities with kids and loved ones in the parks. But it was Halloween that took on a life of its own. From the very beginning, Halloween was celebrated as a major event. With each succeeding year, the celebrations became larger and more elaborate. Groups of artists constructed, painted, and decorated the production floor. One year, Philo Barnhart designed and executed an entire stage set based on the Broadway classic *Phantom of the Opera*.[78] With willing volunteers, he created full-size standee figures of the Disney characters dressed in various roles. Committees formed to plan games and activities during the morning hours. There was trick-or-treating between the departments, games like bobbing for apples were played for prizes, and a costume parade became the highlight of the event. Most memorable were the group performances, as when one year several of the women dressed up as characters from the It's a Small World attraction.[79] Each character represented a different country and they sang new lyrics for the ubiquitous song. Another group consisted of male animators dressed as the Village People, who quickly had the audience standing on their feet cheering and dancing as they performed renditions of "YMCA" and "In the Navy."[80]

As long as the weekly footage quotas were met, the artists were allowed to run amok, provided they didn't damage property or upset the guests. Each year, the Halloween celebrations grew more intense as the artists competed with one another to make the most striking, innovative, or hilarious costumes. Rachele Lord came as Ursula from *The Little Mermaid*, with her signature jewelry created by Philo Barnhart. Her costume won first prize in the judging for that year. At other times, two Andy Warhols (older and younger versions), Charlie Chaplin, and Marilyn Monroe were in attendance.

One year even saw politicians mounting soapboxes in the halls. Most remarkable was when operations director Max Howard dressed as an American cowboy and rode a real horse through the interior of the studio.[81] The studio administration explained these proceedings to park officials as team-bonding exercises, similar to the celebrations conducted at the California studio. They even catered lunch as part of the festivities.

Cast members and guests alike learned this was the event to attend and made efforts to get to the tour corridor early, just to get a spot. Large crowds would show up for the festivities and wouldn't leave the corridor until the artists were finished. These Halloween antics sometimes spilled outside the studio walls. One of the most visible hijinks occurred after the in-studio Halloween celebration had ended. A group of artists, still in costume, decided to walk over to the neighborhood backlot to go trick-or-treating. Waiting until one of the Backstage Studio Tour trams approached the area, they exited through the front door of the *Golden Girls* house in full view of park guests. They then walked toward the next house to knock on the front door. Security was notified, who contacted the studio administration, and a tram was dispatched to pick up the errant artists and return them to their building.[82] In the meantime, several tram loads of guests had a great time laughing and taking photographs of the costumed characters.

The signs in the tour window, decorations on the desks, practical jokes, and general mayhem were all evidence of the familial attitude that existed among the animation crew and extended to the cast members in the tour corridor. It says a lot about the experience of working under daily public scrutiny. Howard spoke about his role in encouraging this creative atmosphere. He was often called upon to defend the antics of the artists to corporate management and addressed any complaints from visiting guests. One of the most frequent ways of releasing tension in the studio was the rubber-band fights. Production used big, thick rubber bands to keep scenes together, securing all materials between pieces of acid-free cardboard. These red rubber bands were also excellent for shooting across the open production floor. At any given moment, someone would shoot one band through the air and a retaliation of rubber bands would start flying around the room. Within the huge open space, dozens of projectiles would zip back and forth, much to the amusement of most guests.

One visitor did object to the animators' antics. A complaint came down from the tour corridor to Howard's office saying they had come to watch artists draw, not to see them goofing off. Howard recalled, "The story is there was a rubber-band fight going on. I may have participated. But there was a complaint [from a guest] and I was asked to explain [to parks management]

what was going on. And I quoted it was one of the great traditions [in animation], and they [the guests] witnessed one of the great traditions of animation that dates back to the earliest days of animation."[83] Howard explained that it was a way for the animators to let off steam. They spent at least eight hours a day drawing at their desks and sought to break the tension in multiple ways—"which they [parks management] couldn't really [believe]. People were flabbergasted. It was one of those excuses: 'I can't believe he's saying that to me. He's quoting Walt Disney in his excuse!' But it was part of what I had to do to have the studio believing it was a studio. Because if the artists didn't believe they were a studio, if they believed they were an attraction only, then I was lost." Another studio tradition was the myriad caricatures that made the rounds at the studio, poking fun at the artists and the characters they were working on. You weren't really part of the family until you became the target of one these wacky portraits.

It is in preserving these stories that I rely on the method of oral histories. They are vital, as the interviewees relive personal memories and recall emotions about the time they spent working on the production floor. I always imagined it might have been interesting to conduct a sociological study on the psychological stressors placed on the animation crew by the simultaneous pressure of work quotas and constantly being on display. The pressure was real, illustrated by one animating assistant who left the Florida studio after the first year because she felt uncomfortable being onstage all the time. ("Onstage" and "backstage" are terms used within the Disney parks and resorts, referring to theatrical concepts of what occurs in front of the audience—that is, park guests—and what takes place unseen behind the curtain.) Yet, most of the artists found they were able to work while being under glass. After the first few weeks, they barely noticed the crowds moving through the corridor, because they were focused on the scenes they had on their desks. The work was no joke, as the artists were required to spend the entire day, and overtime, hunched over a disc, pencil in hand, making drawing after drawing—sometimes redrawing the scene all over again. The weekly footage quotas were strictly enforced, and it was a big responsibility to create characters that brought international recognition.

COHESION OF THE CREW

The Florida studio was built from the ground up in terms of both its structure and its staff. One way of understanding this unique situation is by identifying key individuals who brought the crew together. One of those most responsible for shaping the Florida studio was its first director of operations,

Max Howard, who headed the unit from 1989 through 1994.[84] Howard is a great example of the leadership that was so vital to the studio's well-being and development. While Eisner's executive team controlled the corporate reins in California, and Feature Animation controlled all animation production, Howard's role was to get the young studio up and running and to visualize the growth of the facility in the years to come. In his interview, Howard talked about his contributions to the formation and subsequent expansion of the Florida studio: "We felt we were living in a special place and time, our own version of Camelot—I often think of Florida as Camelot—it was proud of itself; it wasn't cynical."[85] He spoke about not only maintaining relations with the local Walt Disney World administration but also how that relationship was tempered by Feature Animation's California-Florida partnership. Howard's management philosophy and choice of key individuals in his administrative staff allowed the studio to sustain a creative atmosphere while maintaining strict deadlines and footage quotas: "Of course, 65,000 people at Walt Disney World and [as part of the animation crew] you're a star. . . . You make the very things that the company stands for."[86]

Howard's background was in London's West End theater management, where he first worked with artistic temperaments. While animators are usually seen quietly working at their desks, they are often regarded as "actors with a pencil."[87] So it was Howard's knowledge and experience working with creative personalities that allowed him to know "when it was appropriate for an artist to come and cry in my office or when it was time to give him a kick in the pants."[88] This management style might not work well in a typical office environment, but overseeing an entire staff of highly creative individuals required more sensitive handling to inspire and maintain the quality and quantity of artistic output—pencil mileage—expected from a Disney artist. In this way, Howard was regarded as both boss and friend to the entire crew, willing to fight for their individual and unique status within the corporate environment.[89] He unified the studio and created an extended family for the artists, many of whom had no prior social contacts in Florida. He was conscientious enough to include the animation families as well, scheduling events where husbands, wives, partners, and kids spent time together, and encouraging that bond both inside and outside the studio walls. Thus, the animation crew did not feel so isolated in a tourist town far from the main hub of the filmmaking industry. Howard acknowledges, "We certainly were not living in a very real world—in the middle of Florida, in the middle of a theme park."[90]

A poignant example that displays the heart of the Florida studio is the commemoration of the untimely passing of one of its original members, Brigitte Hartley.[91] Hartley was a British animator who had initially been part of Richard Williams's London crew on *Who Framed Roger Rabbit*. She reprised her role of Baby Herman for *Roller Coaster Rabbit* and continued to lead many of the miscellaneous characters in crowd sequences for *The Rescuers Down Under* (1990).[92] Hartley was a well-respected and well-loved member of the crew who, shortly after the premiere of *The Rescuers Down Under*, was diagnosed with breast cancer. In the course of a few months, she was obliged to return to London, where she quietly passed away in 1991.[93] Her loss deeply affected the animation crew, who, by this time, had formed a tight-knit artist community. Howard remembers, "That's why it's so important to tell this story correctly. [Brigitte] was cut off in her prime and that's the sort of person who gets lost in the big picture. Everything that went on in Florida is really a reflection that's gone on everywhere, every animation

Figure 1.5. Photograph of British animator Brigitte Hartley drawing Baby Herman. Source: Animator Alex Williams.

Figure 1.6. Bronze plaque commemorating the opening of Brigitte's Garden on November 18, 1994, behind the main building. Source: Author photo.

Brigitte's Garden

This garden of remembrance was built in Brigitte Hartley's memory.

Every Disney animated film is a tribute to the collaboration of countless talented people. In honor of that collaboration, and especially to the memory of those who are gone, we dedicated this garden.

November 18, 1994

Figure 1.7. Photograph of Brigitte's Garden. Source: Author photo.

studio anywhere in the world."[94] Animation is not an individual endeavor. It requires groups, often large groups, of people working together to create even a minute's worth of moving entertainment. It utilizes a wide range of creative skills. As a studio working together, this bunch of creative individuals bonded closely over these projects, so when Brigitte unexpectedly passed away, it affected the whole crew.

Hartley's memory is preserved in a special section of the landscape behind the original Animation building. It is a typical English garden, complete with meandering flagstone pathway, park benches, and a gurgling stream. The area was dedicated to her in a ceremony on November 18, 1994 (figs. 1.6 and 1.7).[95] This loss of one of their own brought the crew together and solidified the studio as a singular entity within the Walt Disney World population. Hartley's memorial illustrates the cohesion of the Florida unit, defining the personality of its artists as they became immersed within this extraordinary production environment. This story is only one of many that demonstrates the sense of camaraderie and community within the mixed bag of artists, administrators, and support personnel that made up the Florida studio's crew. Brigitte's Garden is evidence of the interconnectivity of this small group at the beginning of the studio's history, and it provides context for the communal changes that occurred later.

2

Traditional or Digital:
It's All Hand-Drawn (1989–1990)

The Florida studio is not an isolated example of animation production happening within the "Sunshine State." There were other attempts at bringing animation to Florida before Walt Disney Feature Animation opened its studio in the guise of a theme park attraction. In the 1930s the Fleischer Studios moved their New York operation to Miami, into a custom-built state-of-the-art animation facility designed by Max Fleischer himself.[1] Between the years 1935 and 1949, his production team worked on the popular *Popeye the Sailor Man* and *Superman* series, but the main reason for making this enormous change was that the Fleischers intended to expand their operations by producing their first full-length film, *Gulliver's Travels* (1939).[2] After the phenomenal success of Walt Disney's *Snow White and the Seven Dwarfs*, the Fleischer Studios' (now known as Famous Studios and without the Fleischer brothers) parent company, Paramount Pictures, finally green-lit plans to produce a feature of their own. With crowded working conditions in their New York base, the tax incentives and real-estate opportunities in Miami, as an alternative to California, lured the Fleischers into moving their operation south.[3] However, there were also significant drawbacks to the new location. Miami did not have the filmmaking infrastructure, such as film laboratories or experienced and technical personnel, that New York or California could offer. Along with Fleischer's veteran crew, a school was set up to train local artists in drawing for animation. The Miami studio remained open for almost fifteen years (producing two feature films), but the operation was ultimately abandoned and Max was forced to return to New York.[4]

Some forty years after the Fleischer Studios closed in Miami, Disney brought animation back to Florida, banking on a new approach to produc-

tion. The studio/attraction added a new dimension; it was open to guests, who were welcome to watch the animators at work. This not only provided a new kind of experience in the theme park but also helped to underwrite an additional production facility. During the first eighteen months of operation, from May 1989 through November 1990, the Florida studio's creative projects were intended as a form of voyeuristic entertainment. Park guests visiting the Magic of Disney Animation might see artwork from any of four films: *The Little Mermaid, Roller Coaster Rabbit, The Prince and the Pauper* (1990), and *The Rescuers Down Under*.

While the sporadic release of animated fare kept the art form alive during the 1970s, it was not a thriving business. However, in the late 1980s, the Walt Disney Studios was once again becoming the focus of rejuvenated interest, and its Florida counterpart was poised to act as its public representative. At the dawn of the meteoric rise of the Disney Renaissance, we see two remarkable shifts taking place: first, how the Florida studio's mission began to change, moving from an emphasis on theme park entertainment to one of being a reliable source of production footage; and, second, how computer technology contributed to Disney's cel animation process, through both CAPS and CGI, aiding in the construction of handcrafted films.

The Florida studio started production using the traditional method of cel animation. While the facility would always produce hand-drawn animation, the finishing process quickly moved from Disney's original procedure of using acetate sheets and cel-vinyl paint to a new digital method whereby drawings were scanned and painted in the computer. This chapter investigates both production styles, teasing out their differences and similarities and demonstrating how the pipeline displayed in the Magic of Disney Animation attraction was rapidly being eclipsed by new procedures happening on the other side of the glass. Taking a closer look at *The Prince and the Pauper* and *The Rescuers Down Under*, it is possible to see how the new CAPS software had an immediate impact on contemporary production methods. Both films demonstrate how the Magic of Disney Animation and its counterpart, the Florida studio, debuted at the brink of a technological revolution, because after November 17, 1990, animation production would never be the same.

The Debut of the Florida Studio

But let's back up a bit. On May 1, 1989, simultaneous with the opening of the Disney-MGM Studios theme park, the Magic of Disney Animation opened its doors. The entire day was filled with celebrities and festivities to celebrate the occasion. In the weeks before the opening, the animation crew

was adjusting to their new surroundings. They were getting settled into their desks and becoming accustomed to new working procedures and appearance regulations. They began meeting colleagues, forming new friendships, and defining their roles within the production process. Most of all, they marveled at the large plate-glass windows of the tour corridor above. In the corridor, WDI's work crews were putting the finishing touches on the attraction. In the weeks before the official premiere, Disney executives escorted small groups of publicity agents and press correspondents through the attraction, allowing them a sneak peak of Michael Eisner's new park. These tours began with a trickle of people walking through the halls but quickly escalated into larger and larger groups moving through the attraction. This steady growth helped the artists get used to the audience on the other side of the glass and alerted them to how different their life would be from any other production environment.

On May 1 the floodgates opened and the tour corridor was filled with throngs of people from the time the park opened until the attraction closed. Walt Disney was correct when he assumed the general public was more than just a little curious about the animation process. During the opening day festivities, Michael Eisner, Roy E., and Jeffrey Katzenberg attended all press events throughout the park. In the animation department, Katzenberg made a point of going through the entire studio and personally introducing himself, congratulating each artist and shaking their hand. In the ribbon-cutting ceremony in front of the attraction, a massive press event featured several of the remaining Nine Old Men: Ward Kimball, Ollie Johnston, Marc Davis, and Frank Thomas. These animation legends were asked to participate in a handprint ceremony, where they placed their hands in squares of wet cement and signed their names for posterity. Those concrete slabs were eventually installed in the Animation Courtyard, similar to the Hollywood signature and handprint slabs found in front of the park's Chinese Theater. In addition to these celebrities, a new generation of Disney animators was introduced to the press, including Mark Henn, Barry Temple, David P. Stephan, Alex Kupershmidt, and Bill Kopp. The event gave the press and the public new names to look for in upcoming releases.

Multiple festivities were planned by Disney's public relations department to celebrate the completion of this major milestone: the opening of a new theme park. At the Magic of Disney Animation attraction, an opening night party allowed the crew to bring their families to see where they would be working. This opportunity had not been available before. As the people wandered the attraction, buffet tables were set up within the tour corridor and multiple forms of musical entertainment were scattered throughout the

premises. In the Animation Courtyard, with its topiaries of Sorcerer Mickey surrounded by bucket-carrying brooms, a trio of musicians played Disney melodies on full-size floor harps; in the plaza in front of the attraction, a DJ spun more contemporary fare and the dancing went on all night. Champagne and other beverages were served to keep the attendees refreshed.

Once the turnstiles opened, the new park was packed. Wait times for the animation attraction grew longer, sometimes going over two hours. The tour corridor was crowded with guests wanting to see the animators at work. It was good that the artists had been working in the studio a few weeks prior, because they were already used to the glass walls and had been introduced, somewhat gradually, to eyes staring back at them whenever they looked up. Now that the park was open, there was always someone, usually huge crowds, looking in to see what they were working on.

The First Project: *Roller Coaster Rabbit*

The live-action/animated film *Who Framed Roger Rabbit* went into production about the same time as Eisner's expansion in the theme park business. After the film wrapped production, many of the artists and administrators who had worked on the London crew were invited to move to Orlando to form the nucleus of a new kind of animation studio based within a theme park attraction.[5] Max Howard recalls, "We got a lot more jack-of-all-trades in London, that sort of 'boutique-y' part of the industry."[6] The *Roger Rabbit* crew was joined by a core group of California veterans in key positions. Promising candidates from the industry, many originating from New York and Toronto, filled in the gaps.[7] During its first twelve months of operation, the crew concentrated on producing high-quality full animation to match the original footage from the opening sequence of the live-action film, making the studio's connection with *Who Framed Roger Rabbit* evident. *Roller Coaster Rabbit* was a direct result of that film, both in terms of its impact in jump-starting a brand-new era in animation production and because a significant part of its crew had worked on the original feature.

Who Framed Roger Rabbit broke new ground in advancing the illusion of human actors and animated characters coexisting within the same environment. In his book *Animating Space*, J. P. Telotte notes that this live-action/animation hybrid "appeared at precisely the time when the new digital technologies were starting to have an influence on both live-action and animated filmmaking."[8] Telotte is acknowledging the early inroads being made in adapting computer technology to contemporary filmmaking practices within the industry. He credits Robert Zemeckis, as director of the film, with

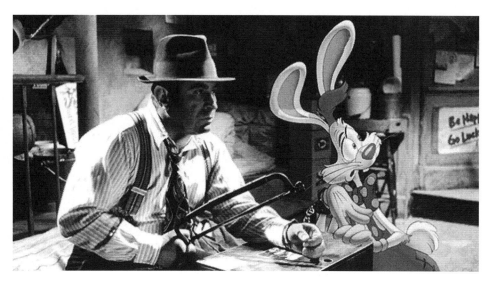

Figure 2.1. Film frame of Eddie Valiant (Bob Hoskins) and Roger Rabbit from *Who Framed Roger Rabbit*.

having the foresight to push the boundaries of conventional cinema with an eye toward greater entertainment value for the audience.[9] These advancements were received with enthusiasm by the ticket-buying public, so much so that Roger Rabbit quickly became an iconic fixture in the new Disney-MGM park. The film's "classic Hollywood" art direction influenced the overall design of the streamlined architecture, and the concept of animated characters existing within physical space was relished by the guests who flooded into the attraction. Ironically, despite *Who Framed Roger Rabbit* demonstrating great strides forward in achieving this visual effect, the actual production method used in creating its cartoon characters was traditional hand-drawn cel animation.[10] Thus, while the film hints at the rise in technological advancements, it never really strayed far from the old creative process.

Who Framed Roger Rabbit opens with an animated short, *Somethin's Cookin'*, reminiscent of the slapstick comedy style of vintage 1940s Warner Bros. cartoons.[11] Capitalizing on the enormous popularity of Roger Rabbit, Jessica Rabbit, and Baby Herman, Disney continued the Maroon Cartoon series by producing three autonomous shorts: *Tummy Trouble* (1989), *Roller Coaster Rabbit*, and *Trail Mix-Up* (1993).[12] While *Tummy Trouble* was nearing completion in California, the Florida studio was given the second in this series, *Roller Coaster Rabbit*.[13] The seven-minute short was intended to train and organize the green crew, who needed the experience of a small project

to bring them together and work the kinks out of the new pipeline. It also displayed recognizable characters for the pleasure of the theme park guests. The project was directed by California animator Rob Minkoff and overseen by veteran producer Donald W. Ernst.[14] The credit list on *Roller Coaster Rabbit* includes several artists whose work would come to define the Florida studio's output: character animators like Tom and Tony Bancroft, Aaron Blaise, Mark Henn, Alex Kupershmidt, and Barry Temple, as well as considerable talent in other departments, such as Rob Bekuhrs, Barry Cook, Jeff Dutton, Ric Sluiter, Bob Stanton, Bob Walker, and Chuck Williams.[15]

Six months after the Florida studio opened, while *Roller Coaster Rabbit* was still in production, on Friday, November 17, 1989, Walt Disney Pictures premiered its twenty-eighth full-length animated feature, *The Little Mermaid*. The film catapulted animation back into the public spotlight.[16] Dazzled audiences clamored for more. This garnered the Florida studio more importance as an attraction in the Disney-MGM Studios theme park. The Magic of Disney Animation became a gateway for displaying the cel animation process to the general public. Guests were curious to see the method by which Ariel and her friends were brought to life. This boost in popularity gave the crew working behind the glass increased status within the Walt Disney World cast-member hierarchy—especially when *The Little Mermaid* went on to win two Oscars at the 62nd Academy Awards.[17] This immense transformation of the art form's popularity is impressive when, just a few years earlier, the company had barely resisted a hostile takeover and narrowly missed being ripped apart for its legendary assets. Now, with renewed interest in the animation division, Feature Animation sought ways to capitalize on this resurgence of popular demand and came up with the idea of using this distant source of talent.

The Prince and the Pauper and Cel Animation

With the completion of *Roller Coaster Rabbit*, the role of the Florida studio changed dramatically.[18] The short proved that both the quality and quantity of animation coming out of Florida were up to the standards necessary for feature-length productions. When the California studio found they needed help staying on schedule for the next release, they looked to Florida for additional manpower. Management realized they could better utilize Florida's talent by contributing to Feature Animation's more expansive, and more expensive, theatrical projects rather than shorts and featurettes. This decision allowed California's directorial teams to begin assigning scenes to the satellite facility.[19] As footage quotas became a higher priority to studio management

than park guests seemed to have become, the Florida studio evolved into a new role that would last over the next fourteen years.[20]

It started with assigning multiple scenes from two films concurrently in production; *The Prince and the Pauper* and *The Rescuers Down Under* were scheduled to be released as a double feature, slated for November 1990. *The Prince and the Pauper*, a featurette starring Mickey Mouse and the gang, acted as a cartoon short before the main feature. At twenty-five minutes, it was longer than the standard seven-minute cartoon, so between the two films a brief ten-minute intermission was scheduled.[21] The second film, *The Rescuers Down Under*, ran approximately eighty minutes. It was the first time Disney had produced a theatrical release that was a sequel to an earlier film, *The Rescuers* (1977). While *The Three Caballeros* (1944) is often regarded as a film sequel to *Saludos Amigos* (1942), these two films do not follow a single continuous narrative but instead consist of episodic segments that have been labeled as "package films." Direct-to-video sequels or television specials capitalizing on an earlier film's success, not meant for theatrical release, were not animated by the main California studio but through a different division, Disney Television Animation, also known as DisneyToon Studios, using smaller budgets, less time, and higher quotas during production.[22] *The Rescuers Down Under* was a fully animated project produced under Feature Animation's guidelines and designed to continue the narrative premise of author Margery Sharp's original stories.[23] With the assignment to contribute to both these films, the Florida studio took on the position of B unit to the California studio.

These first three projects allocated to the Florida studio—*Roller Coaster Rabbit*, *The Prince and the Pauper*, and *The Rescuers Down Under*—illustrate a major transition occurring in the industry. Together they demonstrate the early stages of the computer's integration into the two-dimensional (hand-drawn) process. During those first eighteen months of production, traditional cel animation, as an art form, was synthesized by the computer into something new. The films chronologically document Disney's movement away from traditional materials to a completely computer-driven underpinning. While both *Roller Coaster Rabbit* and *The Prince and the Pauper* were produced using the old cel animation method, *The Rescuers Down Under*, simultaneously, utilized the company's new digital software, CAPS. By the end of this production period, a new era began for the Walt Disney Studios wherein cels were no longer a by-product of the animation process.

Working in tandem with California, the Florida studio clearly displays the duality of the animated art form at this time. Half of its small crew worked in the traditional cel animation style (*The Prince and the Pauper*) while the

other half adapted to the new digital process (*The Rescuers Down Under*).[24] Directors from both films traveled to Florida to assign major and minor character roles and crowd scenes. The two films tested the capabilities of the young studio, as they required differing skill sets from one department to the next. Management divided the crew into sections depending on their contribution to the pipeline. The feature and featurette shared common ground as well, requiring several departments to be called to double duty in order to maintain footage quotas. Significantly, this period witnessed the introduction of the computer in a supporting role to the traditional hand-drawn process rather than a starring one—the new technology was integrated into the old mechanical formula. Both films attest to the diverse roles the artists were asked to perform at this time.

Production on *The Prince and the Pauper* required a complete cel animation pipeline in which all departments, including Xerography and Ink and Paint, were used in the traditional sense. This was the same method used for *Snow White and the Seven Dwarfs* and every other feature up to and including *The Little Mermaid*. Tom Sito, a lead animator at both Disney and DreamWorks, notes how "films like Walt Disney's *The Little Mermaid* (1989) were drawn and painted just as their ancestor *Pinocchio* (1940) had been."[25] By the summer of 1990, one year after the Florida studio opened, *The Prince and the Pauper* was already the third cel-painting project for the new ink and paint department. Even before *Roller Coaster Rabbit*, Ink and Paint had been kept busy supplying cels for *The Little Mermaid*.[26] For *Mermaid*, pencil drawings were shipped from California to Florida, where they were prepared for Xerography and Ink and Paint. The Florida studio maintained a fully stocked paint lab, where custom colors were mixed for each day's quota. Once completed, the painted cels were sent back to California to be checked and shot onto film. Guests in the tour corridor were treated to glimpses of the massive storm-filled finale, where Ariel and Prince Eric face off against Ursula, the evil Sea Witch.[27] Ultimately, *The Prince and the Pauper* would prove to be the last time the Walt Disney Studios used acetate cels for theatrical production. From the moment the double feature debuted in theaters, hand-painted cels became exclusively the métier of creating iconic images from classic Disney films intended for purchase in gift shops and galleries.[28]

To explain the traditional cel animation process, I'll use a scene that passed through the Florida studio: *The Prince and the Pauper*'s Sequence (Sq.) 1, Scene (Sc.) 35.10 (8–00).[29] It features Captain Pete, as head of King Henry VIII's palace guard, cavorting drunkenly with his weasel cohorts as they rollick about in the royal carriage through the frozen, wintry streets of London.[30] The scene consists of layout elements, levels of character and effects

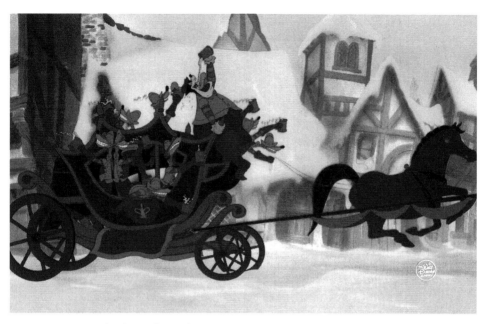

Figure 2.2. Film frame from *The Prince and the Pauper* (Sq. 1, Sc. 35.10), depicting Captain Pete and the weasels as their carriage moves through the streets of London. Source: Collection of the author.

animation, a computer-generated carriage, and a panning background that allowed the camera to follow the scene's action. The background of medieval city streets was painted on a long strip of canvas board with various overlays of snow and debris moving simultaneously on panning sheets of clear acetate. The length of this background was dictated by the timing of the scene and the speed at which the carriage traveled as it moved from frame to frame. In this case, Pete's carriage lopes through the city streets, the vehicle heavy with its load of peasant plunder as they make their way back to the castle.

Beginning in the editorial department, the scene was timed for its dialogue, thereby providing the footage length and any phonetic sounds heard in the voice track (like the weasels' singing[31]). It entered the production pipeline through the layout department. The layout artist, supervisor, and directors determined the speed and trajectory of the carriage as it moved through the London streets. Layout determined the placement of the characters as they appeared in relation to the camera: Pete and the weasels in the coach, Mickey Mouse in the foreground snow. The scene then moved to the CGI department, where a 3D model of the carriage was animated. They provided

wire-frame drawings of the model to be used as reference by the animators in registering their characters to the vehicle.

The animators were responsible for roughing out the various movements of Pete and the weasels, and even the horses as they pulled the carriage along. (This scene also included a level of drawings showing the back of Mickey's head as he watches the carriage pass by in the first few frames.) Every animator approaches their characters from unique perspectives. Some rough drawings look like a mass of scribbled lines, but when viewed in motion, a character glides across the screen. It often fell to the animator's assistant to shape these rough lines into the character's model, while the in-betweener created additional drawings according to the timing charts. Mark Henn's work often looked like loose shapes with certain key details filled in (see Ariel, Belle, Jasmine, Young Simba, Pocahontas, Mulan, and Tiana). Barry Temple was one of the cleanest animators in the business but had the habit of ripping the pegs off the bottom of his drawings and taping them back together to smoothly articulate the motion of the arcs. Temple's x-sheets were also very strictly filled out, as he was one of the best at creating nervous action through staggered drawings (see Lumiere, the Sultan, Zazu, Cri-Kee, Pleakley, and Mrs. Calloway). Aaron Blaise's four-legged characters were beautiful examples of sinuous motion, particularly his big cats (see Rajah and Young Nala); he excelled at animating two-legged characters as well (see Beast, Jasmine, Pocahontas, Yao, and the Ancestors). Both Tom and Tony Bancroft were masters of comedic timing, especially with complex character designs like Pumba and Mushu.

When the animator's work was done, a rough pencil test was ordered from the camera department. For *The Prince and the Pauper*, these traditional pencil tests were shot on either film or video.[32] After processing, a work print was delivered to California's editorial department for sweat box (the equivalent of "rushes" or "dailies" in the animation industry) approvals with the directors and various heads of departments. The test was cut into the current work reel to determine how it fit in with the surrounding scenes. The animation would be scrutinized, frame by frame, to critique the acting and see how well it synced with the dialogue.

Once the rough test was approved, the scene moved on to the cleanup department, where the animator's loose, sketchy drawings were transformed into the fine, fluid lines for which Disney animation is famous. Cleanup (CU) was traditionally the largest department in the production pipeline. Their crew would be divided into teams working on specific characters. Some teams had a wider scope when working on the miscellaneous characters that abound in each film. After the cleanup was finished, the scene moved

directly to the special effects (FX) department, where it received atmospheric animation, such as rain, sleet, or snow, and physical props, such as the barrel and foodstuffs loaded onto the back of the carriage. There were even drawings of beer foam frothing from the weasels' brew.[33] Once the effects levels were in place, the scene went back to the camera department for its CU/FX test. Simultaneous with the cleanup and effects stages of the pipeline, Layout was busy creating cleaned-up versions of the environments. These would be used as guides by painters in the backgrounds department to complete the final color artwork.

The CU/FX test was the final round of approvals before the scene moved into color. The animation, effects, layouts, and camera moves were completely nailed down before going forward with the most expensive part of the animation process: cel creation. To confirm that the scene was complete, it traveled to the animation check department, which was responsible for determining that all elements in the scene were accounted for. Laurie Sacks, who headed Florida's animation check department for several years, described her job as 50 percent art and 50 percent technology.[34] She talked about how animation checking was the midway point between the front end and the back end of the pipeline, where the black-and-white artwork was transformed into color. The animation checker set up each frame according to the x-sheet in order to make sure all the drawings were present (with their lines complete), that the effects animation followed its trajectories, and that the camera's movement coincided with the coordinates labeled on the drawings and layout elements. Once Animation Check verified the completeness of the scene, the entire scene was sent to Xerography.[35]

During Xerography's three-step process, guests moving through the tour corridor were allowed to view only two of the three production rooms; the middle chamber served as a darkroom where the sensitive photochemical process occurred.[36] In an electrochemical procedure, exact reproductions of the cleaned-up pencil lines were fused onto the front of registered acetate sheets, now identifiable as cels. Next, an inking specialist minutely examined each cel, retouching any missing lines to maintain consistency within the scene. At this point, if any custom line work was required, often referred to as *self-lines* (see chapter 3), these artists traced those details from the original drawings as well. The scene then moved into the paint department, where each cel was colored using custom-mixed cel-vinyl paint.

In the paint department, the scene was split into small segments to allow multiple painters to work simultaneously and complete it more quickly. In the case of our carriage scene, there were six animation levels along with a background and overlay. The topmost level briefly displayed the back of

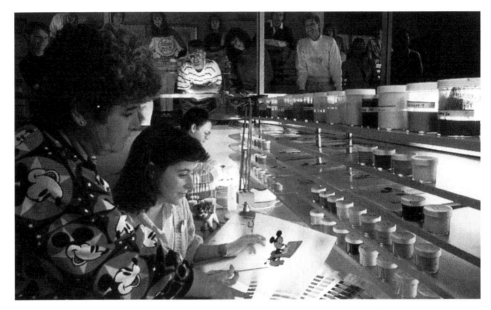

Figure 2.3. Publicity photograph of the ink and paint department at the Magic of Disney Animation attraction, featuring (l-r) Fran Kirsten, Pam Darley, and Michael D. Lusby. Source: Collection of the author.

Mickey's head as he pans out of frame. The next level consisted of snow splashes thrown out by the carriage wheels. Beneath this were the horses and the occupants of the carriage: one level for the horses and another for Pete and the weasels as they lolled about in the vehicle. A different effects level containing the food and plunder being hauled back to the castle was placed above the carriage, and the level was laid on top of the background. The computer-generated drawings of the carriage then had to be transferred to cels in the same way as the animator's drawings. They were copied onto cels and hand-painted so they could be included in the setup when the color scene went to Camera. (There was no communication between the artwork and the film stock before CAPS came along.)

The painters applied liquid cel-vinyl paint to the back of each cel, keeping within the xeroxed lines adhered to the front. The paint flooded each section of the image with a flat color so that the background wouldn't be seen through the characters. Each character was painted according to a color model specifically approved by the art director for that sequence. If a single element—say, Pete's sleeve—was given the wrong color on a single cel, a flash would register on the screen. That kind of error was known as a paint pop, and it was the final checker's job to make sure this didn't happen.

The final check department, similar to the earlier animation check, reviewed each level in the scene, now as painted cels, along with the completed overlay and background elements. The final checker compared the art with the camera mechanics specified on the final x-sheet. After each frame was confirmed, the scene went one last time to the camera department to be shot onto a color negative. The completed levels of Mickey/overlay, snow slush, horses, Pete and weasels, food and carpet, and royal carriage were lined up with their background according to the x-sheet and placed beneath the camera's glass platen. There, all the artwork was exposed, one frame at a time.

For *The Prince and the Pauper*, the final negative was shot in the traditional three-strip Technicolor process, meaning the shutter over the lens opened three times to expose three separate film frames using different colored filters: cyan, magenta, and yellow. This method allowed California's Technicolor film laboratory to create the brilliantly hued projection prints that were sent to the movie theaters. Cel animation is a lengthy, extremely labor-intensive process. Multiple levels are created for every frame of film and often exposed several times under the camera's lens to create highlights, shadows, and other visual effects. Animation requires 24 frames to create a single second of screen time, or 1,440 frames per minute. Since *The Prince and the Pauper* had a running time of twenty-five minutes, it required 36,000 frames to be put through production. That's a lot of handcrafted cels!

The Prince and the Pauper was the last Disney film to be shot in cel animation. For this process, cutting-edge technology was most often found in the camera department. State-of-the-art animation rostrum cameras used computers to maintain the repeatability of complex camera movements. The Florida studio's camera department boasted this new technology in the form of two motion-control animation stands. They were custom-engineered by Mechanical Concepts in California and designated by name. Camera 1, known as Zeus, contained a 360-degree rotating camera head, while Camera 2, known as Vulcan, was equipped with built-in video and film capabilities. They were christened after the gods in the "Pastoral Symphony" sequence from Disney's original *Fantasia* (1940). Zeus contained the internal mechanism necessary for shooting the three-strip Technicolor process required for final color negatives, while Vulcan was outfitted with a shifting dual camera head, allowing either video or film to be shot through the same lens. This allowed the camera operator to shoot complex camera moves onto video, providing the animators and directors with accurate pencil tests before committing the scene to film.

These computer-controlled cameras maintained individual files for each scene, in every sequence, throughout the entire film. The files could easily be recalled and adjusted for sweat box notes and additional tests until,

ultimately, the final color pass. This quality of repeatability, down to a one one-thousandth increment, enabled multiple-exposure effects, like transparent character shadows and silvery water reflections, to be added in-camera onto the final negative. The automated axes on the camera table (N/S, E/W, and rotation) allowed for greater precision in creating naturalistic camera movement, while the computer calculated exposure percentages on multiple passes and mathematical computations for logarithmic control of cross-dissolves and fades. Even with the mechanical limitations imposed by the innate flatness of the two-dimensional medium, the computer helped to enhance the functionality of the rostrum camera. (As will be seen later, these original cinematic principles pertaining to the rostrum and multiplane cameras served as the foundation for CAPS's technical language and direction, the results of which went well beyond what any traditional camera, or even Disney's original multiplane camera, could achieve.)

After Florida's camera department completed the day's shooting, the exposed film was sealed in light-tight film canisters and shipped overnight to the Technicolor film labs in California. The raw stock was then developed, work-printed, and sent to Editorial, where it was cut into the work reel for the next day's color sweat box.[37] Here, the scene received its final approval. As each sequence was completed, the negative cutter, part of the editorial staff, compared the numbers on the work print with those on the negatives. Those frames were then spliced together to form a master negative of the entire film. All theatrical releases at this time had projection prints struck from copies of this original master negative.

The Computer in Cel Animation

The films we identify with Disney's first golden age were all produced using the above method. The drawings were done in pencil and the final images completed with cels, painted backgrounds, and multiple exposures. Many of the special effects were created optically within the camera housing using various combinations of mattes, filters, and percentages. While the Disney Studios cannot be credited with the original invention of sound, color, or the multiplane camera, they certainly perfected these processes to capitalize on presenting a better performance.[38] Walt was famous for recognizing and building upon emerging technologies, combining them with an emphasis on draftsmanship and carefully constructed storytelling. While *Steamboat Willie* (1928) may not seem sophisticated to us today, it certainly stands out among its contemporaries in narrative and design, mixed with the new sound technology. Moreover, the look of Disney features, with their fluid motion

and fine draftsmanship, constitutes the definition of the studio's house style: the *illusion of life*.[39] The term conjures up images of hand-drawn characters moving through semi-spatial backgrounds. The dimensionality offered by the multiplane camera provided a sort of superficial layered effect rather than floating freely through three-dimensional space. Yet, the beauty of these characters existing within an artificial two-dimensional environment brings a magical quality all its own, like a fine-art painting come to life.

In many ways, the introduction of the computer during the Disney Renaissance echoes the mechanical advancements made during Disney's first golden age. This latest technology enhanced the work of a whole new generation of Disney artists, along with the additional twist of narratives fashioned with elements borrowed from musical theater. The hand-drawn artwork was supported by the computer predominantly in the back end of production. As animator/historian Sito remarks, "Walt Disney Feature Animation initially preferred using CG [computer graphics] primarily to support their traditionally drawn feature films. Something to cover difficult camera moves and offer an expanded choice of colors, but nothing more."[40] This new software, the Computer Animation Production System, was designed to eliminate the repetitive process of creating cels, but it proved valuable in other areas of production as well. As we shall see, CAPS was constructed primarily to mimic the look of cel animation and secondarily to extend its visual properties.

In the summer of 1989, Disney's California studio put an experimental scene into production for the final sequence of *The Little Mermaid*. As Ariel and Eric's wedding barge drifts lazily away from camera, her father, King Triton, sweeps his trident across the sky, creating a rainbow effect. This scene, Sequence 13, Scene 38, has the distinction of being the first scene completed by CAPS for theatrical release.[41] Cut into the final film, the shot convinced studio executives that CAPS had the ability to mimic the flat, two-dimensional quality of cel animation to such a degree that they invested an entire feature in the software. It was a huge risk for the company to dedicate a theatrical release to the relatively untested program. In this case, management depended on the new software to integrate into the traditional hand-drawn pipeline, and while this proved to be a herculean task, it was not without its rewards.[42]

The Rescuers Down Under and the Dawn of the Digital Age

The Rescuers Down Under was to be Disney's first digital feature.[43] Two seasoned animators, Hendel Butoy and Mike Gabriel, were chosen to direct, with Thomas Schumacher acting as executive producer.[44] Supported

by Feature Animation management, the directors and their team set out to prove the feasibility of moving production away from a human/mechanical process and instead harness the power of digital imaging afforded through computerization.[45] Thus, in the late 1980s, while pioneer 3D animators explored alternate methods of animating digital characters within a virtual world, Disney's executives saw CAPS as empowering the hand-drawn line with a more flexible finishing process.[46]

Here is an indication of how early in CAPS's evolution this transition occurred. The software and hardware needed to run the program were available only in California, as the system was still technically in development. (Florida did not have access to it.) During the long months of production on *The Rescuers Down Under*, the software's code was continually being rewritten. Software and hardware specialists worked twenty-four-hour shifts resolving the never-ending technical issues that arose due to the demands of production. Traditional departments like Scene Planning, Animation Check, Color Models, Xerography, Ink and Paint, and Final Check were required to revise their working procedures in order to conflate the physical image with the digital one.[47]

While much scholarship has been devoted to the complete integration of the computer as a vehicle for three-dimensional animation, it must be emphasized that the films of the Disney Renaissance, the second golden age of animation, originally employed computer technology in a supporting role to two-dimensional drawings.[48] Although acetate sheets, inks, and cel-vinyl paint were phased out of production, the drawings were still being created by hand in the rough, cleanup, and effects stages; backgrounds continued to be hand-painted for even longer. Throughout the decade of the 1990s, Feature Animation produced handcrafted films whose computer-assisted visuals were technologically unprecedented; each film became more and more complex in the creation of its aesthetic. In his book *Animating Space*, Telotte notes that "working with both machines and software developed by Pixar, the Walt Disney Company had begun the slow but deliberate move toward digital animation by shifting the inking and painting processes for its animated films onto computers and exploiting the multiplane effect built into the new software to add a greater sense of depth."[49] Telotte is talking about the CAPS program, acknowledging the discussion from his previous book, *The Mouse Machine*. He continues: "Disney had been one of the first traditional studios to recognize the benefits of the computer, as evidenced by the CGI work that was employed in films like *The Black Hole* (1979), *Tron* (1982), and even the animated *The Great Mouse Detective* (1986), as well as the company's adoption in 1990 of the CAPS program, jointly developed

with Pixar, to computer paint the feature *The Rescuers Down Under* and all of the studio's subsequent traditionally animated films."[50] However, Telotte does not go into much more detail, since he is specifically concerned with the advancements being made in purely digital imagery.

This discussion then takes up where Telotte left off in his differentiation between "the Machine Age into which Walt and Roy Disney had been born" and the age of computerization, which certainly by the 1990s had entered the animated art form.[51] At the end of the 1980s, Roy E. Disney, as head of the animation division, was instrumental in pushing for computerization of the traditional hand-drawn pipeline, seeing the advantages in eliminating the fickle peculiarities of cels. Roy E. should be credited for his foresight in reaching out to Pixar as a partner to collaborate on this specialized software. At that point, Pixar was not yet in the business of producing feature films but rather was struggling to sell hardware and software solutions within the emerging industry.[52] With major assistance from Disney, Pixar managed to stay afloat to ultimately fulfill its destiny in taking the lead in producing and perfecting 3D animation.[53] A team from Pixar worked closely with Disney's Animation Technology unit, with members from both companies working together to combine an animation tracking system with digital paint and multiplane capabilities.[54] Thus, in 1989 the unit was ready to test the system. Convinced by the success of the experimental scene in *The Little Mermaid*, they agreed to commit to the larger project. As the software was brought on-line, it forever modified the traditional production pipeline.[55] In an industry hesitant to incorporate the computer into current production methods, the Disney Studios felt they had found a way to embrace computer technology without betraying the aesthetic principles of traditional Disney animation.[56] The software was engineered specifically to mimic and extend effects derived from previously established practices. In this way, the computer was used as a vehicle to convey hand-drawn artwork onto its final look.

While most animation historians recognize *The Rescuers Down Under* as Disney's first digital film, the most common accolade awarded to the CAPS program was its ability to ink and paint the hand-drawn images.[57] In fact, CAPS supported the entire production pipeline rather than simply tracking scenes and painting frames. It was an attempt to use the computer's computational power to alleviate many of the burdensome aspects of production while enhancing the "look" of the cel animation style. The capabilities offered by CAPS went well beyond the mechanical efforts devised by Disney's engineers during the first golden age. Traditionally, moving a scene into color had always been the most expensive part of the animation pipeline in terms of time, labor, and materials, so computerization at this stage made

sense. To relieve the exactitude required by xeroxing or hand-tracing free-flowing graphite lines, along with painting thousands upon thousands of cels, software developers sought to enlist the computer's power of expediting repetitive tasks. In the camera department, CAPS provided greater ease of calculating movement through multiplane space. There was even the added capability of adjusting individual animation levels after they were digitized into the system, thereby saving additional pencil footage and retakes.

FLORIDA'S CONTRIBUTION

Even with the production team based in California, directors on *The Rescuers Down Under* tapped several animators and departments from the Florida crew to work on the project. It must be clear that at this time the Florida studio did not have CAPS, so their contribution to the film was mostly in the traditional stages of production. The computer's impact mainly affected the back end of the pipeline—the mechanical stages—and kept the preliminary hand-drawn element intact. In other words, the artists still drew animation with pencils on paper and painted backgrounds on canvas boards, while the computer handled the more mundane, repetitive, and labor-intensive tasks in the final transformation between black-and-white and color. Florida's technological contribution consisted of the camera department, which planned and calculated camera mechanics that were later exported into CAPS, and the computer graphics department, which modeled and animated mechanical elements used in the films.

Disney's animation pipeline was in a state of flux as the California and Florida studios contributed to each project with the technology they had on hand. Since the Florida studio was originally envisioned as a cel animation facility, it had neither a scene planning department (all moves were handled in Camera) nor a scanning department to digitize the pencil drawings. Florida's cutting-edge cameras were designed to shoot video or film but did not contain the requisite software to scan and composite pencil tests. For Florida's contribution to *The Rescuers Down Under*, the artists were assigned to create rough, cleanup, and effects animation in the traditional manner. Completed pencil tests were shot by the camera department and sent to California for approval, while the physical scene remained in Florida with the animator. Three-quarter-inch videotapes were couriered overnight so that the tests could be studied and critiqued by the character leads. Florida's scenes did not enter CAPS until late in the pipeline, at the point when they were ready to move into color.

The move into color was the real point of departure between cel animation and CAPS. Once a Florida scene was "approved" through its CU/FX test, it was shipped to California to move into the digital phase. Instead of Animation Check sending the character levels to Xerography to be turned into cels, as was done for *The Prince and the Pauper*, scenes for *The Rescuers Down Under*, with all of their artwork and x-sheets, were sent to California to be digitized into CAPS. Although Florida's cameras were computerized, their output was not compatible with the new CAPS software. Therefore, a priority script was written by Master Cameraman Gary W. Smith that allowed the mechanical instructions from Florida to be downloaded into the CAPS x-sheet. California's scene planning department created the electronic x-sheet and imported the approved camera mechanics from Florida's files. With the actual artwork in hand, Animation Check prepared the drawings for high-resolution scans, which were then passed on to Digital Ink and Paint and to Compositing.[58] These differences in working procedures between the two coasts demonstrate the technological transformation taking place in Feature Animation as production moved away from an artisanal process to a semiautomated one.

This working method is indicative of another important aspect of the computer's impact on modern society, seen in its role in revolutionizing traditional business practices: the computer allowed for more fluid communication between both coasts. Computer advancements in the telecommunications industry saw the rise of overnight courier services, interlocking airline schedules, and audiovisual business technology, making twenty-four-hour turnaround times possible from one side of the United States to the other. A schedule of conference calls or satellite linkups between the two studios led to artwork and film being shipped back and forth across the country in time for production meetings the next day. These business upgrades are examples of how the computer precipitated a new global workplace, encouraging business innovations (courier services, conference calls, fax machines, pagers, mobile phones, satellite networks, and scanners), most of which are common office accessories today. Because of this increased versatility in business services, scenes and sequences could be assigned to the Florida unit without delays stemming from distant locations.

The Prince and the Pauper and *The Rescuers Down Under* represent two divergent forms of animation production, although the films were produced simultaneously and theatrically released in 1990 as a double bill.[59] At this pivotal moment, management was able to make side-by-side comparisons of the old and new production methods, thereby encouraging a critical analysis of the computer's visual output with traditional cel animation. It is possible

that this side-by-side production might be a sign of management hedging, as any scenes not completed on time in CAPS could have immediately been put into the cel animation pipeline. However, this scenario never became necessary. That *The Rescuers Down Under* managed to make its deadlines speaks volumes about the dedication of the artists and technicians who were determined to see the project through.

Early 3D in Florida

Another example of the computer in animation was seen well before CAPS came online. This was the introduction of computer-generated elements into Disney's films, both in live action and animation. The company experimented with 3D as far back as *The Black Hole, Tron, The Black Cauldron*, and *The Great Mouse Detective*.[60] Sito gives a realistic estimate when he reports that "over a thousand feet of film on *Oliver and Company* alone" required some kind of 3D elements.[61] Most often, the computer was used for hard-edged mechanical objects, such as falling boxes, multiple types of vehicles, and architectural recreations.[62] Sito has a knowledgeable perspective of these events, since he was an eyewitness to many of them. As a California animator during the Disney Renaissance, he possesses a perspective not readily available to the outside researcher. Sito recalls Disney's early CGI unit, during *The Black Cauldron*, who were asked to supply "simple [3D] animation for the cauldron, a boat, and a glowing magic bauble that Princess Eilonwy possessed."[63] He claims these were the first computer-generated objects to be included in a Disney animated film.[64]

The large number of 3D embellishments found in the first three films from the Florida studio highlights the small, but important, department that was included in the original layout of the production floor. For *Roller Coaster Rabbit*, all manner of computer-generated objects, from darts to a Ferris wheel to roller-coaster cars, were added as effects elements in the film. The climax of the cartoon is located on the dizzying heights of the monumental roller coaster itself. The coaster was digitally constructed with elements of track, rails, signs, and scaffolding engineered into a master model from which various sections were utilized throughout the sequence. A procedure echoing that used in *The Prince and the Pauper* required the computer model to be plotted frame by frame onto individual sheets of punched paper. In both films, these plotted drawings were used as reference material by the animators to aid in positioning their characters, while cleanup versions were sent to Xerography to be transformed into cels.

On *The Rescuers Down Under*, however, this procedure changed altogether. With CAPS it was now possible to import computer-generated elements directly into the program and composite them alongside other digitally scanned levels. There was no longer any need to convert the 3D elements into cels. Sito acknowledges the almost instantaneous effect CAPS had on animation production at that time, well before the cinematic breakthrough of purely digital animation in Pixar's *Toy Story* (1995). In an interview with Sito, California CG designer Scott Johnston recalls, "The transition to digital ink and paint and compositing allowed the CG artists to render their work and composite it with the other elements. No longer did the pen plots have to be put onto cels and painted by hand."[65] This capability allowed the 3D levels to be located within the overall scene hierarchy, plugged into various CAPS operations, and rendered with the other elements in the scene.

During its initial eighteen months, the Florida studio's CGI animators were called upon to work in both modes of production. All 3D elements for *Roller Coaster Rabbit* and *The Prince and the Pauper* were plotted frame by frame, transferred onto cels, and then advanced to the paint department. On *The Rescuers Down Under*, the three-dimensional models were directly imported into the system. Once the pencil drawings were digitized into the system, they could be registered directly to the 3D image. Importing these elements into CAPS eliminated the extra step of creating cels whenever the computer element made its appearance, thereby saving precious production time and expense. Once all the elements—traditional and 3D—were imported into the electronic x-sheet, the scene was composited and, with the directors' approval, cut into the final reel. CAPS allowed the Disney artists to combine the hard-edge graphic qualities of 3D imagery with the soft, round, and exaggerated style of hand-drawn animation.

Yet, while these forays were being made in combining 2D and 3D elements, upper-level management stressed the importance of both kinds of animation being visually compatible with the overall cel animation aesthetic. There had to be as little difference as possible between the two media so that it would go unnoticed by the audience. Did they succeed? There are differing opinions to answer this question, most likely dependent on the example being examined.[66] Computer elements could very easily stand out against a hand-painted landscape unless special care was taken in their texturing and colorization. Disney's artists and technicians sought to seamlessly integrate the two animation techniques, although it would take more films and software updates before this total integration was truly successful.

The Unredeemed Feature

The year 1990 was a turning point in the Walt Disney Studios' history. Animation was moving away from its historical beginnings toward a reorganization of production procedures due to technological advancements. Surely these developments would have made Walt proud, as throughout his career he was consistently a proponent of applying new technology and capitalizing on better methods of making better entertainment. Chris Pallant observes how "technological development was a fundamental part of the renaissance period, but unlike the marketing rhetoric of Disney's 'Golden Age,' the centrality of this new technology during the period was publicly downplayed."[67] Here Pallant is criticizing Disney, the corporation, for maintaining an anonymous stance on CAPS during the release of *The Rescuers Down Under*: "Regardless of the major impact that CAPS had upon the way feature animation was produced . . . Disney did not openly admit to the use of this process for a number of years."[68] In fact, several animation historians have commented on the Disney Studios' reluctance to promote this new technology. Telotte remarks that although Disney had begun to "hire animators who had been schooled in computer-aided animation, its animated product still looked quite conventional—deliberately so—and it continued to be marketed as consistent with the long and popular tradition of Disney cartooning."[69]

I agree with Pallant's and Telotte's assessments of the situation. While the studio's founder was known for showcasing the technological advancements seen in his ongoing releases, corporate Disney downplayed the use of the computer in their latest productions. In Florida, members from the Artist and Professional Development team, when giving tours through the backstage areas, avoided mentioning computer animation. Rachele Lord explained, "At that time, Disney was just experimenting with [computer animation]. However, within the next fifteen years, they went from, 'we're not talking about it' to 'this is how we're making these films'!"[70]

It wasn't until 1992, when the CAPS software received a Scientific and Engineering Award from the Academy of Motion Picture Arts and Sciences in connection with *Beauty and the Beast*, that the company openly acknowledged the computer's part in constructing the film.[71] The award was given in recognition by industry peers of the CAPS program, simultaneous with positive box office revenues for *Beauty and the Beast*, drawing attention to its ability to recreate the look of traditional cel animation in a digital format without compromising aesthetic style. This recognition earned CAPS a

wider, more positive profile within the company, which now capitalized on promoting this bold new innovation.

With the release of *The Rescuers Down Under* in November 1990, Disney proved that the computer was indeed able to synthesize the look of cel animation, eliminating many of its traditional materials. From that moment on, CAPS took formal control of Disney's animation pipeline. So at the end of chapter 2 we are poised on the brink of a transformation in the fundamental processes of filmic construction as well as the transition of habitual social norms. Remember, in 1989 American culture existed without smart phones, tablets, laptops; the intelligent systems built into our homes, offices, and vehicles; and all the many luxuries afforded by microchip technology. These technological advancements have changed global culture forever. Because of its technological significance, *The Rescuers Down Under* should be credited with as much distinction as any of its Renaissance contemporaries, being the means that enabled those future blockbusters to achieve new heights of visual artistry while retaining their hand-drawn aesthetic. Those results give CAPS a legitimate claim to be regarded as one of the key progenitors in integrating the computer within the animated art form.

It would be several years before the CAPS software and hardware was available in the Florida studio. However, management had no objection to relying on that studio's talent during the early stages of black-and-white production. The hand-drawn material was a good show for guests touring the theme park attraction. Row after row of animators sat at their desks drawing and flipping paper, or shooting pencil tests, giving the visitors something to look at. The artists were what Walt would have seen walking through the halls of his studio. In the camera room, film tests were shot in the traditional manner, one frame at a time on a shifting camera table, except that computers moved the camera axes, so they were no longer cranked by hand. While the California studio instituted new CAPS procedures in the final stages of production, the Florida studio maintained the illusion of traditional cel animation in front of the guests. Anyone visiting the Magic of Disney Animation would be unaware of the monumental transition that was taking place.[72]

3

B Unit to the Blockbusters
(1991–1997)

The Disney Renaissance displays an exuberant outburst of hand-drawn animation before the near-total elimination of two-dimensional artwork from Disney's repertoire. With the successful cross-country collaboration on *The Rescuers Down Under*, the Florida studio matured into its role as B unit to the California studio. Encouraged by the resounding success of *Beauty and the Beast*, California came to rely on Florida's help throughout the succeeding decade. With ever-increasing communication capabilities and business services, there was now a steady stream of production materials flowing between both coasts. Although the majority of each film was produced in Burbank and Glendale, Florida became a key factor in their completion.[1] This precipitated the transformation of the young studio from being primarily theme park entertainment to becoming an important contributor to the film division. The Florida studio is seen growing toward its true potential, recognized for its production capabilities as well as acting as a representational figurehead of Feature Animation on display to a curious public. This new identity affected the studio/attraction's prior relationship with other divisions within the company, specifically the Walt Disney World's Parks and Resorts administration and, most immediately, the Magic of Disney Animation attraction itself, where an imperceptible gap began to grow between the two sides of the glass.

The timeline for this chapter, 1991–1997, identifies the span of years when the Florida studio most heavily collaborated on California's films. Although this chapter encompasses a broad range of the Disney Renaissance, much of the discussion centers on the early success of the blockbuster musicals. Thus, while the Renaissance period is defined as beginning with *The Little*

Mermaid in 1989 and extending through *Tarzan* in 1999, the blockbuster years represent a shorter time span, 1991–1994, and feature the critical and financial success of *Beauty and the Beast, Aladdin,* and *The Lion King.*[2] It must be considered the pinnacle of the entire period and recognized as the moment when Disney returned to its former golden-age status. With these successes, what was management's expectation of the "little studio" now? It was incredibly high, particularly after the sweeping success of *The Lion King.*[3] Thus, the blockbuster years see the highest adulation within the Disney Renaissance yet also herald its long, slow demise.

Animation Services

Even as the Florida studio was assigned to the California features, the crew continued working on other small projects, following the original concept by the Imagineers.[4] While the California studio produced the lion's share of the films, Florida contributed significant amounts of footage that aided in reaching production quotas. They were also expected to deliver short films needed throughout the parks and to create commercial tie-ins with Disney's advertising partners. To manage these outside obligations, a new department was formed. Animation Services supervised the additional projects and became the contact point for internal customers and external vendors. The department acted as a separate production unit assembled under the guidance and supervision of executive producer Paul Curasi. The Animation Services crew acted as the executive team when producing these ancillary projects, with fewer members wearing multiple hats. At any given moment there might be three or four short films moving through various stages of production, and the Animation Services crew coordinated with each department in the pipeline. Depending on the final output, many departments (Animation, Effects, Ink and Paint, or Camera) put in extra hours in order to complete the required footage.

As executive producer, Curasi was responsible for bringing the films in on time and on budget according to client-mandated deadlines or schedules for television broadcast. When Imagineering envisioned a new multisensory attraction based on *The Little Mermaid,* they came to Animation Services to order additional footage from the artists who had worked on the original film. When a preshow was needed to entertain the long queues at the Magic Kingdom's Splash Mountain, Curasi's team created a lengthy film loop of a silhouetted figure in a rocking chair that repeatedly played while crowds waited their turn in line. There was footage of Tinkerbell, drawn by Tom Bancroft, used in the new nighttime SpectroMagic parade.[5] A public service

announcement was created in partnership with Jimmy Buffett to raise awareness of the plight of manatees in the busy Florida waters. And numerous other segments were produced for advertising and public relations purposes, supporting the Disney marketing machine.

Animation Services also contracted work from international vendors and Disney partnerships. The Euro-Disneyland theme park (now known as Disneyland Paris) was scheduled to open in Marne-la-Vallée, just outside of Paris, on April 12, 1992.[6] Animation Services, in partnership with France Telecom, supervised an enormously complex project directed by California animator Chris Bailey. They produced over a dozen vignettes featuring several characters from It's a Small World communicating with one another all over the globe.[7] These vignettes were situated in an enormous post-show display at the exit of the European Small World attraction. Curasi and his top creative staff also flew to Germany to shoot live-action footage of supermodel Claudia Schiffer for a Disney-themed television commercial.[8] Schiffer is seen dancing in a nightclub with Mickey Mouse, who was later animated by the Florida crew. The commercial was for a popular European soft drink and linked Mickey with contemporary European culture.[9] When Tokyo Disneyland debuted a new attraction, Animation Services produced several sequences for the hugely popular Pooh's Hunny Hunt dark ride.[10]

Life under Glass

While production demands kept the animation crew busy each day, they were still on display to the theme park audience. It is worth considering how daily life under constant scrutiny affected the creative individual after weeks, months, and even years of working in a theme park. The artists were well aware of the huge popularity of the films and their role in creating them. To relieve tension after long hours at the drawing board, they often went for park walks to grab an ice cream or popcorn, or just to get away from their desks. Inside the studio, they maintained the long-standing tradition of drawing caricatures and playing practical jokes. As described in chapter 1, at any given moment, a large, red rubber band might go sailing across the fishbowl, triggering a melee of rubber-band wars that swept across the open space.[11] The crew were also avid fans of table tennis, so the Ping-Pong tables were not only fiercely contested with challenges and annual tournaments but also served as an after-hours place to hang out. In later years, when the animators were housed in trailers behind the original building, the artists used the geometric layout of the structure as obstacle courses for racing remote control cars.[12] People coming and going through the halls were considered natural hazards.

Another aspect of studio life was the training of new talent and providing resources for current projects going through production. This fell to another division under the Florida studio's roof, Artist and Professional Development. Frank Gladstone was the first manager of this important department and was later succeeded by Gary Schumer and Jack Lew. A large part of the job was to visit top animation programs at colleges throughout the United States to look at hundreds of portfolios of students seeking internships at the Disney Studios. These, hopefully, could lead to the students being hired for production after they graduated. Many future animators came out of the internship programs, filling spots in both Florida and California. Tom and Tony Bancroft had originally come from the California internship program when they attended CalArts. Other interns included Elliot Bour, Sandra Groeneveld, Tracy Lee, Monica Murdock, and Mario Menjivar. These are just a few of the artists who were given the chance and later made huge contributions to the Renaissance films.

Professional Development was also responsible for scheduling lectures and drawing classes tied to the latest films in production. Leading authorities came to the studio to provide workshops on artistic genres or animal behavior. During *The Lion King*, Jeanie Lynd Norman remembers Jim Fowler, the renowned television personality, animal behaviorist, and handler, visiting the studio with several animals that were to be featured in the film.[13] In one of the live-action soundstages, a raised platform was set up where Fowler could display and lecture about different birds and mammals he had brought along. The animators sat at drawing benches sketching on large pads while he demonstrated musculature and recounted anecdotes from his adventures in the wild. Eventually, a pair of lion cubs was brought out and played on the stage while Fowler spoke about their lives within the pride. He talked about the roles of older lions while another handler brought out a juvenile male lion named Chewy. While Fowler spoke, the handler gave the lion a whole raw chicken. Norman was at the front of the stage. As she tells it:

> When Jim Fowler brought Chewy out to feed him, they needed me to hold the bottom of the platform [stage], which I did. However, part of the chicken Jack was feeding Chewy started to fall and I moved a little bit. Chewy came within a couple inches of my face because he thought I wanted to eat his chicken! I was scared to death. After they took Chewy off stage, Fowler had me come back over and pet Chewy and be around him to let him know I wasn't afraid of him. It was an experience. We were literally face to face![14]

This practice of bringing in animals for the animators to draw began during Disney's production of *Bambi*. At the Florida studio they scheduled drawing sessions featuring a couple of bear cubs, a white lion, and a huge Belgian draft horse.[15] They invited fine artists and illustrators, film analysts, and even outsider folk artists, who passed along their knowledge, techniques, and insights to the crew.[16]

However, life at the Florida studio was not for everyone. Some of the artists could not tolerate the gawking crowds behind the glass, uneasy with the knowledge of being watched at all times. Anything that was drawn, flipped, painted, shot, or cut was likely to be seen by unseen eyes. The term "living wallpaper" was coined by the crew for the guests moving behind the glass. The flow of people entering the attraction was controlled by the number of seats contained in Theater One. Once the doors opened to allow guests into the corridor, they usually followed the ongoing *Back to Neverland* vignettes that were strategically programmed to lead them through the tour. But it was the continuous flow of people passing through the tour corridor that many artists found unnerving.

Guests often asked the tour guides if the people behind the glass were really animators or just actors playing a role in the attraction.[17] They wanted to know if the glass was one-way. Could the artists see the crowds on the other side? During construction of the attraction, Max Howard was given the option of installing clear or one-way glass. He admits, "Yeah, so the two-way glass was important, because I thought if you're going to be looked at, you need to know who's looking at you. That also fed into the humor as years went by, because people didn't realize you could see them."[18] When the studio initially opened, the glass was single-paned, but later it was replaced with double-panes after the artists complained about the noise coming from the corridor. At first the artists were curious to see the people moving through the tour, but after a while the novelty wore off and absorption in their work took precedence over the feeling of constant surveillance. Thus, most people came to terms with their environment.

But it often felt like being on exhibit at a zoo; people would tap on the glass just to be noticed or wave hello. Lisa Reinert remembers that this happened all the time to the artists working in Ink and Paint.[19] Another time, a guest asked whether there were animatronic figures on display behind the glass.[20] In this instance, one of the camera operators was reading a technical manual while awaiting that day's shooting. He was concentrating so steadily that he remained absolutely still except to turn a page every few minutes. His desk was some distance from the glass, in a darkened room, and apparently

this particular guest had been watching him for some time. The tour guide assured the guest that the cameraman was, indeed, a living human being. To this day, it's a question as to whether that guest believed the camera operator was a real person and not a robot.

The Florida studio's popularity attracted not only park guests but also visiting dignitaries and celebrities, who often accepted an invitation to tour the backstage areas. The studio hosted many notable personalities from all spheres of music, film, fine art, and politics; guests included Michael Jackson, Billy Joel, Leonard Nimoy, Robin Williams, and Princess Diana with her sons and entourage.[21] Sherrie Sinclair remembers when Princess Di came to the studio:

> As a newbie at Walt Disney Feature Animation Florida in early 1993, while *The Lion King* was in production (I was on the Young Simba team), I spent my initiation time in the "fishbowl." This was the area right under the large glass windows where the public taking the animation tour got a glimpse into our working studio. Celebrities often toured the studio. One such time was when Princess Diana, her sister, and their boys came for a visit. At the time I had a pet rat named Boo, whose aquarium was at my desk and on view. As Princess Di stood at a distance looking on, the boys approached my desk and Prince William—the Future King of England—exclaimed, "May I stroke it?" The boys took turns holding and petting Boo. Boo the rat was also videotaped for reference and action analysis for the film *Pocahontas*. Years later, he passed away and is buried behind the studio in Bridgette's [*sic*] Garden.[22]

Along with the VIP tours, there were weekly visits from the "Star of the Day" program. In the early years of the Disney-MGM Studios, a monthly calendar was published announcing upcoming "Star" appearances, celebrity visits that included parades, interviews, and a handprint ceremony in front of the replica of Grauman's Chinese Theatre. These activities served to reinforce the overall moviemaking theme of the park. Some of the perks of being the "Star" were multiple opportunities to enjoy Walt Disney World from a privileged position. The celebrities' preferential treatment included visits to areas not open to the general public. One of the most popular behind-the-scenes activities was a guided tour of the animation studio, accompanied by a member of the crew, which allowed for personal interactions with the artists. This invitation was seldom turned down. The "Star of the Day" program featured many actors/actresses from film and television; chief among them were celebrities from both the *Star Wars* and *Star Trek* franchises, who found a huge fan base with the animators. Thus, many of the animation personnel guided their favorite stars and their families around the backstage areas of the

studio. They stopped at random desks to see what the artists were working on. Park guests often caught sight of the celebrities through the glass as they made their way around the production floor, and crowds always gathered when these privileged visitors opted to stop and paint a cel in the ink and paint department.

Through the Looking Glass:
The New Identity of the Florida Studio

Although working in a theme park, the crew behind the glass was still responsible for producing the high-quality animation for which Disney is renowned.[23] In the beginning it was intended that Florida would simply produce in-house projects, but that role changed with the ever-increasing popularity of the animated films. Projects were assigned by Feature Animation management in California and helped to keep the pipeline going. They also provided viewing material for guests taking the Magic of Disney Animation tour. Thus, Florida's crew satisfied two entities at once: Feature Animation, by providing pencil footage for the films, and the parks administration, in terms of performance content while being onstage.

Florida's role on *Beauty and the Beast* was structured differently from that of *The Rescuers Down Under*. Whereas the crew worked mostly on crowd scenes and small scenarios within *Rescuers'* sequences, *Beauty's* directors, Gary Trousdale and Kirk Wise, assigned entire segments from the film, beginning with "The Mob Song" (Sq. 20, "Kill the Beast"). In this sequence the men in Belle's village are led by Gaston to attack the Beast's magic castle. Animators like Mark Henn, Aaron Blaise, and Alex Kupershmidt were assigned to create leading characters, while other animators supplied the frightened townsfolk. All departments, particularly Cleanup and Special Effects, contributed to the overall success of the sequence. More assignments followed, including another song, "Something There" (Sq. 15.1) and its reprise, as well as dramatic sequences like "Bargain with the Beast" (Sq. 6), "Invitation to Dinner" (Sq. 11), and "The Library" (Sq. 15.4).[24] Thus, animation from both coasts was intertwined throughout the film. After long months of hard work, *Beauty and the Beast* finally wrapped production and, because of the enthusiastic early response to the film—particularly the "Work in Progress" edition previewed at the New York Film Festival—extravagant media and publicity events were planned.[25]

Let me take a moment to explain another aspect that came with the completion of a film. At the end of every production, a wrap party was planned to celebrate the finishing of the project. These wrap parties were special

events for the artists to see the final version of the film. In Florida it was often scheduled to coincide with larger festivities being held for the movie's release. One of the most magical of these events was the *Beauty and the Beast* wrap party. It took place at the Disney-MGM Studios, beginning with a special screening of the film in the Backstage Studio Tours' main theater. After the screening, the artists and their guests were guided toward a darkened alleyway made up to look like a mysterious wood filled with skeletal trees, billowing mist, haunting music, and fairy lights. Emerging from this path, the artists found themselves on a backstreet that had been dressed as a recreation of Belle's village.

The set had been constructed for the elaborate press junkets that would be taking place all week. To the animators, already familiar with the art direction and set design, it was an amazing spectacle. There were tables of food served buffet style, with wait staff everywhere offering beverages of all sorts. Many of the buildings offered games of chance, designed to facilitate winning, with prizes consisting of merchandise from the film. Feature Animation management was there to congratulate the artists, and many of the celebrity voices attended as well. Roy E. spent much of the evening talking, laughing, and having his picture taken with the artists. Upon exiting the gala, gift bags were distributed filled with T-shirts, watches, and a silk rose in a plastic box with a card featuring the film's logo. The Florida crew didn't go home but moved the party to Pleasure Island, the company's adult nightlife park. Howard himself went to the turnstiles and, using his authority, allowed the crew to enter and take over the nightclub Mannequins for the rest of the evening.

Wrap parties were a special event in the lives of the Florida crew. With all the available resources at Walt Disney World, these celebrations became more and more elaborate as the Disney Renaissance progressed. It was only the beginning with *Roller Coaster Rabbit*, when Howard reserved one of the ferry boats that normally shuttled guests to and from the Magic Kingdom as the venue for the evening. The event included dinner, drinks, and dancing while cruising around Bay Lake, watching fireworks explode in the sky above Cinderella's Castle. Other events soon followed, each themed to a particular film. Some were held in Epcot after the guests were gone (Morocco and France), others at the hotels (the Grand Floridian, Disney's Yacht and Beach Club, and the Contemporary Resort), and still others at restaurants around the property (Brown Derby, House of Blues, and the Soundstage Restaurant). At one point, there was even a family weekend celebration where the entire studio held a sleepover at the Fort Wilderness campground.

The Power of *Beauty and the Beast*

Beauty and the Beast premiered on November 22, 1991. The film continued the forward momentum begun by 1989's *The Little Mermaid*, in part because *Beauty* continued the popular trend of Disney musicals. It was clear from the box office receipts that this was exactly what the public wanted. The film capitalized on the genius of *The Little Mermaid*'s songwriting team, Howard Ashman and Alan Menken, who, like Peter Schneider, Thomas Schumacher, and Max Howard, all came from a New York Broadway/London West End theater background.

In the wake of the film's success, in 1991 *Beauty and the Beast* became the first feature-length animated film to be nominated for the Academy of Motion Picture Arts and Science's Best Picture category.[26] In Florida a celebration was organized to commemorate this unprecedented achievement. At the Soundstage Restaurant, next door to the studio, a dinner was held with a monumental screen that televised the awards ceremony. Even though *Beauty* did not win (*Silence of the Lambs* won Best Picture that year), it did receive Academy Awards for Best Original Song ("Beauty and the Beast") and Best Original Score. The result of this Best Picture nomination eventually led to the creation of a new award category, Best Animated Feature Film, in 2001, acknowledging animation as a formidable force in motion picture entertainment. As of this writing, only two animated films have been nominated for the overall Best Picture category: *Beauty and the Beast* and Pixar's *Up* (2009); otherwise, all feature-length animated films are now considered for the Best Animated Film category.[27] But there was another significant milestone in connection with *Beauty and the Beast*.

By this time CAPS had complete control of Disney's animation pipeline, and cels were a thing of the past. With their elimination, scanned and composited images became the standard in creating animation tests. *Beauty* demonstrates how crucial CAPS had become to Disney's production process. The program allowed multiple formats—traditional drawings and 3D elements—to be combined with special-effects operations and sophisticated camera movement, composited into a single frame. The visuals for this film built upon the initial work done on *The Rescuers Down Under*, where, unlike the creation of physical cels for 3D elements as seen in *The Prince and the Pauper*, the computer-generated elements could be directly imported into CAPS, eliminating the need for tangible artwork to be placed beneath the camera's lens. *Beauty* capitalized on those lessons and took the computer a step further, introducing hand-drawn characters within a 3D environment,

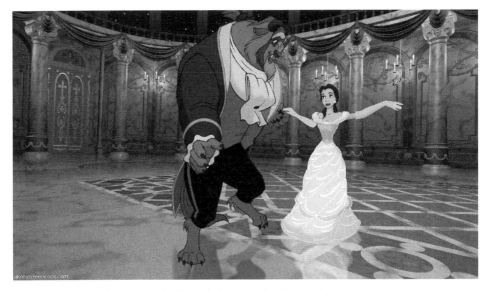

Figure 3.1. Film frame of Belle and the Beast dancing in the computer-generated ballroom from Sq. 18, Sc. 20. Source: Iris print from the Walt Disney Animation Research Library, Burbank, California.

beautifully demonstrated in the now famous ballroom sequence (Sq. 18).[28] Admittedly, it was not the computer that was responsible for the incredible public response to the film. The aesthetic capabilities offered by the new technology simply acted as a support structure for the narrative, art direction, and theatrical elements that came from the best of Broadway musicals.

During that same Academy Award season, the CAPS program was formally acknowledged by the industry, bringing public awareness to the fact that *Beauty and the Beast* was not created in the traditional cel animation method. With the overwhelming success of the film, the sophistication of *Beauty*'s 3D ballroom meant that the inclusion of computers within the film was readily apparent to the public, although the use of CAPS was not so flatly obvious. In a different awards ceremony, the Academy recognized this technological achievement by presenting the CAPS teams from both Pixar and Walt Disney Feature Animation with a Scientific and Engineering Award.[29] In the aftermath, the Walt Disney Company began opening up about the existence of CAPS and its ability to replicate the look of traditional cel animation.

This situation was more in line with the practices of the company's founder, Walt Disney, who emphasized the use of cutting-edge technology in the promotion of his films.[30] Up until this time, the company had insisted that

CAPS maintain a low profile and focus on mimicking the hyperrealistic style; it did not advertise *how* those visuals had been created. With official recognition by the Academy, CAPS was now promoted by its parent company for its contribution to the success of the film. Nonetheless, even with this acknowledgment, it would be years before detailed information about the proprietary program would be released to the general public.[31] Thus, even while *Beauty and the Beast* was celebrated for its successful combination of storytelling, art direction, musical score, and superb draftsmanship, it was hardly ignored for its technological prowess.

The Genie in the Bottle: The Move from Mechanization to Computerization

The Florida studio continued producing larger amounts of screen time with each succeeding film. While *Beauty* was receiving accolades from the press and public alike, crews in both studios were already hard at work on the next film, *Aladdin*, little knowing that it, too, would receive such national acclaim. When discussing *Aladdin*, critical reviews often note its fantastic character animation (both vocal and visual), the beauty of its art direction, its award-winning soundtrack, and the political volatility of its subject matter.[32] The narrative's manic pacing and vocal performances, particularly that of Robin Williams in his role as the Genie, intensified the tumultuous experience for the audience.[33] But Disney's film was not the first animated attempt at a feature based on the Middle Eastern folktales from *One Thousand and One Nights*. Legendary animator Richard Williams devoted much of his career producing an Arabian Nights fantasy known as *The Thief and the Cobbler* (1995).[34] Well before that, a Middle Eastern motif was used in the oldest surviving feature-length animated film, *The Adventures of Prince Achmed* (1926), produced by German silhouette animator and director Lotte Reiniger.[35] The stylistically modern studio United Production Artists (UPA) used this same motif as a vehicle for their most popular, and profitable, animated character, Mister Magoo, in *Magoo's 1001 Arabian Nights* (1959).[36]

With the release of *The Little Mermaid*, codirectors Ron Clements and John Musker were responsible for the birth of the Disney Renaissance. Encouraged by the successful California-Florida collaboration on *Beauty and the Beast*, they decided it was possible to cast their lead animators by character, a common practice in Disney's personality animation.[37] That meant the working relationship on *Aladdin* would take the two studios to a whole new level.[38] They had already cast Robin Williams as the voice of the Genie, with Eric Goldberg as lead animator. The title character of Aladdin was given to master

animator Glen Keane, with vocal talent contributed by Scott Weinger. The twist came when the directors cast Florida's Mark Henn as lead animator on a third principal character, Princess Jasmine, with Linda Larkin providing her speaking voice and Lea Salonga handling her singing parts.[39] Their choice was a bit of a gamble, as work on the main characters, Aladdin and Genie, was being led in California, and Henn resided over twenty-five hundred miles away.[40] We can read their decision as evidence of the strengthening connection between the two studios, emphasizing the status of Florida as a serious contributor to the film division. In contrast to the studio/attraction's debut, this new relationship offers proof of the final transformation of the animation crew from being identified as Walt Disney World cast members to the elite of Feature Animation production personnel.

In the Special Features section of the *Aladdin* DVD, the documentary segment titled "A Diamond in the Rough: The Making of *Aladdin*" stresses the concept of the film as a buddy picture, so the main relationship existed between Aladdin and the Genie.[41] This emphasis on the male bond made the romance between Aladdin and Jasmine secondary to the story line. In the "Designing Jasmine" segment of that same documentary, Henn talks about his inspiration for the look and personality of Princess Jasmine but doesn't mention that he was working on the opposite side of the country. Since Henn was assigned to a major character, it would require more communication time with the directors, but it also brought up concerns about how the other characters would interact with one another.

The solution was to cast other Florida animators on characters being led in California. For example, Alex Kupershmidt was assigned to Glen Keane's Aladdin unit, while Tom and Tony Bancroft (working on both coasts) were assigned to Will Finn's Iago the parrot. Lou Dellarosa drew the villain Jafar, led by Andreas Deja, and Barry Temple was assigned to David Pruiksma's Sultan. A secondary character was also led in Florida: Jasmine's pet tiger, Rajah, led by Aaron Blaise. These additional casting choices allowed many of the sequences to remain in-house, permitting direct interaction between animators working on the same scenes. This practice extended to members of the Cleanup crew, who were also assigned to specific units, keeping the characters on-site in case any questions arose that could be answered directly by the animator. Additional sequences that did not directly involve Jasmine were also given to Florida. For example, the 3D department produced animation for the tower Jafar uses to rocket his rival, Aladdin, to "the ends of the earth." In addition, 3D supplied numerous amounts of atmospheric effects, like the confetti created for the Prince Ali parade sequence. Thus, the entire studio was dedicated to supporting this bicoastal effort.

Despite the fact that CAPS was not available in Florida, by the time *Aladdin* went into production, the software had transformed how the effects artwork needed to be created. Since *The Rescuers Down Under*, the effects department had been divided into two distinct areas: hand-drawn effects (pencil on paper) and purely digital animation (rendered in the computer). Most scenes calling for traditional effects, such as tones, shadows, rim lights, and highlights, were created with the CAPS operations in mind. The two-dimensional drawings were created so that the computer's operations had full control of the effect, like adjusting the amount of opacity in a shadow or how much blur was seen on the edge of a character. Operations such as turbulence, directional blur, and gradation gave the artists tighter control over the finished look of each frame. CAPS also contained a library of stock visual effects like rain, snow, or water reflections that could be downloaded directly into a scene. Even with these stock components, plenty of traditional effects still required pencil drawings, such as mud, snowdrifts, footprints, lightning bolts, or individual droplets of water.[42]

Unlike cel animation, CAPS offered distinct advantages in maintaining color values throughout the film. Acetate cels caused slight variations in the colors of a character depending on whether it appeared on the top level or further down in the stack. The plastic material added a slightly yellowish cast, which altered the color of the model. Disney's original ink and paint artists were aware of this fact and always compensated for it in highly complex scenes. CAPS allowed characters to move from one level to the next without any variation in the hues. It also brought back the practice of using self-lines on a character. Self-lines are a technique of inking the outlines of a character in varying tones of the color palette, creating a richer, more complex image. When Disney moved to the xerox process in the 1960s, they lost this technique except on rare occasions when a money shot called for particular embellishments to the character design. Self-lines can be of different tonal values of the object or even contrasting colors to enrich the overall palette, accentuating the character's features or costume. In a typical Princess Jasmine color model, her black hair is often framed by a purple self-line, while the outlines of her skin are a slightly darker shade than their internal hue. The outlines on her gold jewelry are matched to their interior color, thus showing no borders at all. The CAPS operations offered the look of traditional 2D effects animation while providing increased versatility to enhance the characters and their backgrounds.

Hybrid Animation:
Transferring Disney's Hyperrealism into 3D

Animation allows the artist to create visuals that would be physically impossible to simulate in real life. One of the most important questions when developing an animated project is what elements make it impossible to do the story in live action. (Admittedly, with today's technology, 3D is easier than ever to integrate into live-action films. Witness the current trend of remaking live-action/3D films based on Disney's earlier animated ones.) When the computer entered the animated art form, it helped alleviate costly and time-consuming processes, usually with cleaner, more precise results. In the early stages, production designers and technical engineers sought the computer's help in creating hybrid solutions, combining two-dimensional artwork with three-dimensional models and mechanics, thereby exploiting the best of both methods.

The practice of animation production was shifting from a state of *mechanization* to one of *computerization*. But what do I mean by this statement? According to Canadian animator Norman McLaren, the definition of "animation" is "the art of manipulating the invisible interstices that lie between the frames." Edward Small and Eugene Levinson labored to devise a complete definition that would include the many different forms that comprise the entire genre.[43] Besides the artistic considerations, animation can also be said to be based on a mathematical foundation that determines the amount of character or camera movement taking place on each frame. While the animator determines how much movement occurs from one drawing to the next, the layout artist plans the camera's overall trajectory so that it follows the character as it moves within the scene. When CAPS took over and the artwork was transformed into digital information, the camera and the character's mechanics could now be manipulated using complex mathematical formulas. With CAPS, the original incremental system derived from the cel animation process was incorporated into the program, which used these values to control the scanned image. Doing so allowed far greater versatility in moving both the character and its environment. This capability was available only when using digitized artwork and impossible to imitate with physical drawings, cels, or backgrounds. Thus, the mechanical processes once used in traditional animation were now supplanted by computerization, and the artwork was no longer bound by tangible physiological properties. Now the artists could manipulate each element independently, allowing for the revision of images after they became digital information.

With *Aladdin*, "hybrid animation" was used to create characters that were a combination of both 2D and 3D elements. The term was originally coined to describe the method of creating animated characters that interacted with live-action figures or environments.[44] Telotte expands on this discussion when talking about combining hand-drawn animation and computer-generated objects. He says, "By the time *Toy Story* had entered production, the combination of differently sourced visuals—what we might well think of as another, if almost invisible, sort of hybridity—was becoming just as common in the world of Disney animation as the combination of live-action or miniatures with CGI effects was in big-budget, nonanimated [*sic*] fantasy productions during this same period, as films like *Terminator 2* (1991) and *Jurassic Park* (1993) illustrate."[45] Telotte alludes to experiments by Disney artists without elaborating on how the computer was incorporated into the films. Although it is fairly easy to distinguish between 2D and 3D animation, it was felt that the conflation of both media was necessary to conform to Disney's hyperrealistic style; thus, the hybrid character in a Disney film had to meet a number of criteria before it could be considered a success. That success can be measured in varying degrees when examining the computer-generated ballroom in *Beauty and the Beast* and even more when scrutinizing the Tiger's Head and Magic Carpet from *Aladdin*.[46]

While traditional animators used the CAPS system to enhance their physical drawings, 3D animators sought to harness the plasticity of the graphic medium to capitalize on those possibilities first witnessed in *The Great Mouse Detective*, *Oliver and Company*, and *The Rescuers Down Under*. Computing systems had advanced exponentially since the vehicles and mechanical devices created for those earlier films. Digital 3D elements were now modeled, rigged, rendered, and imported frame by frame into the CAPS system; once there, they were plugged into the leveling hierarchy and composited with other, traditional elements. During *Aladdin* the artists devised several methods by which the computer could be used but always with an emphasis on the seamless integration between the digital and two-dimensional worlds. This was done in order to avoid disrupting the film's overall production design. Significantly, these technological breakthroughs occurred in the California studio, where the software and hardware needed to create such images was located, but this kind of experimentation was also happening, albeit on a smaller scale, at the Florida studio.

First, let's discuss the example of "hybridity in action" that is *Aladdin*'s Magic Carpet. Without dialogue, or even facial features, Magic Carpet aids Aladdin throughout the film: escaping the Havoc in the Cave of Wonders, romancing and winning Princess Jasmine's heart, and rescuing and returning Aladdin to Agrabah in time to overthrow the evil vizier Jafar. Its playful personality and colorful design make Carpet an impressive example of the conflation of two and three dimensions, fulfilling a vital role within the film's narrative. Simply animating such a character was a difficult assignment. How do you give a rug personality when it has no words to describe what it is thinking and no eyes or mouth to transmit clues to what it's feeling?

California animator Randy Cartwright was given the unenviable task of animating the Magic Carpet, making it one of the earliest examples of a hand-drawn 3D hybrid character. Cartwright's dilemma was to find a way to give the rug personality without the usual anthropomorphic features that express emotion in an inanimate object. He describes his initial reaction in the *Aladdin* DVD documentary "A Diamond in the Rough"[47]: "When I was offered the assignment, I think it was Ron [Clements] actually that told me. He kind of called me in and said, 'Well, we have a part for you in *Aladdin*.' And I was, 'Ok, great. What is it?' 'Well, it's Rug.' 'Ok, yeah. So it's alive?' 'Yeah, it's alive.'" Cartwright went on to say, in discussing the role with story artist Ed Gombert, that he realized Gombert saw the true potential of the character when he stated, "If the character succeeded and came to life, it would be memorable." In hindsight, this is an understatement, as millions of animation fans will tell you just how innovative this piece of animation truly is.

Produced in 1991, the Magic Carpet is a hybrid creation that began as paper drawings that were then transformed into a three-dimensional character.[48] Working in the California studio, Cartwright drew the rough animation for the rectangular carpet while 3D animator Tina Price created a computer model using a primitive rectangular shape.[49] An additional step became necessary when the directors, Musker and Clements, requested that the tassels remain hand-drawn throughout the film. Therefore, Cartwright and Price's task was not only to animate the rug but also to combine it with an additional level of animation to create a single cohesive look. Fellow animator and historian Tom Sito sums it up when he says, "The character of the Magic Carpet, drawn by Randy Cartwright and completed in 3D by Tina Price, was conceived as a more purely CG character, worked into the 2D format. He moved like a traditionally animated character but with a complex Persian

rug pattern texture mapped onto him. . . . The goal was to seamlessly blend the CG with Disney's classical 2D animation."[50]

Since all animated characters have an artificial personality of some sort, the trick to making one successful is finding the best way for it to communicate with its audience. *Aladdin*'s Magic Carpet communicates through the elasticity of its geometric form augmented by the expressive gestures of its four tassel appendages. Cartwright cited the art of the mime as his principal influence in giving Carpet personality without the use of facial expressions or dialogue.[51] It communicates emotions solely through poses and gestures that are recognizable to the audience. Cartwright overcame the absence of facial features and dialogue by relying on exaggerated body language balanced with utilitarian function—alternating between the expressive child and the practical object. In one scene Carpet jumps for joy, while in another it molds itself into an airplane's off-ramp for descending passengers. The rectangular figure is squashed and stretched as with any traditional animators' drawing, yet always returning to its original geometric shape.

The computer's contribution to the process was not merely in rotoscoping Cartwright's drawings; it became an intense collaboration between the two artists. Price interpreted the character's personality into digital form. She scanned Cartwright's drawings into the computer, creating a template for each scene.[52] Taking her cue from the four corners of the rectangle, she shaped the 3D plane of Carpet to mimic the drawn line and thus matched the movement and timing of the reference drawings. Without Price's animation of the 3D model, the addition of Carpet's bold graphic pattern and rich color palette would not have been possible. In this way, the computer added new possibilities to the film's aesthetic. After Magic Carpet's animation was approved through the cleanup stage, the rug's complex geometric pattern was texture-mapped onto the 3D model. The pattern adhered to the rectangle like a second skin and followed every movement of the animated form, matching every twist, turn, squash, and stretch of the character's frenetic motion. To animate Carpet's intricate design by hand would have been labor-intensive, time-consuming, and very expensive. It would have been difficult to replicate the bending shapes and lines while retaining its smooth fluid motion. Without the calculating and rendering power of the computer, the directors' vision of Carpet would not have made it to the screen in this highly sophisticated and color-saturated form.

Disney's Magic Carpet acts in a narrative role just as much as it contributes to the film's overall aesthetic. Through its relationship with Aladdin and Abu, Carpet adds to the magical essence of the film and the ultimate success of

the protagonist. It contributes to that most important question put to any animated film: Why not produce it in live action? Contemporary live-action filmmaking did not have the ability to portray characters such as Goldberg/Williams's shape-shifting Genie or Cartwright/Price's Magic Carpet. While the Genie is fantastically two-dimensional in its creation, Carpet would have been less effective without its exuberant personality combined with its elaborately stylized design.

"PINES OF ROME" (SEPTEMBER 1993–DECEMBER 1995)

The hybrid technique developed for the creation of the Magic Carpet in *Aladdin* was used to create another character, around the same time, with a close connection to the Florida studio. While Magic Carpet highlights the initial processes used in constructing a hybrid character, the Baby Whale in *Fantasia 2000*'s "Pines of Rome" sequence illustrates how sophisticated this kind of collaboration would become and the emphasis that was placed on making it conform to Disney's *illusion of life*.[53]

The format for this film followed the same structure as the iconic 1940's *Fantasia*, Walt Disney's highbrow attempt at presenting animation as a form of fine art. Walt's original plan was to create multiple versions of the film using the segmented format, where it was possible to add and subtract sequences to create a new version every few years. When the original *Fantasia* bombed at the box office under scathing critical reviews, Walt shelved plans for future editions. The concept was resurrected in 1991 as a personal project of Walt's nephew, Roy E. Disney, who acted as executive producer, along with Don Ernst.[54] Roy E. contacted Hendel Butoy in May 1991 to ask if he would undertake the new project. The first sequence to go into production was "Pines of Rome," which Butoy elected to direct himself, in addition to overseeing the entire film.[55] The project was originally titled "Fantasia Continued," echoing Walt's original plan, but later changed to *Fantasia 2000* when it was decided to release the film to coincide with the turn of the new millennium.

We have already seen Butoy as the director for *The Rescuers Down Under*, while Ernst was the producer on Florida's first short, *Roller Coaster Rabbit*. Butoy was given the unique position of utilizing small groups of animators from within Feature Animation's overall studio complex. When a crew came off of one project, but before being cast on another, Butoy relied on their talents for the latest segment in production. He drew from both the California and Florida facilities. As the California studio's crew grew exponentially during the 1990s, in an effort to handle two features concurrently in production, it was determined that a separate location was needed to house

Figure 3.2. Publicity photo of the Baby Whale. Note the cartoon eyes on the CGI body. Source: Barbara Robertson, "*Fantasia 2000*," *Computer Graphics World* 23, no. 1 (2000).

this unique project. By 1996 California's main studio had become known as Southside, while a second, digital studio was designated Northside and located in a warehouse district next to the Hollywood Burbank Airport.[56] It acted as home for both the "Fantasia Continued" and *Dinosaur* (2000) crews. Animators from the Florida and Paris studios (established in 1994) contributed to various segments of the film. Thus, different groups of artists are credited with the different sequences that comprise the whole.

The "Pines of Rome" sequence was the first to go into production. With music composed by Ottorino Respighi in 1924, the musical composition was paired with a fantasy narrative involving flying whales in a spectacularly reflective universe. The multitudinous pods of 3D whales travel within a two-dimensional universe. The sequences' x-sheets contain layers of 2D layouts and effects, 3D models, and a hybrid character enhanced through both hand-drawn and digital construction.[57] These elements were imported into CAPS and composited together to complete the final frames.

The adult whales in the sequence were constructed and animated as 3D models. The computer animation is imbued with monumental movement that supports the heavy strains of music at multiple points of crescendo. The Baby Whale was created using the hybrid technique with its original shape

modeled and rigged within the computer. Although "Pines" is but a single segment in the film, the scope of this little character is immense. The process was similar to that established by Randy Cartwright and Tina Price when they created *Aladdin*'s Magic Carpet. While the process recalls Carpet, the Baby Whale was not merely a rectangular plane, nor did it have the look of its enormous parents. The basic shape consisted of a more rounded, cartoonish look and was constructed using a series of geometric forms modeled together into a single cohesive unit. Then 3D model sheets were created and distributed to the 2D animators, who roughed out the drawings, providing personality and timing for a more comedic effect.[58] Similar to the tassels on Magic Carpet, Butoy decided that hand-drawn eyes imbued the characters with a more organic personality.[59] In a film without dialogue, these hand-drawn elements reveal greater emotion, thereby enhancing the pantomime required to communicate with the audience.

While the whale characters were led in California by animator Darrin Butts, part of his team was located at the Florida studio.[60] Many of the Baby Whale scenes were drawn by a group of Eastern European animators newly arrived from overseas. These four men—Darko Cesar, Alexander "Sasha" Dorogov, Serguei Kouchnerov, and Branko Mihanovic—were part of a United States government initiative that came about in communications between government officials and the Walt Disney Company.[61] Animation has always been a multicultural art form, meaning that talent recognizes no national boundaries when it comes to creating animated entertainment. Indeed, animation is often more popular and widely diverse in countries outside the United States.

Max Howard, as director of the Florida studio, was given the assignment of transporting, adapting, and training these new recruits right after the collapse of the Soviet Union in December 1991.[62] It was decided at the executive level that Florida would make for an easier transition into American culture than the confusing cross-cultural identifies found in Los Angeles. One of the animators, Sasha Dorogov, came from the Russian capital of Moscow, and Serguei Kouchnerov was from the region of Ukraine. Darko Cesar and Branko Mihanovic both came from Croatia, where they had formerly been members of the armed forces fighting in the conflict between political factions seeking control during the dissolution of Communism. These men and their families immigrated to the United States to contribute their artistic talents to the creation of Disney's films. It was a whole new world to them, where they were required to achieve fluency in a new language and live in a vastly different cultural setting while conforming their artistic style to fit the Disney aesthetic.

The team's first assignment was to create the 2D drawings for the Baby Whale in the "Pines of Rome" segment. They were trained in Disney's hyper-realistic style and rose to the occasion. Darko Cesar remembers:

> When we got to the studio, we had to go through six months' training for a more Disney style of animation. So they found a guy in Los Angeles. He was an animator from the '80s, Hendel Butoy, who was also directing *Fantasia Continued*. He was pretty much flying back and forth once a month [to Florida] to spend time with us here. . . . That was early on, really the first days, the baby steps of computer animation. We actually animated [the Baby Whale] by hand, and then they were scanning our drawings and made computer images. After they turned our drawings into computer images, then [the animation] went back to the 2D guys, who drew on those big, huge eyes.[63]

The Eastern European animators achieved this task while taking direction in a second language from a director in California while simultaneously adapting to life in the United States. It was a huge transition but a rewarding one.[64]

The "Pine of Rome" sequence was officially introduced to the press on February 14, 1995, but the completed film did not premiere until December 17, 1999.[65] Widespread general release was slated for January 1, 2000, to coincide with the new millennium.[66] *Fantasia 2000* was produced sequence by sequence over the length of several years, approximately 1993 through 1999. That means the "Pines of Rome" was completed years before the film was actually released. An interesting project would be to examine the sequences in the order of their production to see how they reveal the state of computing ability as it progressed throughout the decade. As Igor Stravinsky's *Firebird Suite* was the last sequence to be completed, it makes an intriguing study in the evolution of production techniques during that time.

OFF HIS ROCKERS; OR, CAPS COMES TO FLORIDA

Florida's filmography during the 1990s includes shorts like *Roller Coaster Rabbit* and *Trail Mix-Up*, as well as features like *The Lion King*, *Pocahontas* (1995), *Mulan*, and *Tarzan*. Disney's management often allowed their technology to be used for after-hours collaborations, evidenced by short films like *Oilspot and Lipstick* (Mike Cedeno/David Inglish), *Off His Rockers* (Barry Cook/Tad Gielow, 1992), and *Rudy's Day Off* (Elliot Bour/Saul Blinkoff, 1996–1998).[67] The after-hours projects offered artists chances to experiment with new animation techniques and technology, often working in capacities that were different from their usual production roles. Many times the results

of these experiments contributed to the features themselves and sometimes led to opportunities for advancement.

From the above list, one small short has big merit. Produced just before *Aladdin* kicked into high gear, *Off His Rockers* was one of those after-hours projects.[68] While *Aladdin* demonstrates various methods being used by California to seamlessly integrate computer animation into the two-dimensional format, *Rockers* shows how Florida's animators were keenly interested in introducing a hand-drawn character into a purely digital environment, moving beyond the ballroom sequence from *Beauty and the Beast*. They sought direct interaction between the 2D and the 3D, and the result of this experiment displays the level of technology available in 1991. It also happens to be the first time CAPS was made available at the Florida studio, and with it the animators strove to extend the software's capabilities in achieving this new kind of hybrid.

The short represents Disney's continuing habit of encouraging experimentation from their artists, which was evident in the company's earlier history, seen in several of the 1940s package films: *Saludos Amigos*, *The Three Caballeros*, *Make Mine Music* (1946), *Fun and Fancy Free* (1947), and *Melody Time* (1948). During the 1940s and 1950s, Disney artists sought new ways of combining live action and animation; now, in the 1990s, they were seeking ways to combine digital imagery with hand-drawn animation. This exercise of inserting hand-drawn animation into a 3D environment continues today, as seen in the award-winning Disney short *Paperman* and, later, *Moana*. These films place traditional elements into a completely digital world; *Paperman* used 2D to soften the computerized models, and *Moana* returned to traditional methods to animate the tattoos in the demigod Maui's body art. In 1991 *Rockers* demonstrates that pioneering spirit, displaying the technological resources available at the time.

Off His Rockers was proposed and directed by Barry Cook, a member of Florida's opening crew and an influential figure throughout its history. He had been part of California's special effects department before transferring to Florida to head up the same department when the new studio first opened.[69] In 1989 that department consisted of two other effects animators, Jeff Dutton and Kevin Turcotte. While Cook was a brilliant draftsman (ask him how many bubbles he drew during *The Little Mermaid*), he was keenly interested in directing. He sought to tell stories from an unusual point of view. On several occasions, Cook explored ideas of combining digital imagery with hand-drawn animation. Was it possible to introduce two characters from differing formats with an ability to interact using the technology currently

available? Pitching his idea to management through preproduction sketches, Cook's story was officially sanctioned as an after-hours project, and the animators were given permission to use all available resources as they worked to combine the two processes into a single vision.

Tad Gielow, Florida's technology manager, acted as producer on the short. Gielow had already been part of the crew on an earlier experimental project, *Oilspot and Lipstick*, a completely computer-generated short created at the California studio in 1987. He left California in 1988 to join Max Howard's management team as the head of Florida's new technology department. Tom Sito provides more information on Gielow's career, noting that he "aided in adapting the first CG programs for Disney animated features like *The Black Cauldron* (1985), *The Great Mouse Detective* (1986), and *The Little Mermaid* (1989). Later, he helped set up the systems at Disney's Florida studios."[70] Florida's 3D department included Rob Bekuhrs and Jim Tooley, who created a variety of animated elements for the studio. One early example was a logo spot for Buena Vista Productions, animated by Tooley and featured in the closing credits of *Roller Coaster Rabbit*.

Off His Rockers begins with a Boy entranced by a video game on his television. This hypnotic babysitter is envied by all the traditional toys scattered around the room, principally symbolized by a wooden Rocking Horse abandoned in the closet. The Rocking Horse witnesses the blank devotion the Boy pays to the game and is determined to regain his affection. In the process of trying to attract the Boy's attention, the Horse loses the rockers that bind his feet, thus gaining his freedom and mobility. It is the stuff of childhood fantasies: a Rocking Horse that comes to life and breaks free of his bonds. The Horse goes to greater and greater lengths to divert the Boy from his video hypnosis, eventually concluding with a tap-dance routine that sends the television sailing off into the closet. The television is now relegated to the very same exile from whence the Rocking Horse emerged. After this violent interruption to his electronic trance, the Boy leaps off the chair and runs to retrieve his soporific. He rolls the television back across the room, plugs it in, and looks around for his ray gun. Running to retrieve it, he treads upon the glass frame of an old photograph left lying on the floor: an image of himself and his old friend, the Rocking Horse.

This photograph visually communicates an earlier attachment between the Boy and his Horse. Now it is a discarded image lying unnoticed on the floor. We see the Boy thinking, considering his situation, and we must remind ourselves that this is an impossible act in itself. For the Boy is a two-dimensional image; he is a series of drawings directly from an animator's

pencil, his movement achieved through the succession of individual film frames. The graphite lines on white paper communicate emotions playing upon the audience's sympathy. We, the voyeurs, are kept in suspense as the Boy turns his back on the Horse and stomps off into the closet. The Horse morosely returns to where his rockers lay abandoned on the floor and attempts to reattach them. The frame cuts to a solitary hand holding the ray gun. It is aimed directly at the Horse, but when the trigger is pulled, it is the television that is silenced. The closet door swings wide to reveal the Boy dressed in full cowboy regalia. He enthusiastically leaps toward the Horse, who jettisons his rockers and rushes toward the Boy. The two characters fuse into a single entity as the Boy jumps onto the back of his faithful steed and zooms around the room before finally heading off into the painted sunset. The two characters are united in their ability to transcend the mundane everyday world and transform it into a happy ending.

However, while the moral of the story seems to be the Boy's release from the hypnotic grip of technology, it is an ironic twist that the Rocking Horse itself is an invention of purely digital design. Cook and his supervising animators, Bekuhrs, Kupershmidt, and Tooley, conspired to create a film that featured direct interaction between the two working media. A leap in technological prowess is also observed in the wide spectrum represented by the archaic video game playing on the television screen and the elaborately modeled, rigged, and rendered Rocking Horse who moves in tandem with the hand-drawn Boy. The Horse seeks to free the Boy from his mindless trance by offering him a new vision of digital excitement.

From a historical perspective, the film illustrates an experiment in moving CAPS beyond merely a two-dimensional labor-saving device to a tool that can synthesize multiple media of artwork. While *Aladdin*'s Magic Carpet exists as a 3D element in a primarily hand-drawn universe, *Rockers* reverses that dialogue by inserting a hand-drawn character within a completely digital environment, recalling *Beauty*'s ballroom sequence. *Rockers* goes a step further when the cartoon features one-on-one contact between the hand-drawn Boy and his 3D Rocking Horse. It gives the audience two vivid examples of personality animation—both artificial—and explores how those artificialities can be related to one another.

It is the critical point when the Boy leaps onto his friend's back that the two animation methods collide. Two characters, constructed of differing media, embrace each other on intertwining levels, the Boy over *and* under the Horse. The 2D Boy lives within a 3D world, the opposite of *Aladdin*, where the 3D elements are placed within a 2D one. In *Rockers* most everything but

the Boy is digitally composed: the television set, the video game, the chair, the Rocking Horse, and the other toys; only the whimsical sunset ending reverts back to the two-dimensional world. It's a fairy-tale ending to a short, but emotional, narrative.

Gielow clarified that the Florida studio did not have the CAPS system during the years before *Off His Rockers*.[71] When that project was approved, the studio arranged for two SGI (software from Silicon Graphics Inc.) workstations for the 3D department and a CAPS workstation that was housed within the main computer room, complete with arctic temperatures.[72] This latter location was chosen to make it easier for the technicians to hardwire the CAPS station into the system; that didn't make it any easier for the operators, since the room was kept at freezing temperatures to maintain the equipment. All traditional and 3D elements for the short were combined and composited through this workstation. Even though the majority of the short was created in 3D, the final rendering had to be done in CAPS, since it was the only means of combining the two formats together, reminiscent of the time before CAPS when all 3D elements had to be transformed into actual cels. Cook remembers that as soon as the last scene was completed, that very night, the technicians were told to unhook the machine and send it back on the next flight to California.[73] Production was deep into *Aladdin* and needed all the computing power they could muster. A complete CAPS network would not be up and running at the Florida studio until 1996, well after the release of *The Lion King* and *Pocahontas*.[74] To become compatible, Florida's original building had to be completely rewired; soon after that, CAPS workstations began popping up throughout the backstage areas, no longer limited to the studio's computer room.

Off His Rockers was released on July 17, 1992.[75] Unfortunately, the short never received widespread notice during its theatrical run—opening as the cartoon short before *Honey, I Blew Up the Kid* (1992)—despite the fact that it reveals a revolution occurring in the animation industry. It serves as an example of the many attempts at experimentation during the 1990s. (Indeed, this same period saw Pixar developing its pivotal film, *Toy Story*.[76]) Thus, this little short is often overlooked by animation scholarship. When viewed with a critical eye, there are certainly flaws in the film where the two techniques do not integrate well. The plastic flatness of the hand-drawn Boy does not blend in well with the textured material of his 3D chair. His facial features are simplistically linear compared to the dimensional richness of the woven fabric on the furniture. The combination is more successful when the Boy is in motion. When he jumps onto the back of the Rocking Horse, he comes

alive and actively engages with his digital environment. Thus, both "Pines of Rome" and *Off His Rockers* represent how the Florida studio was used to create animation for differing forms of visual imagery.

The Young Lions

It seemed impossible, but *Aladdin* went on to become an even bigger hit than *Beauty and the Beast*. Whereas *Beauty* broke the one-hundred-million-dollar mark for an animated film, *Aladdin* broke two hundred million. At the next Academy Awards ceremony, *Aladdin* went on to win another two Oscars for Disney, again for Best Original Song ("A Whole New World") and Best Original Score. Encouraged by the successful collaboration on *Aladdin*, the directors for *The Lion King* (Rob Minkoff and Roger Allers) assigned the role of Young Simba to Mark Henn. His playmate, Young Nala, was given to Aaron Blaise, who had done such a good job on Jasmine's pet tiger, Rajah. Having both men in the same studio allowed close collaboration between the artists. Chris Sanders, who was part of the story team on *Lion King*, traveled to Florida to direct the song sequence "Can't Wait to Be King," a sequence whose aesthetic differed greatly from the rest of the film. The entire studio was involved in its production—Layout, Animation and Cleanup, Special Effects, and the bold, bright color styling of the background and color models departments. The animators contributed numerous animals to the sequence, handling the more graphic style when compared to the realistic portrayal in other sequences. Alex Kupershmidt created the finale's animal pyramid that succeeded in trapping the hornbill Zazu beneath a rhinoceros while the two mischievous lion cubs ran away.

Other sequences featuring Young Simba and Nala were given to Florida—including "Day with Dad" (Sq. 3), "Pounce" (Sq. 3.1), and the "Elephant Graveyard" (Sq. 5).[77] In these assignments, the art direction conformed with the rest of the film, showing the versatility of the artists involved. Henn sensitively animated Young Simba's reaction to the death of his father, Mufasa. The stampede and death scenes were as difficult for the artists as they were for the audience. Jeffrey Katzenberg kept a careful eye on the emotional impact of this sequence; he knew full well that if it didn't evoke a strong response, they had lost the power of the story. The "Stampede/Mufasa's Death" sequence (Sq. 10) was a true collaboration between both coasts. California created the awe-inspiring sight of hundreds of wildebeests charging down the canyon toward Young Simba and moved the plot between Mufasa and his treacherous brother, Scar, while Florida animated Young Simba's terror during the stampede and the mournful reaction to its results.

Now that Florida was identified as B unit to the California features, management began to have legitimate concerns that the newer studio did not yet have access to CAPS. It became necessary for the facility to be upgraded to the new technology—that is, without interrupting production. This upgrade occurred five years after the original collaboration on *The Rescuers Down Under*, with the studio dependent on video approvals, satellite linkups, and overnight courier service. Even on *The Lion King* and *Pocahontas*, the Florida studio possessed only traditional technology. Production assignments had to be tailored according to the talent and technology that were available. This meant Florida's departments, from Layout through Animation Check, worked in the traditional manner, while Xerography (now known as Scanning), Ink and Paint, and Final Check were done in California.

The earlier scenario with *Beauty and the Beast* and *Aladdin* happened once more as *The Lion King* easily handled the competition that summer (*Forrest Gump* [1994] led the live-action films). It broke all records for an animated film, reaching and moving beyond three hundred million dollars in the domestic box office. Again at the Academy Awards ceremony, Disney's film won the Oscars for Best Original Song ("Can You Feel the Love Tonight") and Best Original Score. Management began to have hopes that this trend would continue and placed a great deal of pressure on the upcoming film *Pocahontas*. Many of the animators saw *The Lion King* as both a blessing and a curse.[78] It brought a respect and status to animation that had been missing since the Disney's first golden age. However, it also became an impossible benchmark for every film that came thereafter. The constant question was "Is this the next big *Lion King*?" It also spurred management to keep releasing an animated feature every year.

In Florida, even as departments began rolling off *The Lion King*, the Imagineers were planning the retrofit of CAPS for the studio's main building.[79] As Max Howard noted, management already had intentions that the Florida studio was worth the time and investment to become something more than a theme park attraction.[80] Those plans would take time, as Imagineering had to enlarge and redesign the work spaces, running data cables throughout the subfloor and ceiling of the structure. Much of the work was done out of sight of the tour corridor or at night, when both guests and the animators had gone home. Park management considered it "poor show" to display miles of cables being stretched throughout the building, especially since the emphasis of the attraction was still focused on traditional methods of animation. Many months later, CAPS workstations began appearing in the backstage areas, at first out of sight of the guests, limiting public exposure to proprietary software and protecting unpublished images. While the new network

was being installed, many of the artists from key departments were sent to California to be trained on the software. As CAPS became more and more integrated into production, its presence became evident in the increasing number of workstations appearing at various points around the open floor of the fishbowl.[81] These terminals allowed animators to study their pencil tests on repeating loops for long periods of time. By 1996, and through several features thereafter, Florida's technology remained on par with California's, allowing for direct communication between the production teams on both coasts.

Trailers in the Parking Lot: Breakdown of the Attraction's Narrative

As the Florida artists became more closely connected with their West Coast colleagues, the emphasis shifted away from the Magic of Disney Animation attraction. Guests continued to wind their way through the tour corridor; however, the cel animation process that had been the original model for WDI's attraction was no longer being used behind the glass. CAPS quietly took over production and eliminated many of the end processes once described on the tour. The state-of-the-art cameras that had shot film and video were replaced with highly specialized scan cameras, causing a shift in the location of some departments. The new scanning department, once Xerography, was now located in the darkened camera room, while the camera department was transformed into Scene Planning and sequestered away in an area off the corridor in order to keep proprietary software out of sight.

The computerization of the ink and paint department led to a division in its responsibilities. Because CAPS images were painted using computer tablets, styluses, and high-resolution color monitors, those workstations were kept in darkened areas toward the back of the department. This was due specifically to security issues about unpublished images but also because the administration believed that traditional methods like cel painting should take center stage in the attraction. Painted cels had been used in the creation of the original Disney classics, so the painters were kept next to the glass, where guests could peer over their shoulders as they worked. In actuality, after CAPS came online these cels were produced strictly as souvenirs. By 1997 the cel painters had moved off the tour altogether and relocated to the Animation Gallery, where they continued to create limited edition artwork for sale to high-end galleries and park guests.[82] This situation created a paradox because the attraction was advertised as a public display of how Disney cartoons were made. The conflicting information demonstrates how the

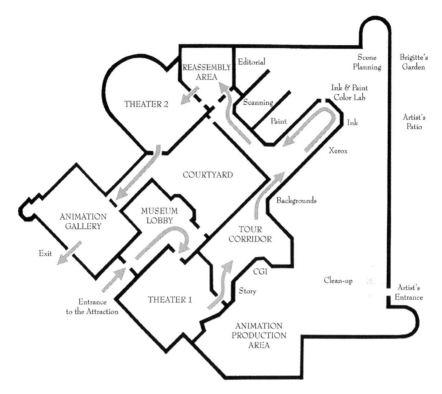

Figure 3.3. Diagram of the adjusted production space within the Florida studio. Note the new scanning and scene planning departments. Source: Author's diagram adapted from the back cover of Roy E. Disney, *The Magic of Disney Animation, Premiere Edition* (1989).

edutainment emphasis of the attraction was no longer the prime objective of the working studio; now the crew was more valuable as contributors to the film division.

Florida's role during these halcyon years was not only as a contributor to the blockbuster films; it also served as a personification of Walt Disney Feature Animation to the general public. This change in identity from "attraction entertainment" to "B unit to California" raises issues about the synergistic relationship that once existed between the Florida studio and its counterpart, the Magic of Disney Animation. As production ties strengthened backstage, there was a growing detachment from its theme park roots, and the relationship with the front of the glass faltered. During the first eighteen months after the Disney-MGM Studios opened, the cast and crew had been united in working toward the success of the new park. There had been frequent

interaction between both sides of the glass, and the small size of the crew engendered outside social contact (see chapter 1).[83]

When the animated films became a nationwide phenomenon, causing pandemic excitement in popular culture, it drove tourism to the Walt Disney World Resort and, consequently, to the Magic of Disney Animation attraction. The popularity of its extremely successful films increased the studio's prestige and conveyed celebrity status on its crew. The animation artists, once considered theme park cast members, were now regarded as part of Feature Animation and identified with its filmic success. This development amplified Max Howard's position as leader of the creative unit. However, as the animators grew in status, their priorities changed. They became less concerned with the guests moving through the corridor, and, contrary to its original intention, management no longer saw the animators as entertainment for vacationing guests; instead, they were now responsible for meeting footage quotas as they worked on the next theatrical release.

By the time *Aladdin* went into production, the crew had been working together for three years. Their new status within the company was associated with the publicity and fame being extended to all of Disney's artists at this time. This new generation of Disney animators, after Walt's Nine Old Men had either retired or passed away, was proving their worth, and the media provided public recognition of their names and roles within the productions. Multiple interviews and articles accompanied the premiere of each film, with animators like Tom and Tony Bancroft, Aaron Blaise, Andreas Deja, Will Finn, Mark Henn, Glen Keane, Nik Ranieri, and others featured in newspapers and trade journals. As the popularity of the Disney Renaissance continued to soar, more guests flooded into the Magic of Disney Animation attraction, where the animators were being touted as celebrities. Initially the attraction's cast members were proud of their studio colleagues toiling away at their desks, but as the months, then years, passed, the cast members were instructed not to distract the animators nor to approach them outside of work.[84] As a result, the familial bonds once present between the cast and crew of the studio/attraction weakened, and in its place arose a performer-spectator relationship more akin to the guest experience.

The studio also began to change internally, in terms of both its staff and their accommodations. With the steady increase in production quotas, management began expanding all departments, bringing them up to parity with California in terms of both the artists and the technology. Now identified with Feature Animation, there was even talk of producing a feature film in Florida. Max Howard remembers, "It must have been around that time that

we started working on the idea of the expansion to do features. We must have laid that seed in '91 or '92. So we worked on *Lion King*, knowing that ultimately we [the Florida studio] would do feature films."[85] Thus, from 1991 through 1997 the animation crew grew in size. The internship program grew in importance and often led to permanent positions within the crew.[86] By the mid-1990s the Florida studio had solidified into an entity unto itself. More artists meant a larger creative community, so the once small group of animators no longer felt so isolated, and more social interaction occurred within the studio rather than with the other side of the glass.

With more artists came the need for more desks. As the Florida studio expanded, the crew rapidly outgrew the occupation limits of its original building. To ease the overcrowding, the studio's administration planned for a series of trailers to be erected behind the main building in the parking lot across the perimeter road. Three complexes were constructed, each consisting of a large square featuring a conference room in the center and multiple office spaces outlining the perimeter of the structure. Labeled Annexes 1, 2, and 3, the temporary quarters were used to re-form the departments so that they would once again be consolidated units within the overall pipeline. These additional work spaces were a direct result of the increasing footage being assigned by California's directors. The expansion dictated which depart-ments would remain on display to the guests, although these changes were not immediately apparent to the casual viewer. Different configurations of the departments were formed based on the needs of each film. Initially, the layout, animation, and effects departments expanded into Annex 1. Annex 2 housed many of the administrative departments, including Finance and Human Resources. Annex 3 was set up for Paul Curasi's animation services, creating their own independent production space.

While these events were happening, a new administration oversaw the renovations of the studio/attraction. Max Howard had been promoted to the upper echelons of California's Feature Animation management, and a new director of operations, Don Winton, took over.[87] Winton came from Walt Disney Imagineering, where he was a design administrator. Although he had previous experience interacting with creative individuals, mainly designers and engineers, he did not come from the usual theatrical background, where many of Feature Animation's executives had been drawn. Winton maintained a more remote position toward production, focusing on the business end of running a studio while allowing the production managers to handle the creative side.[88] He and his team supervised the expansion of Florida's crew and its new work spaces. As the animation crew grew larger, management

Figure 3.4. Diagram of Annexes 1, 2, and 3. Annex 1 was used for the initial expansion of the animation crew, housing the animation, effects, and layout departments. Source: Author's diagram.

worked hard to maintain the same family atmosphere.[89] Winton remained at the helm of the Florida studio over the next four years, seeing it through the successful production of its first feature-length film, *Mulan*.[90]

The addition of the annexes resulted in one significant casualty to the studio/attraction: the loss of cohesion in the Magic of Disney Animation tour.

When multiple departments moved out of the main building, it destroyed the linear progression of the animation pipeline. This directly affected the guests' experience, necessitating changes in how the animation process was to be presented. While many of the artists, painters, and technology crew members remained on view within the main building, the overhead *Back to Neverland* vignettes no longer correlated with what was going on beneath the monitors. And although the addition of the trailers detracted from the guests' understanding of the animation process, it also limited the cast members' relationship with the crew, leading to a growing detachment between the theme park attraction and the studio beyond.

This led to a redefinition of the roles of both the attraction's cast members and the animation crew, breaking the earlier communal bond. The people in the tour corridor were considered part of the theme park workforce, while the artists were more closely associated with the animation division. Earlier, Howard had worked hard to make sure the tour guides felt like part of the animation family. Now, with the loss of this connection, the attraction's hosts and hostesses returned to the same status as the cast members working at the Great Movie Ride, Star Tours, Indiana Jones Stunt Theater, the Monster Sound Show, Superstar Television, the Backstage Studio Tour, and even Voyage of the Little Mermaid, the newest attraction in the park, which opened on January 7, 1992.[91] While the tour guides were always on hand to answer questions about the animation attraction and announce the latest projects, they were no longer as conversant with production procedures, particularly when those procedures involved CAPS. This disconnect with the backstage crew increased throughout the Renaissance years, leading to an almost complete detachment by the time *Hercules* (1997) went into production.

These were the results of the Florida studio's movement away from its original identity as theme park entertainment. The studio was now regarded specifically as a satellite unit of Feature Animation, responsible for ever-increasing amounts of pencil footage needed on the California productions: *Pocahontas*, *The Hunchback of Notre Dame* (1996), and *Hercules*.[92] Furthermore, as the Florida studio became increasingly identified with the omnipresent popularity of the Disney Renaissance films, the tone in the tour corridor shifted from being a place that engendered nostalgia to being associated with the current popularity of this new brand of contemporary entertainment.

Breaking Up the Monopoly

As is usually the case, external factors affected this high point of Disney's second golden age, eventually bringing an end to Florida's version of Camelot.

Coinciding with the rise in critical stature and fiscal prosperity, the Walt Disney Company experienced a political upheaval that rocked the foundations of its executive board. Just as the death of Oscar-winning lyricist and executive producer Howard Ashman (1950–1991) can be seen as contributing to the long, slow decline of the Disney Renaissance, so too did the breakup of the power structure that had initially rescued the Disney Company from hostile takeover in 1984.[93] The dissolution of Michael Eisner's management team occurred at the height of its popularity. It began with a helicopter crash in the Nevada mountains on April 3, 1994, that took the life of Walt Disney Company president and chief operating officer Frank Wells (1932–1994).[94] The sudden loss of Wells touched off a series of events that destabilized the balance of power and led to a political firestorm of personality conflicts that resulted in the departure of Jeffrey Katzenberg four months later.[95] Gone was two-thirds of Disney's power triumvirate that had rejuvenated the company into a cutting-edge entertainment giant. While Eisner gained full control of the company, the breakup spawned competition within the industry where Disney had once reigned supreme. The debut of Katzenberg's DreamWorks Animation SKG (Steven Spielberg, Jeffrey Katzenberg, and David Geffen) led to the shattering of Disney's hold on the animation marketplace.[96] Soon artists were being lured away from the Disney stable with offers of luxurious working conditions, lucrative salaries, and persuasive signing bonuses. The bidding war was akin to that of professional sports, which pays amazing salaries to outstanding athletes.

In the months after the passing of Frank Wells, Max Howard had been promoted and moved from director of the Florida studio to the upper echelons of Feature Animation's executive management.[97] From the outside it seemed like a consolidation of upper-level management, but it was a stunning blow to the Florida studio. Howard had a devoted crew who, although wishing him well, were uncertain about his replacement. In the midst of California's boardroom altercations, Howard felt himself stifled and underutilized, which led to his eventual resignation from Disney's executive team in late summer 1995. He accepted a new position as head of Warner Bros. Studio's new Feature Animation division.[98] He immediately hired Frank Gladstone, Florida's head of Artist and Professional Development, as his second in command.[99] The Florida studio was devastated by losing Howard, and morale plummeted, even while the pipeline continued producing footage for *The Hunchback of Notre Dame*.[100]

As competition in the form of new studios opened in Hollywood, animation personnel now found themselves free agents, hiring entertainment law-

yers to negotiate with studio executives who were bartering for a limited pool of seasoned veterans.[101] The resurrection of the animation division at Warner Bros., led by Howard, was a drain on the dwindling ranks of Disney's animators. Because Katzenberg fished from the same pond, it sparked a bidding war that greatly escalated the economic value of the artists, creating ripples throughout the entertainment industry. Salaries for the major players rose dramatically, contributing to the already skyrocketing cost of films due to the demand for higher technology. The latest computer systems commanded a hefty price tag, as did the highly specialized technicians required to maintain them. The films became exorbitantly expensive even though there was a glut in the marketplace of animated material. Direct-to-video spin-offs were released, capitalizing on characters and situations derived from the features. While *The Rescuers Down Under* was the only sequel to come directly out of Feature Animation, another company branch, DisneyToon Studios, was now responsible for creating multitudinous sequels with lower production costs. These broadcast films included *The Little Mermaid 2: Return to the Sea* (2000 video), *Beauty and the Beast: The Enchanted Christmas* (1997 video), *Aladdin and the King of Thieves* (1996 video), and television spin-offs like *Aladdin* (1994–1995) and *Young Hercules* (1998–1999).

This situation had all but destroyed the public's trust of the Disney brand, and as none of the latter theatrical releases achieved *Lion King* status, the pendulum could be seen swinging the other way. This was the current state of affairs when the Florida studio was at last given the go-ahead to make its own mark in animation history and contribute single-handedly to the Disney legacy. The studio Max Howard envisioned had become a reality, expanding to over three times its original size—enough to handle the production of a full-length feature.[102] Due to this shift in priorities, the original studio/attraction had transformed into a fully functioning production facility with a theme park attraction attached. It could no longer be thought of as simply producing animated shorts for the public's enjoyment. Management's new vision for Florida was to release an animated film every other year. With this goal in mind, Feature Animation green-lit a project specifically chosen for Florida. They tagged Barry Cook, former head of Florida's special effects department, to spend an extended period in California working on preproduction for a new film with the early working title *China Doll*.[103]

4

The Little Studio That Could (1998–1999)

This history of the Florida studio is an examination of its people, its projects, and its technology. On May 1, 1994, the Florida studio celebrated its fifth anniversary two months shy of the opening of *The Lion King* on June 24. After the huge success of that film, the Florida studio continued working on the California features *Pocahontas*, *The Hunchback of Notre Dame*, and *Hercules*. Unfortunately, these latter films were not as successful when compared with the phenomenal returns of the former. Even so, Feature Animation's management, seeking to compete in an aggressive marketplace, considered the advantages of enlarging the Florida studio in order to create theatrical releases rather than continuing its role as the B unit to California. In addition, during the blockbuster years, administration of the studio/attraction was becoming distinctly more divided; Walt Disney Feature Animation controlled the backstage production areas while Walt Disney World Parks and Resorts ran the attraction and supervised the theme park personnel. Thus, we now see the studio/attraction becoming two separate entities.

For the studio, expansion of the crew was the first step toward producing a feature film, as creating eighty minutes of high-quality animated footage is vastly more complex than making a seven-minute short or even a twenty-minute featurette. The growth of the crew from 1995 through 1997 led to the need for more work space. It also lessened the need for social interaction outside of the backstage areas. The Florida studio was transforming into a new identity, moving from the B unit to California's films to a facility large enough to produce one of their own. Three films resulted from this adjustment: *Mulan, Lilo and Stitch* (2002), and *Brother Bear* (2003).[1] Each film marks a particular phase in the Florida studio's history and highlights the

contributions of several of its artists. *Mulan* can be viewed as the full maturity of the Florida studio, no longer identifiable as simply a theme park attraction or satellite unit. The film provided an opportunity for the crew to prove themselves worthy of the Disney name. *Mulan*'s credits include many of the artists who spearheaded Florida's creative development over the years, demonstrating how the studio successfully transformed into its own production entity. Key individuals occupied pivotal roles along the production pipeline. Thus, the investigation continues by examining how Florida's crew added to Disney's legacy through their leadership, their talent, and their drive to create something uniquely beautiful.[2]

On the other side of the glass, these modifications to the Florida studio could not avoid impacting its counterpart, the Magic of Disney Animation attraction. By 1998 the tour's narrative acknowledged the fact that Disney no longer used cels in the creation of its films. (This change came about in response to the company's confirmation of the role of CAPS in the production of the blockbuster films.) Even with small adjustments made to the tour's narrative, what was occurring on the production floor did not correspond to what was presented on the video monitors overhead. The growth of the crew, the addition of new departments, and the rearrangement of the production pipeline meant the attraction no longer displayed a true portrait of Disney's animation process. So although the Magic of Disney Animation still provided a personal experience for the spectator, the educational factor of the narrative was gone. This chapter examines the consequences of this loss of cohesion between the animation pipeline and the attraction's narrative.

Onstage, Backstage: Enlarging the Studio and Redefining the Attraction

THE FLORIDA STUDIO AS A FEATURE FILM FACILITY

The guests' viewing experience began to alter when the Florida studio's emphasis shifted from theme park entertainment to feature film production. However, before that could take place, and well before production could begin on a full-length project, it was necessary for the studio to grow beyond its humble origins. As Mike Lyons pointed out in 1998, "This southern studio has grown from 60 to over 400 employees since first opening their doors in 1988 [*sic*]."[3] This kind of growth has occurred at other turning points throughout the company's history. In the late 1920s, the Disney brothers' staff numbered only 24 employees; by 1934, to satisfy the growing demand for Mickey Mouse and Silly Symphony cartoons, and with preproduction on *Snow White and*

the Seven Dwarfs, California's animation crew grew to 200.[4] By 1940, after the tremendous success of Snow White, and with three more feature films in various stages of development, the Walt Disney Studio employed 1,200 artists, administrators, and support personnel. However, with the passing of Walt Disney in 1966, along with continuing troubles within the company, the animation crew diminished until its fateful rejuvenation in the early 1990s. Even as the Florida studio grew from its original crew to over 350 during the height of production on Mulan, its California counterpart also experienced tremendous growth—due not only to more films being produced but also in retaliation against outside competitors as Michael Eisner fought to keep the best talent working for him.

When the Florida studio initially opened as a studio/attraction, the main building comfortably housed the opening crew, spread throughout multiple departments. By the time Mulan went into production, the crew had outgrown the original space, as the backstage areas were never designed to hold the number of people required to complete a feature-length film. The studio's administration eased the overcrowding by assembling three trailer complexes (nonpermanent structures) known as Annexes 1, 2, and 3. Foot traffic moving from one department to another often required leaving one structure, crossing a utility road, and ascending a ramp leading to the annexes' entrance. During Florida's annual rainy season, this created a very real reason for consolidating trips.

Initially the layout, animation, and effects departments had moved into the annexes, but by the time Mulan shifted into high production, Annex 1 proved insufficient and another trailer was added. Annex 4 was not constructed as part of the original trailer complex but was situated outside the studio's theme park perimeter just before the security entrance to the backstage areas of the park. With the opening of Annex 4, departments were again rearranged to incorporate the additional square footage. Annex 1 now housed the offices of the directorial staff, including directors Barry Cook and Tony Bancroft, producer Pam Coats, and their support staff. The rest of the trailer housed the layout and animation departments. Cleanup, easily the largest department with the most artists, now occupied Annex 3. The effects department, originally housed in Annex 1, moved back into the main building. For Mulan, the effects department grew large enough to take up almost the entire fishbowl, sharing it with 3D, Backgrounds, Animation Check, and various offices for the art director, the animation coordinators, information technology (IT) workers, and other staff positions.

By 1997 the traditional ink and paint department had been downsized, moved off the tour, and into the Animation Gallery shop. It left the jurisdic-

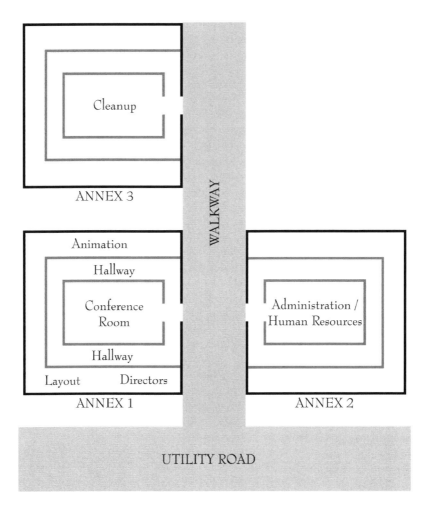

Figure 4.1. Diagram of Annexes 1, 2, and 3, showing the new configuration of departments during production on *Mulan*. Source: Author's diagram.

tion of Feature Animation and now answered directly to Walt Disney World's marketing department. This new location allowed the artists to interact with the guests as they created special-edition cels (limited artworks displaying classic Disney images).[5] With Ink and Paint gone, new departments were arranged within the space: Scene Planning, Animation Check, Color Models, and Final Check. Scene Planning occupied offices behind the original paint

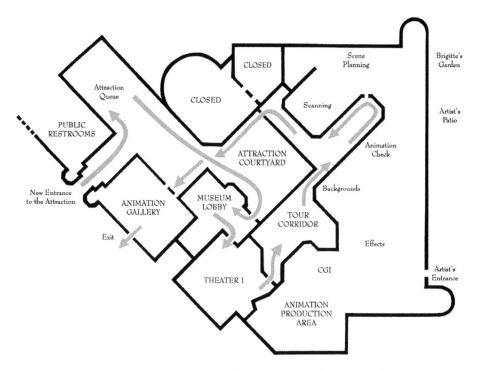

Figure 4.2. Diagram of the new layout of departments in the main building and the adjusted tour of the Magic of Disney Animation. Note the new entry and exit to the tour. Source: Author's diagram adapted from the back cover of Roy E. Disney, *The Magic of Disney Animation, Premiere Edition* (1989).

lab, which remained as window dressing for the tour although it was no longer in use. A new scanning department, sometimes known as 2D Image Processing, took over the original Camera space, where the once state-of-the-art film cameras were replaced by state-of-the-art digital scanning cameras just as large as the original machines. At the height of *Mulan*'s production period, an additional scan camera was set up in the vacant section of the painters' bay to handle the amount of work going through the pipeline. Other new departments, like Color Models and Final Check, were never put on display to the general public, although they remained within the main building to be in close proximity to support from Scanning and Technology.

The new Annex 4 was given over to Animation Services. Its location, outside the park gates, allowed easier access for external clients and vendors. The location also included a gym for the animation crew. With the daily routine of sitting at a drawing board or in front of a computer screen for

hours, the gym afforded an opportunity to work out tired, cramped muscles and release pent-up energy. As the months went by, the production schedule considerably lengthened, meaning longer workdays, usually extending into six-day weeks. In the last six months of production, double shifts were not uncommon and six-day weeks often turned into seven. The company responded by catering meals and scheduling social events to break up the constant demand for creative output. Catering was set up in Annex 1's conference room, while the other conference rooms became gathering places for the crew at mealtimes, where they often shared conversation or watched television programs together. One of these broadcasts was a shockingly new type of animated entertainment called *Southpark*.[6] Ever interested in new content within the industry, viewing this quirky show became a ritual habit and meal breaks were scheduled around its airtime.[7]

BEYOND THE ANNEXES

Simultaneous with the introduction of the annexes, the studio entered into a preplanning phase for a brand-new animation-specific structure within the limited confines of the Disney-MGM Studios theme park. As Jeff Kurtti, author of the *Art of Mulan*, notes, "With The Walt Disney Company's strategy to release three new animated features every two years, and the addition of new animation ventures at the Florida studio, the animation staff had increased from its original 73 members to more than 350. The facility was also expanding from its original 15,000-square-foot headquarters to a complex of buildings that would ultimately total 92,000 square feet."[8] At this stage, the fundamental logistics that were connected with constructing a four-story building within a space currently occupied by other attractions had to be taken into consideration. Sight lines and relocation strategies were examined by Walt Disney Imagineering before any plans could be approved to clear the backstage area in anticipation of a new building and its adjacent parking garage. A focus group with representatives from each department was established to discuss with management, architects, and engineers the specific conditions required by their roles within the pipeline. The group met once a month for nearly a year to hammer out concerns with location, technology, and working configurations. It was an immense project, and periodic updates were given to the entire crew.

The team working on plans for the new building was led by one of Max Howard's handpicked managers, Tim O'Donnell. O'Donnell was part of the original opening crew, initially acting as production manager on *Roller Coaster Rabbit*. Now he was assigned the task of constructing a new and

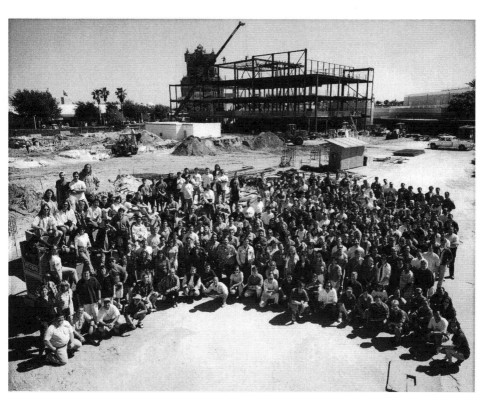

Figure 4.3. Crew photograph in front of the new building site (c. 1997). Note the Hollywood Tower of Terror attraction in the background. Source: Collection of the author.

serviceable home for the animation family. The months of planning resulted in a blueprint of department locations in relation to one another, as well as their size and specific technological needs. From there, the architects determined how the new structure would intersect with the original attraction and, once complete, how the facility would be able to house a feature-sized crew and more.

As the proposed building was to be adjacent to the Magic of Disney Animation attraction, it necessarily obliterated the entrance to the Disney-MGM Studios' Backlot Tour.[9] Therefore, before any construction could begin, a new entrance and holding area for the live-action attraction became necessary. In addition, several of the production bungalows used by the park's entertainment division were also eliminated and replaced by a four-story parking garage. The additional cars added more stress to the traffic already using

Figure 4.4. Cropped section of the 1998 map of Disney-MGM Studios featuring the Animation Courtyard (K, L, & M), without the Backlot Tour entrance. The new Backlot Tour entrance (J) was located on the other side of the park.

the perimeter roadway surrounding the park and required tighter security measures at the backstage/cast-member entrance to the park.

Not everything ran smoothly during construction on the new building. Several times, loud hammering and whining drills were heard on the other side of the wall, but the situation became serious only when the artwork was threatened. During Florida's annual rainy season (June through November), torrential downpours occurred once a day, every day, like clockwork. After the studio first opened in 1989, the architects had to redesign the entryway to the artists' patio when water was directly channeled toward the main computer room next to that outside portal. Now, instead of flooding from below, the flat roof above Scene Planning began retaining water. A severe leak developed directly over the department. On one particular occasion, water rained down on pencil drawings that had been left out on the light tables from the night before. By morning they were thoroughly soaked. (Water also trailed down the walls very near the tangle of wires that threatened the connection between the workstations and the network.) Nothing stops production faster than damaged artwork. Construction immediately ceased while the workers rushed to patch the roof, resolving the structural issues and putting production back on track. The drawings in question were dried, flattened, and kept moving through the pipeline. Thereafter, until Scene Planning moved to their location in the new building, all scenes had to be re-shelved in plastic bags,

light tables were covered with large blue tarps, and all computer terminals were covered as well before the planners went home.

While there was still immense interest in how Disney's animated films were made, the priority of the studio had long since moved away from educating and exhibiting the animation pipeline to the general public. Now the tour was simply a side effect of the Florida studio's life. The attraction essentially remained the same except that two of the *Back to Neverland* vignettes had been adjusted to reflect the fact that CAPS was now a part of the finishing process. The alteration consisted of segments illustrating the role of the scanning department, where Camera used to be, and the use of digital ink and paint, instead of cel painters, to create the final color images. Other departments in Florida's production pipeline—Scene Planning, Color Models, and Final Check—were never acknowledged in the narrative, nor were they put on display to the general public. This was not quite true for Animation Check; while they were never part of the *Back to Neverland* vignettes, this department did have a place beside the glass where guests could see them at work. Unfortunately, their role in the animation pipeline was never explained, so the guests didn't know what the checkers were doing.

Even with these adjustments to the tour, the attraction was secondary to the building's function as a production space. This is particularly apparent, as all layout, character, and cleanup animation was absent from the tour, with guests most likely to see only effects animators drawing scenes or shooting pencil tests. A whole sea of effects animators was necessary for all the footage required on *Mulan*. While this meant the artists were still on display, character animators no longer showed recognizable figures to the audience. Most often, guests saw people drawing large shapes representing tones or shadows on a character, or elemental effects like explosions, fire, or dripping rain. Background artists remained on the tour, painting fine-art landscapes for use in each scene, but gone was the ink and paint department that used to draw such immense crowds. Anyone taking the Magic of Disney Animation tour would now receive all of their information from the video clips without actually witnessing the production pipeline in action.

A more physical change occurred as the animation attraction was altered to accommodate future production needs. To begin construction on the new building, the entrance to the Backlot Studio Tour was relocated to another area of the park. In its place, the entrance to the Magic of Disney Anima-

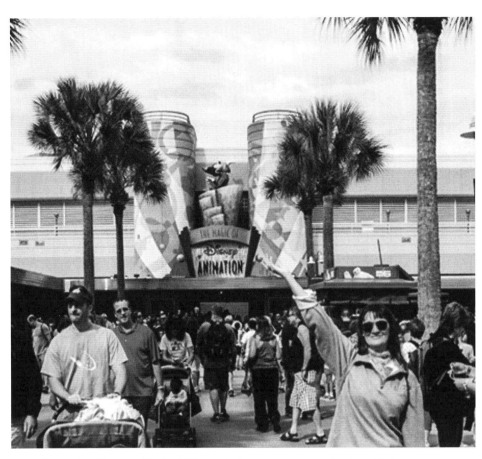

Figure 4.5. The new Magic of Disney Animation attraction façade with Sorcerer Mickey as the "weenie" to attract park guests. (Author on right.) Source: Author's photo.

tion was moved from the opposite end of the building's façade. Guests no longer entered directly into the Museum Gallery space but through a new portal crafted from the original waiting area for the live-action tour. This area provided more shelter for guests to escape the hot Florida sun. To mark the new entrance, a giant statue of Mickey Mouse in his role as the Sorcerer's Apprentice was set upon a rock pedestal, recalling his iconic image from the original *Fantasia*. This icon was used as what the Imagineers termed a "weenie"—a sign that beckoned to park guests, drawing them toward the entrance of an attraction.[10]

Interestingly, this image was neither derived from the Feature Animation logo nor identified with the Florida studio itself, but it served as a well-established icon for anyone familiar with the Disney filmography or knowledgeable about visiting the parks. In fact, this emblem would become even more significant when a giant Sorcerer's Hat was erected directly in front of the Great Movie Ride's Chinese Theater. This came about as a result of the disenfranchisement between the Disney Company and MGM Studios; the enormous hat was constructed to obscure the façade of the Chinese theater as the line-of-sight icon for guests entering the park. It now served as the new Disney-MGM Studios logo, much like Cinderella's Castle acts as the iconic signpost for Walt Disney World's Magic Kingdom. The hat was installed on March 28, 2001, and remained in place until it was taken down on January 7, 2015, as the filmmaking theme park began the rebranding process. This modification of the theme park's icon is suggestive of the park's later name change when the Disney-MGM Studios became Disney's Hollywood Studios in 2008.[11]

With the new entrance to the Magic of Disney Animation, the route through the tour changed to account for the disruption caused by backstage construction (see fig. 4.2). Groups were guided through the interior Animation Courtyard to a door that led into the Museum Gallery. From there, they entered Theater One for the *Back to Neverland* film. At that point the tour resumed its original format until guests reached the scanning department, and from there they proceeded directly into the Animation Gallery—omitting the Disney Classics Theater altogether. With construction of the new building progressing, communication between the two sides of the glass all but stopped. During those long months, interaction between the entities dwindled as access between the park and the studio was greatly restricted due to construction zones and work schedules. With the increasingly rapid turnover of park personnel, newer cast members were unable to achieve the same rapport with the animation crew. Fewer of the attraction's cast members were included in the studio's extracurricular activities, and large holiday celebrations like Halloween and Christmas began occurring out of sight of the guests. Thus, cast members and guests alike were no longer witness to the extraordinary antics that had previously been such an integral part of studio life.

In the spring of 1998, as *Mulan* neared completion, the main and new buildings were finally joined in celebration of the final stage of construction. When their assignment on the film was complete, individual departments moved into their new quarters. The crew packed up their desks, supplies, and memorabilia; technology was transferred; and the animators settled into their

new surroundings with as little disturbance to production as possible. This final phase coincided with the revealing of a new Magic of Disney Animation tour, which would be in effect until the close of the Florida studio in 2004.

Mulan: The Woman Warrior

The Renaissance films continued Disney's fairy-tale tradition with *Beauty and the Beast* but drew upon a wider range of sources as well. *The Little Mermaid*, *Aladdin*, and *The Hunchback of Notre Dame* were Disneyfied retellings of classic literature, modified similarly to how Walt supplemented his Old World narratives with a perspective shaped by popular sentimentalism.[12] But there were also some unusual choices made during the decade. *Pocahontas*'s source material was loosely based on John Smith's historical account of his adventures in the new world, while *Hercules* borrowed elements from Greek mythology but strayed widely from the traditional stories of the gods on Mount Olympus. Seeking to illustrate stories from a global spectrum, a Chinese Wei Dynasty epic poem called "The Legend of Fa-Mulan" acted as the literary source material for *Mulan*.[13] As the inspiration for the Florida studio's first film, it served as a narrative base rather than a strict retelling.

While many of Walt Disney's live-action films were pointedly male-driven stories, as seen in *Treasure Island* (1950), *20,000 Leagues Under the Sea* (1954), *Davy Crockett, King of the Wild Frontier* (1955), *Old Yeller* (1957), and *Swiss Family Robinson* (1960), the opposite was true for many of his animated features; *Snow White and the Seven Dwarfs*, *Cinderella*, *Alice in Wonderland*, and *Sleeping Beauty* all feature female protagonists.[14] There are certainly exceptions to this observation, like *Pinocchio*, *Peter Pan*, *Pollyanna* (1960), *The Parent Trap* (1961), and *Mary Poppins* (1964), but for the most part, animation focused on musical/comedy and live action adhered to action/adventure. The revitalization of the animation department in the 1990s continued the trend of female leads like *The Little Mermaid*, *Beauty and the Beast*, *Pocahontas*, and *Mulan*. This emphasis on strong female leads in animation continues to this day with *Tangled* (2010), *Frozen* (2013), *Zootopia* (2016), and *Moana*.

These latter roles fit with the more contemporary vision of female empowerment rather than the helpless golden-age ingénues. As Jack Mathews points out in his *Mulan* review for *New York Newsday*, "The heroine of Disney fairy tales has undergone a dramatic personality change between the first and second of the studio's animation dynasties. No longer a passive innocent, the new heroine is pro-active, a self-starter, a can-do kind of post-feminist cartoon figure who doesn't sit around humming 'Some day my prince will come.'"[15] Even male-oriented stories during the Disney Renaissance, such as

Aladdin, The Hunchback of Notre Dame, Hercules, and *Tarzan,* featured female characters who display a decidedly strong personality. The story of *Mulan* plays on both male and female gender roles using the same character. As Peter Stack of the *San Francisco Chronicle* notes, "Though seemingly a girl's story, *Mulan* transcends those boundaries. The adventure of a girl disguising herself in an all-male military camp is the perfect setting for sending up gender stereotypes—Mulan as a girl with spark and loveliness, contending in the grunt-and-grunge culture of swaggering recruits. The trick was to find common ground, and *Mulan* accomplishes this with exceptional grace."[16]

Most certainly, the most important film to come out of the Florida studio was *Mulan.* While the studio joined in contributing to the success of the blockbusters and completed two additional features, *Mulan* proved that Max Howard was correct in his belief that this studio was destined to create its own films. Florida's first project was the direct result of management's strategy in creating a second production facility to capitalize on a competitive production schedule. It gave the company the ability to release an animated film almost every year by alternating between the two coasts. In an article published at the time of *Mulan*'s premiere, Andrew Paxman acknowledged Peter Schneider's role in the decision to upgrade the facility: "[The Florida studio's] contributions to previous features, though small, impressed folks back in Burbank to the extent that, in 1992, feature animation president Peter Schneider began to seek an entire project for the facility. 'Artistically, the standard of animation coming out of here meant that it was logical to develop a feature,' Schneider says."[17] Paxman goes further: "[Thomas] Schumacher says two projects are in development for production in Florida."[18] This implies that after *Mulan,* future films were being considered.

Preproduction on *Mulan* began while the Florida studio was still acting as the B unit to the California features (1993–1996). Peter Schneider announced that the first project would be a combination of the ancient Chinese legend of Fa Mulan, sourced from a children's book by Robert D. San Souci, and a postcolonial tale known as "China Doll."[19] Once the project was green-lit, Barry Cook was brought on board as director; he traveled to California in 1993 to work on preproduction for the film.[20] Almost as soon as Florida's film was approved by management, it was given a release date of summer 1998 and the clock started ticking. The studio Howard had originally envisioned became a reality.

By the time *Mulan* went into production in 1996, the Florida studio had grown large enough to shed its previous identity as a satellite unit of the main facility. (As Florida began producing its own film, a new satellite studio in Paris began acting as the B unit to California, supplementing the loss of

Florida's contribution.) The prospect of a feature film presented the crew with a huge challenge: to construct a film entirely their own and worthy of being included in the Disney filmography.[21] In this, *Mulan* displays the Florida studio's significance as a dynamic production entity, employing key individuals in strategic creative positions and delivering a film that is considered one of the jewels of the Disney Renaissance through its storytelling, design, and technological achievements.

Confidence in the studio's ability is apparent from multiple quotes published in Jeff Kurtti's coffee-table book, *The Art of Mulan*, released at the same time as the film. In the book several people in California's management provide insights as to why the Florida studio deserved to get a film of its own. Peter Schneider is quoted as saying, "Florida is a very passionate, interesting group of people because they are somewhat isolated. Yet, at Florida Feature Animation there are some of the best artists in the world, who have found a home, a place, and a lifestyle in Florida that really suits them. They also have a tremendous sense of family and *esprit de corps*, and I think that has added tremendous strength to this movie."[22] Schneider is acknowledging the humble beginnings of the small studio and how they maintained creative output even while being thousands of miles away from the greater part of the industry. Thomas Schumacher, vice president of Feature Animation, echoes Schneider when he says, "They're the most remarkably talented group of people. . . . They're brilliant. Their commitment and readiness for this film is unparalleled. It's their first feature. They're very intimate down there—they want to prove themselves as a team, and they're doing so."[23] This confidence reflects the communal spirit that existed in Florida, which was more difficult to maintain in California, where a larger number of artists worked in multiple locations stretched across a warehouse district in Glendale.[24] Kurtti also acknowledges the unique situation surrounding the film: "Arguably, the greatest influence on the making of *Mulan* is its status as the first feature-length production that is primarily the property of Walt Disney Feature Animation Florida."[25]

Mulan was directed by Barry Cook and Tony Bancroft, with Pam Coats as producer. Cook and Coats began their partnership on *Trail Mix-Up*, the second Roger Rabbit short produced at the Florida studio, and third in the series of autonomous Maroon Cartoons created with permission from Steven Spielberg's Amblin Studios. The credit list for this film includes many Florida studio veterans in leadership roles throughout the production pipeline, including Tom Bancroft (Tony's twin brother), Aaron Blaise, Irma Cartaya, Jeff Dutton, Mark Henn, Alex Kupershmidt, Ric Sluiter, Bob Stanton, and Bob Walker, among others. As Tom Bancroft states in Kurtti's book, "We've

finally gotten to the point where—as corny as it sounds—this is a labor of love for every single one of us. We've all done features before, and they were wonderful experiences. But this one's different. This means more. . . . *This time it's personal*."[26] Thus, *Mulan* must be recognized as being something special to its creators.

The crew had been assembled and working together over several years and multiple films; now they took charge of their own project. *Mulan* was the reason many of the artists stayed in Florida, honing their skills, and they were ready to take on the responsibility. Thus, the crew was unified throughout the entire project. As Tom Bancroft says, "There's no doubt about it. When you talk about journeys, I think the big story of the journey of *Mulan* is the Florida studio. At first we were set up as a small studio and we were just going to do shorts. Within a year, we started helping out on features—*The Rescuers Down Under, Aladdin, Beauty and the Beast, The Lion King, Pocahontas, Hercules*. We've been contributing to features, but this is the first time we have the feeling of full ownership."[27]

The story of *Mulan* must begin with Cook's substantial contribution to its creation. Preproduction on the film began when the former head of Florida's special effects team was assigned to direct. This decision came after Cook proved his directing capability on two of Florida's shorts: *Off His Rockers*, the after-hours project discussed in chapter 3; and *Trail Mix-Up*: "'With Barry Cook living down there and wanting to direct a movie and having directed a short, he was the right person to push to be the director of this movie,' said Peter Schneider, president of Walt Disney Feature Animation."[28] A year and a half later, Tony Bancroft was assigned to be codirector. Cook and Bancroft were both members of Florida's original crew as well as California veterans.[29] Now they worked with California's story department to construct a narrative ready to go into production by 1996.[30]

Tony and Tom Bancroft began their Disney careers through the internship program at the California studio when attending the California Institute of the Arts. They arrived at the Florida studio as assistant animators. In an interview, Tony remembered talking with Rob Minkoff about wanting to direct a film someday.[31] Shortly thereafter, Tony returned to California seeking new career opportunities and perfected his comedic timing with characters like Iago the parrot from *Aladdin* and Pumba from *The Lion King*. Now he was being given the chance to direct. It helped that he already knew the Florida crew and, more importantly, that they knew him. The directors picked their production team from a staff familiar with one another's working strengths. With the team in place, the entire studio united on a project they considered to be the best chance to show what they could do. Tony summed it up

when he said, "I think that this being Florida's first feature has helped us immensely. We have an eager group of artists here. They are willing to work their butts off and do all that they can. They don't know the meaning of the word 'impossible,' or the word, 'no.' It's not just a nine-to-five job, this *means* something to them."[32]

The directors, along with producer Pam Coats, were open to new ideas and fresh suggestions from the crew. It cemented a camaraderie within the unit as they worked toward a common goal: the best animated film they could create. Irma Cartaya, head of the color models department, explained, "With *Mulan*, we're putting our lives on hold more than normal. You always have to put your life on hold to work on a film, but we *want* to do this. We're devoted to this film, and we'll do everything for it."[33] That effort resulted in long and arduous days for extended periods of time; the crew put in weeks—even months—of overtime throughout the two-year production cycle. Yet, even with the pressures of sweat box approvals, extensive hours, catered meals, and computer upgrades, they knew they were working on something special.

Lead character animators on the project included Mark Henn, Tom Bancroft, Ruben Aquino, Alex Kupershmidt, and Pres Romanillos. The leads directed teams that specialized in their characters. They also had corresponding cleanup crews, who were expert at keeping their characters following the models. Because of their close proximity, the animators were able to answer any questions that arose. The double role of Mulan/Ping was given to Mark Henn. Henn began his career as an animator on *Mickey's Christmas Carol* (1988) and swiftly became known for his work on female protagonists, including Ariel, Belle, Jasmine, and Pocahontas.[34] In addition to the lead role, producer Coats talked about the decision to "cast Mark Henn as both Mulan and her dad [Fa Zhou], and the scenes between them are remarkable, because Mark is doing them both."[35] Tom Bancroft led the team animating Mushu, Mulan's dragon companion and guardian. Mushu represents the dragon in Chinese mythology, the symbol of the emperor and masculine force (think of the yin/yang concept).[36] Thus, Mulan receives patriarchal support in the symbolic form of male energy as she undergoes gender transformation in her quest to save her father's life.

Ruben Aquino was assigned the role of Shang, Mulan's military commander and later love interest, while Alex Kupershmidt drew both her beloved warhorse, Kahn, and Shang's father, General Li, leader of the Imperial Japanese Army. An incredibly strong performance of the Hun chieftain, Shan Yu, was created by Pres Romanillos. Shan Yu is a truly dark Disney villain, voiced by Miguel Ferrer, who provided an ominous reading that resonates with his malevolent intent, making his cunning and vengefulness all the more

intimidating.[37] Romanillos was an extremely talented animator and brought a personable spirit to Florida's team. Previously he had animated the Beast, Pocahontas, and several other Disney characters in California. Romanillos subsequently left Disney to work at DreamWorks on several of their features before returning to Disney to take the lead on Prince Naveen for *The Princess and the Frog* (2009). The world lost a truly remarkable talent and genuine human being when Romanillos passed away from cancer in 2010.

Another longtime Florida veteran, Barry Temple, was given the job of mime with Cri-kee, Mulan's lucky cricket. Similar to Randy Cartwright's inspiration for *Aladdin*'s Magic Carpet, Cri-kee does not have any spoken dialogue, but with exaggerated movement combined with novel sound effects, he communicates with Mushu, who vocalizes his sidekick's intentions for the audience. Another secondary character was *Mulan*'s First Ancestor, voiced by *Star Trek* legend George Takei, with animation provided by Aaron Blaise. Mike Lyons credits Michael Eisner with the idea for Mulan's ancestors to play a pivotal role in bringing Mushu into the narrative. He writes, "The idea for the film's other fantasy element, that of the Ancestors, was actually brought into the story by Disney CEO Michael Eisner himself, who suggested it after seeing the film's early storyboards."[38] Numerous other characters were spread across the studio's staff, including animation by Travis Blaise (Aaron's brother), Dominic Carola, Trey Finny, Byron Howard, Jim Jackson, Tony Stanley, and John Webber.[39] The film offered opportunities for the entire animation department, as there were numerous minor characters needed throughout the narrative.

CREATING THE LOOK OF *MULAN*

By the time *Mulan* went into production in 1996, CAPS was fully integrated into the Florida studio. Several of the Disney Renaissance films had already used the program to replicate the look of traditional cel animation. Now, as the software matured, production designers were asking for custom visual effects to match their film's art direction. Various combinations of hand-drawn levels and CAPS operations brought stunning new results.[40] Hans Bacher, production designer on *Mulan*, is credited with creating the film's delicate styling, combining Chinese calligraphy with Tyrus Wong's soft watercolor technique as seen earlier in *Bambi*.[41] *Mulan*'s art director, Ric Sluiter, sought to produce an authentic look to match the film's Chinese heritage. He coordinated that vision through the line work, color palette, and curvilinear shapes seen throughout the film. (These attributes are particularly evident in the drifting smoke designs from cannon explosions, mimicking the scrolling

curves of Chinese calligraphy.) CAPS allowed for the impressive range of color variations and macro-operations that produced Sluiter's vision of a moving Chinese watercolor painting. These macro-instructions were customized for individual effects throughout the production, offering the option of tweaking their intensity from one frame to the next or calculated over a designated period of time. Key scenes in *Mulan* demonstrate these technological advancements, most notably beginning with the film's opening sequence.

In the complex establishing shot (Sq. 1, Sc. 1), the film opens onto a blank screen resembling a clean sheet of rice paper. Elegant Chinese brushwork seems to draw itself across the screen, recalling the style of Song Dynasty ink painting.[42] The effect replicates the appearance of gracefully moving lines flowing effortlessly from the tip of an invisible Chinese brush. (This effect is reminiscent of Disney's *True-Life Adventures* series from the 1950s, which opened with a magic paintbrush that created a color landscape of the region being examined in the episode.[43]) *Mulan*'s brushwork effect was realized through a complex series of mattes and CAPS operations used to enhance the traditional drawings. CAPS also allowed for the creation of a seemingly endless piece of paper that self-reflexively grows and expands to contain the spreading image of ink lines and watercolor shadows. This opening scene was decidedly a collaborative effort, the success of which can be attributed to Arden Chan (layout), Jeff Dutton (effects), and David Wang (backgrounds).[44] The look was intended to set the art-historical tone of the film, echoing Bacher's production drawings and Sluiter's art direction. By the end of the title sequence, the lines have condensed into recognizable shapes, cross-dissolving into a view of a soldier keeping watch on the Great Wall of China.

The very act of ink painting references the age-old practice of Chinese calligraphy, introducing Western viewers to this Eastern storytelling device. Animation theorist Paul Wells discusses the importance of setting the tone of a film, defining this practice as developmental animation, where the imagery is used in "a directly metaphorical way and not working in the realms of the purely abstract."[45] The painted lines recall the intellectual activity associated with the calligraphic form, highly respected in Chinese culture, while also invoking the feeling of the "other" in the way that it can be identified as typically outside of Western motifs. In fact, the wish to evoke China's heritage in the opening scene went through several different versions before the ink-and-wash approach was finally agreed upon. One of the other suggestions was to animate a series of computer-generated shadow puppets providing historical exposition and context before the story began. The shadow puppets were another Eastern storytelling device, but the overriding concept of creating a moving Chinese watercolor played a substantial role in guiding

Figure 4.6. Film frame from the opening sequence of *Mulan* depicting the simple, yet complex, rendering of Chinese calligraphy. (Painting by David Wang.)

the tone of the film, leading to the ink-and-wash illustration that eventually dissolves into the iconic structure of the Great Wall. This visual indicates the landmark location of the action, threatened by the villain's menacing actions and alerting the audience to the monumental events taking place. Thus, two types of stylistic metaphors are used in the opening shot of *Mulan*: classic Chinese calligraphy and the immediately recognizable location of the Great Wall and what it represents.

As a rule, the opening—or establishing—shot sets the tone for the entire film. Recall *The Rescuers Down Under*'s fast-paced, multiplane truck-in careening through the Australian outback, and contrast that with *Mulan*'s serenely flowing ink painting. In *The Rescuers Down Under*, the artists and technicians sought to push the limits of CAPS's multiplane capabilities, thus implying action and adventure through the wide-open expanse of desert landscape that is the Red Centre of Australia. In *Mulan* the opening visuals are purposefully kept flat, two-dimensional, with a delicate approach to the free-flowing calligraphic form, which demands a high degree of subtlety and sophistication. While there is action and adventure in *Mulan*, it is shaped by a series of cultural events rather than being the main theme of the narrative. Comparing these two opening shots—that of *The Rescuers Down Under* and

that of *Mulan*—demonstrate CAPS's versatility in being able to complement the individual art direction and storytelling of each film.

Using Three-Dimensionality in Two Dimensions

Even with complex upgrades extending the 2D capabilities of CAPS, 3D was advancing exponentially, particularly in the wake of Pixar's 1995 blockbuster, *Toy Story*. As Sito remarks, "Everyone in Hollywood was suddenly dabbling in the new CG technologies."[46] Where once Disney used 3D to animate mechanical objects, as seen in McLeach's truck in *The Rescuers Down Under* and progressing toward complex character hybrids like *Aladdin*'s Magic Carpet, easier methods of integrating digital elements increased with each software update. As the 1990s progressed, the occasions for importing 3D imagery were increasingly frequent, and necessary protocols were established for transmitting digital data into the CAPS program. (Remember, in 1997 CAPS was still based on a two-dimensional platform.) Yet, even in the midst of all these advancements, it is notable that even Pixar sought to maintain a sort of hyperrealistic style in their animation, adhering to the laws of physics when simulating objects within the virtual world. Chris Pallant quotes Ed Catmull when defining Pixar's concept of hyperrealism as "a stylized realism that had a lifelike feel without actually being photorealistic."[47] Throughout *Mulan* there are multiple scenes where hand-drawn characters and 3D exist within the same frame while maintaining the same aesthetic.

The dramatic use of 3D in taking a single 2D animated wildebeest and creating an entire herd was a marvel of the computer's capabilities when it debuted in 1994. Christopher Finch discusses this achievement in the *Art of The Lion King*: "To create the wildebeest stampede featured in *The Lion King*, the desire to integrate the sequence aesthetically was considered prior to modeling. . . . All 'camera' moves maintained 'the 2-D multiplane pan style of the rest of the film.'"[48] In Sequence 10, "Stampede/Mufasa's Death," several notes on the x-sheets refer to shepherding this complex sequence through the production pipeline. (One note from Randy Fullmer, artistic coordinator on the film, alerts the final check department to show him the scene for approval before submitting it to Color Sweat Box.) In another note, CGI supervisor Scott Johnston alerts the compositing department that it will take "four days for the final render" of the wildebeest stampede in Scene 28.[49] Yet, even as the wildebeest stampede was visually stunning in its creation, its roots began in typical Disney fashion. The animals' movement was traditionally drawn

by veteran animator Ruben Aquino and used as reference by the 3D animators for the natural timing and locomotion required in creating the animals' realistic performance.

The resounding success of the wildebeest stampede was expanded upon to create the climactic charge of the Hun army in *Mulan*'s Sequence 9.9, "Huns Attack." A massive wave of mounted Hun warriors gallops down the mountainside bent on annihilating Shang's small military unit.[50] The horde was composed of multiple 3D types, modeled and rigged for animation by 3D effects animator Sandra Groeneveld. To create this critical spectacle, a small number of individual Huns and horses were constructed, along with various attributes and weaponry, all modeled within the computer. Instead of building a single wildebeest from which to create an entire herd, as was done for *The Lion King*, additional software was written to randomly combine multiple elements (Hun, horse, and weapon), thereby accumulating a massive number of Mongolian warriors that gives the illusion of individual characters.

In an article by Mike Lyons for *Cinefanastique* magazine, Rob Bekuhrs, one of the Florida studio's key 3D animators, outlined the process used to create the two thousand individual Huns that made up the army: "The [software] program 'Attila' allowed the artists to actually create different soldiers the same way a child might dress up with paperdolls.We had two different guys, and on each guy, we could choose from three different hats, two different swords and a choice of moustaches on or off, hair on or off, three different lapels, etc. Then, there were four different behavior types; there was sword, spear, reins and flags. Then within that we have different poses."[51] 3D effects animator Darlene Hadrika confirmed that the Attila software was written specifically for *Mulan*'s Hun charge by Florida software developers Hans Oskar Porr and Marty Altman.[52] This random assignment of various modular parts recalls the multiple combinations of molds used to create the terra-cotta warriors from the Qin Dynasty burial complex in Xian, China. Using this assortment of types, they could be assembled in random combinations to create similar, yet strikingly different, individuals to make up the horde.[53] Once the Hun army was configured, they could be moved en masse down the mountain. To keep them from colliding with one another, the Florida animators used another program, "boids," an artificial life simulator developed by the California studio's Craig Reynolds for use in *The Lion King*'s wildebeest stampede.[54] The software had three functions: (1) to maintain set distances between the objects in a group, (2) to adjust individual speeds within the group, and (3) to direct the movement of the overall group within each scene. Reynolds

created this software to mimic these qualities demonstrated by flocks of birds in flight, and it was especially successful in the movement of the wildebeests. Now this herding technology was applied to the charge of the Hun army.

Another reason these scenes look so spectacular is the camera mechanics in the "Hun Charge" that shifts between two and three dimensions. Many of the movements created for this sequence utilized three-dimensional camera mechanics, created in the software "Maya" and imported into CAPS, much like a helicopter sweeping over a mountain landscape. These 3D vistas alternated with traditional two-dimensional shots, thereby inserting three-dimensional depth within the two-dimensionality of the overall film. Lyons quotes *Mulan*'s head of Special Effects, David Tidgwell, when he says, "The main thing that we're trying to do is find the balance between two and three-D."[55] Thus, the "Hun Charge" sequence not only used the herd-instinct technology from *The Lion King* combined with custom crowd-generating software, but it also imported 3D helicopter-like movements sweeping across the action, akin to simulating a falcon's flight over the landscape. The option of including the maneuverability of the computer-controlled camera as it moves within three-dimensional space, rather than using traditional multiplane mechanics, recalls director John Musker's decision to use the 3D camera for its subjective roller-coaster effect in *Aladdin*'s "Havoc" sequence.[56] As Aladdin, Abu, and the Magic Carpet escape from the lava in the Cave of Wonders, they race through a series of claustrophobia-inducing tunnels before reaching the portal to the outside world. All the animation was drawn to 3D plots created at a held field (16FC) so that the characters would react to the 3D camera's crazy trajectory at just the right time. In *Mulan* it was the same; all hand-drawn elements in the "Hun Charge" were drawn to registered printouts used as reference by the traditional animators.[57] This method of animating to printouts goes back to our earlier discussion, recalling both the photographic live-action reference used in *Who Framed Roger Rabbit* and the computerized plots created for *Roller Coaster Rabbit* and *The Prince and the Pauper*—all prior to CAPS's ability to import computer-generated images, combine them with the hand-drawn artwork, and place both within the digital format.

After *Mulan*

The Florida studio celebrated the completion of *Mulan* by holding an immense celebration at Walt Disney World's Contemporary Hotel. The crew members and everyone else involved were given the red-carpet treatment with private transportation to and from the Pleasure Island cinemas, where

Feature Animation management was on hand to congratulate the crew on such a stunning success. After the screening, the crew and their guests were whisked away to the Contemporary Hotel's Convention Center and the festivities began. Large round tables accommodated the entire crowd for dinner and drinks, and a live band provided music for dancing. One of the highlights of the evening was when a young Christina Aguilera sang Mulan's song "Reflection," which was one of the tracks featured on the film's soundtrack. In an adjoining room, a series of gaming tables were set up, using "Mulan money" imprinted with various characters from the film. Many of the crew members made their fortunes that night—if only the currency had been real. One of the best parts about holding wrap parties on Disney property was the ease with which the guests could simply walk to their hotel rooms when the night was over.

Mulan can be viewed as the pinnacle of the Florida studio's success, the apex of the animation roller coaster. The world premiere took place at Los Angeles's Hollywood Bowl on June 5, 1998. There was conjecture among movie critics about whether *Mulan* would appeal to the Asian American population (see Gish Jen from the *Los Angeles Times* and Peter Stack from the *San Francisco Chronicle*) and some doubt as to how the film would be received (Barbara Shulgasser from the *San Francisco Examiner*).[58] Reviews of China's reception of the film were dismal; it became a pawn in a governmental dispute with the Disney Studios (according to *BBC News* and the foreign staff at the *Baltimore Sun*) and was not released in China.[59] On the other hand, industry and commercial criticism from sources such as *Animation Magazine* and *Cinefantastique* were overall enthusiastic about the film, while many newspaper reviews merely repeated press-packet information about the number of artists who worked on the film, the large budget that went with it, and its position as the Florida studio's first feature.[60] Many reviews mentioned the studio's new building, which, by the time *Mulan* appeared in theaters, had become home to the animation crew. (Occupancy began in April 1998.)

Nineteen ninety-eight was an amazing year for animated films; Dream-Works, Pixar, and Warner Bros. all released animated features that competed with *Mulan*. Films at the box office included Warner Bros. Feature Animation's *The Magic Sword: Quest for Camelot* (released May 15; U.S. gross $22,717,758), Disney's *Mulan* (June 19; $120,620,254), DreamWorks' completely 3D *Antz* (October 2; $90,646,554), Paramount/Nickelodeon's *The Rugrats Movie* (November 20; $100,491,683), Pixar's *A Bug's Life* (November 25; $162,792,677), and DreamWorks' *The Prince of Egypt* (December 18; $101,413,188).[61] This wide variety in the marketplace succeeded in siphoning

off a large portion of Disney's usual audience and caused havoc with their box office returns.

Mulan can be compared to its closest contemporary competition, Dream-Works Animation's first 2D film, *The Prince of Egypt*, which premiered six months later. Both were inaugural films for their studio, and both crews were composed of artists who had worked together on previous Disney features. Both films were sourced from cultural legends, one East, the other West, although the *Prince of Egypt*'s story would have been more familiar to Western audiences. The narrative for *Mulan* was based on an ancient Chinese epic poem without much other material evidence. While the Chinese were not very receptive to Disney's interpretation of its historic legend, Jeffrey Katzenberg of DreamWorks Animation consulted with various biblical scholars to make sure he got the details correct.[62] In the end, *The Prince of Egypt* made less money at the box office than *Mulan*, $101 million as compared to $120 million, but it was *Prince* that walked away with the Academy Award that year for Best Original Song ("When You Believe").[63]

Though *Mulan* can be seen as the coming of age for the Florida studio in terms of both its artistry and its ability, rumblings within Disney's executive board, and within Feature Animation itself, began showing cracks in the foundation of animation's newfound celebrity. Since the beginning of the 1990s, the popularity of the Disney's Renaissance films and theme parks had been steadily growing. But after the success of *The Lion King* and the departure of Jeffrey Katzenberg, the animation industry saw a free-for-all in the recruitment of experienced talent. Disney's staff was pillaged not just by Katzenberg's DreamWorks Animation but also by the Warner Bros. Studio as both sought to capitalize on the public demand for additional animated fare. Human resource departments drained the finite artist community with the promise of higher wages, comfortable working conditions, and large signing bonuses.[64]

With the increase in competition came the need for more spectacular promotion and advertising campaigns to make the films stand out in a crowded marketplace, thus adding to the increasing production costs of the films. These extra expenditures meant lower profits from the box office, consuming the studio's original investment. The additional competition also created a glut of animated films in the marketplace. Ironically, in the wake of Pixar's outstanding success with *Toy Story* in 1995, we see management's excitement about hand-drawn animation waning with each perceived lackluster performance in the years following *The Lion King*. The increasing financial loss of 2D animated films convinced studio executives that the art form was dead, or dying. Pallant blames the ensuing layoffs on the overwhelming expecta-

tions put on each film's release after *The Lion King*'s phenomenal success. He says, "*The Lion King*'s effect on subsequent Renaissance features went beyond merely setting an impossible box-office benchmark."[65]

As the films diminished in popularity, so did the celebrity status of the animators. The rampant bidding wars for experienced talent that occurred in the mid-1990s would soon turn into a series of layoffs and significant wage reductions. At the Florida studio, once production on *Mulan* was complete, layoffs occurred in all departments before the move into the new building. This mirrored what the California crew had gone through only a year earlier. And while these events would not become critical for another few years, all the films that came after *The Lion King* not only foreshadowed the beginning of the failure of Disney's animation to hold the public's attention but also heralded the slow demise of the Disney Renaissance, until its eventual end in 1999 with *Tarzan*.

5

Shutting Down the Studio
(2000–2004)

In the late 1990s, Disney's executive management began to question whether hand-drawn animation was worth the continued investment. During the first years of the new millennium, we see evidence of the failure of Disney films to perform at the box office, contributing to the end of this second golden age in the form of receipts from *Fantasia 2000* ($60,655,420), *Dinosaur* (2000; $137,748,063), *The Emperor's New Groove* (2000; $89,302,687), *Atlantis: The Lost Empire* (2001; $84,056,472), and *Treasure Planet* (2002; $38,176,783).[1] Most of these films lost money when compared with their production and promotional costs; *Dinosaur* would seem to be the exception to this statement. Although it exceeded its original production budget of $127.5 million, there is a question of whether that budget included the massive research and development costs required to create a completely digital studio and the technology necessary to simulate the visual realism of its characters.

By the year 2000, many of the reasons for this decline in Disney's popularity had become evident. The downward momentum began when Pixar's *Toy Story* broke the traditional animation barrier and proved that three-dimensional computer imagery could compete, strongly, in a thriving marketplace. When DreamWorks' *Antz* and Pixar's second film, *A Bug's Life*, premiered three years later, the box office numbers again pointed to the popularity of the new medium. From a business perspective, the films of Pixar Animation Studio vastly overshadowed the pale Disney competition. As each of Disney's succeeding films did not match, much less overtake, the sensational popularity of 1994's *The Lion King*, management concluded that the missing link must surely be the technology. Tom Sito concurs: "From the zenith of *The Lion King* (1994), Disney's traditionally animated features went into

decline with *Atlantis* (2001), *Treasure Planet* (2002), and *Home on the Range* (2004). Disney management decided the problem couldn't have been that their ideas were weak or their management structure had become top-heavy. . . . They decided CG was the solution to their problems."[2] At the turn of the millennium, Feature Animation still had several hand-drawn films in various stages of production, but management was looking the other way. They noticed the shift in popular attention. In response, during the early 2000s the entire animation division began going through a period of considerable retrenchment and reevaluation. However, can the Florida studio be regarded as merely a casualty in new business strategies meant to regain dominancy in the animation industry? I suggest that the enticement of 3D animation cannot be blamed solely on the failure of Disney's films to perform but that the ultimate decision to close this facility stemmed from multiple factors.

Poor performance at the box office must be included within this list, particularly the repetition of the general Disney formula throughout the 1990s, losing the sparkling originality of the blockbuster years as Disney failed to keep up with newer trends in popular entertainment. As Sito notes, instead of realizing that the problem was in repetition of the films, management supposed the deficiency was in the lack of technology.[3] Even if the computer was a large factor in the failure of hand-drawn animation to perform, one cannot ignore the combination of creative and executive decisions that led to rising costs and formulaic duplication. Another factor was the oversaturation of the Disney brand within the American and global marketplace. Disney Merchandising licensed a vast array of character- and film-related products that flooded store shelves. In addition, numerous less expensive direct-to-video sequels were being released based on Feature Animation originals. The sequels continued the story lines of the original features but were made in less time with less money and higher quotas. The films were produced at other studios around the globe, paying much lower wages than those in the United States.

But other circumstances came from outside the company, affecting box office returns as well. External factors, such as the terrorist attacks of 9/11 in 2001, significantly altered worldwide economic and social stability, which in turn greatly increased competition for the public's leisure-time activities with less money to spend. Thus, a struggling economy contributed to the loss of Disney revenues. (This situation echoes that of World War II, which cut off the European market that Walt depended on for the profitability of his films.) Simultaneously, we must recognize that contemporary audiences were becoming more sophisticated by the early 2000s, and the earlier mystique of animation production lost a little of its charm.

At the company's executive level, an upheaval in the corporate political structure, resulting from the boardroom battles between Roy E. Disney and Michael Eisner, lasted well into the decade and eventually shaped a new beginning for the corporation and its animation division. These corporate machinations during the early years of the millennium, combined with less than stellar performance of the films at the box office, led to the retrenching of the company's assets, which included closing multiple satellite studios that had opened during the Renaissance's heyday. With corporate directness, Florida's studio was shut down and the entire structure was redesigned and renovated into a new attraction for theme park guests to enjoy.

To analyze these claims through the lens of animation production, this chapter examines the films produced at the Florida studio after *Mulan*. In the summer of 1998, with the release of their first film, the Florida studio had proven itself capable of producing a high-quality animated feature. All departments had relocated into the new building, and the crew were waiting to hear about their next project. Since the new film had yet to be announced, smaller projects were assigned to the studio to keep the production pipeline going and allow the crew to get used to their new surroundings. One of these projects was *How to Haunt a House* (1999), a cartoon for broadcast on the Disney Channel featuring recognizable stars from the traditional Disney stable. Another short was *John Henry* (1999), pitched by master animator Mark Henn, who was also approved to direct. Beginning with *John Henry*, we see how this film, produced in the 2D format, was regarded at a time when 3D was fast becoming the dominant presence in the industry. This leads the discussion to Florida's second and third features, *Lilo and Stitch* and *Brother Bear*, concluding with the studio's final project: Barry Cook's "My Peoples."[4]

However, all through the production of these films, we see the politically charged atmosphere that led to the ultimate closure of the Florida studio within the theme park attraction. Due to this boardroom conflict, "My Peoples" was subsequently halted during preproduction. This action supports the argument that Disney's upper management was unable to foresee any future for hand-drawn animation within a digital world, even one that combined 2D and 3D elements. Instead, they decided to shut down the Florida studio and recast the theme park attraction. While it is impossible to substantiate, I argue that if the film had been completed, "My Peoples" would have been a cutting-edge hybrid at the time of its projected release. Instead, the history of these films displays the ever-increasing secondary status of hand-drawn animation within the new digital era. They can be seen as evidence of the last gasps of CAPS production before that program was ultimately abandoned in favor of completely computer-generated imagery.

The Florida Studio in the New Millennium:
John Henry

In the time between feature films, management was always on the lookout for projects to keep the animation pipeline in action. Even during feature production, various smaller films were always moving through Florida's pipeline, including public service announcements from UNICEF and a "Save the Manatees" PBS infomercial, or film segments needed in other theme parks, like Tokyo Disneyland and its animated Pooh's Hunny Hunt ride.[5] The Magic of Disney Animation attraction still had guests walking through the corridors, and to maintain interest and keep the pipeline operating, two short films were given to the studio: *John Henry* and *How to Haunt a House*.

The practice of producing shorts has long been a tradition in animation (see examples from Pixar, UPA, and early Disney). Although no longer a staple in the theatrical line-up, shorts remain a good venue for experimentation with production design and new technology and are a proving ground for promotion within the ranks. A promising director is often assigned a seven-minute cartoon, providing valuable experience and knowledge of the overall production process, before being entrusted with a full-length feature. Sometimes these shorts come about as personal projects, as seen with Barry Cook's *Off His Rockers*, giving the artists a chance to stretch their creativity in alternate roles. *John Henry* is another example of one of those personal projects. Proposed by veteran animator Mark Henn, this nine-minute cartoon was a story pitch that was green-lit by the company with Henn assigned to direct.[6] Steve Keller was named executive producer on the project and Bob Stanton was chosen as art director. The film gave Henn a chance to work with his fellow animators from a new perspective as well as a golden opportunity to bring this national folk legend to the screen.

The ten-minute short is based on the West Virginia folk song and oral history legend of John Henry and his famous competition with the Steam Drill: man versus machine. The story is narrated by John Henry's wife, Polly, recounting their captivity during the time of slavery and their marriage at the end of the Civil War. The newly freed couple heads west looking for work and arrives at a railroad camp in West Virginia, where the workers are discouraged by a tall mountain standing in the way of their progress. Their hopes rally when John Henry joins the crew. However, as they enthusiastically return to work, a new obstacle arises: the Steam Drill, driven by a faceless silhouette nicknamed Shadowman. This new technology threatens the very livelihood of the common workers, so they attempt to retaliate. Instead, John Henry challenges the new technology to a duel. The goal is to

see whether man or machine can lay the most railroad track by sundown. The race reaches its climax at sunset with John Henry emerging from the other side of the mountain victorious. Although he's won the competition, the big man collapses to the ground. He wins the race against the machine, yet it takes every ounce of his humanity to do so.

John Henry is significant when recalling the lack of African American subject matter in Disney's filmography. This absence of racial diversity recalls the tarnished legacy of *Song of the South* (1946), a film that caused a huge public outcry for romanticizing the plight of emancipated slaves. *John Henry*, on the other hand, communicates an entirely different message, based not on race but on man versus technology. Nonetheless, the film delivers a strong African American persona to the viewer through its visual styling and a soundtrack featuring music from the Grammy Award–winning choral group Sounds of Blackness.[7]

Sounds of Blackness is a group of professional musicians who pride themselves on producing an authentically ethnic sound and are celebrated for their use of African American vocalization and musical rhythms. Members from this vocal/instrumental ensemble had already collaborated with Feature Animation as the voices of the Muses in the 1997 film *Hercules*.[8] For *John Henry*, Stephen James Taylor composed the music, and lyrics were written by Gary Hines and Billy Steele.[9] In an email interview with Tim Hodge, one of *John Henry*'s screenwriters, Hodge spoke about the close working relationship between the predominantly Caucasian crew on the film and the African American music group[10]: "They loved what we were doing from the onset, and offered insights that let us know what were touchy areas as well as what we should include."[11] With the musical collaboration in place, the artistic team developed an unusual visual styling for the film to further anchor the story within its African American roots.

The film presented an opportunity for art director Stanton, an original member of Florida's backgrounds department, to experiment with varying motifs. He was responsible for overseeing a complex series of visual styles derived from historic and contemporary modes of African American art. In an email, Stanton discussed the multiple influences that went into *John Henry*'s innovative art direction, including referencing outsider artists who were not necessarily African American but worked in close collaboration with their style.[12] CAPS served as the means of combining these multiple forms of art direction, allowing the art director to maintain three differing "looks" within a single cartoon. The alternating styles were used as tropes to communicate the story visually, as well as verbally, to the audience. Each came with specific instructions on how these styles were to be drawn and

Figure 5.1. Film frame from *John Henry* depicting the linear style.

then how they were to be put through the pipeline. In this way the art direction was used to define time cues indicating past and present events within the film's narrative. CAPS operations were particularly useful in controlling the quality of light that dramatically illustrated the climax of the story: the competition between John Henry and the Steam Drill within the mountain's inky interior. How did the art direction contribute so specifically to the narrative? It begins with the differentiation between the linear and quilt styles.

The *linear style* is defined by rough-line character animation placed over scratchboard backgrounds. The coarse line quality of the artwork conveyed more emotion, fitting in well with the gospel sounds of the chorale. This style was used to illustrate the main story that Polly is relating to her son. For the animation, Henn preferred to retain the structural lines found in rough animation; he worked closely with the cleanup department to develop a technique that retained those sketchy lines without detracting from the overall readability of the drawings. This approach is quite the opposite of the usually pristine draftsmanship for which Disney's cleanup department is known. To accompany the rough look of the animation, a scratchboard technique was used for the linear style's background elements, inspired by contemporary New York artist/illustrator Brian Pinkney. As with many of the films produced at the Disney Studio, experts were brought in to provide training for the artists in history, design, and draftsmanship related to the

Figure 5.2. Film frame from *John Henry* depicting the quilt style.

art direction; multiple resources were offered to the animators on African American art. Pinkney hosted several workshops for the background and layout departments, solving technical issues connected with creating traditional layout elements (overlays, underlays, and backgrounds) in a consistent and readable manner.[13] Henn's partially cleaned-up character drawings read well against the textured scratchboard backgrounds.

A completely different look, the *quilt style*, was used to illustrate the background exposition of the story. This highly graphic motif was based on the pictographic nature of hand-made quilts, derived from the African American crafting tradition seen before, during, and after the Civil War. It provided tall-tale legendary information, such as when Polly talks about John Henry's fabled childhood and his monumental achievements while growing up. Contemporary and post–Civil War slave quilts were studied for their narrative content and structure, while artists from New York's Harlem Renaissance period, including Jacob Lawrence and Aaron Douglas, were referenced for their color palettes, blocky shapes, and graphic design.[14] The repetition of patterns on large patches of color were distinctly separate from the pen-and-ink scratchboard look of the linear style.

Stanton's art direction went a step further, highlighting the climax of the film as John Henry races through the mountain against the Steam Drill. Within the pitch-black darkness of the frame, we catch glimpses of man and

Figure 5.3. Film frame from *John Henry* depicting the graphic silhouette style.

machine silhouetted by bright showers of red and blue sparks. Much of this graphic quality derives from regional woodcut prints from the 1930s, with their large textured areas used to illuminate shapes within the composition. The dramatic lighting accentuates the unseen drama going on between the two combatants. The integration of these three styles of art direction makes *John Henry* a good example of the technical virtuosity of CAPS in 1999, seen in its ability to maintain unique individual styling while presenting them in a homogenous manner. This dexterity allowed Stanton to communicate different intervals of past and present to the audience, creating a unique concept in visual storytelling.

I find it ironic that this version of John Henry's legend can be cited as an example of the current state of Disney's technology when its major thesis emphasizes the man versus machine competition. John Henry succeeds in beating the Steam Drill by pitting his humanity against the power of technology. The Steam Drill cannot push through the mountain with as much

determination as the man. It is driven by a faceless, nameless silhouette rendered in dark tones, who pantomimes his performance; he has no voice. He was called Shadowman by Florida's crew to identify the character within the scenes.[15] This featureless figure originally smoked a cigar, which he used to incinerate the construction contract that boss McTavish holds out to him. He agrees to John's proposal to race against the machine. Shadowman is an anonymous figure, somewhat like a corporate identity that loses its humanity within the business world. He is characterized as the antagonist responsible for the technology that takes jobs away from the common man. Yet, even the rendering of this caricature was too strong; near the end of production, management dictated the removal of Shadowman's cigar. Smoking was not considered politically correct and could not be allowed in a Disney film, so most of Shadowman's scenes were revised to remove the offending iconography.[16] (At the same time, *Pecos Bill* [1954], an earlier Disney Tall-Tale, received the same treatment; his cigarette was digitally removed, since it was no longer acceptable to show animated characters smoking.)

While CAPS was used to transform these hand-drawn characters and painted backgrounds into digital information, shaping them through operations and leveling hierarchies, it is important to remember that the program still acted as a support system to the human-crafted artwork rather than manufacturing the image. Even the Steam Drill, which was constructed in 3D, displays that difference when its precise lines are compared to the rough animation of the human characters. The characterization of technology was purposefully kept clean in order to stand out against the linear style. Thus, *John Henry* the film, while being a morality tale about a human being overcoming a machine, serves as an example of creative beings working with technology to produce a uniquely visual account of the story.

John Henry was eventually released as part of the *Disney's American Legends* (2002) DVD collection, capitalizing on the wave of national patriotism brought about by the 9/11 terrorist attacks on the United States in 2001.[17] This collection contains selections from Walt's earlier Tall-Tales series—*Johnny Appleseed* (1948), *The Brave Engineer* (*The Ballad of Casey Jones*, 1950), and *Paul Bunyan* (1958)—combined with the new cartoon into a package film reminiscent of the late 1940s.[18] The interstitial segments between the shorts feature James Earl Jones introducing the films in cozy, farm-like settings. Florida's film fits nicely within this format and was featured as the first cartoon in the lineup. Since then, *John Henry* has been released on Blu-ray as part of a collection of contemporary Disney shorts, *Walt Disney Animation Studios Short Films Collection* (2015).

The Offbeat Project: *Lilo and Stitch*

While I have already mentioned that by the early 2000s Disney's animation was not as popular as it had once been, there are exceptions to this statement; the Florida studio's second film, *Lilo and Stitch*, was a hit. However, that didn't stop the layoffs and pay reductions from occurring in the California studio shortly after the box office returns of *Dinosaur* and *Atlantis*. Yet, *Lilo and Stitch* was something different from the usual Disney fare. It can be seen as Florida's most oddball film. Production was directed by the dynamic duo of Chris Sanders and Dean DeBlois. Sanders had already displayed a unique sense of visual styling when he art-directed Sequence 4.2, "Can't Wait to be King," one of the sequences given to Florida during their role as B unit on *The Lion King*. Now coming full circle, he returned to Florida when *Lilo and Stitch* was assigned as the follow-up feature to *Mulan*. When DeBlois first arrived at Disney, he worked in the story and layout departments. He became cohead of story development on *Mulan*, where he worked closely with Sanders. Based on this experience, it was decided they would do well as codirectors.

To begin, they cast California animator Andreas Deja in the role of Lilo and Florida crew member Alex Kupershmidt as Stitch. Once again, this film highlights the communal camaraderie present in the Florida crew as they united once more on a feature of their own. DeBlois remembered:

> *Lilo and Stitch* is unlike anything that the Disney studios have ever created in the sense that its scale and scope were deliberately conceived to be small. . . . So when we learned that our budget and time frame were to be considerably modest compared to other films in production, we simply smiled and embraced the notion of making a smaller, gutsier film. . . . Given our time and budget issues, we knew that *Lilo and Stitch* could only be made by a flexible, focused, and dedicated group of people. The Florida studio was the perfect solution. From the moment we presented the story to the crew of nearly 350 people, the notion of breaking conventions and making this film in a unique way was immediately and enthusiastically embraced.[19]

By the time *Lilo and Stitch* went into production, the Florida studio had spent a few years housed within their custom-designed new building.

Lilo and Stitch diverges from the usual Disney formula, moving away from the romantic musical/comedy genre of earlier Renaissance films, including *Mulan*. While it does feature a soundtrack, the songs accentuate the moods of the film, as in *Tarzan*, rather than using the lyrics to push the story forward. The music combines Hawaiian-based rhythms with classic Elvis

Presley recordings, which in themselves evoke numerous references to the island location. These components inspired a new sensibility in the artists as they sought to replace the usual formulaic repetition with a new offbeat attitude toward narrative and production styling. This was purposefully done by Sanders and DeBlois, even to the point of dressing up the title character, Stitch, as an Elvis impersonator. The soundtrack, art direction (once again by Ric Sluiter), and characterization alert the audience not to expect much in the way of Disney princesses, nor to assume conventional behavior from either of the two main characters. In this case it is easy to say *Lilo and Stitch* is representative of the unconventional attitude present in the Florida studio, which did not have the historical legacy nor the close corporate oversight that were present in the California studio. While the work reels were routinely screened for executive management, being three thousand miles away from the main studio created a buffer the artists used to their advantage.

One of the most interesting facts about *Lilo and Stitch* was its unusually short preproduction period before being thrust into the animation pipeline. The Florida studio waited almost two years to hear what their next feature film would be after production on *Mulan* was complete. Generally, as soon as Layout was done on one film, they began workbooking the next. (As discussed earlier, Feature Animation management instead assigned smaller projects like *John Henry* to the studio.) Sanders had such a good experience working with the Florida crew during *The Lion King*, he was positive they would be able to capture the look and spirit of his offbeat project. The problem was timing. He and DeBlois were still working on the plot and storyboarding the film when they were told to go into production.[20] Their schedules were adjusted to include writing and development of the narrative in the morning before heading to approval sessions in the afternoon. They worked simultaneously on getting the story points right while assigning sequences to Animation. This may account for the feeling of spontaneity in the film itself. It is lighthearted fun but with a deep emotional message focusing on family values that triumph in the end. The tagline for *Lilo and Stitch* comes from the Hawaiian concept of *ohana*, which is repeated throughout the film: "Ohana means family, family means nobody gets left behind or forgotten." This could very well be said about the Florida studio.

Sanders used his own unique style in the character designs for the film. These are not the long, lithe hyperrealistic human beings seen in many of the princess films. Instead, these people are pudgy; they have weight, with thick ankles and round noses. There is an earthiness to them that fits the Hawaiian hula more than a European polka. While character design in the film followed Sanders's personal aesthetic, it was up to production designer Paul Felix, art

director Ric Sluiter, and head of Backgrounds Robert Stanton to recreate the beauty of Kauai's tropical paradise. Sluiter and Stanton, influential figures in the Florida studio's history, oversaw the revival of traditional watercolor painting to use on the background elements. Disney artists had not used watercolor backgrounds since *Dumbo* in 1941—over sixty years earlier—favoring gouache and acrylics.[21] Now the artist and professional development department provided workshops for the backgrounds department in both watercolor techniques and plein-air (outdoor) field trips.[22] Many times they drove to Disney's Polynesian Resort to paint the lush tropical landscape featured in that location. In fact, the Polynesian became a favorite spot for doing visual research and for celebrating milestones during the making of the film. At the beginning of production, the entire crew was invited to a kick-off celebration with food and drinks, music and dancing in the South Seas Islands style.

In the book that accompanied the film, *Lilo and Stitch: Collected Stories from the Film's Creators*, several key members of the team provided personal insights into the production techniques and their experiences working on the film.[23] This collection of memoirs is a tribute to the artists, reflecting their cooperative spirit while creating a film decidedly different from any of their previous projects. *Lilo and Stitch* is seen breaking the usual Disney mold—not that it didn't contain songs, comedic sidekicks, or a happy ending, but that its characters are not picture-perfect people; they have tainted pasts and are working under a personal agenda rather than a moral code of ethics. Lilo, her sister Nani, Stitch, Jumba, Pleakley, Cobra Bubbles, and David conform to a personal accounting of their own actions rather than social dictates of right and wrong. They come across as more human.

Production relied heavily on creating personality for the characters, but it was supported through both types of computer technology—CAPS and 3D—as well. Advancements in 3D programs made the acting in those elements more fluid, allowing for a smoother performance with more personality and Disney's hyperrealism. An example of this personality animation is seen in Sequence 2, "Stitch Escapes," where Stitch is confined in a holding container while two genetic guns follow his every move. As he engineers his escape, these guns react, blasting holes in the floor, the walls, and the door. The guns are 3D, yet their quick movements and mannerisms betray an intelligence behind the machinery. Animator Darlene Hadrika commented that these "effects" elements provided her with a real chance to inject personality into a mechanical object.[24] This mechanical personality is also seen in the handling of the spaceships as they move across the sky or among the stars. They are portrayed as solid constructs that can be affected by outside stimuli.

Figure 5.4. Film frame of Stitch teasing the genetic guns from *Lilo and Stitch* (Sq. 2).

As Stitch escapes the prison ship at the beginning of the film, he shuts down the navigational systems and the immense vehicle falls heavily into inaction. On the other hand, the smaller, faster military escort ships careen wildly as they make way of the inert giant.

External circumstances can sometimes affect a film's narrative, leading to the reboarding and reanimating of footage that had already been complete. Production on *Lilo and Stitch* was in high gear during the terrible events of 9/11. Many of the crew remember being at work that morning, glued to the television as the second of New York's twin towers came crashing down, sending shock waves around the world. Everyone was stunned, and word soon came down from management that the studio was closed and everyone was to go home. The reason was that Walt Disney World was on the list of possible targets. The theme parks were closed, although the resorts stayed open to accommodate guests who had nowhere else to go. All air traffic was grounded, so guests already at the resort remained in their rooms with free lodging, food, and park privileges. The cast members did a brilliant job trying to make the best of the situation for the kids and their parents. Many days later, when the travel ban was finally lifted, Pam Darley remembers being surprised to see an airplane moving overhead, as the skies had been quiet for so long.[25]

When this occurred, Clark Spencer, producer on *Lilo and Stitch*, had other things on his mind. He remembers how 9/11 caused a panicked rewrite of a sequence where Stitch hijacks a 747 Jumbo Jet and wreaks havoc on Honolulu.[26] Many of the layouts, animation, and effects had already been completed in color; now they had to be reconfigured to fit a new story line, one whose changes ultimately made for a better fit with the narrative. When the good guys find they need airborne transportation to rescue Lilo from Captain Gantu, Jumba and Pleakley offer their own spaceship, redesigned from the earlier Jumbo Jet. Instead of Honolulu, the sequence stays within the lush tropical paradise of Kauai. Spencer remembers, "When significant changes to the film were made late in production, the Florida studio's passion never waned."[27] Since the narrative could not possibly remain as it was, the crew set about reworking the original artwork to follow the new story line. Remarkably, the rewrite actually answered continuity questions about how Jumba and Pleakley managed to get to Earth in the first place.

Film historian Chris Pallant does not identify *Lilo and Stitch* as part of the Disney Renaissance but considers the film part of a transition period he labels "Neo-Disney," a time just before the company's complete immersion into 3D.[28] However, I believe the film harkens back to a more cartoony approach to art direction and narrative, recalling the groundbreaking attitude of *Who Framed Roger Rabbit*, the film that started the meteoric rise of animated entertainment in the late 1980s. Now in the aught years of the new millennium, that newness had worn off, and the paying audience was seeking other modes of entertainment. This is why *Lilo and Stitch* was seen as something new and refreshing. It did not fit the formulaic repetition of the earlier musicals. It was neither a princess film nor a love story; nor was it a tale rendered from cultural myths and legends. *Lilo and Stitch* is an original story with unique sensibilities, coupled with art direction and character design notably not derived from any of its earlier Renaissance colleagues, so it stands on its own.

Unfortunately, during the production of *Lilo and Stitch*, the entire division of Walt Disney Feature Animation was undergoing severe cutbacks due to underachievement of recent films at the box office. This confirms the lack of confidence from the executive board. Disney management saw that the new 3D films from Pixar were capturing the lion's share of the animation market, and the result was that traditional animators were no longer considered a valuable commodity. When it came time for negotiations of the annual renewal clause on most contracts, the artists were startled to find a 30–50 percent pay reduction being offered.[29] It was either take home less money or stay home altogether. California's fateful town hall meeting on Monday,

March 25, 2002, occurred during Florida's crunch time on *Lilo and Stitch*, which was due to open on June 21, 2002.[30]

This situation reveals two conditions existing in 2002: (1) the ongoing digital revolution taking over the animated art form, and (2) the loss of executive confidence evidenced by corporate decisions concerning hand-drawn animation in the face of public response. Dan Lund and Tony West later created a film, *Dream On, Silly Dreamer* (2005), documenting that fateful meeting when management broke the news to many of the artists that their services were no longer required. This led to layoffs in almost every department. The Florida crew was stunned and could only conjecture what would happen after production was over for them. This was one reason why *Brother Bear* was so important to Florida's crew. With another feature film already slated for Orlando, there was the promise of new roles to be filled by the crew. The animators were cast where they would do the most good, and many of the pipeline artists were already slotted into their production positions.[31]

The Final Film: *Brother Bear*

> Starting in 2003 the Walt Disney Company had begun to eliminate most of the traditional animation crew trained by the golden age masters, as simply as one would dump an old typewriter in the attic. Warner Bros. Feature Animation and DreamWorks Animation shed their pencil-and-paint animators as well, just not as publicly. . . . In Hollywood, traditionally drawn animation slipped to second-class status.
>
> —Tom Sito, *Moving Innovation*

Just as *Mulan* and *Lilo and Stitch* will always have a special place within the heart of the Florida studio, *Brother Bear* will always be a special tailor-made project for the crew. This third film from Florida was the last to be theatrically released and may be seen as a triumphant failure for the "little studio that could." Triumphant in its fluid animation, painterly landscapes, and the seamless merging of current CAPS and 3D technology, *Brother Bear* was also a failure that was underappreciated at the executive level, received little promotional support, and subsequently underperformed in its initial bid at the box office.[32]

The film's directing team consisted of Aaron Blaise and Robert Walker, with Chuck Williams as executive producer, all original crew members of the Florida studio.[33] Blaise began his career at Disney as a young animator, fresh out of the Ringling College of Art and Design. His contribution to

memorable characters on the California features (Beast, Rajah, Nala, etc.) led to his directorial debut on the six-minute short *How to Haunt a House*.[34] Produced after *Mulan* and before *Lilo and Stitch*, *How to Haunt a House* moved through the animation pipeline simultaneously with *John Henry*. The project continued the legacy of the Goofy How-To shorts, featuring the classic Disney characters Goofy and Donald Duck, along with the ubiquitous voice of a narrator.[35] The short was produced for the *Mickey Mouse Works* television series in collaboration with Walt Disney Television Animation. This series appeared on the Disney Channel from 1999 through 2000.[36] (Both shorts, *John Henry* and *How to Haunt a House*, were completed well before production began on *Lilo and Stitch*.)

Similar to how Cook's direction of the shorts *Off His Rockers* and *Trail Mix-Up* led to the opportunity to codirect *Mulan*, *How to Haunt a House* foreshadows the advancement of Blaise's career. While this cartoon is not widely available, its existence provides proof of how the company used these projects as test vehicles for artists who wanted to advance beyond their current production roles. By fall 2001 Blaise had been at the Florida studio for over ten years. Soon after the successful completion of this project, he was offered the opportunity to direct a much larger project using the Florida studio as his production unit. *Brother Bear* was his first directing assignment, but it would not be his last.[37]

Blaise was chosen to codirect alongside the head of Florida's layout department, Robert Walker (1961–2015). Walker had joined the Florida studio as a journeyman layout artist when the Magic of Disney Animation attraction originally opened in 1989. He quickly rose to head of that department, where he served for most of the studio's existence. Walker was layout supervisor for the Florida unit during the blockbuster years and oversaw all layout production on *Mulan*. Both men, Blaise and Walker, had already been responsible for key visual elements in several of the Disney Renaissance films; now they were going to use that experience to create a feature of their own.

Producer on the project was Chuck Williams, who began his career as head of Editorial for the fledgling studio. We can trace Williams's advancement from Florida's editorial department to becoming a key member of Paul Curasi's Animation Services team. He worked in several production capacities, as both director and producer, on several external projects—for example, on McDonald's and Fanta commercials. He later returned to Feature Animation and with that prior experience was subsequently tapped as executive producer on *Brother Bear*.

Like *Lilo and Stitch*, *Brother Bear* was given a short preproduction period before moving into the animation pipeline. As the previous film was coming

to a close, there was pressure to put sequences from the new film into production. Green-lighting a film before preproduction was complete had proved successful on *Lilo and Stitch*, so with certain departments ready to begin, the project moved forward. *Brother Bear* got off to a rocky start. With a production period of approximately two years (fall 2001 through fall 2003), it was set for nationwide release on November 1, 2003.[38] In the early months, some sequences moved through the pipeline while the directors were still working out story issues. This isn't unusual—as was the case on *Aladdin*, *Pocahontas*, and *Lilo and Stitch*—but it must be remembered that later decisions often affected earlier work, and it became a huge consideration when attempting to adjust the narrative. One of those decisions became sort of an in-house joke about how many family members the protagonist, Kenai, had on any given day.[39] At one point the narrative centered on two brothers, then it became a father and son, but in the end the film focused on the relationship between three brothers, which satisfied all of the plot twists.

The protagonist of the film is Kenai, one of three Inuit brothers, whose elder brother Sitka is killed when Kenai seeks revenge on a bear who has stolen their fish. In retaliation for the boy's vengeance, the spirit world transforms Kenai into a bear, who meets up with Koda, a wisecracking, street-smart young cub. Kenai reluctantly agrees to accompany Koda to the Salmon Run because it is close to the mountain where the spirits dwell. Once there, Kenai intends to ask the spirit world to change him back into a human. Koda, meanwhile, is hoping to be reunited with his mother; they had become separated after a man attack. During the journey, Kenai begrudgingly comes to care for the little cub and soon realizes he is responsible for Koda's mother's death. During the journey, Kenai and Koda are doggedly pursued by the third brother, Denahi, who seeks to avenge his brothers' deaths, unaware that Kenai is the very bear he seeks to kill. In the climax on the mountain, the spirit of Sitka gives Kenai the option of returning to his human form, but Kenai refuses, taking responsibility for Koda and choosing to remain a bear. Reconciled with Denahi, Kenai the bear is recognized as a member of the human clan and they all live happily ever after.

The film is a mixture of natural beauty, comedy, and Inuit spirituality. The soundtrack was provided by popular rock musician Phil Collins and Mark Mancina, the team who cowrote the music for Disney's *Tarzan*. As in *Tarzan*, the songs were used to express the mood of the sequence rather than move the narrative forward. A team of visual development artists, including Hans Bacher and art director Robh Ruppel, began working on the look of the film. (Ruppel also supplied visual development for *Mulan*, *Atlantis: The Lost Empire*, and *Treasure Planet*.[40]) They infused the film with multiple aesthetic

motifs particular to the Pacific Northwest, including wildlife art, Inuit folk-lore, plein-air painting, and spirit-guide mysticism. These attributes led to a sensory experience in creating and viewing the film. Preproduction began with research trips to Alaska, particularly along the Inside Passage, where numerous locations were scouted and photographed. The creative team participated in sketching and painting excursions and, most particularly, wildlife encounters in the national parks. Building upon this experience, Florida's Artistic and Professional Development people once again arranged to have animal experts come to the studio to lecture about anatomy and animal behavior related to the various species found in the film. One of the more notable occasions was a drawing session featuring two bear cubs in front of the glass window that was part of the new Magic of Disney Animation tour. The glass allowed guests a short peek into Animation's new building, where they saw the artists drawing the rambunctious cubs. Jack Lew, head of Professional Development, remembers how one of the cubs became a bit too excited and began ripping up the carpet.[41] The handler tapped the bear on the head with a broom handle to redirect his attention. Unfortunately, the glass was open at that time, and it had to be explained to the guests that the handler was not abusing the cubs in any way.[42] That was the last time they attempted to show drawings sessions in front of the glass.

SIMULATING NATURE WITH THE COMPUTER

Several examples of the successful merging of 2D and 3D animation are seen in *Brother Bear*. This becomes even more impressive when remembering how the computer initially entered the animated art form as a purely mechanical method of animating objects; now the technology was contributing to an organic, asymmetrical style of art direction. Multiple 3D elements were created for the film, including a herd of caribou, a flock of seagulls, a shoal of salmon, burning embers, various species of plants and trees, and a glacier. With CAPS it was possible to mimic the distorted reflection of a man as he passed in front of a sheet of ice, and to hesitantly follow Kenai as he cautiously moved through the Valley of Fire. Recalling the discussion in chapter 4 where *Mulan* made notable use of *The Lion King*'s herding software for the "Hun Charge" sequence, *Brother Bear* continued the pattern of borrowing to emphasize the abundance of wildlife. The 3D software used to create *The Lion King*'s wildebeest stampede (Sq. 10) and for Shan Yu's army in *Mulan*'s "Hun Charge" (Sq. 9.9) was now recast for *Brother Bear*'s caribou stampede. This stampede reenacted the wildebeests' action, simulating a herd of charging animals thundering down the hill toward Kenai's waiting brothers.

While the caribou were completely computer-generated, the two moose brothers, Rutt and Tuke, were not. These characters were primarily hand-drawn; however, they sported 3D antlers to provide more stability in their design. The large and unwieldy antlers were constructed in the computer to avoid problems similar to those faced by the Disney animators on *Bambi*. Traditional drawings had to be carefully rendered to avoid any organic movement within the hard bone structures. If they were animated with any fluidity at all, they would look rubbery and disconnected with the anatomy of the head. The moose's broad antlers were created by the 3D-Effects team, working closely with the traditional character leads, Broose Johnson (Tuke) and Tony Stanley (Rutt). Once the rough drawings were approved, they were used as reference by the 3D animators.[43] A procedure was devised to attach the rigid antlers to the animals' skull, resulting in a solid shape without any sliding or rubbery movement whenever the characters turned. In the sequence where Kenai first meets the moose brothers, they become entangled by their antlers in their haste to escape the bear. The solid bone of the antlers had to be believable, particularly during this sequence, where they played a vital part of the action.

One of the most wondrous effects in *Brother Bear* was the simulation of the Northern Lights, the aurora borealis, a naturally occurring phenomenon above the Arctic Circle. The computer not only created this atmospheric effect, but it was also a key element in Kenai's transformation sequence (Sq. 10), where he shifts from his human form to that of a bear. The sequence begins just after Kenai the human has killed the bear in revenge for his brother's death. Silver streams of liquid light surround the boy as he looks about in wonder. He touches a shining column of light with the point of his spear, releasing a multitude of ghostlike creatures moving through shimmering curtains of multicolor light. Working with traditional hand-drawn characters and layouts, the digital production and 3D effects departments created these semi-transparent curtains and populated them with the moving images of animal spirits who interact with the stupefied boy.

At the climax of the sequence, Kenai is raised into the air and transformed into a bear through a multitude of special effects. Glowing energy streams, liquid light, and waves of transparent animation were used to evoke the feeling of enchantment. Unlike images from earlier films, like the vehicles in *Oliver and Company*, the ballroom in *Beauty and the Beast*, or even the fireworks exploding over the Imperial Palace in *Mulan*, these 3D elements do not remotely resemble man-made configurations; nor do they entirely adhere to strictly naturalistic forms. In this case, the aurora borealis in *Brother Bear* served as the stepping-off point to evoke the mystical quality of the

Figure 5.5. Film frame depicting computer-generated graphics used in conjunction with hand-drawn artwork to create the aurora borealis in the "Transformation" sequence (Sq. 10) from *Brother Bear*.

film. It remained natural in its appearance, despite requiring the marriage of traditional art and sophisticated technology to accomplish its aesthetic look. The portrayal of the aurora borealis is, in this author's opinion, one of the most un-3D-like effects ever created on screen for its time.

The Reassessment of 2D

While all of this was going on, management's attention was drawn toward a different method of film production, shying away from hand-drawn animation. The ongoing success of Pixar's films, and the entrance of Blue Sky Studios and DreamWorks into the movie marketplace, confirmed management's belief that 3D was the hottest ticket at the box office. Blue Sky Studios opened with a solid hit, *Ice Age*, in 2002, after DreamWorks received good notices for *Antz* and achieved a blockbuster triumph with *Shrek* (2001). Pixar followed the success of *Toy Story* with *A Bug's Life* in 1998, which outdid DreamWork's *Antz* from two months earlier, and went on to release a string of hits, including *Toy Story 2* (1999), *Monsters Inc.* (2001), *Finding Nemo* (2003), and *The Incredibles* (2004), before finally being acquired by the Walt Disney Company in 2006.[44]

By 2003 CAPS was in transition once more. At this point it is logical to discuss why CAPS was no longer considered a successful production model. Its original emphasis as a two-dimensional support program lost ground when compared with the emerging ideologies in computer-generated images. As a film, *Brother Bear* demonstrates how the animators were increasingly able to integrate the two animation formats (hand-drawn and 3D) in a variety of ways to achieve the most naturalistic representation of the story's Pacific Northwest setting. CAPS was still the foundation platform used as the point of entry for hand-drawn animation into the digital world, but it was becoming increasingly unwieldy when integrated with the complex sophistication of 3D systems.[45]

The assimilation of computer graphics into the animation industry soon required a complete reassessment of the CAPS software and a reevaluation of its place within the Disney production pipeline. Over a decade after its initial introduction, technological procedures now began to require fundamental upgrades in their foundational source code. New upgrades were continually necessary. Disney's software engineers proposed reversing the procedure, putting 2D elements into a 3D world. They proposed rewriting the software, going far beyond its initial concept as a support structure for hand-drawn artwork. It was argued that by reformulating the software's platform, it would still retain its ability to support hand-drawn artwork while at the same time easing its integration with 3D elements. This alteration would require very little difference in the procedures used to input traditional drawings; once digitized into the system, the levels could be mapped onto geometric planes existing like theatrical stage flats within a virtual environment. From there, the animators and technicians could work interactively with all the elements in a scene with near real-time results.

Traditional multiplane instructions would have to be interpolated into new 3D terminology to indicate movement with a new Z-axis in three-dimensional space. The updated version would increase virtual versatility by merging animation methods more efficiently, in line with the continually advancing digital systems, and finding more ways to enhance traditional artwork. As these ideas were being proposed, *Brother Bear* went into production. The film still utilized the original CAPS 2D platform—albeit with slightly more advanced 3D upgrades whenever they became available.

With these goals in mind, the technologies department began rewriting the foundation of the CAPS software.[46] This new version was intended to bring everything together, traditional and digital, within one system. Instead of importing 3D elements into a two-dimensional environment, the process was reversed, achieving results reminiscent of the ballroom sequence in

Beauty and the Beast (see fig. 3.1). (That sequence had been achieved using the original CAPS software.) This method of redirection is symptomatic of the evolving nature of the computer's abilities as programmers sought new ways of integrating and refining working procedures. At the same time, Feature Animation began retraining their staff, both in California and Florida, on all aspects of 3D production, focusing primarily on Maya, Photoshop, and After Effects software, in order to become fluent with these computer systems and integrate their previous traditional experience with the new digital procedures being introduced. In the documentary *Dream On, Silly Dreamer*, the artists said management had hinted that story pitches more suited to computer-generated films would be seriously considered.[47] Thus, all subsequent efforts at retaining hand-drawn images were examined with an eye toward how they translated into the 3D format rather than what had come before.

The Film That Never Was

With the phenomenal, and lucrative, success of Pixar, Disney's upper management saw computer animation as the most feasible option for creating their next blockbuster hit. They had the idea of converting the Florida studio into a digital one, much like Northside in California. The Northside studio acted as the primary digital studio when producing *Fantasia 2000* and *Dinosaur*. Southside was to remain the traditional 2D studio, as Disney was still producing hand-drawn films. Perhaps if *Dinosaur* had been better received at the box office, Northside might have led the way for Feature Animation in the changeover from hand-drawn to computer animation, but the facility was closed during the retrenching of the Disney Studios in the early 2000s.[48] Management sought to keep any traditional artists who could make the transition to contemporary digital systems; specialized training was given at all levels of production.

As production on *Brother Bear* was winding down, preparations were being made for a new pipeline, one that was developed to handle production needs of a different sort. This was in response to Florida's incoming fourth feature, to be titled "My Peoples." The initial step was to change the physical arrangement of departments. This was a fairly common practice for the artists, as they often moved into new configurations according to their roles on an upcoming film. The necessity of these changes had also become apparent since the crew had first settled into their new surroundings. Now the entire studio prepared to move as department locations were strategized to enable optimum pipeline communication.

"My Peoples" was the brainchild of Barry Cook, who brought it to Disney with the hope of producing it at the Florida studio. It was assigned to Florida's schedule as *Brother Bear* was wrapping up production. Keeping in mind the current attitude in technological ideology, "My Peoples" was proposed as a new kind of hybrid film. It would include two- and three-dimensional characters interacting within a blended environment, using both traditional background paintings and geometric shapes. The humans in the story would be hand-drawn, while the dolls, "the *peoples*," would be modeled using the computer. This idea of melding two visual styles to communicate differing story elements is reminiscent of Cook's earlier short *Off His Rockers* and, to some extent, Mark Henn's *John Henry*. In "My Peoples" the differing methods would distinguish the human romance from the behind-the-scenes drama faced by the dolls. With these production demands in mind, "My Peoples" was expected to rely on a new software platform, one based in a three-dimensional world while retaining the ability to import hand-drawn imagery.

Cook, a familiar member of the crew for over a decade, had already picked his creative team, including Ric Sluiter as art director on the project and Bob Stanton as head of Backgrounds. Taking a closer look, we can see how Sluiter's overall stylistic influence at the Florida studio was subtly contributing to a unique house style. While Florida was not open long enough to reveal real results of this development, it would have been interesting to see what might have occurred if this trend had been allowed to continue. Sluiter and Stanton originally made up the backgrounds department when the Florida studio opened. They'd worked with their backs to the glass while guests in the tour corridor looked over their shoulders.

Sluiter was appointed Florida's background supervisor for both *Beauty and the Beast* and *Aladdin*. His working relationship with Cook really took off when he became art director on *Off His Rockers* and the Roger Rabbit short *Trail Mix-Up*. From there he collaborated with various production designers to create the unique styling of both *Mulan* and *Lilo and Stitch*. With Sluiter overseeing the vibrant visuals coming out of Florida, the films showed an overall lushness in the art direction that fully supported the narrative. Not that their visual cues were in any way repeated from one film to the next; there is a decidedly different aesthetic in the stylized line work and landscapes in *Mulan* when compared with the tropical lushness seen in *Lilo and Stitch*. Sluiter was able to envision how the film's characters and their environments would complement each other, making them easy to read by the audience. Now he was called upon to create a Tennessee backwoods country look for "My Peoples."

On this film Sluiter would have to balance the visuals through the continuous intermingling of 2D and 3D characters and their environments, creating a bridge between the two formats so that they merged comfortably in a painterly, yet dimensional, environment. This situation recalls the integration of live action and cel animation from *Who Framed Roger Rabbit* and how Richard Williams developed techniques to place the 'toons believably in the physical world. To merge the formats in *Roger Rabbit*, Williams and his production team created a series of special-effects mattes that gave the animated characters highlights, tones, and shadows, grounding them within the live-action environments.[49] An alternate set of mattes was used for the live-action Eddie Valiant character (Bob Hoskins) when he entered the two-dimensional Toontown.

Cook was once again pushing at the boundaries of integrating animation types. In an email to me, Cook talked about the difficulties present in the contemporary technology, albeit with an artist's hindsight of the end of an era. To ground the two styles, Cook explained, "The backgrounds on *My Peoples* . . . would use [traditional] paintings on simple CG geometry where needed, and camera moves would dictate the necessity of CG geometry on a per shot basis. Vehicles and other props that needed to move in perspective would have been CG models with painted textures. The structures and vehicles would be constructed so that they integrated these two [types of] character designs together."[50] Cook and his team created a preproduction test to show executives the finished look of the film: "The test we did with Angel on the porch was a flat [two-dimensional] BG with just a simple vertical camera move. Amazing, how much perceived depth the set has as the CG character dances toward camera."[51] Thus, the two forms of animation, hand-drawn and 3D, were becoming more and more interchangeable, yet the computer was still incapable of bringing the animator's lines directly into the system. It would be years before computerized tablets (like Wacom's Cintiq tablet) were advanced enough to allow animators with a stylus to draw directly into the system, thereby introducing hand-drawn animation into a digital environment.[52] For now, the two animation formats used in "My Peoples" would have to rely heavily on the new CAPS software to place them within a homogenous environment.

Unfortunately, during the preproduction process, "My Peoples" underwent several modifications, including multiple title changes that reflect manipulations to its story line and ideological structure. Most importantly, these changes can be seen as evidence of upper management's input in response to outside industry factors. The film went through several incarnations, with

alterations in its narrative, characters, and their relationships obfuscating the original story of the *peoples* themselves. The earliest scenario for the film included a *Sleeping Beauty*–type plot, although it was the male lead, Elgin Harper, who fell under a spell.[53] Instead of believing in the secret life of dolls, as introduced in the original story pitch, the *peoples* now became avatars for the ghosts of long-dead relatives. This is seen in one of the title changes: "A Few Good Ghosts." Other proposed titles included "Blue Moon" and "Angel and Her No-Good Sister." (It was even referred to as "Hillbilly Toy Story.")[54] While he continually addressed notes coming out of the executive screenings, Cook hoped for a return to a simpler version of the story and was set to refocus on the stronger points offered by the original narrative. Eventually, even the ghosts narrative was rejected and the film quietly reverted back its original title: "My Peoples."

If completed, the film would have contained combinations of hand-drawn and 3D animation using many of the same principles hinted at in the technological crossover seen in *Off His Rockers*. Unfortunately, this film became a casualty in the corporate politics within the Disney Company in 2003, compounded by the mounting economic losses incurred by the substantial drop in Disney's share of the animation box office. Ultimately, "My Peoples" was never produced. I find this a missed opportunity because I wonder if this film, had it been released, might have been Disney's best attempt to retain 2D animation with the full integration of hand-drawn and digital characters within a composite environment. At the time of this writing, the film has been shelved and its artwork preserved in the Walt Disney Animation Research Library, with no plans to be put back into production.

New Building, New Tour

By the beginning of the new millennium, Florida's crew was well ensconced in their new quarters, filling both the original main building and the new four-story one. At the end of *Mulan*, department by department the artists had packed their desks and moved into the new building. The trailers were dismantled and the entire crew was once again under one roof. Adjusting to the spacious new surroundings, designed specifically for them, Florida's crew, at four times its original size, was distributed within a vast amount of square footage. (As an orientation activity during the opening ceremonies, Tim O'Donnell, Steve Berry, and their operations team sponsored a scavenger hunt throughout the floors and wings of the new structure.[55]) The move into the new building meant that the theme park attraction tour

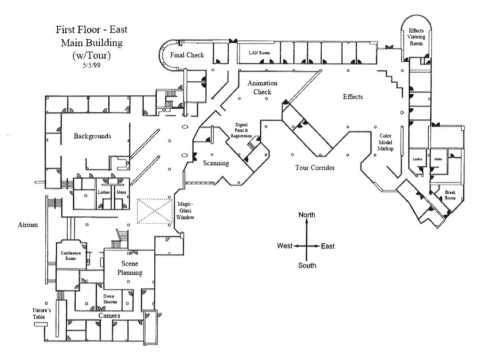

First Floor - East
Main Building
(w/Tour)
5/5/99

Final Check

LAN Room

Effects
Viewing
Room

Animation
Check

Effects

Backgrounds

Digital
Paint &
Registration

Color
Model
Markup

Scanning

Ladies Mens

Tour Corridor

Ladies Mens

Break
Room

Magic-
Glass
Window

North

Atrium

West ←→ East

South

Conference
Room

Scene
Planning

Nature's
Table

Down
Shooter

Camera

Figure 5.6. Diagram of the department layout on the first floor of both the main and new buildings—new on the left and main on the right. Source: Author's diagram adapted from employee map.

was now only distantly related to the production facility; it also meant that the familial camaraderie within the crew threatened to erode due to the compartmentalization of departments within the huge structure.

Occupancy in the new building was the final milestone of many years of hard work for Tim O'Donnell, who served as the studio's main liaison with Imagineering's architects, designers, and contractors.[56] It was not an overnight process but had begun years earlier with the closing and clearing away of backstage structures in preparation for construction. Although this sounds like an ideal situation for the animation studio, the new building presented problems seen in the Disney Studio's earlier history. At specific points along the company's timeline, the animation crew grew large enough to require new accommodations. Often, the original number of Disney's crew was not enough to complete the current workload. During production on *Snow White and the Seven Dwarfs* (1935–1937), not only was there a crew large enough to complete a feature film, but the Mickey Mouse and Silly Symphony car-

toons were also in production. This amounted to three separate production units spread out under multiple roofs. After the phenomenal success of *Snow White*, the entire studio moved from their Hyperion location to the magnificent custom-built structures on the present-day main lot.[57] Each building on the lot was dedicated to a different department, which essentially segregated the artists into differing factions.

A different scenario played out after the installation of Michael Eisner's management team in the mid-1980s, as the animators were moved off the main lot altogether.[58] They found themselves working in a warehouse district in nearby Glendale, California, with the same basic system of housing different departments in separate buildings. After the success of *The Little Mermaid*, the crew expanded into even more locations within that same district. When Feature Animation began working on two films simultaneously, those assigned to the different productions were segregated again into different structures. Now in Florida, with almost four hundred people involved in various stages of production, the new building was large enough to house the entire unit. However, it divided the separate departments into various locations within the huge structure, and this situation threatened to disrupt the communal atmosphere of the studio.

While Florida's close camaraderie was still strong after the success of *Mulan*, by the time *Brother Bear* came into production, nearly three years later, the segregation between departments was leading to anonymity within the ranks. In the new building, entire departments were separated by staircases and cut into sections. The Animation and Cleanup crews were given entire wings on different levels, while back in the fishbowl the special effects department took over most of the production floor. Animation Check joined Digital Paint and Registration where the old ink and paint department once stood, while Scanning remained in the original Camera room because the massive digital scanning equipment was not easily moved. Three floors of the new building were given over to the artists, while a section of the third and fourth floors was occupied by Disney's Design Group (DDG), the department responsible for conceiving and executing artwork used for merchandising Disney's characters, creating T-shirts, coffee mugs, toys, packaging, and so on. The third floor contained a library dedicated to research materials, audiobooks, and a huge selection of films. The fourth floor had a gym, lecture halls, and vast amounts of storage required by the studio.

The compartmentalization allowed fewer opportunities for casual socialization and collaboration between the artists. It was easy to know your immediate crew. But when traveling to other areas of the pipeline, it was possible to get confused by all the new names on the doors. Most of the

animators requested offices and, with their doors closed, became less accessible to their colleagues. The situation became even more confounding when someone from outside the department walked through the halls. Communication between departments was now more often handled by the production managers and their assistants rather than between the artists themselves.

Efforts were made at the administrative level to combat this isolation effect. They frequently sponsored events intended to bring the crew together and encouraged lunchtime club meetings that drew different individuals from within the staff (Weight Watchers, Bible studies, and workout sessions, for example). There were opportunities for social interaction during mealtimes and coffee breaks at the in-house commissary, Nature's Table, in the first-floor atrium. However, while there was still lively social interaction during studio-wide events, newer members of the team did not have the same collaborative experience that once bound the original crew together.

When the Florida studio had taken on the identity of a feature film facility, the original flow of the attraction's narrative was sacrificed in order to meet production needs. Work on Florida's first feature lasted from approximately the summer of 1995 through spring of 1998; *Mulan* opened in theaters on June 19, 1998.[59] By the time the film premiered, the disconnect between studio and attraction had increased, due in part to the convoluted pathways that cast members needed to navigate around the new building in order to access the attraction. This made the studio essentially inaccessible to the tour guides. While *Mulan* was in the flurry of production, constant overtime hours kept the artists working late into the night. As a result, the crew didn't have as much leisure time for excursions into the park, much less to entertain guests.

The once dual identity of the studio/attraction was now segregated into two distinct units. The studio side concentrated on the current film project, with the occasional reminder that the tour corridor still existed, while the attraction side looked on without the educational or entertainment elements that had been the mainstay of the original tour. And unlike the early years of the 1990s, by the 2000s much of the actual working studio was hidden from the guests' view. By the time the new building opened, little to no communication took place between the tour and the production floor. After the events of 9/11, new security measures further restricted access to the studio space. Thus, as the artists adjusted to their new surroundings, their attention turned further and further away from the theme park attraction. By the time *Lilo and Stitch* went into production, the separation between the two sides of the glass was pretty much complete and the sense of camaraderie between the park's cast members and animation crew was lost.

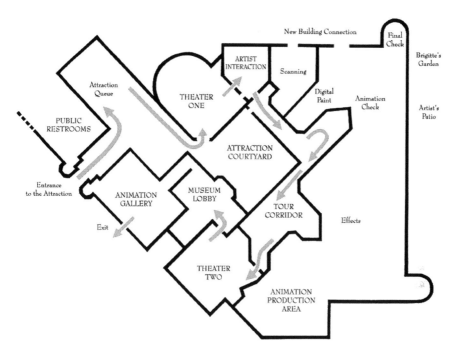

Figure 5.7. Diagram of the reversed tour flow after the attraction reopened in 1998. Source: Author's diagram adapted from the back cover of Roy E. Disney, *The Magic of Disney Animation, Premiere Edition* (1989).

Up in the tour corridor, the Magic of Disney Animation's original narrative was maintained until the attraction closed for renovations at the end of *Mulan*. As construction on the new building neared completion, the Magic of Disney Animation was closed so that WDI's Imagineers could redesign the tour around the parts of the studio still on display. However, simply rerouting the animation tour was not possible. Simultaneous with the opening of the new building, a renovated version of the attraction was revealed. There were still animators on display—specifically, effects animators and interns—but little of the original pipeline remained. With the animation process no longer intelligible, the solution was to restructure the attraction's narrative, moving away from a lesson on animation production and instead focusing on other aspects of the animated art form.

In the new version of the tour, the flow through the corridors was reversed.[60] As we saw in chapter 4, guests no longer entered the attraction through the Museum Gallery but through a façade to the left of the Ani-

Figure 5.8. Diagram of the final tour configuration of the Magic of Disney Animation. Source: Author's diagram adapted from the back cover of Roy E. Disney, *The Magic of Disney Animation Premiere Edition* (1989).

mation Gallery gift shop, beneath the signage of Sorcerer Mickey. Now the guest experience began by entering into what was originally Theater Two. Instead of viewing the Disney Classics film, this theater now screened *Back to Neverland*. After the film, the tour offered a new interactive experience. The antechamber that had once been the Reassembly Area was transformed into a room featuring a dais where a cast-member/artist sat at a lavishly decorated animation desk. These cast-member/artists were required to be skilled enough to draw Disney characters in front of an audience. (Many of these artists were later taken into production when crunch time demanded more hands to complete the film.)[61] The cast-member/artist gave a scripted talk about Disney animation and showed a preview of the latest film. This live interaction with the guests had been an original element of the Magic of Disney Animation's attraction design but was cut as being too impractical when the tour first opened.

With the cast-member/artist's inclusion, we see a shift on the part of the Imagineers toward guest inclusion and participation. These one-on-one

presentations made the guests feel special, even with crowds of up to thirty people. Here was a living person who interacted with children, and adults, on a more personal level—much like the Disney character meet-and-greets springing up all over the parks. As the cast-member/artists presented their spiel, they made a quick sketch of Mickey Mouse or one of the newer Disney characters. They talked with each group entering the attraction, answering questions and giving away the drawing to one lucky guest.[62] The room itself featured a window-like opening in the center disguised as a picture frame. At one point in the presentation, the cast-member/artist turned off the polarized glass with the touch of a button and the screen disappeared to reveal a view of the first-floor atrium in the new building.[63] This was the guests' only glimpse into the new building, but there were no artists seated in that section of the structure. Instead, they looked out over a large hallway that connected the two buildings, a traffic zone between departments. The only people seen within the space were on their way to and from other areas. If the artist happened to look up, they might wave to the crowd, but more often than not, there was no one within the empty space.

After the cast-member/artist interaction, the group was guided into the original tour corridor, albeit moving in the opposite direction, and was now accompanied by an animation tour guide explaining the artistic process. Guests passed by the old Camera room (now Scanning) and, once beyond the corner of the old ink and paint department, emerged to find a newly arranged production floor on the opposite side of the glass. As most departments were now located in the new building, only Special Effects, Animation Check, and Digital Paint and Registration were housed within the fishbowl. The guided tour was meant to compensate for the loss of cohesion without the traditional departments on display. Guests were still able to watch as effects animators flipped their drawings and as animation checkers carefully reconstructed the elements of each scene, frame by frame. The new digital ink and paint department had two CAPS workstations set up a short distance away from the glass. Guests could almost see what the artists were working on; however, the CAPS monitors were set up in such a way as to protect the company's unpublished images from any photos being taken.

Toward the end of the tour corridor, guests moved on to another new feature: a large wall of video monitors displaying an updated version of the *Animators on Animation* video that had played in the original Reassembly Area. This film included new clips from the Disney Renaissance films as the artists discussed their experiences and inspirations. Once the presentation was over, guests entered the Disney Classics Theater (the old Theater One), reliving memories and emotions through Disney's animation. After the film,

guests were invited to stroll around the Museum Gallery, and from there they exited through a new hallway connecting the tour with the Animation Gallery gift shop. This version of the attraction lasted for the rest of the time Feature Animation occupied the studio space—until November 14, 2003, when management called a mandatory town hall meeting.[64]

Shutting Down the Studio

Through the early years of the 2000s, as guests continued moving through the tour corridor, the downward trend in Disney's box office receipts persisted. Although *Lilo and Stitch* had a good showing, with the release of *Brother Bear*, executive management's faith in hand-drawn animation reached an all-time low. Unfortunately, their anticipated response to the film's reception is demonstrated through its initial release. Instead of the normal Friday opening, as is typical with most animated and live-action films in the United States, the company decided it would be more appropriate to release the film on Saturday, November 1. As Cook remembers, "To avoid competition with *The Matrix Revolutions* and *Elf*, Disney rescheduled *Brother Bear* to open on November 1. Analysts and fans alike were shocked, since the date was a Saturday. Disney responded that it did not want to open a family film on October 31, when it would have to compete with trick-or-treating on Halloween."[65] This decision severely affected *Brother Bear*'s box office ratings by excluding the most important day of its opening weekend. Thus, poor box office numbers, $19,802,809 (USA), seemed to justify management's belief in its inability to perform.[66] This circumstance is unfortunate, as *Brother Bear* actually received the second-highest rating during its opening weekend, even without Friday's opening numbers. Cook continues: "There was even more good news for the Florida Studio; *Brother Bear* was a hit. Despite opening on a Saturday, the film collected $19 million. If it had opened one day earlier, *Brother Bear* would have claimed the top spot at the box office that weekend."[67] Nevertheless, the film's performance, or lack thereof, added to the executive board's increasing discomfort with traditional 2D animation.

In hindsight it seems that the Florida studio's final days began counting down with the departure of Feature Animation president Thomas Schumacher. His predecessor, Peter Schneider, had left on June 20, 2001, to join Disney's Broadway administration, with Schumacher stepping in as president of the division. In the Florida studio, the director of operations position also passed through many hands. A list of the directors, after the departure of Max Howard, includes Don Winton from Walt Disney Imagineering, who oversaw the studio during the production of *Mulan*; then Ken Dopher, head

of Finance and prior second in command to Winton; next came Mary-Kay Haseley, the original head of Human Resources for the Florida studio, notably responsible for hiring most of its crew. It was Haseley's HR department that expanded the original crew to feature size. After the tragic events of 9/11, Haseley left the Walt Disney Company and Andrew Millstein took over the position. Millstein had earlier been the general manager of Disney's Secret Lab, a postproduction facility once located in Burbank, and was tasked with shutting down that facility. Now he was put in charge of the Florida studio.

The political situation occurring within California's executive board also needs to be considered. Beyond the scope of the films and the public's reaction to them, an examination of these corporate politics helps clarify the final question in this discussion: Why did the Florida studio close? The year 2003 marked the beginning of a series of corporate upheavals upsetting the balance of power within the company. A year and a half after taking over from Peter Schneider (January 3, 2003), Thomas Schumacher also transferred to the theater division and was succeeded by David Stainton. Once head of Disney Television Animation, Stainton now served as president of the animation division.[68] At that time it was not known that the Florida studio would remain open for only twelve more months, although it soon became apparent that one of Stainton's assignments was to shut down the Orlando facility. It was as these developments unfolded that the tension between Roy E. Disney and Michael Eisner finally came to a head.

Roy E. had been executive producer on *Fantasia 2000* because he believed in continuing the scope of his family's achievements within the animated art form. He had succeeded in resurrecting an ailing animation division in the late 1980s and was single-handedly responsible for rescuing the short *Destino* (2003) from obscurity. (This highly surreal film was originally a collaborative effort begun in 1946 by Walt Disney and Salvador Dalí. Roy E. was responsible for putting the unfinished project back into production.[69]) By this time, Roy E. felt that Eisner had betrayed his family's trust and no longer respected that legacy. Additionally, the animosity that existed between Eisner's management and relations with other studios in the industry was affecting business practices. The harsh treatment (layoffs and pay reductions) within the animation division was more than the last Disney board member could stand. He vowed to bring down Eisner, just as he had brought him into the company. On November 30, 2003, Roy E. resigned from the executive board and, along with Stanley Gold, immediately established a campaign to "Save Disney."[70] This included a highly visible website, Savedisney.com, outlining Eisner's betrayal of the family trust. Roy E.'s abrupt departure from the company led to the eventual downfall of Eisner's management team less

than two years later (September 30, 2005).[71] As the last remaining Disney family member within the company, Roy E. had been Animation's biggest proponent on the executive board; his sudden departure was a severe blow to the artists, and they lost support in what they were trying to achieve.[72] With him gone, they no longer had a voice fighting for their rights and continued existence.

At the town hall meeting in Florida on November 14, 2003, production on the fourth feature, "My Peoples," was called to an immediate halt. The crew was told to stop working and go home.[73] There was no certainty when they would ever be called back into the studio. Paychecks came through each week, but Florida's crew was kept in the dark until an announcement was made just before the Christmas holidays that their services were no longer required, echoing events that had occurred at the California studio in 2002. Now it was unclear what future, if any, the Florida studio had. On January 13, 2004, a small notice in the *New York Times* announced that the Disney Company was closing the Florida facility and that the remaining 258 jobs would be terminated.[74] The final date for the working facility would be March 19, 2004, just weeks shy of the fifteenth anniversary of its opening.

After the *New York Times* announcement, the artists were allowed back onto the studio premises to pack up their belongings and, generously, create demonstration reels to screen for prospective employers.[75] In the weeks remaining, management allowed free use of all production facilities and technologies in order to update portfolios and showreels for finding new employment. Training sessions were offered to the crew in various three-dimensional programs (Maya, Flash, and Photoshop), making them more valuable in a 3D industry. The administration allowed rival animation studios to come to Florida to interview potential candidates for competitive positions—and management was not surprised at how quickly the crew was snapped up by an industry well aware of the caliber of talent located in the Sunshine State.

A few of Florida's artists transferred to the California studio, but many more moved on to respected names within the industry: Blue Sky, Dream-Works, Industrial Light and Magic, Pixar, and Sony Imageworks. (In 2004 Pixar was still a Disney competitor, particularly after the acrimonious split between the two companies. Michael Eisner and Steve Jobs disagreed on the exact terms of the distribution contract between the two studios.)[76] The final days of the Florida studio were a wake-up call to the devaluation of the artists who, only ten years earlier, had been feted as the cream of Disney's newest generation of animators. Twenty-year veterans were now experiencing the confusion of an industry that had not yet divined the complete overhaul

of the art form. It was a bewildering experience and caused a great deal of reevaluation as to whether to continue in the animation industry or instead follow other creative paths. Many of the artists elected to remain in Florida, having made a life there with their families, and worked freelance on various projects through their connections within the industry. Some opened small commercial studios, such as Project Firefly (now Premise Entertainment), with animator Dominic Carola as president and creative director.[77] Some of the staff went on to new careers in the arts and academia; others turned to completely different professions.

Being a multicultural industry, many of Florida's animators found employment at other studios around the world. The real tragedy was the shock of having the studio family torn apart and scattered to all corners of the globe. This crew had been working together continuously for almost fifteen years. They celebrated, argued, and raced for deadlines together as a close-knit family. Many of these artistic personalities felt angry and betrayed. Even now, years later, some of the artists still refuse to discuss the final days of the closing of the Florida studio. Although given the chance, a large number of them turned down the opportunity to participate in this project, as they felt their memories of the last days of the Florida studio were too painful to relive.

The New Magic of Disney Animation

The dissolution of the Florida studio can be linked to the computer, as it affected not only the viability of film production but attraction design as well. It was the increased popularity of computer-generated films that contributed to the deterioration of Feature Animation, thus leading to the demise of the Florida studio and its subsequent eviction from the theme park. The computer not only affected modern filmmaking techniques but also altered social behaviors due to the development of an expanded media consciousness. With the dawn of the new millennium, cell phones, email, and instantaneous information retrieval became everyday realities. The pervasive presence of the computer in modern functionality meant that simply watching the animators at work could no longer be considered entertainment. These emerging ideologies led to the development of a new kind of guest experience: the active participant seeking experiential activities within a theme park setting. This shift is evident in the final renovation of the Magic of Disney Animation, which focused more on the personal experience of the guests rather than educating them. Thus, we have seen that both the artists and their audience were subjected to a continuous state of technological advancement.

Over its lifespan the Magic of Disney Animation attraction went through three stages of development, all in reference to what was occurring on the opposite side of the glass. The original tour from 1989 was maintained, albeit with minor alterations, until production on *Mulan* was all but complete. In 1998 the construction of the new building required revisions to the tour's original itinerary. To accompany the ribbon-cutting ceremony of the new facility, the attraction received a facelift, incorporating new components within its tour. After the Florida studio closed in 2004, a final version of the attraction displayed the complete overhaul of its narrative, reflecting new philosophies in museological presentation integrated within its walls. This final transformation of the Magic of Disney Animation attraction lasted until its subsequent closure in the summer of 2015.

While new theories in audience entertainment are seen subtly influencing the attraction's renovation during the debut of the new building, they were not the only consideration when it came time for its total redesign. In reconstructing the attraction, WDI's designers took the opportunity to update its "edutainment" offerings while still capitalizing on the public's universal love for Disney's popular art form. The Magic of Disney Animation was now geared toward a more participatory experience. Interactive museum exhibitions were popular with the public and attracted far greater numbers of patrons. In response, WDI designers eliminated the dual-sided function of the original structure and altered the attraction to focus solely on the experience of the theme park guest, production no longer being a factor. Computers provided new ways of actively engaging the audience. In 1998 computers had only begun fulfilling this kind of participatory experience (for example, *Aladdin*'s Magic Carpet Ride in Epcot and *A Bug's Life* 3D-Experience in Animal Kingdom). By 2004, modifications to the Magic of Disney Animation's format made it more appealing to guests and reflected the public's increasing comfort level with computer technology.

The pervasiveness of computers engendered a new brand of entertainment—one that satisfied a shift in behavioral patterns by replacing the passive spectator with the active participant. The original Magic of Disney Animation tour had been operating in Florida for almost fifteen years with only one significant modification. But on February 8, 2001, a new kind of animation attraction debuted at Disney's new California Adventure theme park, and it was proving to be a more exciting, more personal experience for the guests.[78] California's animation attraction featured production-related activities for park guests to enjoy on their own. Workstations were available to entertain a more technologically savvy audience, one interested in experiencing animation processes firsthand. This proves that by 2003, guests visiting Disney's

Figure 5.9. The Florida studio character wall in the final renovation of the Magic of Disney Animation attraction. Source: Author photo.

theme parks, particularly younger guests, were comfortable with interactive computer displays. This familiarity translated into new kinds of acceptable entertainment that were now eagerly sought out by the paying public. By the fall of that year, plans were already under way at WDI for an extensive redesign and reconstruction of Florida's Magic of Disney Animation attraction using California's animation attraction as its model.[79]

When the Florida studio closed its doors in March 2004, the Magic of Disney Animation attraction was already closed for reconstruction. With the animators gone, WDI started tearing down walls, eliminating the glass partition, and creating a new open space within the venue. With the second entity eliminated, the Imagineers designed an area that retained the original animation theme, though all traces of actual production were gone. In its place was a new strategy of interaction and participation. The attraction emphasized the individual experience rather than focusing on a passive group encounter. With a few nods toward the building's original heritage, the Imagineers recreated the narrative seen in California's animation attraction.

This final redesign of the Magic of Disney Animation provides evidence of the Imagineers' response to new trends in museological displays made

feasible by computer technology. The attraction capitalized on the public's familiarity with computers through everyday transactions: at the bank, the grocery store, and the gas station. Most people had an email address, and mobile phones had long since replaced pagers for instantaneous communication. Compared with the changes described in the beginning of this chapter, where the animation tour was simply reconfigured and updated while retaining some of its original narrative elements, the new Magic of Disney Animation was designed to appeal directly to a computer-literate public who wanted to experience the animation process firsthand. Instead of being silent observers to the real-life drama of an animation studio in production, the fishbowl was opened up for guest exploration. The area featured multiple activities gleaned from the animation process. The Imagineers offered this experience predicated on the desires of many guests to create their own "magic." This concept had been explored earlier with the opening of Disney University, a campus once located next to the old Disney Village (now Disney Springs). Disney University's tag line was "Make Your Own Magic!" As part of the curriculum, the university had offered classes on animation drawing and cel painting to their guests.

The new Magic of Disney Animation attraction featured a tri-segmented format, which included a short film presentation, a play area within the fishbowl (which offered numerous character meet-and-greets), and a drawing experience known as Animation Academy. The original Theater Two now housed a multimedia show featuring a cast member interacting with an animated character. Much as with Winsor McCay and his *Gertie the Dinosaur* in 1914, guests witnessed a scripted conversation that fictionalized an encounter between a living person and an animated cartoon. Similar to the cast-member/artist interaction seen in the redesign after *Mulan*, this character encounter included a cast member talking to Mushu from *Mulan* and featured film segments with *Mulan*'s story supervisor, Chris Sanders, and Mushu's lead animator, Tom Bancroft. The experience illustrated the development of a major character and treated guests to a visual/verbal repartee between a living being and a cartoon, reminiscent of the interactions seen in *Who Framed Roger Rabbit*.

The public's appetite for computer-generated films coincided with the wish to experience these modes of entertainment firsthand, and the Imagineers were quick to supply all sorts of games, graphics programs, and personal encounters for the guests' enjoyment.[80] No longer roaming through sound-proofed glass corridors, park visitors were given free rein for hands-on activities highlighting differing facets from the "computerized" animation process. The main layout of the attraction was given over to spaces on both sides of

the glass, creating a multilevel play space. Guests wandered about the old production floor (the fishbowl), set up with several groupings of computer stations offering production-related experiences: characterization, dialogue, digital painting, and sound.

However, these computerized processes were more closely related to how CAPS improved two-dimensional film production in the 1990s rather than the three-dimensional world presented by Pixar. The Magic of Disney Animation displayed the role of the computer as it was first envisioned: as a supporting technology. Only simple programs could be made available to park guests, not the highly sophisticated proprietary software that required extensive training before resulting in production-quality images. The Imagineers filled the attraction with simple computer-graphics activities like painting a frame, adding dialogue, or conducting a soundtrack at stations that were easily accessible to young hands. These opportunities greatly enhanced the guests' sense of participation and satisfaction.

This version of the interactive attraction capitalized on growing familiarity with the computer, which was not yet as pervasive as it is today. In 2004 the computer was still a novelty; by today's standards, with an audience having grown up with computers, this type of attraction would come off as passé. Present cellular phone technology has advanced far beyond what the Imagineers could then offer guests. Thus, when reviewing facets of the computer-animation industry today, we would see qualities of modeling, rigging, shading, and lighting along with the addition of dialogue, sound effects, and score, better representing the qualities of three-dimensional production rather than what the Magic of Disney Animation offered in 2004.

A major bonus of the new attraction was the increased accessibility to character meet-and-greets. In staged areas throughout the open floor of the fishbowl, cast-member performers dressed as Disney's beloved characters lavished attention on each fan and their family. These encounters were devoted to making personal memories and providing younger guests with a unique individual experience, which often included an autograph and souvenir photograph as lasting mementos. The attraction capitalized on the timeless popularity of cartoon stars like Mickey and Minnie Mouse while also introducing new characters from the latest films in release, like *Tangled*, *Frozen*, and *Big Hero Six* (2014). This concept was so popular that it expanded into big business for the parks—seen, for example, in the Bibbidi Bobbidi Boutique in the Magic Kingdom, which caters to the small guest's experience and has transformed into a multimillion-dollar industry.[81]

At the other end of the new animation attraction, in the old Theater One, guests discovered another new activity: the Disney Animation Academy.

Instead of being set up for screening a film, this room was remodeled with an animation desk on a platform in front of a large screen with rows of continuous desks filling the rest of the auditorium. There, a cast-member/artist, reminiscent of the second Magic of Disney Animation tour, began a scripted show that taught guests how to draw a Disney character. Using simple lines and shapes, recalling an animator's structural sketch, guests were taken through a series of step-by-step instructions that often resulted in a portrait of Stitch, Winnie the Pooh, or Eeyore. Focusing on simple characters provided a happy outcome for everyone in the room. As guests exited the Animation Academy, they were encouraged to wander around the original Museum Gallery. (Coincidentally, the wall between the Animation Academy and Museum Gallery featured character sketches from all three of Florida's feature films, a subtle nod to its Florida studio origins.) The Museum Gallery was little changed; it still contained its golden Oscar statuettes and featured exhibitions of curated artworks from the latest Disney releases. And to one side, the hallway exiting the attraction deposited guests into the Animation Gallery gift shop.

This last incarnation of the Magic of Disney Animation attraction was a large departure from the Imagineers' original concept of introducing the animation pipeline to the general public. Although the process of cel animation was no longer being demonstrated, neither was the current animation pipeline. There was very little left of Walt's wish to draw back the curtain and reveal the mystical processes of animation production. Ultimately, not even this manifestation of the Magic of Disney Animation survived. Eleven years later, on July 15, 2015, the attraction closed forever, demonstrating that even with the restructuring of the attraction, it was vulnerable to changing cultural trends.[82] Nostalgia for classic Hollywood style gave way to new offerings from the action/adventure genre, emphasizing the increasing popularity of the Disney Company's Pixar, Marvel, and Star Wars franchises. Less than six months after the Magic of Disney Animation closed, a new attraction debuted within the same space: the *Star Wars* Launch Bay (December 4, 2015).[83] This new attraction retains the appeal of a personalized guest experience, featuring meet-and-greets with various *Star Wars* characters and exhibiting a variety of costumes, props, artwork, and related items from past and current productions of the franchise (much like the Magic of Disney Animation's original museum lobby).

The Disney Hollywood Studios theme park has undergone an even more extensive transformation, as several original attractions were closed in preparation for *Toy Story* Land, which opened in 2018, and *Star Wars*: Galaxy's Edge, which opened in 2019 and includes new rides Millennium Falcon:

Smuggler's Run and *Star Wars*: Rise of the Resistance. The Great Movie Ride was replaced with Mickey and Minnie's Runaway Railway. With this rebranding, the theme park has moved beyond its original concept to stay current with, and appeal to, changing cultural trends. This rebranding of an entire theme park is evidence that marketing theories about what creates successful entertainment value consistently drive what is offered to the ticket-buying public.

Postscript

In 2003–2004 the Walt Disney Company was going through a tremendous period of transformation. At the annual shareholders' meeting after Roy E. Disney's departure in 2003, representatives voted against Michael Eisner's maintaining control of the company, and shortly thereafter he elected to leave at the end of his current contract. Tensions lasted until Eisner's final departure on September 26, 2005.[1] With that came the re-staffing of the company's executive board, including the installation of Robert Iger as chairman and chief executive officer.[2] Roy E. had already reconciled with the company earlier that summer, returning to the executive board, and on August 7, 2005, he dismantled the Savedisney.com website.

In an afterword written in 2006, James B. Stewart describes the final transition of corporate power from Eisner to Iger.[3] He notes that any previous difficulties in relations with other industry participants were now smoothed over and that the company had rebounded tremendously with the stunning acquisition of Pixar on January 24, 2006, including the addition of Steve Jobs to the executive board.[4] The acquisition of Pixar and the subsequent reorganization of the creative management team, bringing on board Edwin Catmull and John Lasseter, played a vital role in the phoenix-like rebirth of the Walt Disney Animation Studio and its successful return to critical and financial success.[5] Since then, Walt Disney Animation Studios has seen a huge resurgence of award-winning films, including *Tangled*, *Frozen*, *Big Hero Six*, *Zootopia*, and *Moana*. The studio also succeeded in reinventing Mickey Mouse in 3D, reverting back to his original 1920s design, beginning with the short *Get a Horse* (2013).[6]

As the Walt Disney Animation Studio moves through the first quarter of the new millennium, 3D continues to be the most popular method of producing animation. However, there is a growing nostalgia, expressed by the artists and the audience, for hand-drawn animation, which the latest advancements in computer technology make possible.[7] Outside of Disney, independent projects are being produced that would return to hand-drawn animation, albeit replacing pencil and paper with stylus and tablet.[8] It remains up to the animators, directors, and producers to convince management that this method of creating entertaining films is once again a viable option for theatrical release. For my part, I encourage this return, a new renaissance, to hand-drawn animation that displays a combination of superb draftsmanship and computing capabilities, acting once more in service to the human touch.

The Place of CAPS within the Disney Renaissance

The Disney Renaissance was a time of extreme creativity enhanced by spectacular technological advancement. The Florida studio provides a model of what was taking place in Disney's larger California studio during this second golden age. This infusion of new technology, affecting both 2D and 3D production, takes up where the advancements of Walt Disney's multiplane camera left off, giving the artists fewer limitations and greater dimensionality than was ever possible using traditional cel animation methods. My discussion of the CAPS program shows how the computer was first envisioned in a supporting role to animation production. Examples from the Florida studio's filmography confirm my belief that CAPS should be considered a successful prototype in the integration of the computer into the animated art form, and that the Renaissance films may be seen as evidence of an incredible transformation taking place: the move from traditional materials to digital information or, as I have termed it, the movement from *mechanization* to *computerization*. It is especially important to credit Roy E. Disney as the company's leading advocate for the introduction of new technology to the traditional animation process. He had the foresight to realize his family's company had a vested interest in reviving the animation division and followed his uncle Walt's example of incorporating cutting-edge technology into the films to make them more appealing to contemporary tastes.

Many animation historians analyze and interpret the art form through a series of sociological filters such as formalism, Marxism, feminism, and gender studies. In my research I prefer to document developments taking place during specific periods of production that display cultural growth due

to technological advancement, reflected in new aesthetic visions brought to the screen. I believe these factors have a direct and significant impact in how artistic trends are received by the ticket-buying public. For this reason, I stress the recognition of CAPS, since it demonstrates a human—computer collaboration that amplified and enhanced traditional methods of handcrafted artwork before the complete immersion into digital imagery. Contemporary literature provides scant information about the program's role in the creation of these now "Classic Disney" films, but the software has been acknowledged by some of today's most insightful animation scholars, notably Chris Pallant, Tom Sito, and J. P. Telotte.[9] However, a detailed investigation of its properties is still lacking (and, unfortunately, that is beyond the scope of this work). In any case, I believe CAPS was one of the primary factors that enabled the Disney Renaissance to occur.

While animation is an art form, it is also a business. The creation of animated films costs substantial amounts of money, time, talent, and technology. Therefore, upper management has to trust that the artists are capable of bringing bankable entertainment to fruition and that the films will return a sizable profit on their investment. When the Disney Renaissance films stopped making enormous sums of money, and instead box office receipts flowed toward a different production technique, management concluded that the reason was their technological appeal rather than narrative and formulaic repetition. That is what makes the loss of the Florida studio so poignant, in that it demonstrates this lack of faith in traditional hand-drawn animation. But were they right? Today 3D animation is the most dominant method in the industry, evidenced by the films being released by Blue Sky, Dream-Works, Pixar, and a rejuvenated Walt Disney Animation Studio. However, even computer-generated films are quickly becoming passé as their visual aesthetic begins to look the same from one studio to the next. (Often the general public doesn't know the difference, nor do they care.) Another factor is that these computer-generated releases also face stiff competition from live-action films, whose groundbreaking visuals are created through a conflation of 3D effects and virtual environments with living actors and minimal sets. The line between live action and animation has noticeably blurred as the latest action/adventure films are often more computer generated than not.

The Legacy of Walt Disney Animation's Florida Studio

This book is the history of a unique animation facility, a two-sided structure that showcased Walt Disney Feature Animation Florida operating within

the Magic of Disney Animation attraction at the Disney-MGM Studios in Orlando, Florida. During its fifteen-year lifespan (1989–2004), this studio/attraction grew in status from being merely theme park entertainment to becoming an important contributor to the films of the Disney Renaissance. This period displays significant technological and cultural changes taking place around the end of the twentieth century. My purpose in chronicling this small satellite of Disney's main California studio is so that it will not be forgotten in the annals of animation history. It serves as a case study for how computer technology came to have a significant impact on the human experience. By situating the Florida studio within this time of technological advancement and its unique circumstance of being part of one of the largest entertainment complexes on earth, it deserves to be remembered as a singular example within a period of dramatic change in the human condition.

It is my intention that this account of the Florida studio's contribution to Disney's animation legacy will be invaluable to future scholars both technologically and sociologically.[10] Using primary sources—the oral histories from the men and women who actually experienced this transformation—this book provides an intimate eyewitness account of a unique place and time in animation production. But the Florida studio should also be remembered for the particular sociological makeup that it engendered, creating an unusually strong familial bond between the people who worked there that exists to this very day. In the years since the Florida studio closed its doors, many of its artists and support personnel have moved on to different studios, different countries, or have left the animation industry altogether. A growing number of these artists have passed away since the studio shut down, including Kip Stone (d. 2009), Kevin Proctor (d. 2010), Pres Romanillos (d. 2010), Robert Walker (d. 2015), Marty Altman (d. 2016), Christine Lawrence Finney (d. 2016), Bill Haas (d. 2018), and even Roy E. Disney (d. 2009). I present this work as a testimony to their creative virtuosity, acknowledging the legacy they have left behind for future generations.

Documenting this history is equally fitting as, decades later, hand-drawn animation has become increasingly rare in the face of the highly popular and successful forays into computer-generated imagery. As an author, artist, academician, camera operator, and scene planner, I am encouraged to see how computer technology is finally catching up with the pencil, allowing hand-drawn animation to be created once more, this time using stylus and tablet. Now that the initial novelty of 3D has worn off, there is a growing nostalgia for hand-drawn animation once more, as evidenced by Glen Keane's independent projects *Duet* (2014) and *Dear Basketball* (2017), both of which emphasize traditional line work supported by a computerized founda-

tion.[11] This ability to draw on a digital tablet brings back the look and feel of two-dimensional animation. At this moment new projects are being funded, based in 2D animation, hoping to make a comeback and once again win the approval of the ticket-buying public.[12]

Thus, this book is a testament to the Florida studio's legacy through anecdotes from its staff, a survey of the ever-widening scope of its projects and its lasting contributions to the Disney filmography. It recognizes this studio/attraction as a singular experiment in animation history, existing as the public persona of Walt Disney Feature Animation during the growth, peak, and subsequent decline that was the Disney Renaissance. The closing of the Florida studio was a tragic event in the hearts of artists and fans alike. On the final day of the Florida studio's closure, as the artists packed up their desks and exited through the atrium one last time, a sign was placed in the hallway to let them know they were not entirely forgotten:

> Thank you for your talent, passion, and dedication, for making us feel like family and allowing us to share in the magic of animation with you. We wish you and your families the best.[13]

Notes

Introduction

1. Robert D. Feild, *The Art of Walt Disney* (New York: Macmillan, 1942). See also Robert Durant Feild, "Lecture by Professor Robert Feild of Harvard University" (transcript, Las Palmas Theatre, Hollywood, August 9, 1938). The papers of Robert Durant Feild (1939–1972) are preserved at the Archives of American Art (http://www.aaa .si.edu/collections/robert-durant-feild-papers-6405), including a photograph featuring Leopold Stokowski, Walt Disney, and Robert Feild, dated circa 1940 (http:// www.aaa.si.edu/collections/items/detail/leopold-stokowski-walt-disney-and-robert -feild-16968).

2. Bob Thomas, *Disney's Art of Animation: From Mickey Mouse to Hercules* (New York: Hyperion, 1997). The first edition of *Disney's Art of Animation* debuted with *Sleeping Beauty* in 1959, but the book has since been updated and released by the company to include later films. The author's copy was released at the time of *Hercules*.

3. Howard Beckerman, email to the author, April 10, 2011. The Stern Brothers department store, at that time, was on 42nd Street, across from the New York Public Library.

4. Written years after their retirement from the company, animation artists like Mark Davis, Joe Grant, Ollie Johnston, Floyd Norman, Walt Stanchfield, and Frank Thomas shared their expert skills, memories, and advice from their years of working at the Disney Studios during the first golden age.

5. The Disney Studios and Archives have been opened to a variety of writers—including David A. Bossert, Christopher Finch, Howard Green, Stephan Rebello, and animation producer and filmmaker Don Hahn—who present the artwork and narrative unique to each production.

6. Ralph Bakshi Productions can be said to be the antithesis of Disney's family fare. Bakshi's work received more notoriety than box office share.

7. Frank Thomas and Ollie Johnston, *Disney Animation: The Illusion of Life* (New York: Abbeville Press, 1981).

8. George Silfianos, "The Definition of Animation: A Letter from Norman McLaren," *Animation Journal* 3, no. 2 (1995): 62–66.

9. Edward Small and Eugene Levinson, "Toward a Theory of Animation," *Velvet Light Trap* 24 (Fall 1989): 67.

10. Chris Pallant, *Demystifying Disney* (London: Continuum, 2011); Tom Sito, *Moving Innovation: A History of Computer Animation* (Cambridge: MIT Press, 2013); J. P. Telotte, *The Mouse Machine: Disney and Technology* (Urbana: University of Illinois Press, 2008); and J. P. Telotte, *Animating Space: From Mickey to* Wall-E (Lexington: University of Kentucky Press, 2010).

11. Pallant, *Demystifying Disney*, 89.

12. Mark Langer, "Regionalism in Disney Animation: Pink Elephants and Dumbo," *Film History* 4, no. 4 (1990): 305–321.

13. Telotte, *Animating Space*, 179.

14. Ibid.

15. Pallant, *Demystifying Disney*, 89.

16. *Walt Disney's Disneyland*, season 4, episode 3, "Adventure in Wildwood Heart," directed by Hamilton Luske, aired September 25, 1957, on ABC, http://www.imdb.com/title/tt0904315/?ref_=fn_al_tt_1. The series has had numerous names, most recently *The Wonderful World of Disney*.

17. Jim Carchidi, "Star Wars Launch Bay Opens at Disney's Hollywood Studios," *Orlando Business Journal,* December 1, 2015. At the time of my initial research, the Imagineers were once again using structural information about the attraction's building to aid in the complete redesign for its new role as the *Star Wars* Launch Bay. It opened on December 1, 2015.

18. Valliere Richard Auzenne, *The Visualization Quest: A History of Computer Animation* (Rutherford, NJ: Fairleigh Dickinson University Press, 1994); Peter Weishar, *CGI: The Art of the 3D Computer-Generated Image* (New York: Harry N. Abrams, 2004). Auzenne's book showcases the early pioneers in computer-generated animation, while Weishar's covers the full blossoming of the art form, in particular the emergence of Blue Sky Studios in New York.

19. Werner Weiss, "Disney-MGM Studios: The End of the MGM Name," *Yester Studios at Yesterland.com* (July 2016), http://www.yesterland.com/mgm-end.html. In a well-illustrated online article, Weiss discusses the park's name change from the Disney-MGM Studios to Disney's Hollywood Studios on January 7, 2008. At the time of this writing, Disney's Hollywood Studios is in the process of being rebranded to capitalize on the Disney Company's newer, more popular acquisitions: Pixar Animation Studios, Marvel Entertainment, and the *Star Wars* franchise. This will transform the old Hollywood filmmaking theme into a new action-packed tourist destination.

Chapter 1. A Theme Park Attraction

1. David A. Bossert, *Remembering Roy E. Disney: Memories and Photos of a Storied Life* (New York: Disney Editions, 2013); Kim Masters, *The Keys to the Kingdom: How Michael Eisner Lost His Grip* (New York: HarperCollins, 2000); James B. Stewart, *Disney War* (New York: Simon and Schuster, 2005).

2. Stewart, *Disney War*, 47–49. Michael Eisner and Frank G. Wells were brought on board by Roy E. Disney in 1984 after Disney went into partnership with Bass Brothers Enterprises to stave off a hostile takeover bid by Saul Steinberg. In turn, Eisner brought his right-hand man, Jeffrey Katzenberg, with him from Paramount Pictures.

3. Stewart, *Disney War*, 53–58. For more information on Roy E.'s role as director of Walt Disney Feature Animation, see also Don Hahn, dir., *Waking Sleeping Beauty*, Red Shoes and Stone Circle Pictures, 2009, DVD; Walt Disney Studios Home Entertainment, 2010.

4. Sito, *Moving Innovation*, 226; Stewart, *Disney War*, 55.

5. Bossert, *Remembering Roy*, 139–43; "Alvy Ray Smith Receives the First Check for $1m to Pixar from Disney in 1986," *Pixar Animation Studios*, http://alvyray.com/Pixar/FirstDisneyCheckToPixar.htm; "Confidential Disney Project: Executive Summary: The CAPS Project," *Alvyray*, http://alvyray.com/Pixar/documents/CAPS_ExecSummary_AlvyToPixar_4May86.pdf. Roy E. convinced Eisner and the executive board to fund a collaboration between Disney's technology team and Pixar. In a confidential document (on Alvyray.com), dated May 24, 1986, terms were laid out between the two companies for the CAPS Project. The total cost would be $3.9 million. Frank Wells presented the first payment of $1 million to Pixar; this was a key factor in keeping the young company afloat until their computer-animated films gained momentum.

6. Stewart, *Disney War*, 76–78. Eisner sought to associate himself with Walt Disney by taking on the role of host on the Sunday evening television show ABC's *Wonderful World of Disney*. He spent time in front of the cameras becoming the company's new spokesperson promoting the company and its product. The *Wonderful World of Disney* had two hosts during its run: Michael Eisner and Drew Carey. The series was in production from 1997 through 2005.

7. Masters, *Keys to the Kingdom*, 175; Susan G. Strother, "Universal Delays Park Opening Date Pushed to June," *Orlando Sentinel* (January 31, 1990), http://articles.orlandosentinel.com/1990-01-31/news/9001313239_1_universal-studios-theme-park-studios-florida. Although MCA purchased the land in Orlando in 1982, they did not proceed with construction until many years later. After delays and numerous mechanical problems, Universal Studios Florida finally opened on June 7, 1990. In response to Eisner's earlier announcement, a media war broke out between the two companies, reaching its zenith between the opening of the Disney-MGM Studios (May 1, 1989) and Universal Studios Florida (June 7, 1990).

8. Masters, *Keys to the Kingdom*, 169; Lisa Fritscher, "It Was Universal Orlando's Darkest Day, and I Was There to See It," *Theme Park Tourist*, August 12, 2015, http://www

.themeparktourist.com/features/20150806/30467/opening-day-universal-studios -florida-inside-perspective. As Masters writes, "Eisner was clearly eager to make his mark on the parks. . . . Soon he 'was ordering new projects like they were new movies.'" There has been speculation about where Eisner came up with the original idea for the Disney-MGM Studios theme park, as he had previously worked at Paramount Pictures and had access to their parent company MCA's plans and designs. Many authors make the point that Disney's third theme park was rushed together in order to beat the opening of Universal Studios Florida, which debuted just over a year later in June 1990.

9. Jeffrey Schmalz, "Nastiness Is Not a Fantasy in Movie Theme Park War," *New York Times*, August 13, 1989, http://www.nytimes.com/1989/08/13/us/nastiness-is-not-a -fantasy-in-movie-theme-park-war.html; Todd James Pierce, "Disney-MGM Studio Backlot in Burbank—Part 1," *Disney History Institute*, February 22, 2016, http://www. disneyhistoryinstitute.com/2016/02/disney-mgm-studio-backlot-in-burbank-part-1 .html.

10. Drew Taylor, "How *The Great Mouse Detective* Kick-Started the Disney Renaissance," *Oh My Disney,* September 18, 2015, http://blogs.disney.com/insider/2015/09/18/ how-the-great-mouse-detective-kick-started-the-disney-renaissance/.

11. Robert Zemeckis, *Who Framed Roger Rabbit*, Touchstone Pictures, Amblin Entertainment, and Silver Screen Partners II, 1988, 25th Anniversary Edition Blu-ray; Buena Vista Home Entertainment, 2013. Bonus Materials on this Blu-ray edition include the documentary "Behind the Ears: The True Story of Roger Rabbit." Footage is shown of veteran British animator Richard Williams, who directed the animated segments of the film in a separate production unit based in London.

12. Max Howard, interview by author, Lake Arrowhead, California, July 3, 2014. Years later, another film combining live action and animation was produced by Warner Bros. Feature Animation: *Space Jam* (1996). For examples of earlier combinations of live action and animation, see the Warner Bros. gem *Anchors Aweigh* (1945), where Gene Kelly dances with Jerry Mouse of MGM fame, as well as Disney's own *Mary Poppins* (1964).

13. Donald Crafton, *Before Mickey: The Animated Film, 1898–1928* (Chicago: University of Chicago Press, 1982), 17–18. Jay Stewart Blackton, Émile Cohl, and Georges Méliès began their film careers by learning and exploiting these secrets to entertain the public. This secrecy was particularly important in the subsequent race to the patent office.

14. On the other hand, Winsor McCay showed his audiences the materials associated with the animation process in the live-action segments of his film *Gertie the Dinosaur* (1914), displaying towering reams of paper and barrels of ink. While he did not demonstrate the actual process, he did make it clear that there was a practical method to creating animation.

15. For literature, see the academic work of Robert Feild and the company-sponsored edition by Bob Thomas. Walt's influences included a how-to volume by E. G. Lutz. Museum exhibitions include MoMA's *Fantastic Art, Dada, Surrealism* (MoMA

Exh. #55, December 7, 1936–January 17, 1937); *Disney's Animations and Animators* (Whitney Museum of American Art, June 24–September 6, 1981, https://archive.org/details/disneyanimations628unse); and MoMA's *Designing Magic: Disney Animation Art* (MoMA Exh. 1716, June 10–September 12, 1995, https://www.moma.org/momaorg/shared/pdfs/docs/press_archives/7358/releases/MOMA_1995_0038_32.pdf ?2010).

16. Museum of Modern Art, "Designing Magic: Disney Animation Art" (press release, May 1995), under "Designing Magic," http://www.moma.org/momaorg/shared/pdfs/docs/press_archives/7358/releases/MOMA_1995_0038_32.pdf?2010. Walt Disney was honored to be included in the 1936 milestone exhibition *Fantastic Art, Dada, Surrealism*. More recent exhibitions on animation include 1995's *Designing Magic: Disney Animation Art*; *Pixar: 20 Years of Animation* (December 14, 2005–February 6, 2006); and *Tim Burton* (November 22, 2009–April 26, 2010). Museum exhibitions are held internationally as well, the most recent being *Disney: The Art of Storytelling* exhibition at the Caixaforum in Madrid, Spain (July 19–November 4, 2018).

17. The term "Disneyfication" is found in the *Merriam-Webster Dictionary*. It is defined as "the transformation (as of something real or unsettling) into carefully controlled and safe entertainment or an environment with similar qualities." See also Alan Bryman, *The Disneyization of Society* (London: SAGE Publications, 2004).

18. *Walt Disney Treasures: Behind the Scenes at the Walt Disney Studio*, DVD (Walt Disney Home Video, 2003), disc 1. Two examples of this type of documentary are found on this DVD.

19. Ibid. The RKO featurette *A Trip through the Walt Disney Studios* was produced in July 1937.

20. Steven Watts, *The Magic Kingdom: Walt Disney and the American Way of Life* (Columbia: University of Missouri Press, 2001), 164–66. See Watts's discussion of *The Reluctant Dragon*.

21. Watts, *Magic Kingdom*, 165.

22. "Edutainment," *Oxford Online Dictionary*, http://www.oxforddictionaries.com/us/definition/american_english/edutainment. "Edutainment" is a term formed by the combination of "entertainment" and "education," used as a catchphrase when discussing the qualities of a theme park attraction. The word is recognized as an actual term in the entertainment industry. The *Oxford Online Dictionary* describes the term as originating during the 1980s, coinciding with the arrival of Michael Eisner at the Disney Company.

23. *Walt Disney Treasures: Behind the Scenes at the Walt Disney Studio*, disc 2.

24. Ibid.

25. Ibid.

26. Clyde Geronimi, Wilfred Jackson, and Hamilton Luske, dirs., *Alice in Wonderland*, Walt Disney Productions, 1951; *Alice in Wonderland: 60th Anniversary Edition*, Blu-ray, Walt Disney Studios Home Entertainment, 2011, disc 2. "One Hour in Wonderland" and "Operation Wonderland" were two television specials used by Walt Disney to promote the upcoming release of *Alice in Wonderland*. "One

Hour in Wonderland" aired on December 25, 1950 (http://www.imdb.com/title/tt0251912/?ref_=fn_al_tt_1), and "Operation Wonderland" aired on the *Ford Star Revue* on June 14, 1951 (http://disney.wikia.com/wiki/Operation_Wonderland and http://www.imdb.com/title/tt0915467/?ref_=ttrel_rel_tt). *Alice in Wonderland* premiered on July 26, 1951 (http://www.imdb.com/title/tt0043274/?ref_=nv_sr_2).

27. Hahn, *Waking Sleeping Beauty*, DVD, Bonus Features. See Randy Cartwright's interview on the DVD.

28. Telotte, *Mouse Machine*, 119; Watts, *Magic Kingdom*, 384–85.

29. Watts, *Magic Kingdom*, 384–85. The memo is dated August 31, 1948.

30. Ibid., 113–15. Walt sought to elevate animation as a form of high art. By revealing "the magic," the audience might realize the complex process and multiple talents required to bring the characters to life. See also Robert Feild's *Art of Walt Disney*.

31. Watts, *Magic Kingdom*, 384–85.

32. This two-zone system was used in other filmmaking attractions in the park—for example, the Backstage Studio Tour: Parts 1 and 2. The Backstage Tour initially opened next door to the Magic of Disney Animation. The attraction was based on live-action film production and contained soundstages, recording studios, water tanks, sound effects labs, and the Roy O. Disney Post Group. Subsequent redesigns of the Magic of Disney Animation caused the Backstage Studio Tour entrance to be relocated to another section of the park.

33. Pam Darley, interview by author, Orlando, Florida, April 27, 2015. This information comes from a press packet distributed during the Disney-MGM Studios opening day celebration.

34. Howard interview, July 3, 2014; Sarah Cole, Annette Gayle, and Rosemary Healey, interview by author, Winter Garden, Florida, November 10, 2013. In the late 1980s, most of Disney's animation production was moved off the main studio lot and into warehouses in the Glendale district. (See the "1420 Flower Street" commemorative video (available at https://www.youtube.com/watch?v=8GUGmScqe3g).

35. Kay Salz was the director of the ARL at the time of the opening of the Magic of Disney Animation. She and her team were in constant communication with Max Howard and his staff, providing high-quality exhibition materials for the museum lobby. While the Florida studio was operating, Disney's Animation Research Library was headed by Kay Salz and later Lella Smith. The ARL is currently directed by Mary Walsh.

36. Tamara Khalaf, email message to author, August 24, 2016. A staff member of the Animation Research Library, Khalaf stated that the ARL was unable to display the original artworks due to security issues and climate conditions within the gallery space. She added that the Oscar statuettes were approved reproductions provided to the company by the Academy of Motion Picture Arts and Sciences.

37. Ibid.

38. Rich Proctor, "Pictures That Move People—BRC and the Magic of Disney Animation," BRC Imagination Arts (July 15, 2015), under "BRC, News, Blog, Film," http://brcartsblog.com/2015/07/15/pictures-that-move-people-brc-and-the-magic

-of-disney-animation/. *Back to Neverland* was produced by BRC Imagination Arts, a company run by independent producer Bob Rogers. In collaboration with WDI, the film was directed by Jerry Rees and produced by Bob Rogers and George Wiktor. Procter's article was released on the day the Magic of Disney Animation attraction closed at the Disney's Hollywood Studios.

39. A portfolio of theme park, corporate, and industrial venues can be found on the BRC Imagination Arts website: http://www.brcweb.com/.

40. Rita Street, "BRC Imagination Arts," *Animation World,* November 1, 1996, under "BRC Imagination Arts AWN," http://www.awn.com/animationworld/brc -imagination-arts.

41. Ibid.

42. Sharon Vincent, interview by author, Davenport, Florida, October 10, 2015. This image is from a commemorative limited edition cel created by the ink and paint department at the Florida studio. Vincent was a lead in that department.

43. The *Disney-MGM Studios Guidebook* (1989) was provided to guests by the Eastman Kodak Company. Stephen M. Fjellman, *Vinyl Leaves: Walt Disney World and America* (Boulder, CO: Westview Press, 1992), 290–91. The *Neverland* vignettes illustrated many of these departments along the animation pipeline. The *Disney-MGM Studios Guidebook* mentions some, but not all, of these departments. Fjellman takes his information for *Vinyl Leaves* from the *Disney-MGM Studios Guidebook*. An internal welcome packet given to each new studio crew member explained each department's function within the animation pipeline.

44. Jim Jackson, "The Magic of Disney Animation 1990," Walt Disney Feature Animation Florida: A Collection of Images and Movies from an Unforgettable Time, http://www.wdfaf.com/. This film was created as an orientation video for cast members working in the Magic of Disney Animation attraction.

45. Jim Korkis, "The Story behind Back to Neverland," *MousePlanet*, June 15, 2016, https://www.mouseplanet.com/11434/The_Story_Behind_Back_to_Neverland.

46. Street, "BRC Imagination Arts."

47. Jackson, "Magic of Disney Animation 1990." Max Howard hosts the video.

48. Byron Howard and Jay Shindell are only two of the Magic of Disney Animation cast members who committed to making animation their life's work. Howard advanced to become an animator at the Florida studio and is still with Disney Animation as one of their leading directors. Shindell became a production assistant and moved into visual effects. He is part of Max Howard Consulting Group and lectures at schools around the world.

49. Bob Rogers, email message to author, August 17, 2016. This film was also created by the BRC team.

50. Jackson, "Magic of Disney Animation 1990."

51. Jeffrey Pepper, "The Disneyland Art Corner," *2719 Hyperion*, February 23, 2009, http://2719hyperion.blogspot.com/2009/02/disneyland-art-corner.html.

52. Ibid. The Disneyland Art Corner "began as a temporary location in a striped tent just off the hub near the Red Wagon Inn, when Disneyland opened on July 17,

1955. After work on Tomorrowland was completed later that summer, the Disneyland Art Corner opened there in a new, permanent location on September 5, 1955."

53. Ibid.

54. Ibid.; Courvoisier Galleries, "History," (2016), under "Courvoisier Galleries History," www.courvoisiergalleries.com/faq.html.

55. Pepper, "Disneyland Art Corner"; Courvoisier Galleries website. The Courvoisier Galleries offered original Disney cel setups from 1937 through 1967. Today many galleries offer painstakingly accurate reproductions of many well-known images for sale.

56. Sharon Vincent, email to the author, Davenport, Florida, February 14, 2016.

57. Sotheby's, *The Art of* Who Framed Roger Rabbit (New York: Sotheby's, 1989), and Sotheby's, *The Art of* The Little Mermaid (New York: Sotheby's, 1990). These two exhibition catalogs display the imagery and estimated purchase prices for the artwork put up for auction.

58. Drawings, blueprints, and elevations from the art library at Imagineering's IRC are dated from 1985 through 1989 and beyond. The latter material was created as the attraction underwent renovation several times during its existence.

59. Marty Sklar, *One Little Spark! Mickey's Ten Commandments and the Road to Imagineering* (White Plains, NY: Disney Editions, 2015), 11–12. Sklar (1934–2017) was a long-standing member and eventual head of WDI over a fifty-three-year career with the company. He published the Imagineering method of ten steps, known as Mickey's Ten Commandments, for the successful design of a theme park attraction.

60. Internet Movie Database (hereafter, IMDb), "Walt Disney's Wonderful World of Color" (1954–1992), under "Wonderful World of Disney," http://www.imdb.com/title/tt0046593/. The original *Disneyland* television series began on October 27, 1954, and ran through 1966. The *Mickey Mouse Club* series ran from 1955 through 1958.

61. Roy E. Disney, *The Magic of Disney Animation, Premiere Edition* (White Plains, NY: Hyperion, 1989). This small booklet was distributed at the Animation Gallery to guests visiting the attraction during the first few months of the attraction's opening.

62. Howard interview, July 3, 2014.

63. Many of the original attractions in the Magic Kingdom, such as Snow White's Scary Adventure, Mr. Toad's Wild Ride, and 20,000 Leagues Under the Sea, have been replaced by newer attractions featuring an updated experience or capitalizing on more recent film releases.

64. Telotte, *Mouse Machine*, 118; Scott Bukatman, *Matters of Gravity: Special Effects and Supermen in the 20th Century* (Durham, NC: Duke University Press, 2003), 28.

65. Telotte, *Mouse Machine*, 118; Bukatman, *Matters of Gravity*, 2.

66. Sklar, *One Little Spark*, 72–73. Mickey's Ten Commandments are (1) Know your audience; (2) Wear your guest's shoes; (3) Organize the flow of people and ideas; (4) Create a "Wienie" (visual magnet); (5) Communicate with visual literacy; (6) Avoid overload—create turn-ons; (7) Tell one story at a time; (8) Avoid contradictions—maintain identity; (9) For every ounce of treatment, provide a ton of treat; and (10) Keep it up.

67. Elliot Bour, interview by author, Burbank, California, June 26, 2014.

68. Rosemary Healy, interview by author, Winter Garden, Florida, November 10, 2013.

69. Bour interview, June 26, 2014; Frank Gladstone, interview by author, Burbank, California, July 1, 2014. Gladstone headed the internship program for many years before leaving to join Max Howard when the latter became president of the new Warner Bros. Feature Animation unit.

70. Watts, *Magic Kingdom*, 390–91.

71. Ibid., 391.

72. Howard interview, July 3, 2014.

73. Ibid.

74. While these stipulations were true for the animation crew, it might be asked whether this dual-identity experience was the same for any of the live-action attractions at the Disney-MGM Studios: Wardrobe, Soundstages 1 and 2, and the Special Effects Water Tank. At the time of this writing, many of the Disney dress codes have since been altered to reflect new styles of social taste and acceptance.

75. Catherine Hinman, "Ed McMahon Will Search for Stars at Disney-MGM," *Orlando Sentinel*, May 12, 1992, under "Names and Faces," http://articles.orlando sentinel.com/1992-05-12/news/9205120404_1_ed-mcmahon-disney-mgm-current -stars. *Star Search*, starring Ed McMahon, moved from Los Angeles to Walt Disney World in 1992. He stayed with the show until 1995. A photograph of the newest Mouseketeers (1993–1995), including Christina Aguilera, Britney Spears, and Justin Timberlake, can be found at https://christinaaguilera.fandom.com/wiki/The_Mickey_Mouse_Club. *The All-New Mickey Mouse Club* was in production at the Disney-MGM Studios from 1989 through 1995. Other live-action projects included the television miniseries *From the Earth to the Moon* (1998) and taped segments of the popular game shows *Jeopardy*, *Let's Make a Deal*, and *Wheel of Fortune*.

76. Matt Garbera and Barbara Poirier, interview by author, Lake Buena Vista, Florida, November 9, 2013. This sign really did sit in the lower corner of one of the windows (near Kevin Turcotte's desk) and got quite a few laughs from the guests and cast members. The cast members and crew developed a sort of sign language that they used to communicate through the glass.

77. Bour interview, June 26, 2014. Bour has a long and successful career at Disney, moving up the ranks to animator, story artist, and eventually to supervising director and coproducer of the award-winning television series *Elena of Avalor*.

78. Philo Barnhart, email to the author, March 15, 2019. Barnhart was an assistant animator on *The Secret of NIMH* (1982), *The Black Cauldron* (1985), and *Beauty and the Beast*. He was part of the character design team for Ariel on *The Little Mermaid*. Barnhart is second-generation Disney and has been in the industry for over thirty years. He now makes special guest appearances at animation conventions all over the world.

79. Darley interview, April 27, 2015.

80. Tony Bancroft, interview by author, Pasadena, California, June 30, 2014.

81. Howard interview, July 3, 2014.

82. Rachele Lord, interview by author, St. Cloud, Florida, December 9, 2015. Tim O'Donnell was production manager at the time and notified park officials to pick up the errant animators from the Backlot Tour. Lord remembers that Tad Gielow was the ringleader of the group.

83. Howard interview, July 3, 2014.

84. Ibid. Howard left the Florida studio for a position in California's upper management. Months later, he left to head the new division of Warner Bros. Feature Animation. After Warner Bros. closed that division, Howard went to work for Jeffrey Katzenberg at DreamWorks Animation. Today Howard is an independent film producer and popular speaker at animation events and film festivals worldwide.

85. Ibid. In his interview, Howard talks about using the term "Camelot" for describing the Florida studio.

86. Ibid. Howard himself had a golden-football parking decal, which was awarded to only the highest-level executives at Walt Disney World.

87. John C. Tibbetts and James M. Welsh, eds., "Ollie Johnston on 'Classic' Disney Animation," in *Classic Screen Interviews* (Lanham, MD: Scarecrow Press, 2010), 209. Ollie Johnston, one of Disney's Nine Old Men, is quoted in 1981 as saying, "Actually, the animator is just an actor with a pencil." The "Nine Old Men," a term used by Walt Disney, were a group of animators who worked on some of Disney's original, most famous animated films; some of them went on to become directors.

88. Howard interview, July 3, 2014.

89. Sarah Cole, Annette Gayle, and Rosemary Healy, interview by author, Winter Garden, Florida, November 10, 2013; Darley interview, April 27, 2015; Garbera and Poirier, interview, November 9, 2013.

90. Max Howard, interview, July 3, 2014.

91. Ibid. Howard was a close friend of Hartley's family and was instrumental in the creation and dedication of Brigitte's Garden. Hartley's filmography can be found at http://www.imdb.com/name/nm0366808/?ref_=fn_al_nm_1.

92. *The Rescuers Down Under*'s production number was 0505. In Sq. (Sequence) 6, "Cody and the Animals," animators Tom Bancroft, Aaron Blaise, Brigitte Hartley, and Alex Kupershmidt contributed to the sequence. Hartley was also on the crew that animated Frank, the Frilled Lizard.

93. Howard interview, July 3, 2014. Studio librarian Sharon Fiske had a thank-you card featuring Brigitte's caricature that was created shortly before she passed away.

94. Ibid. Also see the video of the dedication ceremony on Jim Jackson's WDFAF website: http://www.wdfaf.com/celebrations/brigette/index.html.

95. These photographs of Brigitte's Garden and the brass plaque were taken by the author in November 2014 during a walk through the backstage areas. The plaque commemorates the dedication ceremony of Brigitte's Garden.

Chapter 2. Traditional or Digital: It's All Hand-Drawn

1. "Fleischer Studios in 1939," part of the *Popular Science* series. This video provides a walk through the animation pipeline at the Fleischer Studios' new location in Miami, Florida (https://www.fleischerstudios.com/magic.html). See also Richard Fleischer, *Out of the Inkwell: Max Fleischer and the American Revolution* (Lexington: University of Kentucky Press, 2005).

2. "*Gulliver's Travels*: The Story behind the Story," an article on the Fleischer Studio's website (https://www.fleischerstudios.com/gulliver.html). See the Fleischer Studios home page for more information about the studio: https://www.fleischer studios.com.

3. Fleischer, *Out of the Inkwell*; Leslie Cabarga, *The Fleischer Story* (New York: DaCapo Press, 1988).

4. Richard Verrier, "Florida Accuses Former Digital Domain Media Officers of Fraud," *Los Angeles Times,* July 26, 2014 https://www.latimes.com/entertainment/envelope/cotown/la-et-ct-digital-domain-lawsuit-20140725-story.html. Another attempt to take advantage of Florida's bid to lure film production to the East Coast was made after the closure of Disney's Florida studio in 2004. Digital Domain Media Group, a California-based visual effects studio, sought to open an animation facility in Port St. Lucie that would be staffed by many of the artists who elected to stay in Florida. That number was to be augmented by students participating in an animation degree program offered by Florida State University's College of Motion Picture Arts. In 2012, declaring bankruptcy, Digital Domain backed out of the deal, leaving artists, administrators, and politicians shocked by their decision. City and state agencies never recovered from the financial blow, and many of the artists who had uprooted their lives to join the staff were left stranded.

5. When Michael Eisner came to the company in 1984, he quickly implemented strategies to put the company back on its feet. He announced the construction of the Disney-MGM Studios theme park in 1985. Concept designs for the park are preserved in WDI's Information Research Center and date to 1986/1987.

6. Howard interview, July 3, 2014. In this interview, Howard discussed the company's invitation to take on the new studio in Orlando and to hire many members of *Roger Rabbit*'s London crew.

7. John Canemaker, interview by author, New York City, September 25, 2013. Alex Kupershmidt, Matt Novak, Mario Menjivar, and I attended the School of Visual Arts in New York City, while Jonathan Annand graduated from New York University's animation curriculum.

8. Telotte, *Animating Space*, 183.

9. Ibid., 243. Telotte is impressed with Zemeckis's daring in "exploring how the latest technology . . . might be employed not only to enhance the possibilities of cinematic narrative, but also to transform it through an expanded sense of animation." Indeed, Telotte sees Zemeckis's contribution as having a more significant impact on the filmmaking art form than the theories of animation academician Lev Manovich,

who simply interpreted its technological effects on live-action production after the film was released.

10. Adam Eisenberg, "Romancing the Rabbit," *Cinefex* 35 (August 1988); Rita Street, "Toys Will Be Toys," *Cinefex* 64 (December 1995). The reason for the film's remarkable success was the ability to draw directly onto individual photographic images. Physical effects on set and designated sight lines for the actors provided cues for the animators to follow. A complex series of mattes and multiple exposures created tones, shadows, and highlights to blend the characters into their live-action environment.

11. *Somethin's Cookin'* and the majority of the characters in the film were animated by Richard Williams's London unit. *Tummy Trouble* was the second Maroon Cartoon short and was just wrapping production in California when the Florida studio opened.

12. Jim Korkis, "The Magic of Disney Animation Pavilion," *MousePlanet*, June 8, 2016, https://www.mouseplanet.com/11435/The_Magic_of_Disney_Animation_Pavilion. Korkis's article provides production numbers on various films provided by the Florida studio.

13. *Roller Coaster Rabbit* premiered on June 15, 1990. See IMDb, http://www.imdb .com/title/tt0100510/?ref_=fn_al_tt_1. Several attempts were made through the years to perfect a CGI model for a *Roger Rabbit* sequel, but none of the tests were green-lit for production. (Fun Fact: Every Roger Rabbit/Baby Herman cartoon must, under the terms of the original contract, include a walk-on part for Droopy Dog.)

14. The first director on the project was William G. Kopp. Kopp's *Mr. Gloom* received the 11th Annual Student Film Award for Animation Merit from the Academy of Motion Picture Arts and Sciences in 1984 (see Kopp's biography at https://www .themoviedb.org/person/144393-bill-kopp). Kopp received his training at the California Institute of the Arts (CalArts). In the midst of production on *Roller Coaster Rabbit*, he was called back to California and Rob Minkoff took over as director on the short. (Max Howard discussed the change in director during production.) Minkoff was later tapped as codirector with Roger Allers on *The Lion King*. Minkoff left the company and went on to direct live-action/animation hybrid films. He is best known for the *Stewart Little* series. Donald W. Ernst worked as a music and sound editor on several television series (including *Gilligan's Island*) and began his career in animation as film editor for (Ralph) Bakshi Productions. Ernst joined Disney as a producer and has been with the company ever since. See IMDb for additional filmographies on all three men.

15. The other two of the eight starting animators were Brigitte Hartley from England and Mark Kausler from California. It is the art direction that controls the overall styling of the film. When working on California features, the Florida studio had to conform to the look of the film even though the directing team was over two thousand miles away. This conformity to production aesthetics would later be reversed when the Florida studio began producing their own films.

16. Ron Clements and John Musker, dirs. *The Little Mermaid*, Walt Disney Animation Studios, 1989, http://www.imdb.com/title/tt0097757/?ref_=nv_sr_1.

17. *The Little Mermaid* won the awards for the Best Original Song ("Under the Sea") and Best Original Score (Howard Ashman and Alan Menken) from the Academy of Motion Picture Arts and Sciences at the 62nd Academy Awards ceremony on March 26, 1990. "The 62nd Academy Awards, 1990," http://www.oscars.org/oscars/ceremonies/1990.

18. Garbera and Poirier interview, November 9, 2013. On opening day (May 1, 1989) Jeffrey Katzenberg made a point of going through the entire Florida studio and introducing himself to each member of the original crew. All cast members working at Walt Disney World were required to attend a two-day company orientation, which I attended with Aaron Blaise (animation), Ken Hettig (animation), and Robert Walker (layout).

19. Darley interview, April 27, 2015; Laurie Sacks, email interview with author, January 14, 2016. Several in-house projects were also being produced, including commercials for Burger King and McDonald's that tied in with *The Prince and the Pauper*, *The Rescuers Down Under*, and *Beauty and the Beast*. Future projects would include commercials for Fanta and other Disney vendors. There were also public service announcements, including a "Save the Manatee" PSA sponsored by Jimmy Buffet's Parrotheads. Additional Florida parks and resorts assignments included Splash Mountain and Voyage of the Little Mermaid; Euro-Disneyland for France-Telecom's It's a Small World Post-Show; and Disneyland Tokyo for Winnie the Pooh and the Honey Pot.

20. Korkis, "Magic of Disney Animation Pavilion." Korkis's article provides partial information on the footage that the Florida studio contributed to each of the feature productions. Korkis does not cite the source of his information.

21. See YouTube upload of the intermission/credits clip (at 2:35) for *Prince and the Pauper*. Hbvideos, "Rare Intermission Clip The Prince and Pauper Disney Super 8mm Sound," https://www.youtube.com/watch?v=2Jv7BM509xc&feature=youtu.be&t=20s.

22. DisneyToon Studios handled the production of these televised or video-release films. The directorial teams were based in California, but most often the work was done in other countries, such as Vancouver and Toronto, Canada; Sydney, Australia; and Manila, the Philippines.

23. For more information on Margery Sharp and her bibliography as an author of adult and children's fiction, see http://www.goodreads.com/author/show/43970.Margery_Sharp.

24. Without question, this dual production was occurring in the California studio as well, but for the purposes of this book, the Florida studio provides the better case study.

25. Sito, *Moving Innovation*, 219.

26. Vincent interview, October 10, 2015. Fran and Al Kirsten ran a successful cel-painting business in Sebring, Florida, before being hired to set up the ink and paint department in the Florida studio.

27. Vincent interview, October 10, 2015.

28. Vincent email to author, February 14, 2016. The subsequent change in status of the ink and paint department is discussed further in chapter 3.

29. George Scribner, dir., *The Prince and the Pauper*, Walt Disney Pictures, 1990, http://www.imdb.com/title/tt0100409/?ref_=fn_al_tt_3. The sentence references Sequence 1, Scene 35.10, which was a system used to identify each shot. The notation "35.10" indicates the decision to add shots between scenes 35 and 36 to make the story better. The "8–00" refers to the scene being 8 feet of film. At 16 frames per physical foot, this scene was 128 frames, or just over 5 seconds long. Such information was included on the exposure sheet so that everyone knew what to do and where to cut it in.

30. This image is from a cel setup from Sequence 1, Scene 35.10, currently in the author's collection.

31. The weasels can be heard singing, "Captain Pete, Captain Pete, he never met a man he didn't cheat," all to the title tune from the *Mickey Mouse Club*.

32. Scenes were most often recorded on black-and-white film stock, which could be developed in-house.

33. Darley interview, April 27, 2015. Darley notes that the semi-transparent ink for the beer foam was sticky and tenacious stuff, making it hard for the inkers to maintain consistency. Yet they did. For more information about effects animation, see Joseph Gilland's practical textbook, *Elemental Magic: The Art of Special Effects Animation* (Oxford, UK: Focal Press, 2009).

34. Sacks email interview, January 14, 2016.

35. Clyde Geronimi, Hamilton Luske, and Wolfgang Reitherman, dirs., *One Hundred and One Dalmatians*, Walt Disney Pictures, 1961, http://www.imdb.com/title/tt0055254/?ref_=ttfc_fc_tt. The xerox process was grudgingly used by Walt but became standard practice during the Ron Miller years (1966–1984). This process impacted the style of all features following *Dalmatians*. This is clearly an example of how technology influenced style. See *Oliver and Company* for examples of the xerox-like illustration style used during the 1980s.

36. Darley interview, April 27, 2015.

37. Work prints were light, non-color-corrected prints that were struck from the processed negative and sent back from the lab. The work print was used only during production and rarely seen by the general public. Projection prints were color-corrected and timed to provide optimum image quality on the screen. The sweat box APM (assistant production manager) kept an additional list of any scenes during the production cycle that might be termed CBB, short for "Could Be Better." If there was money, or time, left in the budget by the end of production, these scenes would be revisited to see if they could be improved.

38. Fleischer, *Out of the Inkwell*; Leslie Iwerks and John Kenworthy, *The Hand behind the Mouse: An Intimate Biography of the Man Walt Disney Called "The Greatest Animator in the World"* (New York: Disney Editions, 2001); Pallant, *Demystifying Disney*, 26. Pallant describes the color processes that were available before Technicolor struck a deal with Walt Disney Studios. While Walt Disney Studios was

the first to patent the multiplane camera, there were other studios working on that invention simultaneously. Leslie Iwerks's *Hand behind the Mouse*: is a biography of her grandfather, Ub Iwerks, who tinkered with a multiplane design of his own and whose mechanical ingenuity later contributed to the realization of several of Disney's key multiplane scenes. There was also a three-dimensional camera setup used at the Fleischer Studios, seen in several of their films and invented by Max Fleischer himself.

39. Pallant, *Demystifying Disney*, 40–49. Disney's *illusion of life* refers to the pose-to-pose, full-animation method. See Pallant's discussion on hyperrealism where he redefines the term *illusion of life*, renaming it "Disney Formalism" in order to distinguish it from the ubiquitous phrase "Disney Classic." He identifies Disney Formalism as "the formation and continuation of the aesthetic style forged in the films *Snow White and the Seven Dwarfs* (1937), *Pinocchio* (1940), *Dumbo* (1940), and *Bambi* (1942)."

40. Sito, *Moving Innovation*, 234.

41. Ibid., 231–32. Sito says of Sequence 13, Scene 38 (13–14), "The last shot of *The Little Mermaid* [was] the first CAPS shot: King Triton and the merpeople waving goodbye to Ariel and Eric as they sail away." (It is actually the next-to-last shot, as Scene 39 shows Eric and Ariel kissing as the camera fades to black.) This fact is verified in the Bonus Features on *The Little Mermaid* DVD Diamond Edition, released on December 3, 2013. Another point Sito makes is that while *The Little Mermaid* was the first film to feature a digitally painted scene, it was also the last film to use hand-inking, seen in the self-lines used on the characters and in the myriad bubbles throughout the underwater sequences.

42. It was a daring move to invest in a sequel and for it to be produced using the new CAPS system. It was an open invitation for audiences to compare the iconic 1977 film with the new 1990 one. *The Rescuers* was not released on VHS until September 18, 1992 (https://disney.fandom.com/wiki/The_Rescuers). The artists working on the film at that time laughed and said they didn't know it was physically impossible to complete the film in CAPS, so they did it anyway, though it was close to the finish line.

43. A case could be made here for the experimental short *Oilspot and Lipstick* (1986), a completely CGI cartoon produced under the name of the Walt Disney Late Night Animation Group. It premiered at SIGGRAPH's Electronic Theater in Anaheim, California, on July 28, 1987. The short was directed by Mike Cedeno and produced by David Inglish, head of the young 3D unit. Unfortunately, this delightful cartoon was never given wide release. See D23, https://d23.com/a-to-z/oilspot-and-lipstick-film/.

44. "Hendel Butoy," http://www.imdb.com/name/nm0125186/?ref_=fn_al_nm_1; "Mike Gabriel," http://www.imdb.com/name/nm0300265/?ref_=tt_ov_dr. Thomas Schumacher would later become head of the story department and eventually president of Walt Disney Feature Animation. See http://www.imdb.com/name/nm0776665/?ref_=fn_al_nm_1 and http://waltdisneystudios.com/corp/unit/6/bio/38/.

45. Hahn, *Waking Sleeping Beauty*. In an interview, Peter Schneider talked about the adaptation of CAPS into Disney's animation pipeline.

46. Auzenne, *Visualization Quest*; Weishar, *CGI*. See the early work of Ed Catmull, John Lasseter, and Alvy Ray Smith at Pixar, while also noting the experimental work of 3D pioneers such as Robert Abel, James Blinn, Charles Csuri, Ivan Sutherland, and John Whitney Sr. and Jr., among others.

47. At this time there were no scene planning or color models departments at the Florida studio. When it became necessary for a liaison between the two coasts, I became Florida's first scene planner and Irma Cartaya-Torres became Florida's first color modelist.

48. Multiple books and articles have been written about 3D animation. See in particular Auzenne, *Visualization Quest*; Sito, *Moving Innovation*; Telotte, *Animating Space* and *Mouse Machine*; and Weishar, *CGI*.

49. Telotte, *Animating Space*, 181.

50. Telotte, *Mouse Machine*, 162.

51. Ibid., 10.

52. Sito, *Moving Innovation*, 230.

53. Ibid., 250–51.

54. Ibid., 228.

55. Ibid., 231.

56. Pallant, *Demystifying Disney*, 97. See also the multiple graphs Pallant uses to illustrate box office data on pages 91–93.

57. Sito, *Moving Innovation*, 231. Also see Chris Pallant and J. P. Telotte as animation authorities who credit *The Rescuers Down Under* as Disney's first digital film: See also Brian Sullivan et al., "CAPS (Computer Animation Production System)," *People behind the Pixels: The History of Computer Graphics*, January 1, 1991, http://www.historyofcg.com/pages/caps-computer-animation-production-system-/.

58. In California pencil tests were scanned at low resolutions of 512k and 1024k, depending on the complexity of the scene. Once the scenes moved into color, the final scans were done at a higher resolution of 2048k.

59. Thomas Schatz, *Boom and Bust: American Cinema in the 1940s* (Oakland: University of California Press, 1999). "Double bill" and "double feature" are industry terms first used by theater managers who exhibited a two-film program to attract movie patrons and later used by film distributors when marketing two films for the price of one.

60. Sito, *Moving Innovation*, 226n17. In his footnote, Sito clarifies, writing, "The studio does not count *Tron* (1982) or *The Black Hole* (1979) here, because CG production on those films was done in the main by outside contractors." Yet, on page 222 Sito notes that "as in the film *Tron* (1982), the CG images for all these projects were not direct renders but wireframe schematics printed out on plotters, then painted and photographed like traditional animation."

61. Ibid., 229.

62. Ibid., 224.

63. Ibid., 226.

64. It should be noted that *The Black Cauldron* premiered as the first animated release under the new Eisner management; however, the film cannot be entirely credited to that administration, as it was already in production under the Ron Miller/Card Walker organization.

65. Ibid., 232.

66. Two cases in point: the purple flower ground cover used in the opening shot for *The Rescuers Down Under* blends in well with the traditional layout elements, whereas the CGI ballroom where Belle and the Beast are dancing has a distinct look that is different from the other traditionally painted backgrounds.

67. Pallant, *Demystifying Disney*, 102.

68. Ibid., 128.

69. Telotte, *Mouse Machine*, 162.

70. Lord interview, December 9, 2015.

71. Bill Desowitz, "Academy to Honor David Inglish with Bonner Medal," *Animation World Network*, January 3, 2008, http://www.awn.com/news/academy-honor-david -inglish-bonner-medal. The 64th Academy Awards were given for films produced in 1991. Held on March 30, 1992, CAPS won a Scientific and Engineering Award from the Academy of Motion Picture Arts and Sciences. CAPS was a collaborative project between Pixar Animation Studios and Disney. "Tom Hahn, Peter Nye, and Michael Shantzis of Pixar developed the scan and paint part of the system. Randy Cartwright, Lem Davis, David Coons, Mark Kimball, Jim Houston, and David Wolf of Disney developed the Disney Logistics System (DALS) component." Sullivan et al., "CAPS," http://www.historyofcg.com/pages/caps-computer-animation-production-system-/.

72. Pallant, *Demystifying Disney*, 102, 128; Telotte, *Mouse Machine*, 162. These authors confirm facts from Sullivan et al., "CAPS."

Chapter 3. B Unit to the Blockbusters

1. Jim Korkis, "The Magic of Disney Animation Pavilion," *MousePlanet*, June 8, 2016, https://www.mouseplanet.com/11435/The_Magic_of_Disney_Animation_ Pavilion. At the end of Korkis's article is a short list of footage/time amounts the Florida studio contributed to the films of the Disney Renaissance. The Florida studio produced ever-increasing amounts of footage for the films and in many cases was responsible for key elements within the narrative.

2. "The 64th Academy Awards, 1992" (honoring movies released in 1991), Academy of Motion Pictures Arts and Sciences, https://www.oscars.org/oscars/ceremonies /1992; "The 67th Academy Awards, 1995" (honoring movies released in 1994), Academy of Motion Pictures Arts and Sciences, https://www.oscars.org/oscars/ceremonies /1995.

3. Any film that came after *The Lion King* was measured for its success based on how it compared with that film's financial performance.

4. Darley interview, April 27, 2015. From published theme park materials stating

that the Florida studio's purpose was to create cartoons and featurettes. Also from materials gathered at the Walt Disney Imagineering Information Research Center.

5. "Gone, but Not Forgotten: SpectroMagic," *WDW News Today*, July 20, 2013, https://wdwnt.com/2013/07/gone-but-not-forgotten-spectromagic/. The Spectro-Magic parade performed at Walt Disney World's Magic Kingdom from October 1, 1991, through May 21, 1999, and again from April 2, 2001, through June 5, 2010. It was then permanently retired.

6. The grand premiere of Euro Disneyland was on April 12, 1992. But what's in a name? While Euro Disneyland (1992–1993) was the original title for the park, it was not well received by the public. The company tried rebranding the park several times, changing its name to Euro Disneyland Paris in 1994, then Disneyland Paris in 1995, which it remains to this day. The unfavorable beginning of the park has since turned around and Disneyland Paris has become a major European vacation destination.

7. The entire crew came to refer to this project as *Endless World*. The project was directed by Chris Bailey, who is credited with Paula Abdul's "Opposites Attract" video (1989) on MTV (see https://www.youtube.com/watch?v=xweiQukBM_k). France Telecom was the sponsor of Euro Disneyland's Small World attraction, thus the concept of always being in touch through your telephone. The entire project called for each sequence to consist of a loop of cycling animation, followed by short scenes of either receiving or making calls to other Small World characters. Once the phone call was complete, the character then fell back into the opening cycle. The entire project took months of animation, pencil tests, painted cels, and final color. There were constant redos, repaints, and reshoots, so much so that the crew's T-shirt for the project made fun of the many problems faced by every department in the pipeline. The Halloween celebration that year featured a large group of studio women who dressed up in different ethnic costumes and parodied their performance for the crowd.

8. Paul Curasi and Chuck Williams headed the Fanta Orange soda project, working with supermodel Claudia Schiffer. Carbonated bubbles for the commercial were animated by Barry Cook and Jeff Dutton.

9. Claudia Schiffer and Mickey Mouse strut the dance floor in European commercials for Fanta Orange soda.

10. Pooh's Hunny Hunt attraction at Tokyo Disneyland opened on September 4, 2000. For more information, see "Pooh's Hunny Hunt," Disney Wiki, Fandom, https://disney.fandom.com/wiki/Pooh%27s_Hunny_Hunt.

11. Howard interview, July 3, 2014.

12. Sacks email interview, January 14, 2016.

13. Jeanie Lynd Norman, email to the author, February 16, 2019.

14. Ibid.

15. Lord interview, December 9, 2015.

16. Visiting lecturers included paleontologist Dr. Stuart Sumida, film producer and USC cinematic arts professor Bruce Block, New York illustrator Brian Pinkney, and outsider/folk artist Mr. Imagination (1948–2012).

17. Jay Shindell, interview by author, West Hollywood, California, July 1, 2014; Ken Ostrow, interview by author, Lake Buena Vista, Florida, January 19, 2014.

18. Howard interview, July 3, 2014.

19. Lisa Reinert, interview by author, Burbank, California, March 30, 2016; Vincent interview, October 10, 2015.

20. Ostrow interview, January 19, 2014.

21. Healy interview, November 10, 2013. When Michael Jackson took the tour, they closed the tour corridor so that he would not be exposed to the crowds. I (the author) was shooting a scene on Zeus (Camera 1) that day and I felt someone watching me. I looked up, saw Michael, and we waved to each other. Then I turned back to my scene and continued working. He stayed at the window until I finished shooting, and as I wrapped up the scene, he continued his tour.

22. Sherrie Sinclair, email interview with author, February 11, 2019.

23. Pallant, *Demystifying Disney*, 35. Pallant proposes that "Disney Formalism" should be used as an alternate to the phrase "Classic Disney."

24. Sequence numbers are from the film draft for *Beauty and the Beast*, preserved in the Disney ARL.

25. Gary Trousdale and Kirk Wise, "Beauty and the Beast," *Film at Lincoln Center*, https://www.filmlinc.org/events/beauty-and-the-beast/. The "Work in Progress" version was shown at the New York Film Festival in September 1991, two months before its theatrical release.

26. Pallant, *Demystifying Disney*, 110. See also "The 63rd Academy Awards, 1991," Academy of Motion Pictures Arts and Sciences, Academy Awards Database, https://www.oscars.org/oscars/ceremonies/1992.

27. Ibid. In 2010 the animated film *Toy Story 3* also received a Best Picture nomination.

28. This information comes from the film draft preserved at the ARL. Sequence 18 was the *Beauty and the Beast* song. James Baxter was the key animator for this sequence due to his keen sense of drawing in perspective.

29. Bossert, *Remembering Roy E. Disney*, 139; "Scientific and Engineering Award, 1991 (64th)," "The 64th Academy Awards, 1992," Academy of Motion Pictures Arts and Sciences, http://awardsdatabase.oscars.org; Sullivan et al., "CAPS (Computer Animation Production System)." CAPS won a Scientific and Engineering Award at the 64th Academy Awards from the Academy of Motion Picture Arts and Sciences. (The award was received on March 30, 1992.) CAPS was the combined project of Pixar Animation Studios and Walt Disney Feature Animation. Quoted from the Academy's website: "To Randy Cartwright, David B. Coons, Lem Davis, Thomas Hahn, James Houston, Mark Kimball, Dylan W. Kohler, Peter Nye, Michael Shantzis, David F. Wolf, and the Walt Disney Feature Animation Department for the design and development of the 'CAPS' production system for feature film animation." "Scientific or Technical Award, 1991 (64th)," Academy Awards Database, https://awardsdatabase.oscars.org/.

30. Watts, *Magic Kingdom*, 113–15.

31. Barbara Robertson, "Disney Lets CAPS Out of the Bag," *Computer Graphics World* 17, no. 7 (1994): 58–64.

32. Roger Ebert, "Reviews: *Aladdin*," November 25, 1992, http://www.rogerebert .com/reviews/aladdin-1992; Janet Maslin, "Review/Film: Disney Puts Its Magic Touch on *Aladdin*," *New York Times*, November 11, 1992, http://www.nytimes.com/1992/11/11/ movies/review-film-disney-puts-its-magic-touch-on-aladdin.html; Charles Solomon, "Cover Story: *Aladdin*'s Inspiration? They Rubbed Hirschfeld," *Los Angeles Times*, November 8, 1992, http://articles.latimes.com/1992-11-08/entertainment/ ca-5_1_al-hirschfeld; Kenneth Turan, "Movie Review: The 1,001 Delights of *Aladdin*," *Los Angeles Times*, November 11, 1992, http://articles.latimes.com/1992-11-11/ entertainment/ca-38_1_aladdin; Jay Boyar, "Movie Review: *Aladdin* (Video Release)," *Orlando Sentinel*, September 27, 1993, http://articles.orlandosentinel.com/1993-09-27/ lifestyle/9309250022_1_aladdin-mermaid-magic-lamp. *Aladdin* opened on November 25, 1992.

33. "The 65th Academy Awards, 1993" (honoring movies released in 1992), Academy of Motion Pictures Arts and Sciences, https://www.oscars.org/oscars/ceremonies /1993. On a sadder note, the passing of song lyricist Howard Ashman on March 4, 1991, meant he would never realize how his work on *Beauty and the Beast* or *Aladdin* would lead to the rejuvenation of the animated art form. Alan Menken was left to collaborate on the unfinished soundtrack for *Aladdin* with songwriter Tim Rice. They successfully completed the project, leading to an Oscar for Best Original Song, "A Whole New World." (Rice would go on to work with Elton John on Disney's next blockbuster, *The Lion King*.) See Don Hahn's bio-documentary, *Howard* (Stone Circle Pictures, 2018), which provides an in-depth perspective of the events (available at https://www.youtube.com/watch?v=PIDO0KpMNrM). Robin Williams passed away on August 11, 2014. His contribution to *Aladdin* is acknowledged for its comedic artistry and popular appeal. The loss of these two gifted artists was a substantial blow to American creative culture.

34. Richard Williams, dir., "*The Thief and the Cobbler*," Richard Williams Productions, 1993, https://www.imdb.com/title/tt0112389/?ref_=nv_sr_1. This release date for *The Thief and the Cobbler* comes from IMDb, although the film was never actually completed in its true form. Richard Williams worked for nearly three decades before the film was taken away from him by his backers and completed in a cheaper version. The surviving rough cut of the film, while unfinished, includes pencil tests and scratch dialogue and is an animated masterpiece. The film has a tortured history, but one can only wonder what it would have been like if it had been completed as it was originally envisioned.

35. It is currently speculated that two earlier feature-length animated films were made by Argentinian animator Quirino Cristiani, but these have been lost to time.

36. Kevin Schreck, dir., *Persistence of Vision*, Kevin Schreck Productions, DVD, 2012.

37. Ron Clements and John Musker, dirs., *Aladdin*, Walt Disney Animation Studios, DVD, 2004; originally released 1992.

38. In character animation, levels of A, B, and C are specified for each scene, dependent upon whether the character was seen in CU (close up), MS (mid-range), LS (long shot), or XLS (extreme long shot). If a character is far away within the field, not as much detail is given than when a character is close up.

39. Salonga often visited the Florida Studio, flying down from New York where she was starring in the original cast of *Miss Saigon* on Broadway (1989–1992).

40. Ron Clements and John Musker, dirs., *Aladdin: Disney Special Platinum Edition*, DVD, Walt Disney Home Entertainment, 2004. See disc 2, Supplemental Features: "A Diamond in the Rough: The Making of *Aladdin*."

41. Ibid.

42. Michael Montgomery, interview by the author, Orlando, Florida, October 9, 2015.

43. McLaren quoted in Silfianos, "Definition of Animation," 62–66; Small and Levinson, "Toward a Theory of Animation," 67.

44. Michael Barrier, *Hollywood Cartoons: American Animation in Its Golden Age* (New York: Oxford University Press, 1999), 179. For examples of earlier combinations of live action and animation, see the Warner Bros. gem *Anchors Aweigh* (1945), where Gene Kelly dances with Jerry Mouse, as well as Disney's own *Mary Poppins* (1964), in which Dick Van Dyke dances with a troupe of penguins.

45. Telotte, *Mouse Machine*, 206.

46. *Pocahontas* featured a CGI character named Grandmother Willow. This interactive relationship between animated forms is not the same, however, since they never actually touch each other. *Pocahontas* opened in theaters on June 23, 1995, the same year as *Toy Story* (November 22, 1995).

47. Clements and Musker, *Aladdin*, 2004, disc 2, "Diamond in the Rough."

48. Ibid. The production period for case studies from *Aladdin* ranged from December 1991 through September 1992. The film premiered on November 25, 1992.

49. John Culhane, *Disney's* Aladdin*: The Making of an Animated Film* (New York: Hyperion, 1992), 106–110.

50. Ibid., 233.

51. Clements and Musker, *Aladdin*, 2004, disc 2, "Diamond in the Rough." In Cartwright's interview in the segment titled "Pencil and Computer: Creating the Magic Carpet," he explains his philosophy in choosing mime as the inspiration for his character's movement.

52. Culhane, *Disney's* Aladdin, 106–110. See Culhane's chapter on CGI and effects, "FX: Pencils Meet Computers: The Magic Carpet," for more information on the hybrid process, as well as visual demonstrations on disc 2 of the *Aladdin* DVD segment "Pencil and Computer: Creating the Magic Carpet."

53. John Magnum, "Pines of Rome," https://www.laphil.com/musicdb/pieces/561/pines-of-rome. Referenced from the Los Angeles Philharmonic website, "Pines of Rome" (1924) is the second piece in a triptych of orchestral works dedicated to the city of Rome. The others are "Fountains of Rome" and "Roman Festivals."

54. Hendel Butoy, dir., *Fantasia 2000*, Walt Disney Pictures, 1999, http://www.imdb.com/title/tt0120910/fullcredits?ref_=tt_ov_dr#directors.

55. John Culhane, Fantasia 2000*: Visions of Hope* (White Plains, NY: Disney Editions, 1999), 12, 39. The entire segment of the "Pines of Rome" was designated as Sequence 10.

56. Tad Gielow, email to the author, November 30, 2016.

57. Barbara Robertson, "*Fantasia 2000*," *Computer Graphics World* 23, no. 1 (2000), https://www.cgw.com/Publications/CGW/2000/Volume-23-Issue-1-January-2000-/Fantasia-2000.aspx. Robertson discusses three of the segments in *Fantasia 2000*.

58. Darko Cesar, interview by author, Orlando, Florida, December 6, 2015.

59. Culhane, Fantasia 2000, 50. It was Butoy's decision to use hand-drawn eyes on the character rather than model them in CGI. This fact is supported by the notation of eye levels on the x-sheets from the sequence preserved in the ARL.

60. Cesar interview, December 6, 2015. The quartet of Eastern European animators migrated to the United States, arriving shortly after the dissolution of the Soviet Union in December 1991.

61. Howard interview, July 3, 2014.

62. The Berlin Wall was torn down on November 9, 1989, presaging the dissolution of the USSR on December 26, 1991.

63. Cesar interview, December 6, 2015. Cesar mentions the original working title, "Fantasia Continued." That name changed when management decided to release the film at the turn of the millennium, acknowledging this important milestone both in the historical timeline and the premiere of a new edition of Walt Disney's original ongoing project.

64. Cesar interview, December 6, 2015. All four of the Eastern European animators remained in the United States after the Florida studio closed.

65. Culhane, Fantasia 2000, 39. Butoy was brought on board in May 1991. "Pines of Rome" was the first sequence to be put into production by 1993.

66. *Fantasia 2000*, "Release Info," http://www.imdb.com/title/tt0120910/releaseinfo?ref_=tt_dt_dt.

67. Bour interview, June 26, 2014. Bour started at the Florida studio as an intern and produced *Rudy's Day Off* as an after-hours project with fellow intern Saul Blinkoff during production on *Mulan*. Even though the storyboards were 90 percent completed, the film was never finished due to layoffs that occurred after the feature was released.

68. Barry Cook, dir., *Off His Rockers*, Walt Disney Pictures, 1992; see http://www.imdb.com/title/tt0105047/?ref_=fn_al_tt_1. *Off His Rockers* was in production from January 1990 through May 1991. Cook later went on to direct the Amblin/Disney short *Trail Mix-Up*, starring Roger Rabbit and Baby Herman. It was the third in the series of the Roger Rabbit shorts from the 1988 film *Who Framed Roger Rabbit*. Pam Coats was producer for *Trail Mix-Up* and later re-teamed with Cook and Tony Bancroft to produce *Mulan*.

69. Barry Cook, interview by author, Burbank, California, March 29, 2016.

70. Sito, *Moving Innovation*, 229, 275.

71. Tad Gielow, email to the author, November 30, 2016.

72. Don Gworek, email to author, November 16, 2015; Gworek was part of Florida's IT department and involved with CAPS from the start. He was initially responsible for setting up Sun Microsystem workstations when the studio opened.

73. Cook interview, March 29, 2016.

74. Gielow email to the author, November 30, 2016; Todd King, email interview with author, July 20, 2014.

75. Cook, *Off His Rockers*. Randal Kleiser, dir., *Honey, I Blew Up the Kid*. Walt Disney Pictures, 1992; see http://www.imdb.com/title/tt0104437/.

76. John Lasseter and Steven Daly, *Toy Story: The Art and Making of the Animated Film* (White Plains, NY: Disney Editions, 1995), 6–8; Richard Neupert, *John Lasseter* (Urbana: University of Illinois Press, 2016), 90–99.

77. Sacks email interview, January 14, 2016.

78. Bour interview, June 26, 2014.

79. In a telephone conversation from July 25, 2014, Charles Leatherberry, at WDI's Information Research Center, said the records for this retrofit were not available in California but might be stored in the Walt Disney World maintenance department at the Orlando resort.

80. Howard interview, July 3, 2014.

81. The term "fishbowl" became a common designation when referring to the open space of the main building.

82. Vincent email to author, February 14, 2016.

83. Ostrow interview, January 19, 2014; Shindell, interview, July 1, 2014.

84. Ostrow interview, January 19, 2014; Shindell, interview, July 1, 2014.

85. Howard interview, July 3, 2014.

86. Frank Gladstone, interview by author, Burbank, California, July 2, 2014; Mario Menjivar, interview by author, New York, September 26, 2013.

87. Howard interview, July 3, 2014. Howard was promoted to California's Feature Animation management in May 1994 but subsequently left the Disney Company one year later (May 1995) to become president of the revived Warner Bros. Feature Animation unit. He was head of WBFA during the release of *Space Jam*, *The Magic Sword: Quest for Camelot* (1998), and Brad Bird's *The Iron Giant* (1999). Howard then went to DreamWorks Animation, where he was executive producer on *Spirit: Stallion of the Cimarron* (2002).

88. Garbera interview, November 9, 2013; Lord interview, December 9, 2015; Darley interview, April 27, 2015.

89. Peter DeLuca, interview by author, San Pedro, California, June 28, 2014; Montgomery interview, October 9, 2015; Cesar interview, December 6, 2015.

90. Don Winton, https://www.linkedin.com/in/don-winton-1b9a999.

91. "Voyage of the Little Mermaid," Walt Disney World Info.com, http://www.wdw info.com/wdwinfo/guides/mgm/st-mermaid.htm. Star Tours opened at the Disney-MGM Studios on December 15, 1989. See Matt, "History of Star Tours," June 14, 2009, *Studios Central*, http://studioscentral.com/column/matt/history-of-star-tours/.

92. Korkis, "Magic of Disney Animation Pavilion." Korkis's article provides a short list of the footage provided by the Florida studio to the feature productions. It is not a complete list and, unfortunately, Korkis does not cite the source of his information.

93. Bryan Burrough, *The Big Rich: The Rise and Fall of the Greatest Texas Oil Fortunes* (New York: Penguin Press, 2009).

94. "Frank Wells, Disney's President, Is Killed in a Copter Crash at 62," *New York Times,* April 5, 1994, http://www.nytimes.com/1994/04/05/obituaries/frank-wells -disney-s-president-is-killed-in-a-copter-crash-at-62.html; Edmund Newton and James Bates, "Disney President Wells Killed in Copter Crash Accident," *Los Angeles Times,* April 4, 1994, http://articles.latimes.com/1994-04-04/news/mn-42417_1_ frank-wells. These are examples of the newspaper obituaries covering the death of Franklin G. Wells (March 4, 1932—April 3, 1994), COO of the Walt Disney Company since 1984.

95. Stewart, *Disney War*, 182–83; Kim Masters, "The Epic Disney Blow-Up of 1994: Eisner, Katzenberg, and Ovitz 20 Years Later," *Hollywood Reporter*, April 9, 2014, http://www.hollywoodreporter.com/features/epic-disney-blow-up-1994-694476. According to Stewart's version of the story, it was originally decided that Katzenberg would step down after the Labor Day weekend. He did so two weeks earlier, on August 14. See also Kim Masters's biography of Michael Eisner, *Keys to the Kingdom.*

96. Stewart, *Disney War*, 182–83; Howard interview, 2014. Jeffrey Katzenberg left the Walt Disney Company on August 14, 1994, and founded DreamWorks Animation SKG on October 12, 1994, in partnership with Steven Spielberg and David Geffen. "DreamWorks Animation," https://www.britannica.com/topic/DreamWorks -Animation.

97. Howard interview, July 3, 2014. Howard was promoted in May 1994, just before the premiere of *The Lion King* (June 24, 1994). He recalls going around the California studio with Peter Schneider later that summer and talking with animation personnel about Katzenberg's departure.

98. Ibid.

99. Gladstone interview, July 2, 2014.

100. See Marc Graser, "Walt Disney Animation, Pixar Promote Andrew Millstein, Jim Morris to President," *Variety*, November 18, 2014, http://variety.com/2014/film/ news/walt-disney-animation-pixar-promote-andrew-millstein-jim-morris-to-pres-ident-1201359728/. For more information on the Secret Lab, see Jim Hill, "The Sad Tale of Disney's Secret Lab," Jim Hill Media, January 14, 2003, http://jimhillmedia .com/editor_in_chief1/b/jim_hill/archive/2003/01/15/224.aspx.

101. On Nancy Newhouse Porter's background, see Newhouse Porter Hubbard, http://www.nphlaw.com/our-firm/. The entertainment law firm represented "film-makers, production companies, and studios in transactions related to the production of feature films, television programming, new media, and internet content."

102. Howard interview, July 3, 2014.

103. Cook interview, March 29, 2016. Cook talked about his years on *Mulan*. He worked at the 1420 Flower Street location in 1993–1994 on a film that combined the

ancient Chinese epic poem "The Legend of Fa-Mulan" and a postcolonial tale known as "China Doll."

Chapter 4. The Little Studio That Could

1. Barry Cook and Tony Bancroft, dirs., *Mulan*, Walt Disney Pictures, 1998; Chris Sanders and Dean DeBlois, dirs., *Lilo and Stitch*, Walt Disney Pictures, 2002; and Aaron Blaise and Robert Walker, dirs., *Brother Bear*, Walt Disney Pictures, 2003. All crew lists can be found on IMDb.

2. Jan Gutowski, email to author, January 16, 2015. Gutowski has since been inducted into the Disney Legends Hall of Fame.

3. Mike Lyons, "The Florida Studio: The Underdog Has Its Day," *Cinefantastique* 30, no. 3 (1998): 28. Sito, *Moving Innovation*, 234; Stewart, *Disney War*, 233–34. Although Max Howard was placed in charge of opening the studio in 1988, the studio didn't begin operations until May 1989.

4. Watts, *Magic Kingdom*, 166. These figures come from Watts's text, where he describes the growth of the Walt Disney Studios up until the time of World War II.

5. Vincent email, February 15, 2016.

6. The Comedy Central adult animation series *Southpark*, directed by Trey Parker and Matt Stone, premiered during production on *Mulan*, on August 13, 1997 (see http://www.imdb.com/title/tt0121955/). It was not uncommon for several departments to gather at mealtimes to watch this controversial, yet amusing, series with material that was surprisingly contemporary and often not socially acceptable.

7. Shindell interview, July 1, 2014.

8. Jeff Kurtti, *The Art of* Mulan (New York: Hyperion, 1998), 41.

9. This image of the Disney-MGM Studios park map shows the new location of the entrance to the Backstage Studio Tour, moved to the other side of the park, away from the Animation Courtyard.

10. Watts, *Magic Kingdom*, 389. The term "weenie" was used by Walt Disney and his Imagineers as visual imagery meant to entice park guests into shops, restaurants, and attractions.

11. For a photo of the iconic hat, see "The Sorcerer's Hat," Disney Wiki, http://disney.wikia.com/wiki/The_Sorcerer's_Hat_(Disney's_Hollywood_Studios). Further information can be found at https://en.wikipedia.org/wiki/Sorcerer%27s_Hat; Werner Weiss, "Disney-MGM Studios: The End of the MGM Name," *Yester Studios*, http://www.yesterland.com/mgm-end.html.

12. Watts, *Magic Kingdom*, 83–87; Robin Allan, *Walt Disney and Europe: European Influences on the Animated Feature Films of Walt Disney* (London: John Libbey and Company, 1999), 36–52. Both Watts and Allan examine Disney's habit of reshaping European morality tales with contemporary political perspectives.

13. Kurtti, *Art of* Mulan, 12–13; Craig Reid, "The Origins: The Female Chinese Warrior in Legend, Films, and TV," *Cinefantastique* 30, no. 3 (1998): 31. The Chinese epic poem "The Legend of Fa-Mulan," referenced by the filmmakers, comes from

the Wei Dynasty (386–534 CE), although there are numerous variations of the two-thousand-year-old legend throughout the country. As Craig Reid notes, the working title of Disney's film was *The Legend of Fa Mulan*, which was shortened to simply *Mulan* a couple of months before the film's release.

14. Watts, *Magic Kingdom*, 300.

15. Jack Mathews, "This Isn't Your Father's *Pocahontas*," *New York Newsday*, June 19, 1998.

16. Peter Stack, "Disney Gives Animated *Mulan* a Deft Human Touch," *San Francisco Chronicle,* June 19, 1998.

17. Andrew Paxman, "Disney Gets Animated in Florida," *Variety*, June 9, 1998.

18. Ibid.

19. Glen Whipp, "Mulan Breaks the Mold with Girl Power: Newest Heroine Isn't Typical Disney Damsel Waiting for Her Prince to Come," *Los Angeles Daily News*, June 19, 1998; Corie Brown and Laura Shapiro, "Woman Warrior," *Newsweek*, June 8, 1998.

20. Barry Cook, interview by author, Burbank, California, March 29, 2016; Stephen Schaefer, "No China Doll: Disney's Newest Heroine Fights Her Own Battles in *Mulan*," *Boston Herald,* June 16, 1998. As Schaefer notes in his review of the film, "*Mulan* was originally planned as a more straight-to-video short called *China Doll*, and it couldn't have been more politically insensitive for a company that hopes to do much business with China." Mulan's family name in other regions of China is recognized as *Hua* rather than *Fa*.

21. *Mulan* (http://www.imdb.com/title/tt0120762/?ref_=fn_al_tt_1); *A Bug's Life* (http://www.imdb.com/title/tt0120623/?ref_=nv_sr_1). *Mulan* opened on June 19, 1998, and *A Bug's Life* opened later that year, on November 25, 1998.

22. Kurtti, *Art of* Mulan, 182.

23. Ibid., 181.

24. For most of the Disney Renaissance, California's production departments were spread over a two- to five-block radius in warehouses designated as "Airway," "Grand Central," and "1420 Flower Street." A few miles down the road in Burbank, some departments like Camera and Ink and Paint were still located on the main lot. In 1995 the California crew was reunited under one roof in the famous "Hat" building constructed specifically for the artists. Although they did not return to the main campus, which Walt Disney had originally designed for his animators, they were back in Burbank in quarters just across the street from the corporate center.

25. Kurtti, *Art of* Mulan, 181.

26. Ibid.

27. Ibid.

28. Jim Abbott, "The Making of *Mulan*," *Orlando Sentinel,* June 17, 1998.

29. Cook interview, March 29, 2016; Bancroft interview, June 30, 2014.

30. Mike Lyons, "Cover Story: Walt Disney's *Mulan*," *Cinefantastique* 30, no. 3 (1998): 22.

31. Bancroft interview, June 30, 2014.

32. Kurtti, *Art of* Mulan, 181.

33. Ibid., 183.

34. "Mark Henn," http://www.imdb.com/name/nm0377166/?ref_=fn_al_nm_1.

35. Kurtti, *Art of* Mulan, 128.

36. Bancroft interview, June 30, 2014. See the bibliography for Chinese art-historical texts.

37. "Pres Romanillos," http://www.imdb.com/name/nm0738828/?ref_=nv_sr_1. Romanillos's animation desk has been preserved at the Walt Disney Animation Research Library.

38. Lyons, "Walt Disney's *Mulan*," 24.

39. See *Mulan* at IMDb (http://www.imdb.com/title/tt0120762/fullcredits?ref_=tt_ov_st_sm) for a full listing of the cast and crew.

40. CAPS operations included blur, directional blur, opacity, skew, and the highly versatile turbulence. Directional blur added a soft edge to a character in designated directions without affecting its overall hard edge. Skew was effective in simulating cloud movement across the sky. Turbulence was used in multiple ways, from the subtle swaying motion of a hammock as seen in *Lilo and Stitch* to the violent waves of cascading snow in the avalanche sequence in *Mulan*. Both examples display how turbulence could be dialed up or toned down to achieve a wide range of visual effects. Turbulence was extremely useful when creating atmospheric effects such as smoke, fog, mist, or water, adding texture or movement over large areas of flat color.

41. Jenny Peters, "Disney Re-Orients Itself with *Mulan*," *Animation Magazine* 12, issue 6, #68 (1998): 6–9.

42. Metropolitan Museum of Art, http://www.metmuseum.org/toah/hd/nsong/hd_nsong.htm. While Chinese calligraphy and painting were already recognized as classical forms of high art, it saw a particular flowering during the Northern Song Dynasty (960–1127).

43. Disney's *True-Life Adventures* series ran for thirteen episodes beginning with 1948's Academy Award–winning *Seal Island* and going through 1960's *Jungle Cat*. In 2006 a Walt Disney Legacy Collection featured episodes from the series remastered on DVD. For more information, see "Walt and the True-Life Adventures," February 9, 2012, Walt Disney Family Museum, https://www.waltdisney.org/blog/walt-and-true-life-adventures, and "Walt Disney's Legacy Collection: True-Life Adventures, Volume 3—Creatures of the Wild DVD Review," DVDizzy.com, December 5, 2006, https://www.dvdizzy.com/true-life-adventures-v3.html.

44. A great deal of the opening scene's success goes to the film's artistic coordinator, Dutton, who animated and shepherded the scene through the production pipeline. Dutton's background as an original member of Florida's effects department prepared him for the larger role of coordinator, overseeing the multitudinous stages a scene goes through during production. The redlining on the x-sheet's cover provides a diagram of how the CAPS operations were used to create the subtlety of this look. Those notes are preserved in the scene materials at the ARL.

45. Paul Wells, *Understanding Animation* (New York: Routledge, 1998), 44.

46. Sito, *Moving Innovation*, 234.

47. Pallant, *Demystifying Disney*, 133.

48. Christopher Finch, *The Art of* The Lion King (New York: Hyperion, 1994), 184, 188; Pallant, *Demystifying Disney*, 98–99.

49. These notes are from the x-sheets preserved at the ARL.

50. Prod. 1487, Sq. 09.9, "Huns Attack," Sc. 58.3, "The Hun Charge." See the *Mulan* script at https://www.scriptslug.com/assets/scripts/mulan-1998.pdf.

51. Mike Lyons, "Effects Animation: *Mulan*," *Cinefantastique* 30, no. 3 (July 1998): 26.

52. Darlene Hadrika, email to the author, October 15, 2016.

53. Craig Clunas, *Art in China* (New York: Oxford University Press, 1997), 30–32; Robert L. Thorp and Richard Ellis Vinograd, *Chinese Art and Culture* (Upper Saddle River, NJ: Pearson Prentice Hall, 2006), 139–42.

54. Pallant, *Demystifying Disney*, 98–99.

55. Lyons, "Effects Animation," 25.

56. Ron Clements and John Musker, dirs., *Aladdin*, DVD, 2004. Disc 2, Supplemental Features, "The Animators."

57. Darley interview, April 27, 2015; Darlene Hadrika, interview by author, Orlando, Florida, November 20, 2016.

58. Gish Jen, "What Becomes a Legend Most?" *Los Angeles Times*, June 14, 1998; Stack, "Disney Gives Animated *Mulan* a Deft Human Touch"; Barbara Shulgasser, "*Mulan*: Girl Power from Disney," *San Francisco Examiner,* June 19, 1998.

59. BBC, "Chinese Unimpressed with Disney's *Mulan*," *BBC News*, March 19, 1999; Frank Langfitt, "Disney Magic Fails *Mulan* in China," *Baltimore Sun* (May 3, 1999); Bernard Weinraub, "Disney Will Defy China on Its Dalai Lama Film," *New York Times* (November 17, 1996). There was already a dispute between Disney and the Chinese government over the release of the live-action film *Kundun* (1997), directed by Martin Scorsese and based on a biography of Tibet's exiled religious leader, the Dalai Lama. A year after the release of *Mulan*, the Disney Company formally apologized to the Chinese government and went ahead with plans to build the Shanghai Disney Resort.

60. Peters, "Disney Re-Orients Itself," 6–9; Lyons, "Cover Story: Walt Disney's *Mulan*," 18–30.

61. DreamWorks reported that *The Prince of Egypt* had a modest budget ($70,000,000 est.), while *Mulan* was estimated at $90,000,000. These two figures come from IMDb: *The Prince of Egypt* (https://www.imdb.com/title/tt0120794/?ref_=nv_sr_4) and *Mulan* (https://www.imdb.com/title/tt0120762/?ref_=nv_sr_2). All box office numbers are as reported on www.boxofficemojo.com at the time of this writing.

62. Kim Masters, "Cinema: A Sneak Peek at the Promised Land: Will DreamWorks' First Animated Feature Be a Zion King? See for Yourself," *Time* 151, no. 114 (1998); Animation World Network, "Respect for Tradition Combined with Technological Excellence Drives Cambridge Animation's Leadership," SIGGRAPH 98 Special, *Animation World Magazine*, Issue 3.5, https://www.awn.com/mag/issue3.5/siggraph/

s98cambridge.html; Joe and Vicki Traci, "Breathing Life into *The Prince of Egypt*," *Animation Artist*, August 13, 2003, http://animationartist.com/InsideAnimation/ PrinceEygpt.html; Christen Harty Schaffer, prod., *The Making of* The Prince of Egypt, Triage Inc., DreamWorks, LLC, 1998.

63. More detailed statistics can be found at Box Office Mojo: *The Prince of Egypt* (https://www.boxofficemojo.com/oscar/movies/?id=princeofegypt.htm) and *Mulan* (https://www.boxofficemojo.com/oscar/movies/?id=mulan.htm).

64. Gladstone interview, July 2, 2014; Howard interview, July 3, 2014. Both Gladstone and Howard spoke about the circumstances that led to talent raiding and the use of entertainment lawyers in negotiating the artists' contracts.

65. Pallant, *Demystifying Disney*, 94.

Chapter 5. Shutting Down the Studio

1. All domestic box office information comes from Box Office Mojo, http://www.box officemojo.com/.

2. Sito, *Moving Innovation*, 264. See also Stewart, *Disney War*, 416.

3. Ibid., 231.

4. See "My Peoples," Disney Wiki, https://disney.fandom.com/wiki/My_Peoples/; Josh Armstrong, "Director Barry Cook Remembers the *Peoples* of Walt Disney Feature Animation Florida, *Animated Views*, July 30, 2012, https://animatedviews .com/2012/director-barry-cook-remembers-the-peoples-of-walt-disney-feature -animation-florida/.

5. Sacks email, January 14, 2016. Sacks remembers coordinating production on the "Save the Manatees" project supported by Jimmy Buffett and his Parrotheads fan club.

6. "*John Henry*," http://www.imdb.com/title/tt0219105/?ref_=fn_al_tt_1.

7. Sounds of Blackness, http://www.soundsofblackness.org. For more information on this groundbreaking group of musicians, see their website.

8. "*Hercules*, Full Cast and Crew," http://www.imdb.com/title/tt0119282/full credits/?ref_=tt_ov_st_sm. Members of this musical group contributed the dialogue and vocals of the five Muses.

9. "Who We Are," Sounds of Blackness, http://www.soundsofblackness.org/about/. Sounds of Blackness is credited with the score and lyrics for *John Henry*'s soundtrack. Also see "*John Henry*, Full Cast and Crew," http://www.imdb.com/title/tt0219105/ fullcredits#writers.

10. Tim Hodge, email to author, October 31, 2009. Hodge was one of three writers involved with *John Henry* from the beginning of the project.

11. Ibid.

12. Robert Stanton, email to the author, November 9, 2009. For outsider artists influences, see the woodblock print of John Henry by Frank W. Long from the 1930s. This print is located at the Warren and Julie Payne Fine Art Gallery in Louisville, Kentucky. For an image of the print, see https://balladofjohnhenry.com/. Another

resource on John Henry is Scott Reynolds Nelson and Marc Aronson, *Ain't Nothing but a Man: My Quest to Find the Real John Henry* (Washington, DC: National Geographic Children's Books, 2007), 63.

13. Lord interview, December 9, 2015.

14. Stanton email, November 9, 2009.

15. Darley interview, April 27, 2015.

16. Ibid. Walt Disney himself lost his own battle with cancer from his lifelong habit of smoking cigarettes.

17. "John Henry Disney," http://www.amazon.com/Disneys-American-Legends -Alfree-Woodard/dp/B00005RDST?ie=UTF8&keywords=john%20henry%20disney &qid=1464375897&ref_=sr_1_2&s=movies-tv&sr=1-2. The *Disney Legends* collection was released on February 12, 2002. "*John Henry*, Awards," http://www.imdb.com/ title/tt0219105/awards?ref_=tt_awd. Although *John Henry* met the theatrical screen criteria to be considered for an Academy Award (Best Animated Short), it was not nominated. It was screened at Disney's El Capitan Theatre but never received nationwide theatrical release. The short earned a nomination at the animation industry awards, the Annies, for Outstanding Achievement in an Animated Short Subject, and won a Silver Gryphon from the Giffoni Film Festival 2000 in the Early Screens Section—Best Short Film.

18. "Disney Animated Filmography," https://www.imdb.com/title/tt0372866 /?ref_=fn_al_tt_1/. In the 1940s Walt Disney released several package films, including *Make Mine Music, Fun and Fancy Free*, and *Melody Time*.

19. Dean DeBlois, "Keeping It Small," in Lilo and Stitch: *Collected Stories from the Film's Creators*, ed. H. Clark Wakabayashi (New York: Disney Editions, 2002), 37–38.

20. Chris Sanders, "Pitching Stitch," Lilo and Stitch: *Collected Stories from the Film's Creators*, ed. H. Clark Wakabayashi (New York: Disney Editions, 2002), 27.

21. Ric Sluiter, "The Master's Pebbles," Lilo and Stitch: *Collected Stories from the Film's Creators*, ed. H. Clark Wakabayashi (New York: Disney Editions, 2002), 57–58.

22. Jack Lew, email to author, August 27, 2015.

23. H. Clark Wakabayashi, ed. Lilo and Stitch: *Collected Stories from the Film's Creators* (New York: Disney Editions, 2002).

24. Hadrika interview, November 20, 2016.

25. Darley interview, April 27, 2015.

26. Sanders, Chris, and Dean DeBlois, dirs., *Lilo and Stitch*, Walt Disney Pictures, 2002, DVD (Walt Disney Studios Home Entertainment, 2002). See "Special Features: Deleted Scenes."

27. Clark Spencer, "Taking the Plunge," Lilo and Stitch: *Collected Stories from the Film's Creators*, ed. H. Clark Wakabayashi (New York: Disney Editions, 2002), 45.

28. Pallant, *Demystifying Disney*, 117–19.

29. Ibid.

30. Armstrong, "Barry Cook Remembers." See also the documentary short *Dream On, Silly Dreamer*, directed by Dan Lund and produced by Tony West, which describes the first of these painful meetings on Monday, March 25, 2002, in California. The

Extra Features section includes an epilogue on the meeting and final closure of the special effects department at the Florida studio in 2003–2004. It was believed this action was motivated by the tremendous success of Blue Sky Studios' *Ice Age* (2002).

31. Sito, *Moving Innovation*, 265. See also Lund, *Dream On, Silly Dreamer*.

32. Stewart, *Disney War*, 509. See also Box Office Mojo and IMDb for production and box office figures. Box Office Mojo, http://www.boxofficemojo.com/movies/?id=brotherbear.htm; "*Brother Bear*," https://www.imdb.com/title/tt0328880/?ref_=fn_al_tt_1/. For Academy Award information, see the Academy Awards database: "Academy Awards Database; Animated Feature Film; 2003," http://awardsdatabase.oscars.org/Search. Nominations for Best Animated Feature Film 2002 (76th Academy Awards) were *Brother Bear*, *Finding Nemo*, and *The Triplets of Belleville*. *Finding Nemo*, directed by Andrew Stanton, won the Oscar.

33. "Aaron Blaise," http://www.imdb.com/name/nm0086431/?ref_=nv_sr_1; "Robert Walker," http://www.imdb.com/name/nm1074107/?ref_=fn_al_nm_6; "Chuck Williams," http://www.imdb.com/name/nm0930285/?ref_=nv_sr_3. All at the Internet Movie Database.

34. "Aaron Blaise," IMDb.

35. *How to Haunt a House*, http://www.imdb.com/title/tt0791079/?ref_=ttspec_spec_tt. See also "How to Haunt a House," Disney Wiki, http://disney.wikia.com/wiki/How_to_Haunt_a_House. *How to Haunt a House* debuted on television on October 30, 1999, just in time for Halloween. The narrator for the film was Corey Burton.

36. Caitlin, "*Mickey Mouse Works*; Plot Summary," http://www.imdb.com/title/tt0198181/plotsummary?ref_=tt_stry_pl. "This [series] is comprised of new animated shorts featuring the classic Disney characters: Mickey Mouse, Minnie Mouse, Pluto, Donald Duck, and Goofy. A great effort was made to capture the classic Disney look and feel, using basic colors and the original sound effects."

37. "*How to Haunt a House*; Full Cast and Crew," http://www.imdb.com/title/tt0791079/fullcredits?ref_=tt_cl_sm#cast. My reason for mentioning this short project is to demonstrate how it impacted future roles of the artists working in Florida. The film's team included Robert Gannaway as executive producer and art direction by Sean Sullivan from the Florida backgrounds department. Since the closing of the Florida studio, Blaise has found a ready audience for his online animation, painting, and Photoshop courses ("The Art of Aaron Blaise," https://creatureartteacher.com/). He is a popular speaker at conventions and film festivals and teaches workshops around the world.

38. "*Brother Bear*," http://www.imdb.com/title/tt0328880/?ref_=nv_sr_2. Production information was drawn from the dates referenced on x-sheets located at the ARL.

39. Darley interview, April 27, 2015.

40. "*Brother Bear*; Full Cast and Crew," http://www.imdb.com/title/tt0328880/fullcredits?ref_=tt_ov_st_sm.

41. Lew email, August 27, 2015; Lord interview, December 9, 2015.

42. Lew email, August 27, 2015.

43. Hadrika interview, November 20, 2016.

44. See IMDb for all release information. DreamWorks' *Antz* opened on October 2, 1999, and Pixar's *A Bug's Life* opened on November 25, 1998. Katzenberg moved up his film's release date to hit the marketplace before Pixar's insect film.

45. Darley interview, April 27, 2015. An initial version of the upgrade, named CHIP, was used while CAPS2 was still in development.

46. Ibid. Paul Yanover, director of Disney's technology and digital production department, began the project while still with the company. He was soon promoted to vice president of that division. However, he left Disney soon afterward and subcontracted the CAPS2 project to his corporation.

47. Lund, *Dream On, Silly Dreamer*.

48. Northside opened in late 1996 and closed in 2002. Not only was it the home of *Fantasia 2000* and *Dinosaur*, but it also contributed to other films like *Hercules*, *Mulan*, and *Tarzan*.

49. Adam Eisenberg, "*Who Framed Roger Rabbit*: Romancing the Rabbit, *Cinefex* 35 (August 1988). Also see Disney's *Dinosaur*, directed by Eric Leighton and Ralph Zondag, which combined CGI characters with live-action backgrounds (https://www.imdb.com/title/tt0130623/?ref_=fn_al_tt_1).

50. Barry Cook, email message to author, June 17, 2016.

51. Ibid.

52. The concept of adding hand-drawn animation into CGI is seen in the Academy Award–winning short *Paperman*, directed by John Kahrs in 2012 (Walt Disney Animation Studios). *Paperman*, http://www.imdb.com/title/tt2388725/?ref_=fn_al_tt_1. See YouTube for short how-to videos on the making of the cartoon—for example, SnoutyPig, "Paperman and the Future of 2D Animation," featuring John Kahrs (https://www.youtube.com/watch?v=TZJLtujW6FY).

53. Armstrong, "Barry Cook Remembers." "My Peoples" was set in the lush rural landscapes of the Kentucky-Tennessee mountains, an area very familiar to the director.

54. Cook interview, March 29, 2016; Armstrong, "Barry Cook Remembers."

55. Kathy Schoeppner, interview by author, Burbank, California, June 22, 2014.

56. "Tim O'Donnell," http://www.imdb.com/name/nm0640849/?ref_=nv_sr_5. O'Donnell began at the Florida studio as production manager on *Roller Coaster Rabbit* and was a member of Max Howard's original administrative staff. He transferred from Feature Animation in California after work on *Who Framed Roger Rabbit* was complete. He stayed with Disney for his entire career.

57. Watts, *Magic Kingdom*, 166–67. See also David A. Bossert, *Kem Weber: Mid-Century Furniture Designs for the Disney Studio* (Los Angeles: Old Mill Press, 2018). Bossert's impressive book documents the Kem Weber interior design created for the new Disney Studios in Burbank, California.

58. Stewart, *Disney War*, 416.

59. Notes from x-sheets preserved in the ARL have production tests going back as far as July 1995.

60. Jen Kagel, email to author, June 18, 2016; Anne-Marie Martinez, interview by

author, Tallahassee, Florida, July 21, 2016. Kagel discussed the reversed flow of the attraction after the new building opened. While the attraction was closed for renovations, its cast members were reassigned to other venues around the park, like the Indiana Jones Epic Stunt Spectacular, Muppet*Vision 3D, and the Great Movie Ride.

61. Lew email, August 27, 2015; Kagel email, June 18, 2016.

62. Jim Korkis, "The Magic of Disney Animation Pavilion," *MousePlanet*, June 8, 2016, https://www.mouseplanet.com/11435/The_Magic_of_Disney_Animation_Pavilion; Jim Korkis, "The Story behind *Back to Neverland*," *MousePlanet,* June 15, 2016, https://www.mouseplanet.com/11434/The_Story_Behind_Back_to_Neverland.

63. Greg Chin, email message to author, June 21, 2016.

64. Armstrong, "Barry Cook Remembers." On March 19, 2004, the Florida studio closed its doors forever.

65. Ibid.

66. "*Brother Bear*," http://www.imdb.com/title/tt0328880/business?ref_=tt_dt_bus; Box Office Mojo, "*Brother Bear*," http://www.boxofficemojo.com/movies/?id=brotherbear.htm. These numbers come from the IMDb and Box Office Mojo websites, which contain financial figures submitted by the studios for public knowledge. Box Office Mojo provides a more complete breakdown of the film's total business numbers.

67. Armstrong, "Barry Cook Remembers."

68. Stewart, *Disney War*, 363, 415–17; Leigh Godfrey, "David Stainton Named President, Disney Feature Animation," *Animation World Network*, January 3, 2003, http://www.awn.com/news/david-stainton-named-president-disney-feature-animation. See also David Stainton's biography at https://www.cartoonbrew.com/disney/david-staintons-website-12924.html. Thomas Schumacher left Feature Animation on January 3, 2003. David Stainton remained president of the animation division through 2006.

69. David A. Bossert, *Dali and Disney:* Destino (New York: Disney Editions, 2015), 142–43, 147, 152–54. Roy assigned the short to the Paris studio with Dominique Monféry to direct. The multinational crew at the Paris studio carefully oversaw its completion in 2003.

70. Jim Korkis, "When Roy E. Disney Resigned from Disney Twice," *MousePlanet*, April 13, 2016, https://www.mouseplanet.com/11377/When_Roy_E_Disney_Resigned_from_Disney_Twice; Bossert, *Remembering Roy E. Disney*. Unfortunately, it should be noted that Roy E. resigned from the Walt Disney Company merely a month after *Brother Bear* opened in the theaters. While he was able to eventually "save Disney," he was unable to save the Florida studio. In the aftermath, Jim Korkis from *MousePlanet* wrote an article outlining the end of the Eisner era, or as I prefer to call it, the Roy E. Disney Era. Roy E. Disney passed away on December 16, 2009.

71. Bruce Orwall, "Roy Disney Quits Company Board and Calls on Eisner to Resign, Too," *Wall Street Journal*, December 1, 2003; CNN, "Eisner and Mickey at Last Parting Ways," *CNN Money*, September 10, 2004; Laura M. Holson, "A Quiet Departure for Eisner at Disney," *New York Times*, September 26, 2005, http://www

.nytimes.com/2005/09/26/business/media/a-quiet-departure-for-eisner-at-disney
.html?_r=0.

72. Stewart, *Disney War*, 472.

73. Armstrong, "Barry Cook Remembers."

74. Associated Press, "Company News: Disney to Close Animation Studio in Orlando," *New York Times*, January 13, 2004, http://www.nytimes.com/2004/01/13/business/company-news-disney-to-close-animation-studio-in-orlando.html?_r=0; CNN, "Disney Shutters Florida Studio," *CNN Money*, January 12, 2004, http://money.cnn.com/2004/01/12/news/companies/disney_layoffs/.

75. Gutowski email, January 16, 2015; Todd Pack, "Disney Animation Unit Fades Away in Orlando," *Orlando Sentinel*, January 13, 2004, http://articles.orlandosentinel.com/2004-01-13/news/0401130269_1_feature-animation-walt-disney-feature-magic-of-disney; Associated Press, "Disney Pulls Its Animators from Orlando," *St. Petersburg Times*, January 13, 2004, http://www.sptimes.com/2004/01/13/news_pf/Business/Disney_pulls_its_anim.shtml.

76. Armstrong, "Barry Cook Remembers"; also see Stewart, *Disney War*.

77. Premise Entertainment, https://www.premiseentertainment.com.

78. This was not the first attraction to capitalize on computer-activated entertainment. Disney's first digital theme park, DisneyQuest, had already opened on June 19, 1998. This unique concept included exhibits in virtual reality and computer-assisted design and manufacturing that allowed guests to manipulate their own entertainment experience. DisneyQuest closed on July 2, 2017, to make room for the NBA Experience during the rebranding of Disney Springs. The Walt Disney Company announced DisneyQuest's final date on its *Disney Parks Blog*. Thomas Smith, "Making Way for the NBA Experience: DisneyQuest at Disney Springs to Close July 3," *Disney Parks Blog*, January 30, 2017, https://disneyparks.disney.go.com/blog/2017/01/making-way-for-the-nba-experience-disneyquest-at-disney-springs-to-close-july-3/.

79. While specific blueprints and construction records are unavailable to outside researchers, Aileen Kutaka, head librarian at WDI's Information Research Center, was most helpful with my preliminary research. Files in the IRC's art library contain preparatory sketches of the final design of the Magic of Disney Animation dating from August 18 to November 12, 2003. This work was done before both *Brother Bear*'s opening and Florida's town hall meeting.

80. This experience recalls the space-capsule-shaped ride machines once found at local shopping malls. These rides offered a crude version of virtual reality. The capsule was a small controlled environment that usually simulated a roller-coaster or helicopter experience for its patrons.

81. Merissa Marr, "Disney Reaches to the Crib to Extend Princess Magic," *Wall Street Journal,* November 19, 2007; Drew Harwell, "How Theme Parks Like Disney World Left the Middle Class Behind," *Washington Post,* June 12, 2015.

82. Korkis, "Magic of Disney Animation Pavilion."

83. Dewayne Bevil, "Star Wars Launch Bay Finds Fans Quickly at Disney," *Orlando Sentinel,* December 1, 2015; Carchidi, "Star Wars Launch Bay Opens"; Marjie

Lambert, "Disney's Hollywood Studios Offers Sampler of 'Star Wars' Goodies to Tide Fans Over until 'Star Wars' Land Opens," *Miami Herald*, December 23, 2015. The four-story animation building behind the attraction is primarily being used as office space for call centers and administrative personnel. Brigitte's Garden still blooms in back, albeit with restricted access and fenced-in anonymity.

Postscript

1. Holson, "Quiet Departure for Eisner." Michael Eisner still left the company with a golden parachute.

2. Ibid.

3. Stewart, "Afterword," *Disney War*, 535–41; Richard Verrier, "Feud at Disney Ends Quietly," *Los Angeles Times*, July 9, 2005, http://articles.latimes.com/2005/jul/09/business/fi-disney9; Reuters, "Roy Disney to Dismantle Site after Striking Truce," *Los Angeles Times*, July 15, 2005, http://articles.latimes.com/2005/jul/15/business/fi-rup15.4. Stewart also includes an impressive bibliography of his journalistic sources covering the events in each chapter.

4. Laura M. Holson, "Disney Agrees to Acquire Pixar in a $7.4 Billion Deal," *New York Times*, January 25, 2006; Paul R. LaMonica, "Disney Buys Pixar," *CNN Money*, January 25, 2006; Merissa Marr and Nick Wingfield, "Disney Sets $7.4 Billion Pixar Deal," *Wall Street Journal*, January 25, 2006.

5. Gene Maddaus, "John Lasseter Will Exit Disney at the End of the Year," *Variety*, June 8, 2018; Borys Kit, "John Lasseter to Head Animation at Skydance," *Hollywood Reporter*, January 9, 2019; Scott Mendelson, "Without Disney, Even John Lasseter Can't Turn Skydance into the Next Pixar," *Forbes*, February 19, 2019; Amid Amidi, "John Lasseter Resistance Grows as Lightbox Expo Nixes Skydance Sponsorship," *Cartoon Brew*, February 20, 2019. In January 2019 John Lasseter was forced out of Disney after complaints of unwanted attention toward women in the workplace. He is one of several executives in the film industry exposed by the #MeToo campaign, which increased the power of women professionals to fight back against unwanted attention. Unfortunately, that blow seems to have been lessened by the fact that Lasseter was almost immediately picked up by Skydance Animation. Skydance received tremendous backlash from industry professionals, but that doesn't seem to make any difference to CEO David Ellison.

6. Walt Disney Animation Studios produced 3D *Mickey Mouse* shorts including *Mickey Mouse Mixed-Up Adventures* (https://disney.fandom.com/wiki/Mickey_Mouse_Mixed-Up_Adventures), which debuted in 2017.

7. Tom Bancroft and Tony Bancroft, "Brad Bird Interview: From Tomorrowland and Back," *Bancroft Brothers Animation Podcast*, Podcast #19, May 21, 2015. Bird's contract with the Disney Company to direct *The Incredibles 2* (2018) included an option to direct a hand-drawn feature when that project was finished. He went on to work on *Toy Story 4*, released in 2019.

8. While Japanese and Korean studios still frequently use 2D animation, the SPA

(Sergio Pablos Animation) Studios in Madrid, Spain, released a 2D/3D hybrid called *Klaus* during the Christmas season of 2019. With luck, this project will convince the moneymen that 2D is still a viable medium for storytelling and lead to a resurgence of the technique.

9. Pallant, *Demystifying Disney*, 97–98; Sito, *Moving Innovation*, 231, 315; Telotte, *Animating Space*, 181.

10. From 1998 to 2022, it has been nearly twenty-five years since the release of *Mulan* and approximately thirty years since the releases of *Who Framed Roger Rabbit*, *The Little Mermaid*, *The Rescuers Down Under*, *Beauty and the Beast*, *Aladdin*, and *The Lion King*.

11. Terry Flores, "Veteran Animator Glen Keane on His 'Duet' with Google," *Variety*, December 4, 2014, http://variety.com/2014/film/awards/veteran-animator -glen-keane-on-his-duet-with-google-1201370375/; Charles Solomon, "With 'Dear Basketball,' Kobe Bryant Could Add an Oscar to His Victories," *New York Times*, February 20, 2018, https://www.nytimes.com/2018/02/20/movies/kobe-bryant-oscar -dear-basketball.html. *Duet*, a four-minute animated short, debuted on June 26, 2014, and was nominated for the 2015 Annie Awards' Best Animated Short Subject. (Walt Disney Animation Studio's *Feast* won that year.) *Duet* represents a pairing of Glen Keane's fluid hand-drawn style and technology from Google's Advanced Technology and Project Group. *Dear Basketball* was produced by Kobe Bryant, an homage to his successful career as a professional athlete, and showcases the hand-drawn virtuosity of Keane's signature look. It won the Oscar for Best Short Film (Animated) at the 90th Academy Awards, on March 4, 2018.

12. The 2019 release of SPA Studios film *Klaus* was a demonstration of a 2D/3D hybrid, meaning that both animation methods were conflated to create a single signature look, using the strongest attributes of each technique to narrate an engaging story.

13. Lund, *Dream On, Silly Dreamer*. This quote is from a sign placed in the atrium by management as the Florida crew walked out the door for the last time.

Animation Glossary

2D. *See* **two-dimensional**

3D. *See* **three-dimensional**

animatic: An animatic is a work reel constructed of storyboards enhanced by camera movement and often sound and visual effects. It is a visual rough draft of the film constructed to provide a sense of the action within each sequence and demonstrate the flow of the narrative.

animation: Animation is a method where an object is made to appear to move through a series of continuous frames. Animation can be made with pencil drawings, painted cels, computer-generated images, puppet and stop-motion, and cutouts, to name just some of the techniques.

animation camera, *also* **rostrum camera**: The animation, or rostrum, camera is a device specifically engineered to shoot one frame at a time. It usually features a camera attached to a vertical column with its lens pointing down toward a flat, horizontal shooting surface, known as the camera table or bed. The camera head itself is able to move up and down on the column in small increments, drawing the lens closer or farther away from the artwork. The camera has the ability to rewind and shoot multiple exposures on the same frame of film. It contains a mechanized shutter control that regulates the amount of exposure, used for fades and dissolves. Filters are often placed in front of the camera's lens to create in-camera special effects.

Animation Check: Animation check is the midway point in production between the front end and the back end of the animation pipeline. At this point in the process, the imagery moves from low-resolution to high-resolution scans. The animation checker is responsible for determining that all elements in the scene are accounted for and that their hierarchy is correct, thereby insuring the correct rendering of the scene.

animator, *also* **assistant animator and rough in-betweener**: An animator is an artist who creates a series of images that move when seen in rapid succession. The animator provides the character with personality, action, and timing. In each animation team there are different levels of working, including the assistant animator, who creates more drawings to follow the animator's extremes (or keys), and the rough in-betweener, who completes the scene before being sent to Approvals.

anticipation: In animation, anticipation can be seen in the hesitation before moving into action. It can convey surprise, tension, or suspense in the character.

arc: Story and motion arcs are a sustained narrative or action that has been timed out by the director or animator to have a beginning, climax, and resolution. Timing of the arc can be adjusted so that the high point is reached at a critical moment within the film or the action.

approvals: Daily or weekly meetings with the directors or heads of departments to go over scenes and either give further notes on the scene or approval so that it can move to the next department in the pipeline.

Background (BG), *also* **environment**: The Background department is responsible for painting the final color elements of a scene's environment. These often use cleaned-up layouts as a guide. The background artists follow an overall color palette designed by the art director so that it maintains consistency throughout the sequence.

bipack: Inside an animation camera, it is possible to run two strips of film sandwiched together through the camera's gate to create a bipack, or in-camera, effect. The second strip of film is normally a high-contrast black-and-white negative used to hold back the exposure of certain areas on the negative. After the first pass through the camera, the mask (used to prevent exposure of part of the film) would be changed for an exact opposite mask and the unused portion of the negative would be exposed using a different series of images.

blocking: Blocking is a theatrical term for certain points within a set or staged environment that the character must contact during the action of a scene.

body language: Body language includes various signals and movements used to convey emotion or attitudes that communicate messages to the audience in addition to, or without, dialogue.

breakdown, *also* **breakdown artist**: The breakdowns are additional drawings that come in between the keys (extremes) created by the animator. These drawings are usually done by the in-betweener or breakdown artist in the animation unit.

camera shake: A camera shake is used to register a sudden impact within a scene. This can be when a character runs into a wall or a car crash occurs off-screen. The film image can rock violently from side to side, up and down, or zoom in and out, generally starting with a large amount of travel and dwindling down to none.

camera table: The camera table, or camera bed, is a flat horizontal table that contained a series of 16-field and 24-field peg bars that move incrementally east and west. The entire table is also able to move north, south, east, or west, and rotate clockwise and counterclockwise.

casting: In animation the director casts, or assigns, a character role to an animator who will bring specific personality traits to the acting. These traits can be comedic, dramatic, villainous, or shy.

cel: A cel is a transparent piece of registered plastic acetate that consists of line art on the front and cel-vinyl paint on the back.

cel animation: Cel animation is a process by which hand-drawn animation on paper is transferred onto registered acetate cels. Each cel is opaqued with special cel-vinyl paint and laid on top of a colored background to be shot in sequence onto the film negative.

character: A character is a specific role assigned to an actor or animator that plays a part in a film or story. In animation, character animators handle the roles of living and inanimate objects that function within the narrative. This is different from effects animators, who concentrate on atmospheric and non-character elements such as shadows, tones, and highlights.

character animation, *also* **personality animation**: Character, or personality, animation is the process by which an animator imbues qualities into their character that give them individual identities. With particular traits, the characters move through the narrative in ways the audience expects them to react or, in certain cases, surprises the viewer by responding in a different manner.

charts, *also* **timing charts**: In animation, the animator provides the key movements in a scene and creates a chart for the assistants to follow that contains instructions for overall movement, dialogue, or specific actions and reactions within the timing of the scene.

choreography: Choreography is the movement or interaction between characters within a scene or sequence. The director defines how the actors should move within a scene, or a choreographer designs the dance or fight movements within a sequence.

CGI. *See* **computer-generated images**

Cleanup: The Cleanup department takes the animator's loose, sketchy drawings and transforms them into fine and fluid outlines of the character while still following the animator's action. Cleanup is responsible for maintaining consistency in the character's model so that it is recognizable in scenes and sequences throughout the film.

color models: Color model artists work with the art director to create specific color combinations for costumes and characters that remain consistent throughout a film. They create models that represent these combinations during daytime and night, or during specific lighting sequences.

computer-generated images, *also* **CGI**: Computer-generated images are created completely inside the computer, where the characters and backgrounds inhabit a virtual world. No tangible, physical artwork comes as a by-product of computer-generated images

contact point: A contact point is where a character comes in direct contact with another character or a background element. Normally, registration (which deter-

mines the over/under of levels so that a character would be over the background, etc.) is necessary to create the illusion of contact with a prop or background locations. Contact points are vital in how a character moves across the background and appears grounded within its environment.

cross-dissolve. *See* **dissolve**

cut: A cut in a film is the abrupt transition from one scene to the next. It is the most often used method of linking scenes within a sequence. Other transitions include fades, cross-dissolves, and wipes.

cycle: Cycles are a particular movement repeated over a series of frames. A walk or run movement may be animated to complete one loop of the action, linking up with the first image so that the movement can be repeated for an unlimited number of times necessary within the scene. Cycles can be repeated throughout a film or a series, providing a specific way of moving for a character and thus saving valuable animating time for the artist.

dailies: Dailies, also known as "rushes" in live action, are the results of a day's film shoot or animation tests that are screened for the director's approval. Dailies in animation were often shown once a week to the crew so that they could see the progress of scenes individually or compiled within a sequence.

digital: Digital is a term for the storage of information in ones and zeros. Scanned images become digital information, which is readily called back into virtual versions of the original visual form.

dissolve, *also* **cross-dissolve**: A dissolve is the gradual transition from one image to another, usually overlapping those images at the midpoint within the process.

ease in, *also* **ease out**: Unless it is a cut-to-cut movement, meaning the camera starts moving on the first frame and doesn't stop until the end, most camera mechanics require an ease in and ease out of the move. This keeps the action on the screen from jumping suddenly into motion or coming to an abrupt halt. In certain instances, these abrupt movements help with the action of the scene, like with a camera shake, but normally the character's movement should drive the camera and not call attention to the camera travel.

effects. *See* **special effects**

environment. *See* **background**

exaggeration: In animation, exaggeration is necessary to create convincing movement in an animated character. Without it, the action becomes stilted and wooden. While in live action these extremes aren't necessary, in animation they are vital for fooling the eye or to emphasize the impossibility of the action.

exposure, *also* **double exposure**: Every frame of film constitutes a single exposure on a roll of film stock. The term "exposure" comes from the original method of shooting individual frames in succession within a camera device. Most films are projected at twenty-four frames per second, allowing the human eye to blend the images together, creating a moving image from static frames. A double exposure is when two incongruent images are exposed on the same individual frame, often

creating a special effect like shadows or lightning, or to show contrasting images as one visual composition.

exposure sheet, *also* **x-sheet**: An exposure sheet is necessary for every scene in animation and contains all timing, dialogue, animated levels, background elements, and camera mechanics used in that particular scene. It records all information necessary for the correct composite of the scene.

extremes. *See* **key poses**

fade, *also* **fade-in, fade-out**: A fade is a method of transitioning between two scenes. It can be used to differentiate one scene from the next, as in a change of sequence or fade into a new location. Very often, fade-outs are used at the end of a film to signal the end of the narrative or to give the impression that the action continues without the audience.

film, *also* **movie**: "Film" originally referred to the physical material that ran through a camera. Now it is a description for projecting a series of moving images shown as entertainment.

film frame: A film frame is a single unit that, when projected at high speed, produces the illusion of a moving image. In the evolution of filmmaking, it took twenty-four frames of film to make one second of movement. In contemporary filmmaking, the rate of frames used in a film's projection now gives more definition to the image, leading to high definition (HD) or a high frame rate (HFR).

filters: In achieving visual effects, multiple types of filters can add particular looks to a scene or sequence. Many go unnoticed by the viewer, like UV (ultraviolet), ND (neutral density), polarizing, diffusing, and colored additives. Specialized filters can create visual effects like six-pointed stars, blurred outlines, or water ripples.

Final Check: Final Check, similar to Animation Check, reviews each level in the scene, now as colored artwork, along with the painted overlay and background elements. The final checker compares the art with the camera mechanics specified on the final x-sheet. After each frame is confirmed, the scene goes to Compositing to be approved for cutting into the final reel.

flip book: A flip book is made up of a series of slightly different pictures that, when viewed in rapid succession, creates the illusion of movement.

follow-through: Follow-through is an animation term where the animator creates the primary action, with the character continuing that movement as part of physical inertia or gravity.

green-light: Green-light is an industry term for when a project gets the approval to go into production.

hand-drawn, *also* **traditional**: Hand-drawn animation typically involves a series of sequential drawings using paper and pencil that, when viewed in succession, creates a moving image. In this volume, I define hand-drawn or traditional animation as the process Walt Disney used in creating his classic animated films.

held field: The field is what the camera sees and captures. Field guides define the relationship between the camera and the art. A held 16 field (approximately 16

inches across) means the camera is locked in place (held) and capturing what is within that 16-inch field size.

hold, *also* **moving hold**: A hold is when the image on the screen comes to a complete stop until it begins moving again. In animation, a held cel is used to keep static elements on the screen, like footprints in the snow. Oftentimes, if a character is at rest, a small number of drawings will be cycled to avoid the unnatural feeling of a completely static image, a practice known as a moving hold.

hook-up: A hook-up provides continuity between scenes. If a character or camera is moving at a certain rate of speed in one scene, it is necessary to be moving at the same rate within the next. Hook-ups can also be the continuation of an action from one scene to the next, creating a relationship between the characters from one scene to the next.

in-between, *also* **rough in-betweener**: An in-betweener is the animator responsible for creating the drawings between the keys created by an animator for the scene. Often, this is the starting position to gain experience in the craft before being promoted to assistant animator or animator.

Ink and Paint: Ink and Paint is the department responsible for transferring hand-drawn animation into cels. The inker has to be meticulous in following the animator's lines to prevent a jiggling effect. Once the cels are inked, they move to Paint, where the characters are colored with standardized hues as decided by the scene's color model.

interstitial: An interstitial refers to a short segment between the main sections of the film. In *Fantasia* the live-action segments that showed the musicians and commentators were interstitials to the animated sequences.

key poses, *also* **extremes**: Key poses are the main action frames of an animated scene. They can be the extreme points within a character's action or the mouth shapes necessary for lip-syncing with the dialogue. This is the animator's main task in creating his character's movement within a scene.

layer. *See* **level**

Layout: The Layout department creates environments where the action of the characters is placed. Layout artists must be aware of the continuity of the landscapes within a particular sequence and how the perspective is handled, and they must provide character poses for the animators to show how they will exist within their environment.

level, *also* **layer**: Levels are placed on top of each other over a background. In traditional cel animation, a scene could have only six levels plus the background or shadows that would appear around the edges of the character while filming. The multiplane camera allowed multiple levels to be placed on separate racks (or levels), providing greater depth between objects in the foreground and those in the background. In today's digital systems, multiple levels can be placed before the camera lens, but they are still kept within a systemized hierarchy so that those closest to the camera move at a different rate of speed than those farther away.

linear move: A linear move in camera mechanics is one that moves at the same rate

of speed from beginning to end. When moving directly from the head or through the end of the move, there should be no ease in or ease out of the mechanics, except in special circumstances.

lip sync: Short for "lip synchronization," lip sync is the method of using specific mouth shapes on a character to match the consonant and vowel sounds of the dialogue or song lyrics.

main lot: In this book, the main lot refers to the Disney Studios' original campus in Burbank, California. These custom-designed buildings housed the animation personnel after the studio moved from its Hyperion location. The main lot has since become the corporate headquarters, with a series of live-action soundstages located on the property.

mass, *also* **weight, volume**: These terms refer to how the character moves as it would react to gravity, its own girth, and how much room it takes up within the environment. The character's action would be affected by these factors in making realistic and believable motion.

mime, *also* **pantomime**: Mime is one of the most important factors in animating a character. The visual action should communicate with the viewer without the aid of dialogue. When creating movement, the animator strives to provide a clear silhouette of the character and their movement. Since the art of mime does not use words to communicate, this is a useful skill when planning action in animation.

modeling: Modeling, in a three-dimensional or computer-generated sense, is the technique of building the character or environment using essentially primitive shapes to construct a digital representation of the object.

motion path, *also* **path of action**: The motion path is how the camera records movement during a scene. It usually refers to a complex set of camera mechanics, like during a high-speed chase scene, or creates tension when moving through an abandoned house. In animation the character always leads the camera, as if the operator is unsure of what will happen next. Of course, in animation the entire trajectory of the camera is planned out during the layout stage, but once animated, the mechanics can be adjusted to follow the character's motion.

movie. *See* **film**

moving hold. *See* **hold**

multiplane, *also* **parallax**: Multiplane refers to a method of moving through dimensional space (z-depth) in animation. Disney's multiplane camera allowed two-dimensional artwork to seem as it if was moving through three dimensions by creating realistic proportional movement with foreground objects moving faster and background objects moving slower than those in the mid-ground.

offset, *also* **reposition**: Offset is an animation term for repositioning a character or background element to create a better composition. The number of increments can be held throughout a scene, or they can be animated to create motion.

on 1s, *also* **on 2s, on 4s**: On 1s refers to the amount of time a drawing is held on the screen. For action shots, the characters are normally animated on every frame (on 1s). In calmer, less frenetic action, the drawings can be held on 2s and still

retain a sense of full animation. Any longer than that results in a staggered look, with individual drawings being noticed by the human eye. For longer holds, like 4s, 6s, and 8s, cross-dissolves between drawings create a slow-motion action with two images being seen at the same time.

overlapping action: Overlapping action is a technique of drawing multiple images of part of a character to create a sense of speed or frenetic motion. These multiple extremities, like arms and legs, simulate faster action than simply moving the character or its background at greater speeds.

overpaint: In cel animation the cel-vinyl paint was applied to the back of the cel, and the character outlines were placed on the front. The color was kept within the lines, but every so often it would bleed past that boundary. This was termed an "overpaint" and it was easy to fix; once the paint dried, a sharpened stick, usually the end of the paintbrush, was used to gently scrape off the paint that extended beyond the line.

overshoot: Overshooting usually refers to a camera action where the movement goes beyond the character or action in an attempt to simulate a live-action camera operator missing the quick, unexpected movements of the actor. The overshoot creates tension and quick snap backs to give the scene a more frenetic feeling.

paint pop: A paint pop is when an element on a character level is painted the wrong color on a single cel, causing a momentary flash when the scene is played at speed.

pan: In camera mechanics, a pan is when the camera moves either vertically (N/S) or horizontally (E/W) to follow a character as it moves within the scene. This type of movement can be used to create a panoramic view of the environment.

pantomime. *See* **mime**

parallax. *See* **multiplane**

path of action. *See* **motion path**

pegs: In 2D animation, drawings and background elements were kept in exact registration by a series of pegs located along the top or bottom of the artwork. The setup consisted of a round central peg with two oblong pegs on either side. In the early days of the Disney Studios, five pegs were used: a central round peg and two oblong pegs on either side. That later changed to the industry standard of three pegs. In early animation production, two types of registration peg systems were used. The Oxberry peg system was found on the East Coast, in the New York industry, while the ACME peg system was dominant on the West Coast, in Los Angeles. ACME came to be the industry standard.

persistence of vision: Persistence of vision is an optical effect that occurs when the human eye retains an image for a fraction of a second before registering the next. Scientifically, the human brain can process only so many visuals (10–12) in one second; thus, seeing minutely sequential images within a short time span creates the illusion that a static image is moving.

personality animation. *See* **character animation**

pipeline, *also* **workflow**: The pipeline is an assembly-line process that takes scenes from their initial storyboard or workbook concept through different stages of

production until all the animation and layout elements are complete. It is then recorded as the final image in the film.

platen: The platen on an animation stand is a large expanse of glass that presses down on top of an animation setup of character cels and background elements. The weight presses down to flatten the artwork, minimizing the appearance of shadows on a multiple-level scene. For each frame, the platen is lifted, a new setup is placed on the camera table, and the platen is lowered, and one frame is exposed.

primary action: The primary action in an animated scene is the most important movement required in the shot. If the character is running, throwing, speaking, or turning, that is its primary action. Any follow-through movement in reaction to the primary action is known as secondary action and is not the main thrust of the scene.

production: The actual period when an animated film is in construction, moving through the pipeline toward a finished product.

pose-to-pose: A method of animating the character's action from key pose to the next within a scene.

poses: Individual drawings of a character or effect that guides the extreme actions within a scene.

postproduction: Postproduction refers to all the finishing processes of a film. After all the scenes are completed, sound effects and the music track are added, and pickup dialogue is inserted. This is also when the credits are added to the end of the film.

preproduction: Preproduction is the development period before a film goes into production. Story lines, characters, art direction, and other assets are conceived that answer questions about the film, its characters, its look, and its environment.

prop, properties: Props are items placed within the scene for the actors to use during the action or aid in dressing the environment to make it more believable.

reposition. *See* **resize**

resize, *also* **reposition**: Resize refers to the operation of reducing or enlarging an object or character and repositioning it to fit better within the action or landscape. If a character is drawn too large, it can be adjusted to match the proportion of the background. This operation also allows an image or group of images to be resized and repositioned multiple times in order to create a crowd without animating every individual. This was done with several of the hyena levels during Scar's song "Be Prepared" during *The Lion King*.

rig: A rig is the inner framework or skeleton that controls the movement of a three-dimensional model. Each joint acts as a control point, often with constraints on how that joint is allowed to move.

rostrum camera. *See* **animation camera**

rotoscope: Rotoscoping is a process by which a recorded filmstrip was projected down onto a flat surface where the image could be traced and later used as a matte or direct reference to create an animated character. The Fleischer Brothers' Koko the Clown was often a rotoscoped figure of David Fleischer wearing a clown suit and performing action for the films.

rough, *also* **ruff**: In its earliest form, drawings for an animated scene are known as roughs. These are the first sketches an animator makes when outlining the action of a scene. They can be as simple as a few suggestive lines of action or more complex, as when creating specific mouth shapes for lip-syncing to the dialogue. Individual animators have different methods of drawing that make them looser or tighter with their rough animation. Shooting a test of rough animation was usually referred to as the rough test.

rough timing: When first animating a scene, the animator usually creates a sense of rough timing to see how the character is moving within the allotted number of frames. This sense of action is then sharpened once the overall movement has been defined.

ruff. *See* **rough**

scale: The scale operation is used to shrink or expand an object so that it fits within the correct proportions of its scene or environment.

scanning: Scanning is a process by which drawings, backgrounds, or live-action photography is transformed into digital information. Once these elements are scanned, or imported, into the computer, they can then be manipulated for use in the scene.

scene, *also* **shot**: In animation, individual segments within a sequence are known as scenes. They can also be called shots, which more directly derives from live-action cinematography.

Scene Planning: Working with the director, layout artists, and animators, the scene planner constructs the camera mechanics that create naturalistic movement that follow the action of the scene. Scene planning also formats the distances within a multiplane setup and has the ability to target specific pass-through points where a character or background elements appears within the shot. This occurs in both 2D and 3D scenes.

secondary action: Secondary action refers to any follow-through movement that occurs in reaction to a character's primary movement. It is not the main action of the scene but helps to ground the movement, often through gravity or inertia.

self-lines: Self-lines are a technique of inking the outlines of a character in varying tones of the color palette, creating a richer, more complex image. They can be used in multiple ways, outlining shapes with darker or lighter tonal values than the object, contrasting hues to enrich the overall color palette, or accentuating the character's features or costume. Self-lines can also use the same color value as the object, creating the illusion of no outline at all.

sequence: A sequence a series of segments that move the narrative from the beginning to the end of the film. Each sequence is usually concentrated in one location with communication from a defined set of characters. Often songs or a dramatic turn of events make up an entire sequence.

shot. *See* **scene**

silhouette: A clean and clear silhouette is important when animating a character or

creating a background element because it provides an easily read visual shape for the viewer. Action taking place within the interior of a character is less readable than action taking place in a clearly silhouetted form. It allows the eye to more quickly recognize what is taking place.

skew: Skew is a subtle method of deforming a piece of artwork over a period of time to create specific visual effects—for example, creating the illusion of clouds drifting overhead or readable text moving toward a central vanishing point.

slippage, *also* **sliding**: When a character's feet move at a different rate than the background speed, the effect is known as slippage or sliding. This comes about when the character's rate of speed is not in unison with the ground plane.

slow-in, *also* **slow-out**: Slow-in and slow-out refer to the number of frames used to slow down a camera movement, whether it is at the beginning of a move or at the end.

Special Effects, *also* **Effects, EFX, SFX**: The Special Effects department animates elements other than the characters. They take care of atmospheric effects like rain, sleet, or snow; lighting effects that ground the character within their environment like tones, highlights, and shadows; and even footprints in the snow. They also create physical props such as barrels, farm implements, bubbles, and even beer foam.

sprocket, *also* **sprocket holes**: Sprocket holes are the perforations that guided film through the camera's shutter or, more specifically, the gate. Thirty-five-millimeter film was the same size for both photography and motion picture stock. The difference was that photography used a horizontal format with eight sprocket holes to every frame, while motion picture film used a vertical format with four sprockets to every frame. The sprockets were immensely important for registering bipacks within the camera housing so that the mattes would line up between shoots.

squash and stretch: Squash and stretch are the basic tools in learning how to animate. While actual human anatomy does very little of this, these qualities are used in animation to emphasize the action of gravity and follow-through, helping to create convincing movement.

staging: The directors and layout department devise the staging of each animated scene in a sequence. These directions provide the animator with motivation for the character's action. They also dictate the overall movement in a sequence so that the camera trajectory hooks up from one scene to the next.

stop-motion: Stop-motion is an animation technique different from two- or three-dimensional animation. It is usually done with puppets constructed with full body armature and often with removable heads so that different mouth shapes can be used to create lip sync for dialogue. Stop-motion requires physical puppets moving within a physical environment. For examples, see animation from Aardman Animations, Laika Studios, and films from director Harry Selik: *The Nightmare before Christmas* (1993), *James and the Giant Peach* (1996), and *Coraline* (2009).

story, *also* **narrative**: The plot of a book, film, or play, the story or narrative introduces the characters and sets up the situation leading to the crises and resolution of the

conflict, usually with a happy ending. A good story is the critical element in a film and often dictates the technology used to communicate it to the audience, whether live action or animation, two-dimensional, three-dimensional, or stop-motion.

storyboard: Storyboards are a series of small drawings, normally pinned to a large board, that display the action of a sequence. The boards convey information about the composition, the emotion, and how this scene exists within the sequence.

straight ahead: Straight ahead is a method of animating from the beginning of the scene to its end without using poses or extremes to choreograph the action.

sweat box: Sweat box is a term used to designate approval sessions with the directors and heads of departments. Scenes would be projected within the context of their sequence to see them in continuity and critique the animation. The term probably originated because the supervisor or animator would be on the proverbial hot seat and sweating as they awaited approval or notes from the director.

tangent: When character, element, or background lines brush the edge of the frame, this causes a tangent within the viewing area. These tangents destroy the silhouette of the action and are avoided except in special cases as dictated by the director.

texture map: Texture mapping is a computer process whereby an image or texture is attached to a geometric plane and moves proportionately with the plane when it is animated.

thumbnails: When planning out the action for a scene, some animators draw quick, small thumbnail images of the characters to work out their action and timing before beginning to rough out the entire movement.

timing, *also* **timing charts**: Different from the timeline, timing refers to the number of frames a drawing or action uses within a scene. According to the timing charts, a character's walk cycle can be slow or fast as it moves against the background. These charts can be broken down into separate charts, designating different parts of the character moving at different rates of speed, creating primary movements and secondary reactions.

timeline: The timeline of a film, scene, or historical period is a delineating factor whereby there is a defined start and end point, and the amount of time in between.

traditional, *also* **hand-drawn**: Traditional animation is a term used to refer to hand-drawn, two-dimensional animation, often exemplified by the cel animation method used in the early films from Walt Disney Productions.

truck-in, *also* **truck-out**: A truck-in or -out is when the camera physically changes position, advancing toward or away from the subject being recorded. This is also referred to as a dolly or tracking shot (also see **pan**). When the camera moves, the relative position of all elements within the shot change proportionally according to their position in the depth of field. This method can be achieved using a multiplane camera in animation.

three-dimensional, *also* **3D**: Three-dimensional, or 3D, animation refers to several different methods of animation production. Originally, it referred to actual solid three-dimensional objects, like puppets and miniature sets, now more of-

ten termed as stop-motion. In the twenty-first century, three-dimensional (3D) animation refers to computer-generated imagery (CGI) created within a virtual environment that contains not only a N/S and E/W coordinate system, but a Z-axis that represents depth in three-dimensional space.

two-dimensional, *also* **2D**: Two-dimensional, or 2D, animation most often refers to the traditional hand-drawn (cel animation) process used to create most early animated films. Using paper and pencil, the animator creates a series of drawings that move either a character or effect incrementally within the scene. Two-dimensional animation uses directions of N/S and E/W but most often remains flat, unable to move within three-dimensional space. Depth is achieved using a multiplane setup, where the camera is able to move through layers of two-dimensional artwork, giving the illusion of proportional rates of speed as it passes through the environment.

x-sheet. *See* **exposure sheet**

volume. *See* **mass**

weight. *See* **mass**

workbook: The workbook is a stage that comes after storyboards and before the assignment of layouts. The workbook for a sequence contains a copy of each scene's storyboard and/or a more detailed image of the action, as well as timing, dialogue, character poses, effects, and camera notes.

workflow. *See* **pipeline**

work print: Work prints were light, non-color-corrected prints that were struck from a processed negative and sent back to the editorial department from the film lab. Work prints were often shown as dailies. The work print was used only during production and rarely seen by the general public.

work reel, *also* **showreel, demo reel**: A work reel is a film portfolio of examples of an artist's or studio's work shown to prospective employers or clients.

zip pan: A zip pan is a quick panning movement where the action is so fast, the middle of the move is seen only as a blur. Often, the middle of the background for a zip pan is actually painted as a blurred image with streaks running in the direction of the movement.

zoom-in, *also*, **zoom-out**: A zoom-in or -out on the subject makes it larger or smaller in the frame by shifting the focal length of the lens, moving from a long shot to a wide angle or vice versa. In this case, the camera does not physically move as the subject changes size within the frame, so the spatial relationship between the character and the environment around it does not change.

Filmography

Walt Disney Animation Studios and Related Films (**bold** denotes Florida studio films):

Snow White and the Seven Dwarfs (1937). Dirs. William Cottrell, David Hand, and Wilfred Jackson. Walt Disney Productions/Walt Disney Animation Studios. Animated. 1h 23m.

Pinocchio (1940). Dirs. Norman Ferguson, T. Hee, and Wilfred Jackson. Walt Disney Animation Studios/Walt Disney Productions. Animated. 1h 28m.

Fantasia (1940). Dirs. James Algar, Samuel Armstrong, and Ford Beebe Jr. Walt Disney Productions Walt Disney Animation Studios. Live action/Animated. 2h 5m.

Dumbo (1941). Dirs. Samuel Armstrong, Norman Ferguson, and Wilfred Jackson. Walt Disney Animation Studios/Walt Disney Productions. Animated. 1h 4m.

Bambi (1942). Dirs. James Algar, Samuel Armstrong, and David Hand. Walt Disney Animation Studios/Walt Disney Productions. Animated. 1h 10m.

Saludos Amigos (1942 short). Dirs. Wilfred Jackson, Jack Kinney, and Hamilton Luske. Walt Disney Animation Studios/Walt Disney Productions. Animated. 42m.

The Three Caballeros (1944). Dirs. Norman Ferguson, Clyde Geronimi, and Jack Kinney. Walt Disney Productions/Walt Disney Animation Studios. Live action/Animated. 1h 11m.

Make Mine Music (1946). Dirs. Robert Cormack, Clyde Geronimi, and Jack Kinney. Walt Disney Animation Studios/Walt Disney Productions. Animated. 1h 15m.

Fun and Fancy Free (1947). Dirs. Jack Kinney, Hamilton Luske, and William Morgan. Walt Disney Pictures/Walt Disney Productions. Live action/Animated. 1h 13m.

Melody Time (1948). Dirs. Clyde Geronimi, Wilfred Jackson, and Jack Kinney. Walt Disney Animation Studios/Walt Disney Productions. Live action/Animated. 1h 15m.

The Adventures of Ichabod and Mr. Toad (1949). Dirs. James Algar, Clyde Geronimi, and Jack Kinney. Walt Disney Animation Studios/Walt Disney Productions. Animated. 1h 8m.

Cinderella (1950). Dirs. Clyde Geronimi, Wilfred Jackson, and Hamilton Luske. Walt Disney Productions/Walt Disney Animation Studios. Animated. 1h 14m.

Alice in Wonderland (1951). Dirs. Clyde Geronimi, Hamilton Luske, Wilfred Jackson, and, Jack Kinney. Walt Disney Animation Studios/Walt Disney Productions. Animated. 1h 15m.

Peter Pan (1953). Dirs. Clyde Geronimi, Wilfred Jackson, and Hamilton Luske. Walt Disney Productions/Walt Disney Animation Studios. Animated. 1h 17m.

Lady and the Tramp (1955). Dirs. Clyde Geronimi, Wilfred Jackson, and Hamilton Luske. Walt Disney Animation Studios/Walt Disney Productions. Animated. 1h 16m.

Sleeping Beauty (1959). Dirs. Clyde Geronimi, Eric Larson, and Les Clark. Walt Disney Animation Studios/Walt Disney Productions. Animated. 1h 15m.

One Hundred and One Dalmatians (1961). Dirs. Clyde Geronimi, Hamilton Luske, and Wolfgang Reitherman. Walt Disney Productions/Walt Disney Animation Studios. Animated. 1h 19m.

The Sword in the Stone (1963). Dirs. Wolfgang Reitherman, Clyde Geronimi, and David Hand. Walt Disney Productions/Walt Disney Animation Studios. Animated. 1h 19m.

The Jungle Book (1967). Dir. Wolfgang Reitherman. Walt Disney Animation Studios/Walt Disney Productions. Animated. 1h 18m.

The Aristocats (1970). Dir. Wolfgang Reitherman. Walt Disney Animation Studios/Walt Disney Productions. Animated. 1h 18m.

Robin Hood (1973). Dirs. Wolfgang Reitherman and David Hand. Walt Disney Productions/Walt Disney Animation Studios. Animated. 1h 23m.

The Many Adventures of Winnie the Pooh (1977). Dirs. John Lounsbery, Wolfgang Reitherman, and Ben Sharpsteen. Walt Disney Animation Studios/Walt Disney Productions. Animated. 1h 14m.

The Rescuers (1977). Dirs. John Lounsbery, Wolfgang Reitherman, and Art Stevens. Walt Disney Animation Studios/Walt Disney Productions. Animated. 1h 18m.

The Fox and the Hound (1981). Dirs. Ted Berman, Richard Rich, and Art Stevens. Walt Disney Animation Studios/Walt Disney Productions. Animated. 1h 23m.

The Black Cauldron (1985). Dirs. Ted Berman and Richard Rich. Walt Disney Pictures/Silver Screen Partners II/Walt Disney Animation Studios. Animated. 1h 20m.

The Great Mouse Detective (1986). Dirs. Ron Clements, Burny Mattinson, and David Michener. Walt Disney Pictures/Silver Screen Partners II/Walt Disney Animation Studios. Animated. 1h 14m.

Oliver & Company (1988). Dir. George Scribner. Walt Disney Animation Studios/Silver Screen Partners III/Walt Disney Pictures. Animated. 1h 14m.

The Little Mermaid (1989). Dirs. Ron Clements and John Musker. Walt Disney Pic-

tures/Silver Screen Partners IV/Walt Disney Animation Studios. Animated. 1h 23m.

The Rescuers Down Under (1990). Dirs. Hendel Butoy and Mike Gabriel. Silver Screen Partners IV/Walt Disney Animation Studios/Walt Disney Pictures. Animated. 1h 17m.

Beauty and the Beast (1991). Dirs. Gary Trousdale and Kirk Wise. Walt Disney Pictures/Silver Screen Partners IV/Walt Disney Animation Studios. Animated. 1h 24m.

Aladdin (1992). Dirs. Ron Clement and John Musker. Walt Disney Pictures/Silver Screen Partners IV/Walt Disney Animation Studios. Animated. 1h 30m.

The Lion King (1994). Dirs. Roger Allers and Rob Minkoff. Walt Disney Pictures/Walt Disney Animation Studios. Animated. 1h 28m.

Pocahontas (1995). Dirs. Mike Gabriel and Eric Goldberg. Walt Disney Pictures/Walt Disney Animation Studios. Animated. 1h 21m.

The Hunchback of Notre Dame (1996). Dirs. Gary Trousdale and Kirk Wise. Walt Disney Animation Studios/Walt Disney Pictures. Animated. 1h 31m.

Hercules (1997). Dirs. Ron Clements and John Musker. Walt Disney Pictures/Walt Disney Animation Studios/Walt Disney Feature Animation Paris. Animated. 1h 33m.

Mulan (1998). Dirs. Barry Cook and Tony Bancroft. Walt Disney Animation Studios/Walt Disney Feature Animation Florida/Walt Disney Pictures. Animated. 1h 28m.

Tarzan (1999). Dirs. Chris Buck and Kevin Lima. Walt Disney Pictures/Walt Disney Animation Studios. Animated. 1h 28m.

Fantasia 2000 (1999). Dirs. James Algar, Gaëtan Brizzi, Paul Brizzi, Hendel Butoy. Walt Disney Pictures/Walt Disney Animation Studios. Animated. 1h 15m.

Dinosaur (2000). Dirs. Eric Leighton and Ralph Zondag. Walt Disney Pictures/The Secret Lab (TSL)/Walt Disney Animation Studios. Animated. 1h 22m.

The Emperor's New Groove (2000). Dir. Mark Dindal. Walt Disney Animation Studios/Walt Disney Pictures. Animated. 1h 18m.

Atlantis: The Lost Empire (2001). Dirs. Gary Trousdale and Kirk Wise. Walt Disney Animation Studios/Walt Disney Pictures. Animated. 1h 35m.

Lilo & Stitch (2002). Dirs. Chris Sanders and Dean DeBlois. Walt Disney Animation Studios/Walt Disney Feature Animation Florida/Walt Disney Pictures. Animated. 1h 25m.

Treasure Planet (2002). Dirs. Ron Clements and John Musker. Walt Disney Animation Studios/Walt Disney Pictures. Animated. 1h 35m.

Brother Bear (2003). Dirs. Aaron Blaise and Robert Walker. Walt Disney Animation Studios/Walt Disney Feature Animation Florida/Walt Disney Pictures. Animated. 1h 25m.

Home on the Range (2004). Dirs. Will Finn and John Sanford. Walt Disney Pictures/Walt Disney Animation Studios. Animated. 1h 16m.

Chicken Little (2005). Dir. Mark Dindal. Walt Disney Pictures/Walt Disney Animation Studios. Animated. 1h 21m.

Meet the Robinsons (2007). Dir. Stephen J. Anderson. Walt Disney Animation Studios/ Walt Disney Pictures. Animated. 1h 35m.

Bolt (2008). Dirs. Byron Howard and Chris Williams. Walt Disney Animation Studios/Walt Disney Pictures. Animated. 1h 36m.

The Princess and the Frog (2009). Dirs. Ron Clements and John Musker. Walt Disney Animation Studios/Walt Disney Pictures. Animated. 1h 37m.

Tangled (2010). Dirs. Nathan Greno and Byron Howard. Walt Disney Animation Studios/Walt Disney Pictures. Animated. 1h 40m.

Winnie the Pooh (2011). Dirs. Stephen J. Anderson and Don Hall. Walt Disney Pictures/Walt Disney Animation Studios. Animated. 1h 3m.

Wreck-It Ralph (2012). Dir. Rich Moore. Walt Disney Animation Studios/Walt Disney Pictures. Animated. 1h 41m.

Frozen (2013). Dirs. Chris Buck and Jennifer Lee. Walt Disney Animation Studios/ Walt Disney Pictures. Animated 1h 42m.

Big Hero 6 (2014). Dirs. Don Hall and Chris Williams. FortyFour Studios/Walt Disney Animation Studios/Walt Disney Pictures. 3D Animated. 1h 42m.

Zootopia (2016). Dirs. Byron Howard, Rich Moore, and Jared Bush. Walt Disney Pictures/Walt Disney Animation Studios. Animated. 1h 48m.

Moana (2016). Dirs. Ron Clements, John Musker, and Don Hall. Hurwitz Creative/ Walt Disney Pictures/Walt Disney Animation Studios. Animated. 1h 47m.

Ralph Breaks the Internet (2018). Dirs. Phil Johnston and Rich Moore. Walt Disney Animation Studios/Walt Disney Pictures. Animated. 1h 52m.

Frozen II (2019). Dirs. Chris Buck and Jennifer Lee. Walt Disney Animation Studios/ Walt Disney Pictures. Animated. 1h 43m.

Raya and the Last Dragon (2021). Dirs. Don Hall, Calos López Estrada, and John Ripa. Walt Disney Animation Studios/Walt Disney Pictures. Animated. 1h 47m.

Encanto (2021). Dirs. Jared Bush, Byron Howard, and Charise Castro Smith. Walt Disney Animation Studios/Walt Disney Pictures. Animated. 1h 42m.

Bibliography

Books

Allan, Robin. *Walt Disney and Europe: European Influences on the Animated Feature Films of Walt Disney*. London: John Libbey, 1999.

Auzenne, Valliere Richard. *The Visualization Quest: A History of Computer Animation*. Rutherford, NJ: Fairleigh Dickinson University Press, 1994.

Barrier, Michael. *Hollywood Cartoons: American Animation in Its Golden Age*. New York: Oxford University Press, 1999.

Bossert, David A. *Dali and Disney: Destino*. New York: Disney Editions, 2015.

———. *Kem Weber: Mid-Century Furniture Designs for the Disney Studio*. Los Angeles: Old Mill Press, 2018.

———. *Remembering Roy E. Disney: Memories and Photos of a Storied Life*. New York: Disney Editions, 2013.

Bryman, Alan. *The Disneyization of Society*. London: Routledge, 2004.

Bukatman, Scott. *Matters of Gravity: Special Effects and Supermen in the 20th Century*. Durham, NC: Duke University Press, 2003.

Burrough, Bryan. *The Big Rich: The Rise and Fall of the Greatest Texas Oil Fortunes*. New York: Penguin Press, 2009.

Cabarga, Leslie. *The Fleischer Story*. New York: DaCapo Press, 1988.

Clunas, Craig. *Art in China*. New York: Oxford University Press, 1997.

Crafton, Donald. *Before Mickey: The Animated Film, 1898–1928*. Chicago: University of Chicago Press, 1982.

Culhane, John. *Disney's Aladdin: The Making of an Animated Film*. New York: Hyperion, 1992.

———. *Fantasia 2000: Visions of Hope*. White Plains, NY: Disney Editions, 1999.

DeBlois, Dean. "Keeping it Small." In Lilo and Stitch: *Collected Stories from the Film's*

Creators, edited by H. Clark Wakabayashi, 37–38. New York: Disney Editions, 2002.

Disney, Roy E. *The Magic of Disney Animation, Premiere Edition*. White Plains, NY: Hyperion, 1989.

Feild, Robert D. *The Art of Walt Disney*. New York: Macmillan, 1942.

Finch, Christopher. *The Art of* The Lion King. New York: Hyperion, 1994.

Fjellman, Stephen M. *Vinyl Leaves: Walt Disney World and America*. Boulder, CO: Westview Press, 1992.

Fleischer, Richard. *Out of the Inkwell: Max Fleischer and the Animation Revolution*. Lexington: University of Kentucky Press, 2005.

Gilland, Joseph. *Elemental Magic: The Art of Special Effects Animation*. Oxford, UK: Focal Press, 2009.

Iwerks, Leslie, and John Kenworthy. *The Hand behind the Mouse: An Intimate Biography of the Man Walt Disney Called "The Greatest Animator in the World."* New York: Disney Editions, 2001.

Kurtti, Jeff. *The Art of* Mulan. New York: Hyperion, 1998.

Lasseter, John, and Steven Daly. Toy Story: *The Art and Making of the Animated Film*. White Plains, NY: Disney Editions, 1995.

Masters, Kim. *The Keys to the Kingdom: How Michael Eisner Lost His Grip*. New York: HarperCollins, 2000.

Nelson, Scott Reynolds, and Marc Aronson. *Ain't Nothing but a Man: My Quest to Find the Real John Henry*. Washington, DC: National Geographic Children's Books, 2007.

Neupert, Richard. *John Lasseter*. Contemporary Film Director Series. Urbana: University of Illinois Press, 2016.

Pallant, Chris. *Demystifying Disney: A History of Disney Feature Animation*. London: Continuum, 2011.

Sanders, Chris. "Pitching Stitch." In *Lilo and Stitch: Collected Stories from the Film's Creators*, edited by H. Clark Wakabayashi, 27. New York: Disney Editions, 2002.

Schatz, Thomas. *Boom and Bust: American Cinema in the 1940s*. Oakland: University of California Press, 1999.

Sito, Tom. *Moving Innovation: A History of Computer Animation*. Cambridge: MIT Press, 2013.

Sklar, Marty. *One Little Spark! Mickey's Ten Commandments and the Road to Imagineering*. White Plains, NY: Disney Editions, 2015.

Sluiter, Ric. "The Master's Pebbles." In *Lilo and Stitch: Collected Stories from the Film's Creators*, edited by H. Clark Wakabayashi, 57–58. New York: Disney Editions, 2002.

Sotheby's. *The Art of* Who Framed Roger Rabbit. New York: Sotheby's, 1989.

———. *The Art of* The Little Mermaid. New York: Sotheby's, 1990.

Spencer, Clark. "Taking the Plunge." In Lilo and Stitch: *Collected Stories from the Film's Creators*, edited by H. Clark Wakabayashi, 45. New York: Disney Editions, 2002.

Stewart, James B. *Disney War*. New York: Simon and Schuster, 2005.

Telotte, J. P. *Animating Space: From Mickey to* Wall-E. Lexington: University of Kentucky Press, 2010.

———. *The Mouse Machine: Disney and Technology*. Urbana: University of Illinois Press, 2008.

Thomas, Bob. *Disney's Art of Animation: From Mickey Mouse to Hercules*. New York: Hyperion, 1997.

Thomas, Frank, and Ollie Johnston. *Disney Animation: The Illusion of Life*. New York: Abbeville Press, 1981.

Tibbetts, John C., and James M. Welsh, eds. *Classic Screen Interviews*. Lanham, MD: Scarecrow Press, 2010.

Thorp, Robert L., and Richard Ellis Vinograd. *Chinese Art and Culture*. Upper Saddle River, NJ: Pearson Prentice Hall, 2006.

Wakabayashi, H. Clark, ed. Lilo and Stitch: *Collected Stories from the Film's Creators*. New York: Disney Editions, 2002.

Watts, Steven. *The Magic Kingdom: Walt Disney and the American Way of Life*. Columbia: University of Missouri Press, 2001.

Weishar, Peter. *CGI: The Art of the 3D Computer-Generated Image*. New York: Harry N. Abrams, 2004.

Wells, Paul. *Understanding Animation*. New York: Routledge, 1998.

Newspapers, Periodicals, Websites, Other Media

Abbot, Jim. "The Making of *Mulan.*" *Orlando Sentinel*, June 17, 1998.

Amidi, Amid. "John Lasseter Resistance Grows as Lightbox Expo Nixes Skydance Sponsorship." *Cartoon Brew*, February 20, 2019. Online.

Animation World Network. "Respect for Tradition Combined with Technological Excellence Drives Cambridge Animation's Leadership." SIGGRAPH 98 Special. *Animation World Magazine*, Issue 3.5 (1998).

Armstrong, Josh. "Director Barry Cook Remembers the People of Disney Animation Florida." *AnimatedViews.com*, July 30, 2012. Online.

Associated Press. "Company News: Disney to Close Animation Studio in Orlando." *New York Times*, January 13, 2004.

———. "Disney Pulls Its Animators from Orlando." *St. Petersburg Times*, January 13, 2004.

BBC. "Chinese Unimpressed with Disney's *Mulan.*" *BBC News*, March 19, 1999.

Bevil, Dewayne. "Star Wars Launch Bay Finds Fans Quickly at Disney." *Orlando Sentinel*, December 1, 2015.

Boyar, Jay. "Movie Review: *Aladdin* (Video Release)." *Orlando Sentinel*, September 27, 1993.

Brown, Corie, and Laura Shapiro. "Woman Warrior." *Newsweek*, June 8, 1998.

Carchidi, Jim. "Star Wars Launch Bay Opens at Disney's Hollywood Studios." *Orlando Business Journal*, December 1, 2015.

CNN. "Disney Shutters Florida Studio." CNN, January 12, 2004.

———. "Eisner and Mickey at Last Parting Ways." *CNN Money*, September 10, 2004.

Desowitz, Bill. "Academy to Honor David Inglish with Bonner Medal." *Animation World Network*, January 3, 2008. Online.

Ebert, Roger. "Reviews: *Aladdin*," November 25, 1992. RogerEbert.com. Online.

Eisenberg, Adam. "Romancing the Rabbit." *Cinefex* 35 (August 1988).

Feild, Robert D. "Lecture by Professor Robert Feild of Harvard University." Las Palmas Theatre, Hollywood, August 9, 1938.

Flores, Terry. "Veteran Animator Glen Keane on His 'Duet' with Google." *Variety*, December 4, 2014.

"Frank Wells, Disney's President, Is Killed in a Copter Crash at 62." Obituary. *New York Times*, April 5, 1994.

Fritscher, Lisa. "It Was Universal Orlando's Darkest Day, and I Was There to See It." *Theme Park Tourist*, August 12, 2015. Online.

Gish, Jen. "What Becomes a Legend Most?" *Los Angeles Times*, June 14, 1998.

Godfrey, Leigh. "David Stainton Named President, Disney Feature Animation." *Animation World Network*, January 3, 2003. Online.

Graser, Marc. "Disney Animation, Pixar Promote Andrew Millstein, Jim Morris to President." *Variety*, November 18, 2014.

Harwell, Drew. "How Theme Parks Like Disney World Left the Middle Class Behind." *Washington Post*, June 12, 2015.

Hinman, Catherine. "Ed McMahon Will Search for Stars at Disney-MGM." *Orlando Sentinel*, May 12, 1992.

Holson, Laura M. "Disney Agrees to Acquire Pixar in a $7.4 Billion Deal." *New York Times*, January 25, 2006.

———. "A Quiet Departure for Eisner at Disney." *New York Times*, September 26, 2005.

Kaufman, Catherine. "Ed McMahon Will Search for Stars at Disney-MGM." *Orlando Sentinel*, May 12, 1992.

Kit, Borys. "John Lasseter to Head Animation at Skydance." *Hollywood Reporter*, January 9, 2019.

Korkis, Jim. "The Magic of Disney Animation Pavilion." *MousePlanet*, June 8, 2016. Online.

———. "The Story behind *Back to Neverland*." *MousePlanet*, June 15, 2016. Online.

———. "When Roy E. Disney Resigned from Disney Twice." *MousePlanet*, April 13, 2016. Online.

LaMonica, Paul R. "Disney Buys Pixar." *CNN Money*, January 25, 2006.

Lambert, Marjie. "Disney's Hollywood Studios Offers Sampler of 'Star Wars' Goodies to Tide Fans Over until 'Star Wars' Land Opens." *Miami Herald*, December 23, 2015.

Langer, Mark. "Regionalism in Disney Animation: Pink Elephants and Dumbo." *Film History* 4, no. 4 (1990): 305–321.

Langfitt, Frank. "Disney Magic Fails *Mulan* in China." *Baltimore Sun*, May 3, 1999.

Lyons, Mike. "Cover Story: *Mulan*: Disney Animates the Epic Folk Tale of an Ancient Warrior Woman." *Cinefantastique* 30, no. 3 (1998): 19–31.

———. "Effects Animation: Mulan." *Cinefantastique* 30, no. 3 (1998): 26.

———. "The Florida Studio: The Underdog Has Its Day." *Cinefantastique* 30, no. 3 (1998): 28.

Maddaus, Gene. "John Lasseter Will Exit Disney at the End of the Year." *Variety*, June 8, 2018.

Marr, Merissa. "Disney Reaches to the Crib to Extend Princess Magic." *Wall Street Journal*, November 19, 2007.

Marr, Merissa, and Nick Wingfield. "Disney Sets $7.4 Billion Pixar Deal." *Wall Street Journal*, January 25, 2006.

Maslin, Janet. "Review/Film: Disney Puts Its Magic Touch on *Aladdin*." *New York Times*, November 11, 1992.

Masters, Kim. "Cinema: A Sneak Peek at the Promised Land: Will DreamWorks' First Animated Feature Be a Zion King? See for Yourself." *Time* 151, no. 114 (1998).

———. "The Epic Disney Blow-Up of 1994: Eisner, Katzenberg, and Ovitz 20 Years Later." *Hollywood Reporter*, April 9, 2014.

Mathews, Jack. "This Isn't Your Father's *Pocahontas*." *New York Newsday*, June 19, 1998.

Mendelson, Scott. "Without Disney, Even John Lasseter Can't Turn Skydance into the Next Pixar." *Forbes*, February 19, 2019.

Newton, Edmund, and James Bates. "Disney President Wells Killed in Copter Crash Accident." *Los Angeles Times*, April 4, 1994.

Orwall, Bruce. "Roy Disney Quits Company Board and Calls on Eisner to Resign, Too." *Wall Street Journal*, December 1, 2003.

Pack, Todd. "Disney Animation Unit Fades Away in Orlando." *Orlando Sentinel*, January 13, 2004.

Parker, Trey, and Matt Stone, dirs. *Southpark*. Comedy Central, 1997–present.

Paxman, Andrew. "Disney Gets Animated in Florida." *Variety*, June 9, 1998.

Pepper, Jeffrey. "The Disneyland Art Corner." *2719 Hyperion* (blog), February 23, 2009. Online.

Peters, Jenny. "Disney Re-Orients Itself with *Mulan*." *Animation Magazine* 12, no. 6, #68 (1998): 6–9.

Pierce, Todd James. "Disney-MGM Studio Backlot in Burbank." *Disney History Institute*, February 22, 2016. Online.

Proctor, Rich. "Pictures That Move People—BRC and the Magic of Disney Animation." *BRC Imagination Arts*, July 15, 2015. Online.

Reid, Craig. "The Origins: The Female Chinese Warrior in Legend, Films, and TV." *Cinefantastique* 30, no. 3 (1998).

Reuters. "Roy Disney to Dismantle Site after Striking Truce." *Los Angeles Times*, July 15, 2005.

Robertson, Barbara. "Disney Lets CAPS Out of the Bag." *Computer Graphics World* 7, no. 7 (1994): 58–64.

———. "*Fantasia 2000*." *Computer Graphics World* 23, no. 1 (2000).

Schaefer, Stephen. "No China Doll: Disney's Newest Heroine Fights Her Own Battles in *Mulan*." *Boston Herald*, June 16, 1998.

Schmalz, Jeffrey. "Nastiness Is Not a Fantasy in Movie Theme Park War." *New York Times*, August 13, 1989.

Shulgasser, Barbara. "*Mulan*: Girl Power from Disney." *San Francisco Examiner*, June 19, 1998.

Silfianos, George. "The Definition of Animation: A Letter from Norman McLaren." *Animation Journal* 3, no. 2 (1995): 62–66.

Small, Edward S., and Eugene Levinson. "Toward a Theory of Animation." *Velvet Light Trap* 24 (Fall 1989): 67–74. Online.

Solomon, Charles. "Cover Story: *Aladdin*'s Inspiration? They Rubbed Hirschfeld." *Los Angeles Times*, November 8, 1992.

———. "With *Dear Basketball*, Kobe Bryant Could Add an Oscar to His Victories." *New York Times*, February 20, 2018.

Stack, Peter. "Disney Gives Animated *Mulan* a Deft Human Touch." *San Francisco Chronicle*, June 19, 1998.

Street, Rita. "BRC Imagination Arts." *Animation World*, November 1, 1996. Online.

———. "Toys Will Be Toys." *Cinefex* 64 (December 1995).

Strother, Susan G. "Universal Delays Park, Opening Date Pushed to June." *Orlando Sentinel*, January 31, 1990.

Sullivan, Brian, et al. "CAPS (Computer Animation Production System)." *People behind the Pixels: The History of Computer Graphics*, January 1, 1991. Online.

Taylor, Drew. "How *The Great Mouse Detective* Kick-Started the Disney Renaissance." *Oh My Disney*, September 18, 2015. Online.

Traci, Joe, and Vicki Traci. "Breathing Life into *The Prince of Egypt*." *Animation Artist*, August 13, 2003.

Turan, Kenneth. "Movie Review: The 1,001 Delights of *Aladdin*." *Los Angeles Times*, November 11, 1992.

Verrier, Richard. "Feud at Disney Ends Quietly." *Los Angeles Times*, July 9, 2005

———. "Florida Accuses Former Digital Domain Media Officers of Fraud." *Los Angeles Times*, July 26, 2014.

Weinraub, Bernard. "Disney Will Defy China on Its Dalai Lama Film." *New York Times*, November 17, 1996.

Weiss, Werner. "Disney-MGM Studios: The End of the MGM Name." *Yester Studios at Yesterland.com* (July 2016). Online.

Whipp, Glenn. "Mulan Breaks the Mold with Girl Power: Newest Heroine Isn't Typical Disney Damsel Waiting for Her Prince to Come." *Los Angeles Daily News*, June 19, 1998.

Films

Blaise, Aaron, and Robert Walker, dirs. *Brother Bear*. Walt Disney Animation Studios/Walt Disney Feature Animation Florida/Walt Disney Pictures, 2003.

Butoy, Hendel, dir. *Fantasia 2000*. Walt Disney Pictures, 1999.

Clements, Ron, and John Musker, dirs. *Aladdin*. Walt Disney Pictures, 1992,

———. *Aladdin: Disney Special Platinum Edition*. DVD. Walt Disney Home Entertainment, 2004.

———. *The Little Mermaid*. Walt Disney Animation Studios, 1989.

Cook, Barry, dir. *Off His Rockers*. Walt Disney Pictures, 1992.

Cook, Barry, and Tony Bancroft, dirs., *Mulan*. Walt Disney Animation Studios/Walt Disney Feature Animation Florida/Walt Disney Pictures, 1998.

Geronimi, Clyde, Wilfred Jackson, and Hamilton Luske, dirs. *Alice in Wonderland*. Walt Disney Productions, 1951.

———. *Alice in Wonderland: 60th Anniversary Edition*. Blu-ray. Walt Disney Studios Home Entertainment, 2011.

Geronimi, Clyde, Hamilton Luske, and Wolfgang Reitherman. *One Hundred and One Dalmatians*. Walt Disney Pictures, 1961.

Hahn, Don, dir. *Howard*. Stone Circle Pictures, 2018.

———. *Waking Sleeping Beauty*. Red Shoes and Stone Circle Pictures, 2009.

———. *Waking Sleeping Beauty*. DVD. Walt Disney Studios Home Entertainment, 2010.

Kahrs, John, dir. *Paperman*. Walt Disney Animation Studios, 2012.

Kleiser, Randal, dir. *Honey, I Blew Up the Kid*. Walt Disney Pictures, 1992.

Leighton, Eric, and Ralph Zondag, dirs. *Dinosaur*. Walt Disney Animation Studios, 2000.

Lund, Dan, dir. *Dream On, Silly Dreamer*. WestLund Productions. 2005.

Rees, Jerry, and Bob Rogers, dirs. *Back to Neverland*. BRC Imagination Arts, 1989.

Sanders, Chris, and Dean DeBlois, dirs. *Lilo and Stitch*. Walt Disney Animation Studios/Walt Disney Feature Animation Florida/Walt Disney Pictures, 2002.

Schaffer, Christen Harty, producer. *The Making of* The Prince of Egypt. Documentary. Triage Inc., DreamWorks, LLC, 1998.

Schreck, Kevin, dir. *Persistence of Vision*. Kevin Schreck Productions, DVD, 2012.

Scribner, George, dir. *The Prince and the Pauper*. Walt Disney Pictures, 1990.

Walt Disney Treasures: Behind the Scenes at the Walt Disney Studio. Walt Disney Productions, 1937–1957; Walt Disney Home Video, DVD, 2002.

Williams, Richard, dir. "The Thief and the Cobbler." Richard Williams Productions, 1993.

Zemeckis, Robert, dir. *Who Framed Roger Rabbit*. Touchstone Pictures, Amblin Entertainment, and Silver Screen Partners II, 1988.

———. *Who Framed Roger Rabbit: 25th Anniversary Edition*. Blu-ray. Buena Vista Home Entertainment, 2013.

Interviews and Email Correspondence

Adams, Jo Anne. October 10, 2015, Orlando, Florida

Bancroft, Tony. June 30, 2014, Pasadena, California

Barnhart, Philo. March 15, 2019, via email

Beckerman, Howard. September 26, 2013, New York, New York

Beckerman, Howard. April 10, 2011, via email
Bennett, Sylvie. February 22, 2017, via email
Blanchard, Pam. July 1, 2015, Orlando, Florida
Bour, Elliot. June 26, 2014, Burbank, California
Canemaker, John. September 25, 2013, New York, New York
Cesar, Darko. December 6, 2015, Orlando, Florida
Chin, Greg. June 21, 2016, via email
Cipriano, Tony. September 22, 2013, via email
Cole, Sarah. November 10, 2013, Winter Garden, Florida
Cook, Barry. March 29, 2016, Burbank, California
Cook, Barry, June 17, 2016, via email
Darley, Pam. April 27, 2015, Orlando, Florida
DeLuca, Peter. June 28, 2014, San Pedro, California
Duhatschek, Gabriella Lynn. March 8, 2017, Clermont, Florida
Duhatschek, Michael. March 8, 2017, Clermont, Florida
Garbera, Matt. November 9, 2013, Lake Buena Vista, Florida
Gayle, Annette. November 10, 2013, Winter Garden, Florida
Ghertner, Ed. May 26, 2014, via email
Gielow, Tad. November 30, 2016, via email
Gladstone, Frank. July 2, 2014, Burbank, California
Gorey, Richard. September 9, 2013, Tuckahoe, New York
Gutowski, Jan. January 16, 2015, via email
Gworek, Don, November 16, 2015, via email
Hadrika, Darlene. October 15, 2016, via email
Hadrika, Darlene. November 20, 2016, Orlando, Florida
Healy, Rosemary. November 10, 2013, Winter Garden, Florida
Hodge, Tim. October 31, 2009, via email
Howard, Max. July 3, 2014, Lake Arrowhead, California
Kagel, Jen. June 18, 2016, via email
Khalaf, Tamara. August 24, 2016, via email
King, Todd. July 20, 2014, via email
Leatherberry, Charles. July 25, 2014, telephone conversation with author
Lew, Jack. August 27, 2015, via email
Lord, Rachele. December 9, 2015, St. Cloud, Florida
Martinez, Anne Marie. July 21, 2016, Tallahassee, Florida
McDermott, Steve. January 19, 2019, Madrid, Spain
Meek, Stephen. June 27, 2014, Studio City, California
Menjivar, Mario. September 26, 2013, New York, New York
Middleton, Tammy. October 11, 2015, Orlando, Florida
Montgomery, Michael. October 9, 2015, Orlando, Florida
Norman, Jeanie Lynd. February 16, 2019, via email
Poirier, Barbara. November 9, 2013, Lake Buena Vista, Florida
Ostrow, Ken. January 19, 2014, Lake Buena Vista, Florida

Reinert, Lisa. March 30, 2016, Burbank, California
Rogers, Bob. August 17, 2016, via email
Sacks, Laurie. January 14, 2016, via email
Santos, Danny. February 2, 2019, via email
Schoeppner, Kathy. June 22, 2014, Burbank, California
Shindell, Jay. July 1, 2014, West Hollywood, California
Sinclair, Sherrie. February 11, 2019, via email
Stanton, Robert. November 9, 2009, via email
Tiano, Brent. December 8, 2015, Windermere, Florida
Vincent, Sharon. October 10, 2015, Davenport, Florida
Vincent, Sharon. February 14, 2016, via email
Williford, Paula. March 7, 2017, Deland, Florida
Williford, Ronnie. March 7, 2017, Deland, Florida

Suggested Reading

Abrams, Janet. "Interview with Michael Eisner: New Projects for the Walt Disney Company." *Ottagono* 99 (June 1991): 38–72.

Arnheim, Rudolf. *Visual Thinking*. Berkeley: University of California Press, 1969.

Artz, Lee. "The Righteousness of Self-Centered Royals: The World According to Disney Animation." *Critical Arts* 18, no. 1 (2004): 116–36.

Bacher, Hans. *Dream Worlds: Production Design for Animation*. New York: Focal Press, 2006.

Ball, Ryan. "Interview with Max Howard." *Animation Magazine*, November 3, 2005.

Bancroft, Colette. "Lost Art." *St. Petersburg Times*, December 21, 2003.

Barr, Alfred H., Jr., ed. *Fantastic Art, Dada, Surrealism*. Exh. Cat., Museum of Modern Art, New York, December 1936–January 1937. New York: Simon and Schuster, 1946.

Bayles, David, and Ted Orland. *Art and Fear: Observations on the Perils (and Rewards) of Artmaking*. Santa Cruz: Image Continuum, 1993.

Beckerman, Howard. *Animation: The Whole Story*. Mattituck, NY: Amereon House, 2001.

Beckman, Karen, ed. *Animating Film Theory*. Durham, NC: Duke University Press, 2014.

Bell, Elizabeth, Lynda Haas, and Laura Sells, eds. *From Mouse to Mermaid: The Politics of Film, Gender, and Culture*. Bloomington: Indiana University Press, 1995.

Bendazzi, Giannalberto. *Cartoons: One Hundred Years of Cinema Animation*. Bloomington: Indiana University Press, 1994.

Betsky, Aaron. "Animated Architecture" (Feature Animation Building). *Architectural Record* 183 (March 1995): 72–81.

Block, Bruce A. *The Visual Story: Seeing the Structure of Film, TV, and New Media*. Boston: Focal Press, 2001.

Brode, Douglas. *From Walt to Woodstock: How Disney Created the Counterculture*. Austin: University of Texas Press, 2004.

———. *Multiculturalism and the Mouse: Race and Sex in Disney Entertainment*. Austin: University of Texas Press, 2005.

Bryman, Alan. *Disney and His Worlds*. London: Routledge, 1995.

Bukatman, Scott. *The Poetics of Slumberland: Animated Spirits and the Animating Spirit*. Berkeley: University of California Press, 2012.

———. "There's Always Tomorrowland: Disney and the Hypercinematic Experience." *October* 57 (1991): 55–78.

Byrne, Eleanor and Martin McQuillan. *Deconstructing Disney*. London: Pluto Press, 1999.

Canemaker, John. *Before the Animation Begins: The Art and Lives of Disney Inspirational Sketch Artists*. New York: Disney Enterprises, 1996.

———. "The *Fantasia* That Never Was." *Print* 42, no. 1 (1988): 76–87, 139–40.

———. *Paper Dreams: The Art and Artists of Disney Storyboards*. New York: Disney Editions, 1999.

———, ed. *Storytelling in Animation: The Art of the Animated Image*. Vol. 2. Los Angeles: American Film Institute, 1988.

Cappiccie, Amy, Janice Chadha, Huh Bi Lin, and Frank Snyder. "Using Critical Race Theory to Analyze How Disney Constructs Diversity: A Construct for the Baccalaureate Human Behavior in the Social Environment Curriculum." *Journal of Teaching in Social Work* 32, no. 1 (2012): 46–61.

Catmull, Ed, and Amy Wallace. *Creativity, Inc.: Overcoming the Unseen Forces That Stand in the Way of True Inspiration*. New York: Random House, 2014.

Cavalier, Stephen. *The World History of Animation*. Berkeley: University of California Press, 2011.

Cheu, Johnson, ed. *Diversity in Disney Films: Critical Essays on Race, Ethnicity, Gender, Sexuality, and Disability*. Jefferson, NC: McFarland and Company, 2013.

Cholodenko, Alan. *The Illusion of Life: Essays on Animation*. Sydney: Power Publications, 1991.

Chris, Cynthia. "Beyond the Mouse-Ear Gates: The Wonderful World of Disney Studios." *Afterimage* 23 (Nov./Dec. 1995): 8–12.

Crafton, Donald. "Animation Iconography: The 'Hand of the Artist.'" *Quarterly Review of Film Studies* 4, no. 4 (1979): 409–427.

———. *Emile Cohl: Caricature and Film*. Princeton, NJ: Princeton University Press, 1990.

Crary, Jonathan. *Suspensions of Perception: Attention, Spectacle, and Modern Culture*. Cambridge: MIT Press, 1999.

———. *Techniques of the Observer: On Vision and Modernity in the Nineteenth Century*. Cambridge: MIT Press, 1992.

Crawford, Holly. *Attached to the Mouse: Disney and Contemporary Art*. Lanham, MD: University Press of America, 2006.

Culhane, John. *Walt Disney's* Fantasia. New York: Harry N. Abrams Publishers, 1983.

Culhane, Shamus. *Talking Animals and Other People*. New York: St. Martin's Press, 1986.

Dalle Vacche, Angela. *Cinema and Painting: How Art Is Used in Film*. Austin: University of Texas Press, 1996.

Darley, Andrew. "Bones of Contention: Thoughts on the Study of Animation." *Animation* 2, no. 1 (2007): 63–76.

Davis, Amy M. "The Fall and Rise of *Fantasia*." In *Hollywood Spectatorship: Changing Perceptions of Cinema Audiences*, edited by Melvin Stokes and Richard Maltby, 63–78. London: British Film Institute, 2001.

Deja, Andreas. *The Nine Old Men: Lessons, Techniques, and Inspiration from Disney's Great Animators*. Boca Raton, FL: CRC Press, 2016.

Desowitz, Bill. "Swept Away: The Making of *Lilo and Stitch*." *Animation Magazine* 16, no. 6, #114 (2002): 30–34.

Detmers, Fred H., ed. *American Cinematographer Manual*. 6th ed. Hollywood: ASC Press, 1986.

Dewey, Donald. *Buccaneer: James Stuart Blackson and the Birth of American Movies*. Lanham, MD: Rowman and Littlefield, 2016.

Disney and Dali: Architects of the Imagination. Exh. Cat., Walt Disney Family Museum, San Francisco, July 10, 2015–January 3, 2016. New York: Disney Editions, 2015.

Disney, Walt. *Tips on Animation*. Anaheim, CA: Disneyland Art Corner, 1956.

Downey, Sharon D. "Feminine Empowerment in Disney's *Beauty and the Beast*." *Women's Studies in Communication* 19, no. 2 (1996): 185–212.

Ebert, Roger. "*Mulan*: Review." *Chicago Sun-Times*, June 19, 1998.

Eco, Umberto. *Travels in Hyperreality*. San Diego: Harcourt, Brace, and Company, 1983.

Eisenstein, Sergei. *Eisenstein on Disney*. Edited by Jay Leyda and translated by Alan Upchurch. Calcutta: Seagull Books, 1986.

———. *Film Form: Essays in Film Theory*. Edited and translated by Jay Leyda. San Diego: Harvest Book, 1949–1977.

Finch, Christopher. *The Art of Walt Disney: From Mickey Mouse to the Magic Kingdoms*. New York: Harry N. Abrams, 1973.

Furniss, Maureen. *Animation: Art and Industry*. London: John Libbey Publishing, 2009.

———. *Art in Motion: Animation Aesthetics*. London: John Libbey Publishing, 1998.

Gabler, Neal. *Walt Disney: The Triumph of the American Imagination*. New York: Vintage Books, 2007.

Girveau, Bruno. *Once Upon a Time: Walt Disney, the Sources of Inspiration for the Disney Studios*. New York: Prestel, 2006.

Grant, John. *Masters of Animation*. New York: Watson-Guptill Publications, 2001.

Green, Howard E. *The Tarzan Chronicles*. New York: Hyperion, 1999.

Griffin, Sean. *Tinker Bells and Evil Queens: The Walt Disney Company from Inside Out*. New York: New York University Press, 2000.

Hahn, Don. *Disney's Animation Magic: A Behind-the-Scenes Look at How an Animated Film Is Made*. New York: Hyperion, 1996.

———. "Oscars 1992: Producer Don Hahn on How *Beauty and the Beast* Changed Animation." *Inside Movies*, February 22, 2012. http://insidemovies.ew.com/2012/02/22/oscars-1992-beauty-and-the-beast.

Hinman, Catherine. "Animators Back to Drawing Board: Spinoffs from Disney Movies Keep Theme Park's Artists Busy." *Orlando Sentinel*, February 7, 1994.

Hoermer, Keisha L. "Gender Roles in Disney Films: Analyzing Behaviors from *Snow White* to Simba." *Women's Studies in Communication* 19, no. 2 (1996): 213–28.

Jackson, Kathy Merlock. *Walt Disney: A Bio-Bibliography*. Westport, CT: Greenwood Press, 1993.

Johnson, Mindy. *Ink and Paint: The Women of Walt Disney's Animation*. New York: Disney Editions, 2017.

Kanfer, Stefan. *Serious Business: The Art and Commerce of Animation in America from* Betty Boop *to* Toy Story. New York: Scribner, 1997.

Kaufman, J. B. "Before *Snow White*." *Film History* 5, no. 2 (1993): 158–75.

———. *The Fairest One of All: The Making of Walt Disney's Snow White and the Seven Dwarfs*. San Francisco: Walt Disney Family Foundation Press, 2012.

———. *The Walt Disney Family Museum: The Man, The Magic, The Memories*. New York: Disney Editions, 2009.

Klein, Norman M. *Seven Minutes: The Life and Death of the American Animated Cartoon*. London: Verso Books, 1996.

Knight, Cher Kraus. "Adam and Eve . . . and Goofy: Walt Disney World as the Garden of Eden." *Visual Resources* 14, no. 3 (1999): 339–53.

Korkis, Jim, ed. *How to Be a Disney Historian*. N.p.: Theme Park Press, 2016.

Krause, Martin, and Linda Witkowski. *Walt Disney's Snow White and the Seven Dwarfs: An Art in Its Making*. Exh. Cat., Indianapolis Museum of Art. New York: Hyperion, 1994.

Kuenz, Jane. "It's a Small World After All: Disney and the Pleasures of Identification." *South Atlantic Quarterly* 92 (1993): 63–88.

Kurtti, Jeff. Atlantis: The Lost Empire: *The Illustrated Script*. New York: Disney Editions, 2001.

———. Dinosaur: *The Evolution of an Animated Feature*. New York: Disney Editions, 2000.

Kuwahara, Yasue. "Japanese Culture and Popular Consciousness: Disney's *The Lion King* vs. Tezuka's *Jungle Emperor*." *Journal of Popular Culture*, 31, no. 1 (1997): 37–48.

Lefkon, Wendy. *Atlantis, The Lost Empire: The Illustrated Script*. New York: Disney Editions, 2001.

Leslie, Esther. *Hollywood Flatlands: Animation, Critical Theory, and the Avant-Garde*. New York: Verso, 2002.

———. "*Pocahontas*." *History Workshop Journal* 41 (Spring 1996): 235–39.

Mallory, Michael. "Feature Animation: Not Just Kids Play Anymore." *Animation Magazine* 10, no. 6, #46 (1996): 30–35.

Maltin, Leonard. *The Disney Films*. New York: Disney Editions, 2000.

———. *Of Mice and Magic: A History of American Animated Cartoons*. New York: Plume/Penguin Books, 1987.

McKinnon, Robert J. *Stepping into the Picture: Cartoon Designer Maurice Noble*. Jackson: University Press of Mississippi, 2008.

Merritt, Russell, and J. B. Kaufman. *Walt Disney's Silly Symphonies: A Companion to the Classic Cartoon Series* (rev. ed.). Glendale, CA: Disney Enterprises, 2016.

———. *Walt in Wonderland: The Silent Films of Walt Disney*. Baltimore: Johns Hopkins University Press, 2000.

Mikulak, Bill. "Mickey Meets Mondrian: Cartoons Enter the Museum of Modern Art." *Cinema Journal* 36, no. 3 (1977): 56–72.

Milo, Mike. "Tony Santos: Interviews about Animators by Animators." *Animation Insider*, March 7, 2012. http://www.animationinsider.com/2012/03/tony-santo.

Moore, Alexander. "Walt Disney World: Bounded Ritual Space and the Playful Pilgrimage Center." *Anthropological Quarterly* 53 (1980): 207–218.

Nelson, Steve. "Reel Life Performance: The Disney-MGM Studios." *TDR* 34, no. 4 (1990): 60–78.

Norman, Floyd. *Animated Life: A Lifetime of Tips, Tricks, and Stories from a Disney Legend*. New York: Focal Press, 2013.

O'Brien, Pamela Colby. "The Happiest Films on Earth: A Textual and Contextual Analysis of Walt Disney's *Cinderella* and *The Little Mermaid*." *Women's Studies in Communication* 19, no. 2 (1996): 155–83.

Once Upon a Time: Walt Disney, The Sources of Inspiration for the Disney Studios. Exh. Cat., Galeries Nationales du Grand Palais, Paris. New York: Prestel, 2006.

Paik, Karen. *To Infinity and Beyond! The Story of Pixar Animation Studios*. San Francisco: Chronicle Books, 2007.

Pallant, Chris, ed. *Animated Landscapes: History, Form, and Function*. London: Bloomsbury, 2015.

———. "Disney-Formalism: Rethinking 'Classic Disney.'" *Animation: An Interdisciplinary Journal* (December 2010): 341–52.

Peary, Danny, and Gerald Peary, eds. *The American Animated Cartoon: A Critical Anthology*. New York: Penguin, 1980.

Peters, Jenny. "*Hunchback of Notre Dame*: Ooh La La!! Hunchback Gets Animated and It's an International Affair." *Animation Magazine* 10, no. 6, #46 (1996): 36–43.

Plantec, Peter. "Will Digital Animation Replace Traditional Animators?" *Animation Magazine* 10, no. 6, #46 (1996): 9, 54.

Pilling, Jayne. *A Reader in Animation Studies*. London: John Libbey Publishing, 1997.

Pixar: 25 Years of Animation. Exh. Cat., Oakland Museum of California. San Francisco: Chronicle Books, 2010.

Polson, Tod. *The Noble Approach: Maurice Noble and the Zen of Animation Design*. San Francisco: Chronicle Books, 2013.

Project on Disney. *Inside the Mouse: Work and Play at Disney World*. Durham, NC: Duke University Press, 1995.

Pugh, Tison, and Susan Aronstein, eds. *The Disney Middle Ages: A Fairy-Tale and Fantasy Past*. New York: Palgrave Macmillan, 2012.

Rebello, Stephen. *The Art of* The Hunchback of Notre Dame. New York: Hyperion, 1996.

———. *The Art of* Pocahontas. New York: Hyperion, 1995.

Rebello, Stephen, and Jane Healey. *The Art of* Hercules: *The Chaos of Creation*. New York: Hyperion, 1997.

Roper, Caitlin. "Disney's *Big Hero 6*." *Wired* 22, no. 11 (2014): 96–107, 132.

Rosen, Stanley. "China Goes Hollywood." *Foreign Policy* 134 (Jan./Feb. 2003): 94, 96, 98.

Rubin, Susan. *Animation, the Art, and the Industry*. Englewood Cliffs, NJ: Prentice-Hall, 1984.

Salyers, Stephen N. "The Theme Park as Art and Narrative: A Case Study of the Disney-MGM Studios." PhD diss., Florida State University, 2000.

Schickel, Richard. *The Disney Version: The Life, Times, Art, and Commerce of Walt Disney*. Chicago: Simon and Schuster, 1968.

Schroeder, Russell. *Disney's* Mulan. New York: Disney Press, 1998.

Sito, Tom. *Drawing the Line: The Untold Story of the Animation Union from Bosko to Bart Simpson*. Lexington: University of Kentucky Press, 2006.

Sklar, Marty. *Dream It! Do It!* New York: Disney Editions, 2013.

Smith, Dave. *Disney A-Z: The Official Encyclopedia*. 3rd ed. Glendale, CA: Disney Editions, 2006.

Smith, Lella F. *Dreams Come True: Art of the Classic Fairy Tales from the Walt Disney Studio*. New York: Disney Editions, 2009.

Smoodin, Eric. *Animating Culture: Hollywood Cartoons from the Sound Era*. New Brunswick, NJ: Rutgers University Press, 1993.

———, ed. *Disney Discourse: Producing the Magic Kingdom*. New York: Routledge, 1994.

———. *Snow White and the Seven Dwarfs*. New York: Palgrave Macmillan, 2012.

Solomon, Charles, ed. *The Art of the Animated Image: An Anthology*. Los Angeles: American Film Institute, 1987.

———. *Disney Lost and Found*. New York: Disney Editions, 2008.

———. *The Disney That Never Was*. New York: Hyperion, 1995.

———. *Enchanted Drawings: The History of Animation*. New York: Hyperion, 1989.

Stern, Robert A. M. "The Pop and the Popular at Disney." *Architectural Design: AD* 62 (July/August 1991): 20–23.

Telotte, J. P. "The Changing Space of Animation: Disney's Hybrid Films of the 1940s." *Animation* 2, no. 3 (2007): 245–58.

———. "Disney's Cows, the Mouse, and the Modernist Moment." *Screen* 51, no. 3 (2010): 219–31.

———. "Minor Hazards: Disney and the Color Adventure." *Quarterly Review of Film and Video* 21, no. 4 (2004): 273.

———. "Ub Iwerks' (Multi)Plain Cinema." *Animation* 1, no. 1 (2006): 9–24.

Thomas, Bob. *Walt Disney: An American Original*. New York: Hyperion, 1976.

Thomas, Frank, and Ollie Johnston. *The Disney Villain*. New York: Hyperion, 1993.

———. *Too Funny for Words*. New York: Abbeville Press, 1987.

———. *Walt Disney's* Bambi: *The Story and the Film*. New York: Stewart, Tabori, and Chang, 1990.

Thompson, Kristin. "Implication of the Cel Animation Technique." In *The Cinematic Apparatus,* edited by Teresa de Lauretis and Stephen Heath, 106–120. New York: St. Martin's Press, 1980.

Trites, Roberta. "Disney's Sub/Version of Anderson's *The Little Mermaid.*" *Journal of Popular Film and Television* 18, no. 4 (1991): 146–52.

Walt Disney Feature Animation. *Beauty and the Beast Yearbook*. Burbank, CA: Disney Editions, 1992.

———. *Brother Bear Yearbook*. Burbank, CA: Disney Editions, 2003.

———. *Hercules Yearbook*. Burbank, CA: Disney Editions, 1997.

———. *Hunchback of Notre Dame Yearbook*. Burbank, CA: Disney Editions, 1996.

———. *The Legend of Mulan: A Folding Book of the Ancient Poem That Inspired the Disney Animated Film*. New York: Hyperion, 1998.

———. *Mulan Yearbook*. Burbank, CA: Disney Editions, 1998.

———. *Pocahontas Yearbook*. Burbank, CA: Disney Editions, 1995.

———. *Walt Disney Feature Animation Florida: 1989–1994*. Burbank, CA: Disney Editions, 1994.

Walt Disney Imagineering. *The Imagineering Field Guide to Disney's Hollywood Studio's Tour at Walt Disney World: An Imagineer's-Eye Tour*. New York: Disney Editions, 2010.

Ward, Annalee R. *Mouse Morality: The Rhetoric of Disney Animated Film*. Austin: University of Texas Press, 2002.

Ward, Paul. "Some Thoughts on Practice-Theory Relationships in Animation Studies." *Animation* 1, no. 2 (2006): 229–45.

Warner, Marina. "Beauty and the Beasts." *Sight and Sound* (1992): 6–12.

Weishar, Peter. *Blue Sky: The Art of Computer Animation*. New York: Harry N. Abrams, 2002.

Wells, Paul. *Animation and America*. New Brunswick, NJ: Rutgers University Press, 2002.

———. *Animation: Genre and Authorship*. London: Wallflower, 2002.

Williams, Richard. *The Animator's Survival Kit*. London: Faber and Faber, 2001.

Index

Page references in *italics* refer to illustrations.

public information on, 81; in *The Rescuers Down Under*, 53, 54, 61–66, 67, 195n42, 196n48; rewriting of software, 153; role in finishing process, 115; rotoscoping by, 87; Scientific and Engineering Award, 68, 80, 197n71, 199n29; support of Disney Renaissance, 7, 176–77; synthesizing of multiple media, 94; technical language, 60; in traditional animation, 4, 6, 16; training for, 98; transitions in twenty-first century, 153; transmission of digital data into, 126; turbulence effects, 207n40; 2D effects using, 83, 126, 153, 171; upgrades to, 212n45; use for hard-edged objects, 66, 67; workstations, 163; Z-axis of, 153. *See also* animation, digital; computer-generated images; computerization; 3D imagery, computer-generated

CAPS2, development of of, 212n45

Carola, Dominic, 167

Cartaya, Irma, 122

Cartwright, Randy, 19–20; *Aladdin* work of, 86–88; *Mulan* animation, 123; use of mime, 201n51

Cataya-Tores, Irma, 196n46

Catmull, Ed, 126, 175

Cedeno, Mike, 195n43

cels: CBB ("Could Be Better"), 194n37; commemorative, 30; limited edition, 98, 110. *See also* animation, cel; animation, hand-drawn

cels, Courvoisier: sale of, 29, 188n55

cels, production: reuse of, 29; sale of, 29–30

cels, reproduction, 30, 54; souvenir, 98

Cesar, Darko, 90, 91, 202n63

character development (animation), 3

character motion, planning of, 84

characters: A, B, C levels of, 201n38; artificial personalities of, 87–88, 94; how-to-draw lessons for, 172

China Doll (planned video), 105, 206n20

"China Doll" (postcolonial tale), 119, 205n103

CHIP (CAPS upgrade), 212n45

Clements, Ron, 86; role in Disney Renaissance, 81

Coats, Pam, 202n68; production of *Mulan*, 120, 122

Cohl, Émile, 17, 184n13

Collins, Phil, 149

computer-generated images (CGI), 3, 6, 10; in action/adventure films, 177; combina-

tion with 2D, 67, 126–28, 150–54, 197n66, 216n8, 216n12; combined with hand-drawn animation, 13, 67; compatibility with cels, 67–68; direct import of, 67, 79, 128; Disney management's investment in, 177; Disney's downplaying of, 68; Disney's reliance on, 134; in *The Great Mouse Detective*, 62; hand-drawn, 178, 212n52; importation into CAPS, 128; outsourcing of, 196n60; popularity of, 167. *See also* CAPS; 3D imagery

computerization: in communications revolution, 3; in daily life, 4; and dissolution of Florida studio, 167; effect on social behavior, 167; global workplace of, 65; public comfort with, 168, 170, 171; revolutionizing of business practices, 65; societal dependence on, 3; transition from mechanization, 1, 3–4, 61–66, 81–83, 84, 176. *See also* technological growth

Cook, Barry, 105, 204n103; on *Brother Bear*, 164; on CAPS machinery, 95; direction of *Mulan*, 109, 120, 148; direction of *Off His Rockers*, 92–93, 94, 121, 136, 148, 155; direction of *Trail Mix-Up*, 120, 121, 148, 202n68; "My Peoples" project, 135

Cristiani, Quirino, 200n35

culture, American: effect of technological advancement on, 7, 32, 176–77, 178; pre-digital, 69

culture, global: transformations in late twentieth century, 12

culture, pop: technological affirmation of, 32–33

culture, postmodern: cinematized, 7

Curasi, Paul, 198n8; Animation Services work, 72, 73, 101, 148

Dalí, Salvador, 165

Darley, Pam, *58*, 194n33; on September 11 attacks, 145

Davis, Marc, 49

Dear Basketball (2017), 178; Oscar of, 216n11

DeBlois, Dean, 142, 143

Deja, Andreas, 82; interviews with, 100

Destino (2003), 16, 165

"A Diamond in the Rough" (*Aladdin* documentary), 82, 86

Diana, Princess, 76

Digital Domain Media Group, 191n4

Dinosaur (2000), 89; box office ratings, 133

direct-to-video productions, 53, 105, 193n22; sequels, 134

Disney, Roy E., 15–16, 88, 183n2; advocacy for technology, 176; animation supervision, 16; at Beauty and the Beast wrap, 78; computerization under, 63; conflict with Eisner, 135; death of, 178, 212n70; directorship of Walt Disney Feature Animation, 165, 166, 183n3, 183n5; *The Magic of Disney Animation*, 188n61; at Magic of Disney Animation opening, 49; promotion of animation, 165, 166; resignation from executive board, 165–66, 173, 212n70; "Save Disney" campaign, 165, 175, 212n70

Disney, Roy O., 15

Disney, Walt: on amusement parks, 20; on animation as high art, 19, 88, 186n30; ARL presentation, 8; death of, 109, 210n16; demonstration of animation processes, 17–19, 32, 172; documentary filmmaking practice, 19–20, 21–22; golden age animation of, 28; influences of, 184n15, 185n16; Old World narratives of, 118; use of emerging technology, 60, 80–81, 176; use of sentimentalism, 118; use of xerox, 194n35

Disney Channel, 148

Disneyfication, 185n17; of animation processes, 17, 18; performance of, 38

"Disney Formalism" style, 6, 195n39, 199n23

Disneyland: "Hat" building, 206n24; studio component of, 20–21

Disneyland (television series), 4, 188n60

Disney Merchandising, 159; oversaturation by, 134

Disney-MGM Studios, 1; animation-specific structure of, 112; Backlot Studio Tour, 113, 115, 190n82; Backstage Studio Tour, 37, 186n32, 205n9; cross-corporate branding, 11; filmmaking facility at, 16; live-action filmmaking at, 11; logo of, 117; media war with Universal Studios, 183n7; origin of, 16; Star Tours of, 103, 203n91; target audience of, 11. *See also* Disney's Hollywood Studios

Disney-MGM Studios Guidebook (1989), 187n42

DisneyQuest (digital theme park), 213n78

Disney Renaissance: aesthetic style, 6; archives of, 9; blockbuster period (1991–1994), 2, 4, 71–72, 107; CAPS support of, 7, 176–77; computer's role in, 4; creativity in, 12; decline of, 104, 131, 133–34; film sources during, 118; Florida studio's contribution to, 1, 99, 178; forward momentum of, 79; hand-drawn animation in, 71; male-oriented stories during, 118–19; popularity of, 100, 130; second golden age in, 62, 103, 133, 176; technological advancements during, 7, 12, 61, 176–77; Walt Disney Feature Animation's role in, 48

Disney's American Legends (2002), 141

Disney's Animal Kingdom (Walt Disney World), 11

Disney's Broadway, 164

Disney's Design Group (DDG), 159

Disney's Hollywood Studios, 2, 117; *Star Wars*: Galaxy's Edge, 172; *Star Wars* Launch Bay, 172, 182n16; *Toy Story* Land, 172; transformations to, 172–73. *See also* Disney-MGM Studios

Disney's Polynesian Resort, 144

Disney's Secret Lab (postproduction facility), 165, 204n100

Disney Studios and Archives, 181n5

Disney Television Animation (Disney Toon Studios), 53, 193n22

Disney University, "Make Your Own Magic!" tag line, 170

Disney Village (Disney Springs), 170, 214n78

documentaries, Walt Disney's philosophy of, 19–20

Dopher, Ken, 164

Dorogov, Alexander "Sasha," 90

double bills, 196n59

Douglas, Aaron, 139

Dream On, Silly Dreamer (2005), 147, 154, 210n30

DreamWorks Animation SKG, 104, 105; *The Prince of Egypt*, 130; successes of, 152

Duet (2014), 178, 216n11

Dumbo (1940): Disney Formalism of, 195n39; watercolor backgrounds, 144

Dutton, Jeff, 92

"edutainment," 19; in theme park entertainment, 185n22

Eisner, Michael, 109, 183n2; animators under, 159; conflict with Roy E. Disney, 135; departure from Disney, 175, 215n1; Disney-MGM under, 191n5; executive board chairmanship, 15–16; at Magic of Disney Animation opening, 49; management

team, 15, 104, 159, 165–66; relations with industry studios, 165; television hosting, 183n6; theme parks under, 16, 184n8

Elena of Avalor (television series), 189n77

Ellison, David, 215n5

Epcot (Walt Disney World): *Aladdin*'s Magic Carpet Ride, 168; target audience for, 11

Ernst, Donald W., 192n14; "Pines of Rome" work, 88

Euro-Disneyland theme park: Animation Services' project for, 73; premiere of, 198n6

Famous Studios, 47. *See also* Fleischer Studios

Fanta Orange soda project, 148, 198nn8–9

Fantasia (1940), 88; "Pastoral Symphony" sequence, 59

Fantasia 2000, 16, 202n57; Northside Studio's work in, 154; production of, 91. *See also* "Pines of Rome"

Fantastic Art, Dada, Surrealism (MoMA, 1936), 184n15, 185n16

Feild, Robert Durant: *The Art of Walt Disney*, 4; papers of, 181n1

Felix, Paul, 143–44

Ferrer, Miguel, 122

Finch, Christopher: *Art of the Lion King*, 126

Finding Nemo (2003), 152

Finn, Will, 82; interviews with, 100

Fiske, Sharon, 190n93

Fjellman, Stephen M.: *Vinyl Leaves*, 187n43

Fleischer, Max, 47; three-dimensional camera of, 195n39

Fleischer Studios, 47, 191nn1–2

Florida, rainy season, 109, 114

Florida State University, 191n4

Forrest Gump (1994), 97

Fowler, Jim, 74

France Telecom, 198n7

From the Earth to the Moon (television miniseries), 189n75

Frozen (2013), 171

Fullmer, Randy, 126

Future World (Walt Disney World): World Showcase, 11

Gabriel, Mike, 61

Gannaway, Robert, 211n37

Geffen, David, 204n96

Gertie the Dinosaur (1914), 170, 184n14

Get a Horse (2013), 175

Gielow, Tad, 93, 190n82

Gladstone, Frank, 74, 189n69; management of Artist and Professional Development, 74; on talent raiding, 209n64; at Warner Brothers, 104

Gold, Stanley, 165–66

Goldberg, Eric, 81, 88

Gombert, Ed, 86

Goofy How-To shorts, 148

Google, Advanced Technology and Project Group, 216n11

The Great Mouse Detective (1986), 16, 93; CGI in, 62

Groenveld, Sandra, 127

Gulliver's Travels (1939), 47

Gutowski, Jan, 205n2

Gworek, Don, 203n72

Hadrika, Darlene, 127, 144

Harlem Renaissance, artists of, 139

Hartley, Bridget, *43*, 190n92, 192n15; caricature of, 190n93; filmography of, 190n91; memorial garden, *44*, 45, 190n91, 190n95, 215n83; passing of, 43

Haseley, Mary-Kay, 165

Henn, Mark, 56; *Aladdin* work, 82; interviews with, 100; *John Henry* project, 135, 138; *Lion King* work, 96; *Mulan* animation, 122

Hercules (1997), 103, 107; Sounds of Blackness in, 137

Hines, Gary, 137

Hodge, Tim, 137, 2009n10

Hollywood Reporter, 10

Honey, I Blew Up the Kids (1992), 95

Hoskins, Bob, *51*, 156

Howard, Byron, 187n48

Howard, Max, *22*; on "Camelot," 190n85; creative atmosphere under, 37, 40–41; departure from Florida studio, 164; Eastern European animators and, 90; on Florida studio, 97, 100–101; and Florida studio's potential, 119; on glass wall, 75; on golden age of animation, 28; on guests, 32; at Halloween celebrations, 40; leadership of, 42, 100; on London crew, 50–52; on Magic of Disney Animation tour, 27, 28; promotion of, 101, 104, 204n97; relations with Walt Disney World administration, 42; on *Roger Rabbit* crew, 191n6; on talent raiding, 209n64; theater management background, 42, 79; at Warner Brothers, 104, 189n69, 190n84; at wrap parties, 78

197n3; 2D/3D animation in, 126–27; x-sheets of, 126

The Little Mermaid (1989), 25, 54; awards for, 193n17; CAPS sequence in, 61, 63, 93, 195n41; Oscars of, 52; pencil drawings of, 54; songwriting team, 79; success of, 159; Walt Disney Feature Animation work in, 48, 64–66

live-action films, Disney, 11; male-driven stories, 118

Long, Frank W.: John Henry print, 209n12

Lord, Rachele, 39, 190n82; on CGI, 68

Lund, Dan, 147, 210n30

Lusby, Michael D., *58*

Lyons, Mike, 108, 127, 128

Magic Kingdom (Walt Disney World): Bibbidi Bobbidi Boutique, 171; Cinderella's Castle, 117; SpectroMagic Parade, 72, 198n5; Splash Mountain, 72; target audience for, 11; updating of, 188n63

Magic of Disney Animation attraction (Walt Disney World, Florida): Animation Academy, 170, 171–72; Animation Gallery, 21, 24–26, 29–30, 33, 98, 109, 164, 172; animators on display at, 38–41, 69, 73–77, 162, 189n76; Art Corner, 29, 187n52; attendance figures, 32; audience appeal of, 18; breakdown of, 98–103; cast members/artists of, 38–41, 162; cel animation display, 52; celebrity visitors, 76–77; changing elements in, 32, 160–64; character meet-and-greets at, 170, 171; closure of, 3, 168, 172; computer-literate guests at, 170–71; cultural developments embodied in, 1, 3–4; debut of, 1; design phases of, 9; development states, 168; display of animation processes, 21–30; dual identity with WDFAF, 2, 7, 12, 48, 189n74; educational aspects of, 33, 108; effect of feature film production on, 108; entertainment in, 30–34; entrance to, 115–16; exhibitions at, 23–24; façade, *116*; "fishbowl" of, 98, 109, 163, 171, 203n81; glass walls of, 26, 50, 75, 77; golden age montage of, 28–29; guest immersion in, 6–7, 162–64, 167–71; illusion of traditional animation at, 69; Imagineers' designs for, 21, 26, 27, 34, 72, 172, 213n79; key design elements of, 31; layout of walkthrough, 21–30, *23*; loss of cohesion, 102–3; merchandise from, 24, 29–30, 33; Mickey Mouse display, 26, 187n42; Museum Gallery, 34, 117, 161,

164, 172; museum lobby, 21, *24*, 186n35; nostalgia at, 31, 103; original narrative of, 7; as physical experience, 20; play area, 170; popularity of, 33; proactive experience of, 7; as promotional outlet, 33–34; publicity for, 32, 34, 49; Reassembly Area, 21, 27–28, 162, 163; reconstruction of, 169–71; reliving of narratives at, 32; role of computer display at, 171; separation from WDFAF, 71, 99–103, 107, 157–58, 160; short films at, 24–26, 27; "Star of the Day" program at, 76; teaching function of, 2; as technological spectacle, 33; Theater One, 21, 24–26, 75, 117; Theater Two (Disney Classics Theater), 21, 28–29, 30, 162, 163; as theme park attraction, 21–30, *23*; theme park design, 30–31; tour corridor, 21, 26–27, 32, 49, 54, 69, 75, 103, 160, 163; tour corridor adjustments, 115–18; tour corridor floor, *161*; tour formats, 17; tour hosts, 27, 32, 103, 163; tour revisions, 115–18, 160–64, *162*, 168, 213n60; vicarious experience of animation at, 17; video monitors, 26, 27, 28; video presentations, 19, 21; as voyeuristic exercise, 33, 48. *See also* Walt Disney Feature Animation Florida

Magoo's 1001 Arabian Nights (1959), 81

Maltin, Leonard, 5, 19

manatees, public service announcements for, 73, 136, 209n5

Mancina, Mark, 149

Manovich, Lev, 191n9

maquettes (character statues), 22

Maroon Cartoon series, 51, 120

Marvel franchise, popularity of, 172

Mary Poppins (1964), 184n12, 201n44

Masters, Kim, 16, 184n8

Mathews, Jack, 118

Max Howard Consulting Group, 187n48

Maya software, 128, 154

McCay, Winsor, 170, 184n14

McLaren, Norman, 5, 84

McMahon, Ed, 189n75

Mechanical Concepts, 59

mechanization, transition to computerization, 1, 3–4, 61–66, 81–83, 84, 176

Méliès, Georges, 17, 184n13

#MeToo campaign, in film industry, 215n4

Miami, business incentives in, 47

Mickey Mouse, Sorcerer "weenie" of, *116*, 116–17

Mickey Mouse cartoons, 108; in 3D, 175; crew size for, 158–59

economy, 134; effect on *Lilo and Stitch*, 145; national patriotism following, 141; security following, 160

shadow puppets, in *Mulan*, 124

Shanghai Disney resort, 208n59

Sharp, Margery: *Rescuer* stories, 53

Sharpsteen, Ben, 20

Sheinberg, Sid, 16

Shindell, Jay, 187n48

shorts, animated: experimentation in, 136, 148; filmography of, 5; personal projects, 136

Shrek (2001), 152

SIGGRAPH's Electronic Theater, 195n43

Silicon Graphics Inc., software of, 95

Silly Symphony cartoons, 108; crew size for, 158–59

Sinclair, Sherrie, 76

Sito, Tom, 6, 177; on CGI, 61, 66, 67, 126, 196n60; on Disney Renaissance decline, 133–34; on Gielow, 93; on traditional animation, 32

Sklar, Marty, 188n59; *One Little Spark*, 33

Skydance Animation, 215n5

Sleeping Beauty: Stern Brothers exhibition (1958), 5; traveling exhibition (1959), 4

Sluiter, Ric, 144; Florida projects of, 155; *Mulan* work, 123–24

Small, Edward, 5–6, 84

Smith, Gary W., 65

Smith, Lella, 186n35

smoking, Disney's suppression of, 141

Snow White and the Seven Dwarfs (1937): crew size for, 158; Disney Formalism of, 195n39; documentary explaining, 18; in golden age montage, 28; preproduction on, 108–9; success of, 109

Song Dynasty, ink painting of, 124

Song of the South (1946), 137

Sotheby's, exhibition/auction of cels, 30, 188n57

Sounds of Blackness (choral group), 209nn8–9; in *John Henry*, 137

Southpark (television series), 112, 205n6

Soviet Union, collapse of, 90, 202n62

SPA (Sergio Pablos Animation Studios), 216n8, 216n12

Space Jam (1996), 184n12

Spencer, Clark, 146

Spielberg, Steven, 120, 204n96

Stack, Peter, 119

Stainton, David, 212n68

Stanley, Tony, 151

Stanton, Robert: *John Henry* work, 136, 137, 139, 140; work on *Lilo and Stitch*, 144

Star Search (television series), 189n75

Star Trek franchise, 76

Star Wars franchise, 76, 172–73, 182n17, 182n19

Steamboat Willie (1928), 60

Steele, Billy, 137

Steinberg, Saul, 183n2

Stewart, James B., 175, 204n95, 215n3

Stewart Little series, 192n14

"The Story of the Animated Drawing" (television episode), 19

Stravinsky, Igor: *Firebird*, 91

Sumida, Stuart, 198n16

Superman series, 47

sweat box (rushes): for *The Lion King*, 126; for *The Prince and the Pauper*, 56, 60; production style, 194n37

Takei, George, 123

Tall-Tale series, 141

Tangled (2010), 171

Tarzan (1999), 72, 131; soundtrack of, 142, 149

Taylor, Stephen James, 137

Technicolor film labs, 60; agreement with Disney Studios, 194n38; three-strip, 59

technological growth: in American culture, 7, 32, 176–77, 178; social modification through, 3. *See also* computerization

telecommunications, computer advancements in, 65

television series, Disney, 189n75; sale of cels from, 30; soundstages of, 37

Telotte, J. P., 6, 7 177; *Animating Space*, 50–51, 62–63; on CGI, 68; on Disneyland, 20; on hybrid animation, 85; *The Mouse Machine*, 62; on Zemeckis, 191n9

Temple, Barry, 56, 82; *Mulan* work, 123

Terminator 2 (1991), 85

terra cotta warriors (Qin Dynasty, China), 127

theater, musical: use in animated features, 61, 80, 143

theme park entertainment: cinematized, 6; cultural revolution in, 1; edutainment in, 185n22; under Eisner, 16, 184n8; interactive computer displays at, 168–69; rebranding of, 172; revitalization of 1980s, 16; total immersion in, 6–7

99; after-hours projects of, 91–92; *Aladdin* work, 82, 92; ancillary products of, 72–73; Animation Check department, 57, 62, 65, 110, 159, 163; Animation Services department, 72–73; animators' working environment, 35; Annexes 1–3, 101–3, *102*, 109, *110*; Annex 4, 109, 111–12; Artist and Professional Development division, 74, 150; black-and-white production use, 69, 194n32; as B unit to California, 21, 53, 71, 97, 99, 107, 119; California-Florida relationship, 42; camaraderie at, 41–43, 45, 142, 160, 167, 178; as "Camelot," 190n85; Camera department, 58, 64, 65; CAPS access, 97, 123; cartoon productions, 198n4; catering at, 112; cel animation at, 21, 48; CGI department, 55–56; character wall, *169*; Cleanup (CU), 56, 77, 96, 109, 138, 159; closure of, 2, 118, 135, 164–67, 179, 191n4, 212n64, 216n13; Color Models department, 62, 110, 111; commercials by, 72, 73, 148, 193n19; communal atmosphere of, 159; compartmentalization in, 159–60; Compositing department, 65; contribution to animation history, 4; contribution to Disney Renaissance, 1, 99, 178; contribution to film division, 71; crew expansion, 101–3, 105; crew of, 2, *22*, *113*; crew training, 51–52; departures from, 164–65; differing kinds of imagery at, 96; Digital Ink and Paint department, 65; Digital Paint and Registration department, 159, 163; as Disney showcase, 12, 179; dual animation processes at, 53–54; dual identity with Magic of Disney Animation, 2, 7, 12, 48, 189n74; dual productions with California, 53–54, 193n24; as dynamic production entity, 120; early 3D in, 66–67; effects department, 83, 109; enlargement of, 107, 108–18, *110*, *111*, 129; *esprit de corps* at, 120; experiment in sociological change, 7; factors influencing closure, 134–35; feature films of, 2, 100–101, 108–12; featurettes of, 198n4; fifth anniversary, 107; filmography of, 91, 176, 179; Final Check department, 59, 62, 111; footage quotas of, 35, 39, 41, 52–53, 54, 72, 100, 101; four-story (new) building, 9, 112–18, *113*, 128, 131, 135, 142, 150, 154, 157–64, 215n83; four-story (new) building gym, 111–12, 158; four-story (new) building layouts, *110*, *158*, *162*; four-story (new) building move, 117–18; four-story (new) building opening ceremonies, 157; guest responses to, 35–36; house style of, 155; Ink and Paint department, 54, *58*, 62, 98, 109–10; integration with California studio, 98; interdepartmental communication, 160; internships at, 35, 74, 101; lack of racial diversity, 137; layoffs at, 131, 147; Layout department, 96, 97, 143; lecturers at, 74, 150, 198n16; legacy of, 177–79; life and work at, 8; loss of original identity, 103; in Magic of Disney Animation layout, 21; management of, 2, 77; media coverage of, 10; morale problems at, 104; new identity for, 77–78; opening of, 48–52; oral histories of, 9–10, 12, 41, 178; origin of, 15; overcrowding at, 101; parking garage, 113–14; pencil footage from, 103; photography ban at, 36; popularity of tour, 36; post-9/11 security, 160; preshows produced by, 72; in *The Prince and the Pauper*, 48, 52–60; public persona of, 21; public records of, 8, 10–11; public service announcements by, 72–73, 193n19; rearrangements at, 154; redefinition of roles, 103; relationships with other departments, 34; *The Rescuers Down Under* work, 48, 64–66, 77; responsibility to California studio, 34, 52, 53, 71, 107; retrofitting of, 97; role in *Beauty and the Beast*, 77; role in *Mulan*, 96, 102, 107, 118–28; *Roller Coaster Rabbit* work, 48, 50–52; Scanning department, 159, 163; Scene Planning department, 62, 98, 110–11, 114; segregation between departments, 159; separation from Magic of Disney Animation attraction, 71, 99–103, 107, 157–58, 160; shorts produced by, 91; social interaction activities, 160; Special Effects department, 77, 96, 163, 211n30; technological experimentation at, 85; technological transitions in, 12–13, 61–66; theme park environment of, 2, 11; 3D department, 82; transformation into interactive exhibition, 2; twenty-first century projects, 136–41; 2D Image Processing, 111; upgrading of, 119; Walt Disney World Parks and, 35; water damage to, 114–15; work for Disney partnerships, 73; work outside guest experience, 34; work week of, 35; wrap parties, 77–78; Xerography department, 54, 57, 62, 65, 66. *See*

MARY E. LESCHER (1957–2019) was an animator, art historian, and museum curator. She worked as a cameraperson and scene planner for Walt Disney Feature Animation and DisneyToon Studios from 1989 to 2006. The exhibits she curated include Collectibility: Art and Commodity from the Disney Renaissance and The Florida Studio: Disney Art and Artifact.

The University of Illinois Press
is a founding member of the
Association of University Presses.

———————————————————

Composed in 10.5/13 Adobe Minion Pro
with Avenir display
by Jim Proefrock
at the University of Illinois Press
Manufactured by Bookmobile, Inc.

University of Illinois Press
1325 South Oak Street
Champaign, IL 61820-6903
www.press.uillinois.edu